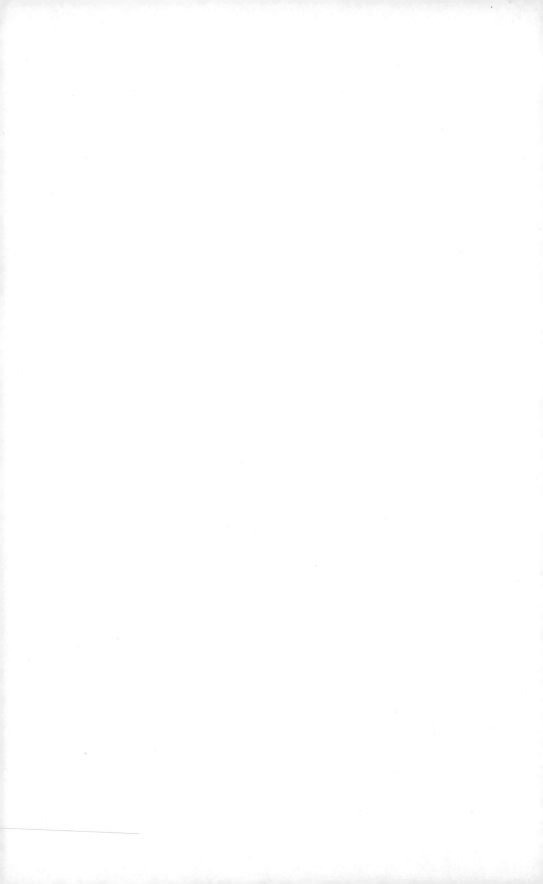

WILLIAM POWELL
FRITH

*To my friend and mentor
the late Jeremy Maas*

WILLIAM POWELL FRITH

A PAINTER & HIS WORLD

CHRISTOPHER WOOD

SUTTON PUBLISHING

Sutton Publishing Limited
Phoenix Mill · Thrupp · Stroud
Gloucestershire · GL5 2BU

First published 2006

British Library Cataloguing in Publication Data
A catalogue record for this book is available from the British Library.

ISBN 0-7509-3845-5

Typeset in 11/14.5pt Sabon
Typesetting and origination by
Sutton Publishing Limited.
Printed and bound in England by
J.H. Haynes & Co. Ltd, Sparkford.

Contents

Colour Plates

between pages 144 and 145

Acknowledgements

When one has been working on a book for thirty years, one is apt to forget who to thank. Frith was the central figure of my book *Victorian Panorama: Paintings of Victorian Life*, published in 1976, and I have been wanting to write a book about him since then. I am grateful to Sutton Publishing for at last giving me the chance to do so.

I have dedicated this book to the late Jeremy Maas, whose books *Gambart, Prince of the Victorian Art World* and *The Prince of Wales's Wedding: the Story of a Picture* contributed so greatly to our knowledge of Frith and the Victorian art world. Had he lived longer, Jeremy might have written a book on Frith, so I see myself as carrying on his work. Anyone writing about Frith is also indebted to Sir Oliver Millar for his magnificent catalogues of pictures of the Royal Collection; to Jeannie Chapel for her catalogue of the pictures at Royal Holloway College; to Mary Cowling for her extraordinary book about art and physiognomy; and to Diana Macleod for her pioneering book about Victorian collectors. (These are all listed in the Bibliography.)

Not surprisingly for a man who had nineteen children, Frith has many descendants. Several have been generous and helpful to me with photographs, information, and memorabilia, in particular Lady Thomas (and her late husband Sir Michael Thomas), William Manners and Laurie Oppenheim (and his late father Charles Oppenheim). I am grateful to them all for their help, and their encouragement over many years. We all look forward to the Frith exhibition in 2006, ably curated by Mark Bills of the Museum of London, and Vivien Knight of the Guildhall Art Gallery; I am grateful to both of them for their support of my book.

The illustrations are all reproduced by the kind permission of their owners, and I can only thank them collectively, be they private individuals, trustees, curators, auctioneers or dealers. I simply could not produce art books without their help. In particular, Simon Toll of Sotheby's has been unfailingly helpful, and also Barbara Thompson of the Witt Library.

I also owe a great debt of gratitude to Olivia Thornton, who has transcribed all the Frith letters at the National Art Library, Victoria and Albert Museum, and the letters to Thomas Miller at the Royal Academy Library: a great feat, considering the awfulness of Frith's handwriting. My son Henry has also been a great help to me in looking up reviews, delving in the basement of the London Library, the British Library and Colindale. Dianne Tyler typed my manuscript (hand-written), and Deborah Greenhalgh has coped brilliantly, as ever, with corrections, alterations, and putting the whole thing together. My thanks also to my editor, Jaqueline Mitchell, for hopefully turning an art historian into a biographer.

Although I wrote most of this book at my School House in Somerset, I always find that I tend to finish books in other people's houses. In this respect, I am grateful to Spyro and Milly Flamburiari in Corfu, Martin and Elaine Buss in Greenwich, Connecticut, and lastly Robert and Ann Wallace in Guernsey. Finally, a big thank you to my wife Rosie for helping to create the conditions under which the book could ever be written at all, let alone finished.

<div align="right">

Christopher Wood
Somerset, 2006

</div>

Introduction

My own interest in Frith began in the 1960s, when I met one of Frith's granddaughters, Miss Flora Hastings, who lived in a large house at Mortlake, by the River Thames. She was by that time an old lady, and although she could remember Frith, she said that the only thing she could recall about him was that he smelt strongly of cigars. Frith died in 1909, two months short of his ninety-first birthday. In 1976 I published my first book about Victorian modern-life painting, *Victorian Panorama – Paintings of Victorian Life*. Frith was the central figure of this book, and I have been planning to write a book about him ever since. Now, thirty years later, I have finally achieved it. Hopefully, I know a little more about Frith, and about Victorian painting, than I did in 1976.

There is as yet no biography, or even good art book about William Powell Frith RA, one of the great figures of the Victorian art world. He was among the most popular and successful of all Victorian artists, the painter of *Ramsgate Sands*, *Derby Day* and *The Railway Station*. In its day, *Derby Day* was hailed as 'the picture of the age'. More than any other artist, it was Frith who created the vogue for paintings of modern life. He has still not had the credit for being the first European artist to paint large groups of people in modern dress, engaged in ordinary, everyday activities; Frith was doing this well before the French Impressionists, who are still credited with 'inventing' the modern-life picture.

Frith's own life spans the entire Victorian age; he was born in 1819, the last year of the reign of King George IV, and the year in which Queen Victoria was born. He died in 1909, the last year of Edward VII's reign, just before the accession of George V. Frith outlived Queen Victoria by eight years, surviving to the ripe old age of ninety, in spite of smoking several cigars every day of his adult life. Frith also outlived two wives, and nearly all his contemporaries. The story of Frith's life is therefore much more than an artist's biography; it is a remarkable picture of the entire Victorian age, told by one of its greatest characters.

Like so many of those eminent Victorians, Frith also lived a double life. In addition to his wife Isabelle, he had a mistress, Mary Alford, whom he married after Isabelle's death in 1880. Between the two ladies Frith notched up an impressive total of nineteen children. In life, as in art, Frith seemed to like crowds. My researches have uncovered new and rather sensational information about Mary Alford, which helps to explain why Frith virtually never mentions his wives or his children in his autobiography. It is not simply that he was obsessed by his own career and his own success, which he was; he was covering up a guilty secret. And his friends covered up for him too; in the entire Frith literature I have not been able to find one reference to Mary Alford. The Victorians certainly knew how to turn a blind eye. The existence of skeletons rattling in the Frith family cupboard is confirmed, indirectly, by remarks made in a book by Frith's daughter Jane ('Cissie'), later Mrs Panton. In her memoirs, *Leaves from a Life*, she makes it very clear that Mary Alford, who she never mentions by name, was 'the one great and fatal error of his life' and 'an evil influence'. As so often when writing a biography, one has to learn to read between the lines.

For anyone writing a life of Frith, his *Autobiography and Reminiscences*, published in 1887, is the primary source. It is a long, discursive and very entertaining book, but it leaves out virtually everything about his private life. I have therefore had to cast my net wider, over a huge ocean of material about Frith and the Victorian art world. Frith's diaries, sadly, have been lost, almost certainly destroyed by his family, but many of his letters survive, as well as several albums of letters written to him. Frith's *Autobiography*, published in two volumes, was so successful that he followed it with a third volume, *Further Reminiscences*, in 1888. The success of these memoirs was not only due to Frith's long and distinguished career; they also reveal him to be an acute, often humorous observer of the Victorian age, and some of its most famous men and women. As all his friends and family knew, he was a born raconteur. Frith seemed to have met everyone – not only all the most famous artists of his day, but writers, actors, royals and personalities as well. Although the *Autobiography* leaves out so much, Frith had no illusions about himself and his abilities: 'I know very well that I never was . . . a great artist, but I am a very successful one. . . .'[1] That statement is typical Frith, laconic, self-deprecating. All his life Frith remained an archetypal Yorkshireman – plain-spoken, stubborn, dogmatic in his opinions, cautious and shrewd in his business affairs,

utterly unimpressed by pomposity and grandeur, but a warm-hearted and hospitable friend once you got to know him.

Frith came from a modest, middle-class background. He grew up in Harrogate, in Yorkshire, where his father was the landlord of the Dragon Inn. His parents were convinced he had artistic talent; Frith himself was not so sure; he thought he would rather be an auctioneer. Frith must be the only example of a boy forced by Victorian parents to take up art as a career. The parents of Atkinson Grimshaw, another Yorkshire artist, were said to have been so horrified to discover that their son was an artist that they threw his paints, palette and brushes on to the fire. This was a much more normal Victorian reaction. So Frith and his father made a pact; they would go to London and show Frith's drawings to a Royal Academician. If the verdict was favourable, he would become an artist; if not, he would become an auctioneer. It was favourable, and in 1835, Frith entered the Academy of Henry Sass, at the tender age of sixteen. Frith's background, and the way he became an artist, inevitably made him cautious, practical and hard-headed. His approach to art was not idealistic but commercial; he was always to be happy supplying what his patrons and the Victorian public wanted. Frith was a typical product of his time; a Samuel Smiles's 'self-help' figure who valued hard work above artistic talent or genius as a means of getting on. He was a Victorian self-made man, like most of his clients, which is why they got on so well together. The story of Frith's life is also a reflection of the changing status of artists that happened right across Europe, and in America, in the nineteenth century. The artist became a respectable member of bourgeois society; a professional man, on a par with other professionals and successful businessmen. Many of them built magnificent houses and studios; although only Leighton House and Linley Sambourne House survive intact, blue plaques on many other grand houses around London bear testimony to the amazing success and prosperity that Victorian artists enjoyed.

Frith's account of his student days, at Sass's Academy and later at the RA Schools, is one of the best we have, describing the long and arduous training that Victorian artists had to undergo. Many artists, such as Rossetti, did not have the patience or the stamina to go through with it. Frith did and followed the academic routine of drawings, studies from the model, composition studies and oil sketches for the rest of his life. Frith and a group of young rebel spirits formed a student group which

they called The Clique. Among them were John Phillip, Richard Dadd, Henry Nelson O'Neil, Alfred Elmore, E.M. Ward, and Augustus Egg. All went on to illustrious careers as Academicians, except of course poor Dadd, who went mad, murdered his father, and spent the rest of his life in lunatic asylums.[2] Henry Sass would invite well-known artists to evening *conversazioni*, and in this way the teenage Frith met Constable, Wilkie, Haydon, Etty, Eastlake, and many of the great artists of the day. Poor Sass soon afterwards went mad too, his illness first manifesting itself in a tendency to sit on other people's hats.

Frith made his name in the 1840s painting historical and literary subjects, becoming an ARA in 1845, and a full RA in 1851, in place of Turner, who died that year. Frith tells many amusing and interesting stories about Turner in his memoirs, including an extraordinary, rambling speech which Turner made at an RA dinner. Frith continued to paint historical subjects to the end of his life, after the vogue for modern-life pictures had declined. Although out of favour today, these historical and literary pictures are an important part of Frith's oeuvre. For one thing, he used much the same methods for his modern-life pictures as he did for his historical ones, so they have to be considered together. Frith painted the present as if it was the past. As the German historian, Richard Muther, put it, Frith painted modern life as if it was 'the good old times'.[3]

Frith claims in his memoirs that he was always inclined towards modern-life subjects. Being naturally cautious, it was not until 1851 that he finally decided 'to try my hand on modern life, with all its drawbacks of unpicturesque dress'. Both Richard Redgrave, and several of the Pre-Raphaelites, had already ventured into modern life, but it was Frith who was to make it both fashionable and popular. Once he realised that modern life was a winner, Frith continued to paint modern-life pictures until the 1880s. He explored the highly emotive topic of gambling, in *The Salon d'Or, Homburg*, and also in his set of five 'gambler's progress' pictures, *The Road to Ruin*. A great admirer of Hogarth, Frith was the only Victorian artist to emulate him, producing two moralistic sets of five pictures, *The Road to Ruin* and *The Race for Wealth*. The fact that both these sets have been out of sight and out of England for many years has been a severe loss to Frith's reputation. Inevitably, Frith's pictures represent a Victorianisation of Hogarth, but they are nonetheless fascinating for that. One of the few artists to emulate Frith's moralistic series was the French artist, Tissot.

Frith was a close friend of several *Punch* editors, notably Mark Lemon and Shirley Brooks, and a welcome guest at *Punch* dinners, usually held on Wednesday nights, when they discussed the 'big cut', the main cartoon for the next issue. Frith's friendship with many of *Punch*'s illustrators – John Leech, John Tenniel, and George du Maurier – undoubtedly influenced his own paintings of modern life. Frith was an especially close friend and admirer of John Leech, about whom he wrote a biography. There can be no doubt that many of Leech's social types found their way into Frith's pictures, and that Frith was Mr Punch's unofficial painter-in-chief. The importance of *Punch* in Frith's life and work cannot be overestimated, which is why I have devoted a chapter to the topic.

One of Frith's greatest difficulties was finding subjects, and he resorted to the surprising expedient of advertising in the press for suggestions, even offering a reward if the subject was used. In spite of receiving many ideas, Frith turned them all down. It seems that modern-life painters had to choose their subjects as carefully as a film producer chooses the subject for a film. It is to Frith's credit that he did choose the right subjects, and he was intensely proud of the fact that a rail was put up to protect his pictures at the Royal Academy no less than six times, still a record.

Frith's modern-life pictures aroused intense passions. Although hugely popular with the public, most critics hated them for that very reason; they thought them vulgar, and not really art at all. Frith had to suffer critical hostility all his life, and claimed he gave up reading reviews. But even his critics had to admit that Frith was the best painter of modern-life subjects. He had many imitators, such as George Elgar Hicks, but for many people Frith was simply *the* painter of Victorian life. No one could equal his ability to manipulate and arrange large groups of figures in a satisfactory whole. No one could equal his ability to characterise successfully, and accurately, so many different social types from all levels of Victorian society. The Victorians were fascinated by physiognomy, and it formed part of the mental apparatus of most Victorian painters, Frith included.[4] Although Frith was sceptical about phrenology, and possibly about physiognomy too, he firmly believed that the face was a sure index of character. He prided himself on his ability to convey character and class through both facial expressions and facial types, and through dress. It was a measure of his success that the Victorian public saw themselves reflected in Frith's paintings; they could spot instantly certain social types

with which they were familiar. This is an important ingredient in Frith's success. His people looked 'right', and he was better at this than any of the other Victorian painters who attempted modern life.

Frith's first great modern-life picture, *Life at the Seaside*, also known as *Ramsgate Sands*, was bought by Queen Victoria and Prince Albert, and Frith remained a favourite with the royal family. In 1863, Queen Victoria commissioned Frith to paint the wedding of the Prince of Wales to Princess Alexandra, one of his biggest and most difficult commissions. His most troublesome sitter was the young Crown Prince of Prussia, later Kaiser Wilhelm II. The surprising fact that Frith received no honour or award for the picture, apart from his fee, argues that Queen Victoria had found out about his irregular domestic situation. Queen Victoria found out about most things, and on marital matters she was inflexible. For years she refused to receive Millais' wife Effie, because she had been divorced from Ruskin. (In fact, the marriage had been annulled.) Frith's other patrons, except for Lord Northwick, were mostly typical Victorian self-made businessmen, and he writes about many of them in his memoirs.5 Around 150 of Frith's letters to Thomas Miller of Preston, one of his most loyal patrons, are preserved in the Royal Academy library, together with a handwritten list of all Miller's pictures, and a large number of the original bills. They shed fascinating light on the artist–patron relationship in the Victorian period, and so far none of this archive, totalling over 700 letters from artists, has been published. Having transcribed all the letters, including those from Frith, I am able to quote from them for the first time.

No one was more involved in the Victorian art market than Frith. He had private patrons, but from the 1850s onwards he found it much more convenient to deal with art dealers. His main dealers were two of the biggest in London, Ernest Gambart and Louis V. Flatow. Both were personal friends of Frith, and he writes about both very entertainingly in his memoirs, as well as giving precise details of their contracts and financial arrangements. Frith was also greatly involved in the Victorian market for reproductive engravings, and benefited from it enormously. The sale of engravings of his pictures spread his fame literally around the world. Gambart sent *Derby Day* on a world tour to promote the sale of the engravings before the picture was given by its owner, Jacob Bell, to the National Gallery. Like Holman Hunt and Millais, Frith was often able to sell the engraving rights to his pictures for as much, or more, than the picture itself.

It was Frith's fate, like so many Victorian artists, to live too long. He lived to see all the artistic beliefs which he held dear completely overthrown, as art moved towards the advent of modernism in the twentieth century. Frith's reaction was to carry on regardless: there was not much else he could do. He refused to change his style, or to adapt to new ideas; instead, he became a reactionary, denouncing French Impressionism, and anything else he saw as threatening the purity of English art. His last major modern-life picture, *A Private View at the Royal Academy in 1881*, was intended as an attack on the aesthetic movement. The picture was a success at the RA, but no one took much notice of the anti-aesthetic message. Once artistic movements get going, no one can stop them, or turn the clock back. Changes in taste are nearly always a deliberate reaction against what went before. Thus the aesthetes were determined to ditch the mid-Victorian, Ruskinian approach to art, along with its moralistic work ethic and insistence on narrative.

The celebrated *Whistler* v. *Ruskin* libel trial of 1878 is now seen by many as the death-knell of the Ruskinian ethos, and the triumph of aestheticism. It came about because of Ruskin's savage criticism of a picture by Whistler at the first Grosvenor Gallery exhibition the previous year, 1877. Ruskin had great difficulty in finding any artists to appear in court on his behalf, but had the bright idea of asking Frith. Frith did so unwillingly, but he proved a good choice, and helped Ruskin's case. He spoke well and forcibly against Whistler, made jokes and engaged in banter with Ruskin's counsel which greatly entertained the gallery. What Frith did not know is that the prosecution planned to use damaging information about his private life to discredit him. In the end they did not use it, and Frith never knew what a lucky escape he had had: it could have ruined his career. By an extraordinary fluke the legal notes in question survive; they are in the Whistler archive in the USA.

As his career as a painter waned, Frith achieved new fame as a writer, with the publication of his autobiography in 1887–8. Quite apart from the story of his own life, the great success of the book was due to the many first-hand descriptions and conversations that he could recall with so many famous and interesting people. His memory was not only vivid, but he enjoyed a good story, and a good joke. Reading his racy and gossipy stories about Victoria and Albert, Kaiser Wilhelm and other royals, about Turner, Constable, Landseer, Dickens, Thackeray,

William Beckford, the Duke of Wellington, the Count d'Orsay, and so many others, not to mention his tall tales about murderers, ghosts and madmen, one can appreciate why Frith's family and many friends so enjoyed his company. One can almost hear the roars of approval around the *Punch* table, thick with cigar smoke. Frith had a truly Dickensian relish for character; he enjoyed people from every walk of life and every level of society. This is no doubt what made him the great painter of modern life.

Frith's *Autobiography and Reminiscences*, I hope, will be republished; it deserves to become a standard text. It is one of the best autobiographies written by an English artist. The Frith exhibition at the Guildhall Gallery in 2006, moving to Harrogate in 2007, may well help to bring this about, as will the publication of this biography. Frith deserves to be better remembered, not just as an artist, but as a remarkable character, a typical Victorian, and a writer; the story of his life is indeed the story of the Victorian age.

ONE

The Wonder of High Harrogate
1819–40

Like so many self-made Victorians, Frith was born in humble, but respectable circumstances. He was also a Yorkshireman, a breed famous for their stubborn independence of spirit and intense pride in their own county. To the end of his life, Frith remained a Yorkshireman at heart, and in all probability retained his Yorkshire accent too.

Frith was born in the small village of Aldfield, near Ripon, on 9 January 1819. Princess Victoria of Kent, later Queen Victoria, was born in May of the same year; she was destined to play an important part in Frith's life. Frith's father worked on the estate of Mrs Lawrence at nearby Studley Royal, a fine eighteenth-century classical house by Colen Campbell. The ruins of Fountains Abbey stand in its grounds. Frith's mother's maiden name was Powell, from which comes his middle name. Frith had two brothers, George born in 1816 and Charles born in 1822, who were not to play a large part in his life as they both died young; his younger sister, Maria, was born in 1825. Frith senior also collected pictures and prints. The youthful William made a copy of one of his father's engravings, a dog by George Morland; his father began to think his son had a talent for art, and rewarded him with a sixpence.

In 1826 the family moved to the prosperous spa town of Harrogate, where Frith's father became the landlord of a large and rambling old inn, the Dragon. Frith went to school, first in Knaresborough in Yorkshire, then at St Margaret's, near Dover, where Frith recalled that he learnt nothing, 'except a little French'.[1] While at school he made a drawing, now in Dover Museum, of an auction, revealing an early interest in auctioneering, and in the contrasting types of character that attended them.[2] He did enjoy reading, especially romantic novels by Mrs Radcliffe, Walter Scott and Fenimore Cooper. Frith continued with his drawings and, before long, as he wrote later in his *Autobiography*

and Reminiscences, he was 'the wonder of high Harrogate'.[3] People called in to see and marvel at his work, which his parents showed off with pride. But when his father asked if he would like to go to London and become a real artist, the young Frith was doubtful: 'I don't care much about it,' he replied.[4] He said he would rather be an auctioneer. 'I had been two or three times to an auction room,' he wrote, 'and the business seemed a very easy, and, I had heard, a profitable one.'[5] Contrary to the norm, it was Frith's parents who urged him to become an artist. So, from the start, Frith's attitude to art was down-to-earth and practical, even mercenary. Like a character in a Victorian novel, he believed more in hard work than in genius or inspiration. He remained to the end of his days modest about his own accomplishments. 'I know very well that I never was, nor under any circumstances could have become, a great artist,' he wrote later, 'but I am a very successful one. . . .'[6]

The whole subject of artistic inspiration and the problems of becoming a professional artist obsessed Frith, and in his *Autobiography* he constantly wrote about it. In his long life he met many artists, and fellow students. Many of them had talent, many did not, but only a handful of the talented ones had a successful career. The moral of all Frith's stories is that it takes more than mere talent to make a successful artist. One typical story concerns a painter, referred to as H., who he was taken to visit in Knaresborough. This artist made a living as a portrait painter, and painted Frith's mother. Frith greatly admired the portrait at the time, but he later wrote that it was 'a forlorn production, without one quality of decent art in it'.[7] The artist H. sent picture after picture to the Royal Academy, and they were all rejected. He became convinced that the Academy was acting out of spite and jealousy and he decided to send in his next picture under an assumed name. Of course, this was rejected too. H. then retired to the north of England where he married a local girl, and settled down to the life of provincial portrait painter. But he remained convinced that the Royal Academy had ruined his career, a belief 'not uncommon amongst disappointed artists', wrote Frith laconically.[8] It was stories like this that doubtless made his *Autobiography* so popular. He was a born story-teller, and his accounts of failed artists make just as good reading as those about his famous contemporaries. He could show his readers, from his own experience, just how difficult and how uncertain the life of an artist really was. Frith quoted Constable, who was asked about

an artist who thought his work should receive more attention, because painting had been his passion all his life. 'Yes,' replied Constable, 'a bad passion.'[9]

However, Frith senior persisted. Consulting distinguished visitors to the Dragon, he was advised to send his son to London to study under Mr Sass, in Charlotte Street, Bloomsbury, who might train him up to enter the Royal Academy Schools. Frith was still doubtful, and protested that his health might not be up to it. His father, not to be deterred, proposed a pact. He would take his son to London, to show his drawings to a 'Mr What's-his-name in Bloomsbury'. If this gentleman thought they were no good, then he agreed to apprentice him to Oxenhams in Oxford Street, where he could learn auctioneering. To this Frith agreed. [10]

And so, on what Frith described as 'a bleak March afternoon in 1835',[11] he and his father set out for London by coach. The journey, which was cramped and uncomfortable, took at least twenty-four hours. By the time Frith was writing in the 1880s, an express train could do it in four hours. Frith, then aged only sixteen, was disappointed by London at first, finding it dirty, ugly and swathed in fog. Most early Victorian visitors must have felt the same. The coach deposited them at the Saracen's Head, Snow Hill, and from there they took a lumbering hackney-coach, drawn by two 'miserable horses', to his uncle's hotel in Brook Street, Mayfair, off Grosvenor Square.[12] The hotel was called Scaife's, and Mr Scaife was married to Frith's mother's sister. Both he and Mrs Scaife were suitably appalled by their nephew's wish to become an artist (a much more normal Victorian reaction), and urged him to settle for auctioneering instead. Mr Scaife expressed contempt for RAs (members of the Royal Academy), declaring them 'poor as rats'[13] and prone to not paying their bills. Nonetheless, he and his wife were kind and hospitable to the young man, and he was to remain devoted to them for the rest of his life.

At first, Frith and his father could not find 'Mr What's-his-name in Bloomsbury', who was Mr Phillips RA. (This must have been Thomas Phillips (1770–1845) who in his younger days had painted a famous portrait of Byron.) Instead, it was decided to approach another RA, John Partridge, who lived nearby. Frith wrote ironically, 'Nothing less than the veto of a real RA would satisfy my father that I was worthy of following the arts.'[14] John Partridge (1790–1872) is little remembered today, although in 1837 he briefly became court painter to the young

Queen Victoria. (He was not in fact an RA.) Partridge looked at the drawings, but declined to comment. He promised to show them to the Chalon brothers, both Academicians, who were visiting him that evening. This was Alfred Edward Chalon (1780–1860) and his brother John James Chalon (1778–1854). Both were noted portrait painters, in oils and watercolours, and Alfred Edward made something of a speciality of ballerinas. Apparently, the Chalons' verdict was favourable, and Frith senior returned in triumph to tell his unenthusiastic son that he was going to be an artist after all.

Frith wrote that he still felt indifferent about the whole thing. He also, with admirable candour, wrote that he showed the drawings many years later to Alfred Chalon himself, thanking him for his 'favourable verdict'. He said to Chalon that 'if it had not been for you I should not have been an artist at all'. Chalon claimed to remember nothing about it, and when shown the drawings, exclaimed, 'I ought to be ashamed of myself.'[15] This self-deprecating humour is typically Frith, and typically Yorkshire. Frith was then taken to meet Thomas Phillips, whose gentlemanly manner and elegance much impressed his father. Phillips treated the young Frith to a discourse on art, of which Frith later wrote that he understood not a word. Breadth, tone, chiaroscuro – what did they all mean?

Mr Frith then visited Sass's School of Art in Bloomsbury, and was much impressed by its size, and the number of large plaster casts. Sass had also agreed to take the young Frith as a lodger. Before handing him over, there was time for a few days' sightseeing. Frith asked if they could go to the theatre. This was to be the beginning of Frith's lifelong love affair with the stage. The first play he saw was Shakespeare's *King John*, with William Macready as the King, and Charles Kemble as Falconbridge. 'Can I ever forget it, or my delight in it?' he wrote.[16]

His pleasure was marred by his father, typically, having a noisy argument with his neighbour, who insisted on sucking oranges in 'a loud slobbery fashion' at critical moments. Frith also went to see Madame Vestris, and 'fell madly in love with her at once', as did most young Victorian men at the time.[17] Madame Vestris was one of the leading actresses and beauties of her day; she was also one of the first women to become an actor-manager. Frith was stage-struck, and it was to be a passion that never left him. He was later to befriend many of the great actors, actresses and playwrights of the Victorian age.

But finally the dreaded day came, when he and his father set off from Brook Street to Charlotte Street. The father plied the son with fatherly advice; the son was more concerned about how much pocket-money he was going to get. He had on him a few shillings, and a half-sovereign his mother had given him. His father gave him £2, and told him to keep an account book. If he needed more money, he must apply to his uncle. At this stage the young Frith burst into tears. As they parted, his gruff father, a man of few words, kissed him goodbye. Frith wrote, 'I can feel now the rough scrub of his shaven chin.'[18] He then entered no. 6 Charlotte Street, which was to be his home for the next two years.

Henry Sass had been a student of the Royal Academy, and was a contemporary of Wilkie, Mulready and B.R. Haydon. Artistic success eluded him, and like many nineteenth-century artists, he took to teaching instead. Frith did not have a high opinion of Sass as a painter, and wrote that 'his pictures were coldly correct, never displaying an approach to the sacred fire of genius, and almost always unsaleable'. He occasionally exhibited small pictures at the Royal Academy, usually entitled *A Study of a Head*. Frith noted that even one of these was slated by a critic, who wrote, 'Mr Sass continues to exhibit a study of something which he persists in calling a head'.[19] Once again, poor Sass attributed his lack of success to the ignorance of the public, and the malignity of the critics. But he proved a dedicated and respected teacher. Many future Academicians passed through his school, including the young Millais.

Frith found the course slow and arduous. First there was 'drawing from the flat', which consisted of copying outlines from antique sculpture, prepared by Sass himself. These had to be repeated until Sass felt able to write 'Bene' at the bottom. Then, and only then, was the pupil allowed to move on to the mysteries of light and shade. A large white plaster ball, on a pedestal, had to be drawn endlessly, followed by a large bunch of plaster grapes. Frith spent six weeks working on the plaster ball, and soon began to feel impatient. Antique fragments then followed, especially feet and hands, and finally the entire figure. Frith was bored by the whole procedure, but spent his evenings drawing from the Italian Masters: Michelangelo, Guercino, the Carracci and Poussin. Frith later regretted that he had not applied himself more to drawing, but he clearly found the academic routine irksome. Nonetheless, he was awarded a medal for drawing by the Society of Arts in 1835, which he reported home in letters to his mother.[20] Among his fellow students

were Edward Lear and Abraham Solomon, elder brother of Rebecca and Simeon Solomon, both of whom were later to become artists, and two grandiloquently named sons of artists, Michael Angelo Green and Claude Lorraine Richard Wilson Brown; of the two latter, absolutely nothing further is known. In spite of their names, they seem to have sunk without trace.

Although benevolent at heart, Sass had an explosive temper, and pupils were often expelled for cheeky behaviour. One such was Jacob Bell, son of a prosperous chemist, who later became a collector of pictures, and a friend and patron of Frith. Bell's father, a strict Quaker, strongly disapproved of his son buying pictures; Frith recorded the following conversation between them:

'What business hast thou to buy those things, wasting thy substance?'
 'I can sell any of these things for more than I gave for them, some for twice as much.'
 'Is that verily so?' said the old man. 'Then I see no sin in buying more.'[21]

Mr and Mrs Sass were kind to the young Frith, and treated him as one of the family. They also introduced him to many of the great artists of the day, who often came to call. One day Wilkie arrived, and Sass urged him to stay. Wilkie, very tall and wearing a long blue cloak, demurred, saying he was in a hurry. Sass pointed out the young Frith to him, as 'one of my pupils who has just finished his drawing for the Academy'. 'Varra weel,' replied Wilkie, in a thick Scottish accent, and then left.[22]

Sass also gave evening *conversazioni*, at which Frith met other well-known artists and personalities of the day – William Etty, John Martin, Charles Eastlake, Constable and Wilkie. At one of these, Frith sat between Eastlake and Constable, but was too shy to speak. Frith had the greatest admiration for Constable, but described him as 'an embittered, disappointed man. . . . For whilst artists of far inferior talent sold their pictures readily and for large sums, Constable was neglected and unpopular.'[23]

After two hard years of drawing, Frith was admitted as a student of the Royal Academy. This meant he could begin painting, and for this he returned once again to Sass's Academy. At first, only black and white paints were provided, and the students made studies, in monochrome,

from an antique model. Frith wrote that from that moment he began to take real pleasure in his work. After all the dreary months of drawing, to work with the brush was a delight, and gave him a real sense of liberation at last. He became frustrated yet again, by having to make endless copies from the Old Masters. He pleaded with Sass, who finally allowed him to move on to still life. His first attempt was a still life of a brown jar, a wicker oil bottle and an old inkstand.

From this he moved on to painting the figure, using the Sass boys as models. One of these, *A Page with a Letter*, he entered for the British Institution in Pall Mall, where it was hung. This was his first ever success, and he felt suitably elated. He crossed swords with Sass yet again, because of his habit of picking up striking characters in the street, and persuading them to model for him. Sass strongly disapproved, but already the young Frith was showing his inclination towards real life.

Sass's behaviour became increasingly eccentric and forgetful, the first signs of mental trouble. His illness manifested itself on a trip with the students to Hampton Court Palace. Sass insisted that he was wearing a gibus or folding hat. He was in fact wearing a white beaver hat, and proceeded to sit on it. He wore the flattened beaver for the rest of the day, insisting that it was a gibus. The students laughed, but matters grew steadily worse. Poor Sass was going mad, and in the end the school had to close. Frith was lavish in his praise; in his book he wrote, 'I feel I owe everything to him and his teaching', and he felt many Academicians would say the same.[24]

At the Royal Academy, Frith was now allowed to visit the Life School, which he much enjoyed, and paint from the nude model. One, a guardsman called Brunskill, was a particular favourite, because of his magnificent physique, and ability to hold difficult poses. One day he arrived late, and had clearly been drinking. For a while he struggled with the pose, but eventually announced: 'I can't do it. I ain't fit to do it. This 'ere thing what I hold ain't right. Nothing's right, so I wish you gentlemen good night. There now!'[25] On another occasion, Frith noticed that a female model, posing in the nude, was crying. He pointed this out to the RA present, George Jones, who told him to ignore it and carry on. Some months later, the same girl came to Frith's house to model, although this time not in the nude. Frith recognised her, and asked why she had modelled at the Academy. She replied that she had done it to prevent her father going to prison for debt, and would never do it again. Like many Victorian artists, Frith loved telling stories about

models. He was also a firm believer in the importance of studying from the nude figure.

George Jones RA, then in charge of the Academy Schools, was a battle painter, and prided himself on his resemblance to the Duke of Wellington. Frith later wrote that the Duke, hearing of this, remarked that 'no one ever mistakes me for Mr Jones'.[26] Jones painted a large picture of the Battle of Waterloo (now in the Institute of Directors, Pall Mall, London). On seeing it, the Duke observed that there was 'too much smoke'.

Another RA who occasionally acted as a 'visitor' (i.e. teacher) to the Life School was the great Edwin Landseer, by that time a famous and fashionable figure. He made no attempt to teach the students, but merely sat and read a book. One night an old gentleman shuffled into the room, wearing slippers and with a speaking-trumpet under his arm. It was John Landseer, the celebrated engraver, and Edwin's father. Frith recorded the conversation that ensued, with both men bellowing at the tops of their voices:

'You are not drawing then, why don't you draw?' said the old man, in a loud voice.

'Don't feel inclined,' shouted the son down the trumpet.

'Then you ought to feel inclined. That's a fine figure; get out your paper and draw.'

'Haven't got any paper,' said the son.

'What's that book?' said the father.

'Oliver Twist,' said Edwin Landseer, in a voice loud enough to reach Trafalgar Square. [The Royal Academy was then situated in the National Gallery.]

'Is it about art?'

'No, it's about Oliver Twist.'

'Let me look at it. Ha! It's some of Dickens's nonsense, I see. You'd much better draw than waste your time upon such stuff as that.'[27]

Frith had an extraordinary memory for conversations, and quotes many of them in his book.

Art students have a habit of banding themselves together into groups. It was very common in Victorian times, and many sketch clubs, social clubs, and other associations were formed in the nineteenth century, the most celebrated being the Pre-Raphaelite Brotherhood. Frith belonged

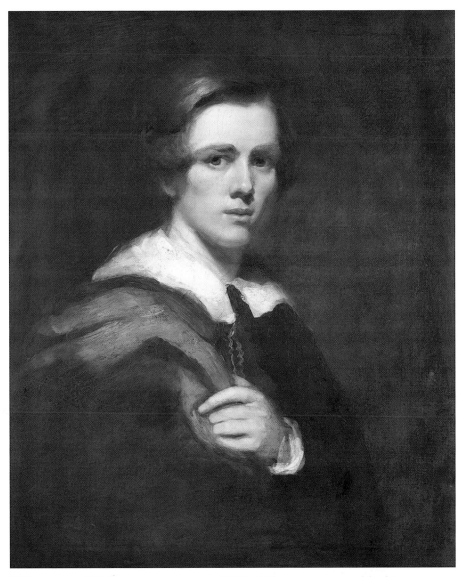

Self-portrait of Frith as a young man, *c.* 1840. Frith was encouraged by his parents to take up art; he preferred the idea of becoming an auctioneer. At first, he supported himself by painting portraits. *(Private Collection)*

to an artistic group, now known as the Clique, though he does not refer to it as such. It included John Phillip, Richard Dadd, Henry Nelson O'Neil, Alfred Elmore, E.M. Ward and Augustus Egg. Of these, the one best remembered today is the fairy painter, Richard Dadd, who later went mad and murdered his father. Frith wrote of him as 'a man of

genius . . . had not a terrible affliction darkened one of the noblest of
natures and brightest minds that ever existed . . . the noble mind is
destroyed, though the body still survives'.[28] The Clique was part club of
friends, part sketching club, but it did not survive their student days.
They were all to remain close friends, without The Clique. A portrait of
the young Frith, painted at this time by his friend Egg, shows a dark-
haired, slight young man, with a sensitive face, and calm, penetrating
eyes.

At this time, Frith also began to support himself by painting portraits.
First he painted his uncle and aunt Scaife, and several of their friends.
This led to his first real commission, to paint an old gentleman from
Lincolnshire, for which he was paid £5. He then visited Lincolnshire
where he 'went from house to house, chiefly among the higher class of
gentleman farmers . . .'.[29] After four months he decided it was time to
return to London, but he always regarded it as very useful experience.

In 1837, Frith's father died, on a visit to London. He was only sixty,
but had suffered badly from asthma, and this, combined with a bad
attack of influenza, carried him off. As a result of this, Frith's mother
decided to sell up the Dragon in Harrogate, and move to London. A
house was found at 11 Osnaburgh Street in Paddington, just north of
Hyde Park. Frith moved in with his mother and brother, and a new
chapter in his life began.

TWO

Early Struggles and Successes
1840–5

Like most young Victorian artists, Frith struggled in his early years to establish himself. Following the fashion of the day, he painted costume pictures, drawn from literary or historical sources. With one of these, he achieved his first sale, always an important moment. The picture was of two lovers, the man 'in a Spanish costume fresh from the masquerade shop'.[1] He sent the picture to the Liverpool Exhibition, where it sold for £15.

Encouraged by this, Frith moved to larger, more complicated pictures, based on the works of Walter Scott, one of his favourite authors: one from *The Lay of the Last Minstrel* and another from *The Heart of Midlothian*. Although Scott was dead, his novels were still hugely popular both in England and all over Europe. *The Lay of the Last Minstrel* was one of Queen Victoria's favourite poems. Both pictures caused him immense difficulty, both in composition, and in finding suitable models. These and two others, *Rebecca and Ivanhoe*, and a scene from *Othello*, were all sent to the Royal Society of British Artists in Suffolk Street. This was a less prestigious alternative to the Royal Academy exhibitions, but many well-known artists exhibited pictures there, as well as young artists trying to attract attention. Frith conspicuously failed in this, and *Rebecca and Ivanhoe* was rejected, the only picture Frith ever had rejected in his life. But he did receive his first notice in the press. The *Art Journal*, at that point still called the *Art Union*, praised some of his pictures, and concluded, 'The young painter has given proof that he thinks whilst he labours.'[2]

At the Suffolk Street Galleries, Frith attended a lecture by Benjamin Robert Haydon, the painter of grandiose historical scenes. Frith and Haydon became friends, and the older artist was generous with help and advice. Frith called on Haydon, who was working on two huge cartoons for the Houses of Parliament Competition, *The Expulsion*

from Paradise and *The Entry of the Black Prince into London*. It was the rejection of these that was to lead to Haydon's tragic suicide in 1846. Nowadays Haydon is less remembered for his pictures, which have mostly sunk without trace, than for his wonderful journals. These are among the best, and most readable diaries of the nineteenth century.[3]

In 1840, Frith exhibited his first picture at the Academy. The subject was *Malvolio, cross-gartered before the Countess Olivia*, from Shakespeare's *Twelfth Night*. Frith waited in trepidation to hear whether it had been accepted. A friendly RA porter called Williamson sent him a pencilled note to say that his picture was in, and hung. At the opening, Frith looked everywhere for his picture, and could not find it. He had to find Williamson, who took him to the Architecture Room where the picture was hung high up and virtually invisible.

In the 1840s, the custom of 'varnishing days' still prevailed at the Royal Academy. This allowed the RAs to come in and make final touches to their pictures, as well as re-varnishing them. Generally varnishing extended to three days, but by the time Frith became an Associate in 1844, this had increased to a week, with convivial lunches laid on in the Council Room. Frith also records that one artist went so far as to tone down and re-varnish a picture by an non-RA artist hanging next to his, as he thought its colours clashed with his own picture. The artist complained that his picture, a portrait of an admiral, had been tampered with, the culprit was reprimanded, and the practice forbidden in future. It was thereafter referred to as 'toning down the admiral'. Frith himself did not make great use of varnishing days, but he approved of the idea, particularly as a social occasion. One artist who made full use of varnishing days was the great J.M.W. Turner, by then in the last decade of his life. In his long coat and top hat, which made him look like a coachman, he was famous for repainting and finishing entire pictures on varnishing days. Although revered by his fellow artists, his late works mystified and horrified the general public and most of the critics. It was for this reason that a young Oxford graduate named John Ruskin wrote his celebrated defence of Turner, published in the first volume of his *Modern Painters* in 1843.

Frith's income from painting was still not enough 'to pay for my washing', as his uncle Scaife put it.[4] He was reduced to selling his pictures to friends for very modest sums, which they often forgot to pay. Sometimes he simply gave them away. The *Malvolio and Olivia* picture

was bought for £20 by a picture dealer who immediately went bankrupt. Things looked bleak and his uncle suggested he try auctioneering instead. To make money, Frith went back to Lincolnshire, where he had already painted a number of portraits, mostly of farmers; this time he painted several members of the gentry, and county squires.

An artist whom Frith greatly admired at this stage was the brilliant Irish artist, Daniel Maclise (1806–70), then enjoying great success with his historical and fairy pictures. Like many other artists of the 1840s, Frith tried to imitate Maclise, which he later admitted was a mistake. 'Until a young painter finds out his natural bent,' he wrote, 'he is apt not only to imitate the manner of his favourite artist, but also to try and paint similar subjects.'[5] It was Maclise who helped to popularise subjects from *Gil Blas* and *The Vicar of Wakefield*. This led Thackeray, who wrote art criticism for *Fraser's Magazine* to suggest that a separate room should be set aside for pictures of 'The V——r of W——d' as he would mockingly refer to them. In his book, Frith advised all artists, young and old, never to read art criticism, and claimed that he never did.[6]

In spite of Thackeray's remarks, Frith enjoyed his first success at the Royal Academy in 1842 with a subject from *The Vicar of Wakefield*. The scene was that in which Mrs Primrose makes her daughter and Squire Thornhill stand back to back to see who is the tallest. The picture was hung on the line (at eye level), and was sold on Private View day for 100 guineas (in other words £100 plus 100 shillings, or £105) to Mr Zouch Troughton, who was to remain a faithful friend and supporter. Encouraged by this success, Frith set about a larger composition, with more figures, of all the main characters in Shakespeare's *The Merry Wives of Windsor*. This he sent off to the Royal Academy of 1843, where it was skied in the Octagon Room, and failed to sell. Frith relates that William Etty climbed some steps to get a look at it, and then consoled Frith 'in his gentle voice, "very cruel, very cruel"'.[7] Frith sent it to Liverpool, where it sold for £100. Later it was lent to another London exhibition gallery, the British Institution, much used by RAs for pictures that had not sold at the Academy. Frith continued to exhibit occasionally at the British Institution, which lasted until 1867. After this the only rivals to the RA's monopoly were the Society of British Artists, the Dudley Gallery, which opened in 1865, and the Grosvenor, which opened in 1877.

Frith's greatest difficulty was finding a good subject, and he wrote that, 'my inclination being strongly towards the illustration of modern

life', he began to read the works of Dickens in search of inspiration. He chose Dolly Varden, a character from *Barnaby Rudge*, and painted at least four different versions of her, all of which sold easily. The one to become most famous was the laughing Dolly standing by a tree, which was later engraved. Early in 1842 Frith had been astonished and delighted to receive a letter from the great man himself:

> My Dear Sir
> I shall be very glad if you will do me the favour to paint me two little companion pictures, one, a Dolly Varden (whom you have so exquisitely done already), the other a Kate Nickleby.
>
> Faithfully yours always
> Charles Dickens.[8]

So great was their respect and admiration for Dickens that, Frith wrote, he and his mother both wept tears of joy on receipt of this letter. Frith was then very concerned that Dickens should be pleased with *Kate Nickleby*, and made many sketches for her. Finally, he fixed upon a scene showing her seated sewing a ball-gown, when she was working as a seamstress for Madame Mantalini. Then came the great day when the author himself called to see the pictures. Frith describes the scene: 'Enter a pale young man with long hair, a white hat, and a formidable stick in his left hand, and his right hand extended to me with a frank cordiality, and a friendly clasp that never relaxed until the day of his untimely death.' Frith and Dickens were from much the same lower-middle-class backgrounds and, not surprisingly, they were to remain firm friends until Dickens's death in 1870. Dickens then sat down before the easel, and looked at the two pictures. Frith waited in suspense until Dickens announced, 'All I can say is, they are exactly what I meant, and I am very much obliged to you for painting them for me.' Dickens then proposed calling the following Sunday with his wife and sister-in-law. They duly came, saw and approved, and Dickens gave Frith a cheque for £40. Frith was proud to record that at the Dickens sale at Christie's in 1870, the pair sold for 1,300 guineas.[9]

Frith may have been encouraged by this success with a modern-life subject, yet it was to be over ten years until he felt confident enough to embark on a major picture of this type. Until 1852, he continued to exhibit only historical and literary pictures at the Academy. He knew they were a safe bet, and was not prepared to take risks. The only artist

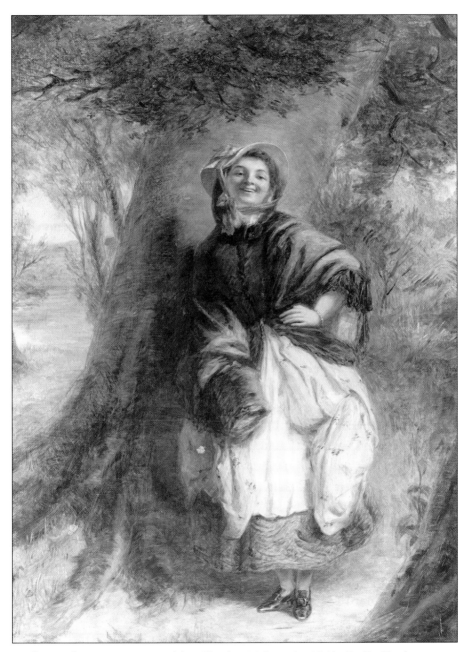

Dolly Varden. Commissioned by Charles Dickens in 1842, Dolly Varden was a character from *Barnaby Rudge.* It was Frith's first attempt at a modern-life subject; he painted many versions of it. *(Photo: Sotheby's, London)*

brave enough to paint modern life in the 1840s was Richard Redgrave (1804–88). His picture *The Seamstress* (privately owned), based on Thomas Hood's celebrated poem *The Song of the Shirt* caused a sensation when it was exhibited at the RA in 1844. Redgrave followed this up with *The Poor Teacher*, of which there are several versions, one in the Victoria and Albert Museum, *Fashion's Slaves* (privately owned) and other pictures drawing attention to the exploitation of female labour. It is Redgrave who really deserves the title of the Father of Victorian modern-life painting.[10]

Frith's relations with the other great Victorian novelist, Thackeray, were not so cordial. He met Thackeray at a club in Dean Street, Soho, called the Deanery. They shook hands, but Frith was so overawed by the company that he did not venture to speak. Later, Thackeray sang a song, and then seemed to single Frith out. 'Now then, Frith, you damned saturnine young Academician, sing us a song.' Frith was again too shy to oblige, and later Thackeray said to him, 'I tell you what it is, Frith, you had better go home; your aunt is sitting up for you with a big muffin.' Frith felt both pained and humiliated, but he did not shirk telling the story in his book.[11]

Feeling the need to escape from these bruising experiences at the hands of Thackeray and the Royal Academy, Frith decided it was time for a trip to Europe. With his fellow Clique member, Augustus Leopold Egg, he set out up the Rhine for Cologne, taking in Antwerp and Brussels on the way. In Antwerp, he felt a sense of inferiority before the works of Rubens, as any artist would do. Coming back via Paris, he visited the Salon, and was impressed by the technique and talent of many French painters. He arrived back in London refreshed and reinvigorated, determined to press on with his career, and do better.

On his return, Frith completed two more historical pictures for the Academy of 1844. Once again he chose a scene from the dreaded *Vicar of Wakefield*: '*Thornhill relating his London adventures to the Vicar's family*'. The other picture was of *Knox reproving Mary Queen of Scots*. At the RA exhibition, there were two pictures of identical subjects, one by William Mulready, the other by Alfred Edward Chalon. But it was Frith's *Vicar of Wakefield* that was hung on the line, and as he wrote proudly later, 'for the last eight and forty years, I have never been off it'.[12]

Frith was by this time beginning to acquire patrons. One of the first was John Gibbons, a Birmingham banker. Frith had sent two pictures to

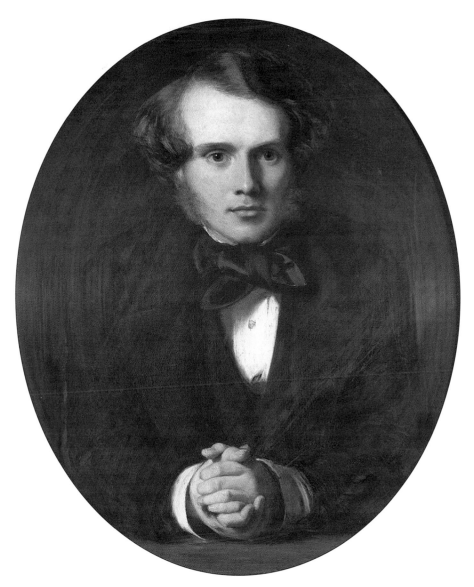

Augustus Leopold Egg RA: Portrait of Frith in the 1840s. The young Frith, painted by Augustus Egg, a fellow-student at Sass's Academy and a lifelong friend. *(Private Collection)*

an exhibition in Birmingham, where they were both sold. Gibbons, arriving too late, commissioned Frith to paint a subject from Sterne or Goldsmith. Frith suggested some lines from Goldsmith's *A Deserted Village*. The picture was to be called *The Village Pastor* and the price agreed was £200, the highest price Frith had so far achieved. Although

Gibbons was by then elderly, and in poor health, he came to visit Frith in London to see how the picture was getting on. He also made suggestions, some of which Frith found useful. Gibbons amassed a large collection of English pictures, including works by Turner, Constable, Gainsborough, Francis Danby, John Linnell, William Mulready, Richard Redgrave, David Wilkie and many others, including Frith, Thomas Creswick and Charles Robert Leslie. Although Gibbons died in 1851, his collection was not dispersed at Christie's until 26 May 1894.[13] A number of the pictures were unsold, and remain in the possession of his descendants today. When Gibbons sold one of Frith's pictures at a good profit, he gave Frith a present of 50 guineas.

The Village Pastor was completed, and duly shown at the RA exhibition of 1845. By this time, Frith had become a close friend of the landscape painter, Thomas Creswick. In future, they were often to paint pictures together, Frith putting the figures into Creswick's landscapes. Creswick suggested that he should put his name forward as an Associate member of the RA, which you had to do before becoming a full member. Frith thought it a crazy idea, thinking he had no hope whatever and was too young. Creswick, however, went ahead. To his complete astonishment, Frith was told by his porter friend Williamson that he had been elected. At first, Frith thought Williamson was pulling his leg, but a few hours later, he received his diploma, signed by Turner. He was now allowed to put ARA after his name.

At that time, it was still the custom for new ARAs to go round and visit all the Academicians, to make their acquaintance. Frith found this an arduous chore, particularly as most of the RAs were not at home, and those that were had no idea who he was. Frith had heard of this happening to other ARAs. To one young painter, an old Academician said, 'Well, I suppose I must congratulate you. You are an *architect*, ain't you?'[14] Frith called on the portrait painter, Henry William Pickersgill, who was kindly and polite, but Mrs Pickersgill, on being introduced to the new ARA, said, 'Well . . . he is no better for that.'[15]

Frith was also now eligible to attend his first Academy dinner. He was to attend many more, but he never forgot his first. Sir Martin Archer Shee, a portrait painter in the Lawrence tradition, was still President (he died in 1850), and the principal speaker was the Duke of Wellington, by then a hugely revered national figure. Frith was as fascinated as any young man might be, to hear the victor of Waterloo speak. He wrote of it: 'after the toast of "The Army and Navy" the great Duke rose to

reply. I can see him now, the grey head bent in acknowledgement of the thunder of applause that greeted him, the broad blue ribbon of the Garter across the white waistcoat, and then the thin piping voice in which, in a few well-chosen words, he replied to the toast.'[16] Later Frith encountered the Duke looking at Turner's now famous *Rain, Steam and Speed* (National Gallery) and reading the quotation from the artist's poem, *The Fallacies of Hope*. 'Ah, poetry,' muttered the Duke and moved on. Like most of Turner's contemporaries, Frith could not understand the picture, which he described as 'a rather eccentric representation of a train in full speed on the Great Western Railway'.[17] At the same dinner, Frith saw the aged banker and poet Samuel Rogers descend the stairs on the arm of Dickens. According to Maclise, Rogers looked 'so old, that Death seemed to have forgotten him'.[18] Frith's career was beginning to blossom at last.

Curiously, Frith fails to mention in his book another important event that happened in 1845: on 22 June, he married Isabelle Baker, a pretty, dark-haired woman who was often to appear in his pictures. Frith made a drawing of her, inscribed 'Benny', which may have been his nickname for her.[19] Isabelle's family was also from Yorkshire, and she had been born at Studley Royal, so Frith must have known her, or her family, from childhood. Isabelle's mother, a woman much given to visions and dire prophecies, was born in York, and claimed Roman descent.[20] Isabelle also had a sister, Victoria, known as Vicky. She and Frith became very close friends, and she lived for a time in their household. Frith wrote many of his letters to Vicky, and referred to her as his 'sister'. Frith and his wife were to have twelve children, of whom ten survived, five sons and five daughters. At the time, Frith was still living at 11 Osnaburgh Street, Regents Park, but by 1846 he and his wife had moved to 31 Charlotte Street, an area north of Soho now called Fitzrovia.

THREE

The Young Academician
1845–52

Encouraged by his early successes, Frith embarked on a new and larger subject, but once again looked to the past for inspiration. The picture was called *An Old English Merrymaking*, an evocation of English village life in Tudor times. The Victorians had a seemingly limitless appetite for nostalgic pictures of the 'golden olden tyme' as it was frequently called. This mood pervaded much of the art and architecture of the time, and produced a spate of neo-gothic and Jacobethan country houses. In politics, it had its equivalent in Disraeli's Young England group, who longed for a return to what they imagined was the paternalistic benevolence of feudal times. Most Victorians thought their own age irredeemably ugly and unromantic.

The picture was a large composition of many figures, and Frith wrote, 'I put no trust in fancy for the smallest detail of the picture.'[1] Even the oak tree was painted from a large and venerable tree in Windsor Great Park. As usual, Frith had great difficulty with models, in particular with one old woman who was terrified by the suit of armour in Frith's studio. She would only return if 'the steel man' was removed.[2] His friend Thomas Creswick helped him with the landscape background. When the picture was shown in Frith's house on 'Show Sunday', the Sunday before the opening of the RA exhibition, Creswick came to visit. A stranger whispered to him, 'What a pity it is, Mr Creswick, that these figure painters don't study landscape more! Look how bad that is!' He was pointing to the very area painted by Creswick.[3] The custom of opening your studio on 'Show Sunday' was a major day in the Victorian social calendar. It naturally gave rise to many funny stories about visitors' remarks, many of which ended up as cartoons in *Punch*.

The *Merrymaking* picture was hung on the line at the RA of 1847, and was sold to a dealer for £350. It subsequently changed hands many times, and by the 1880s was in a collection in the north of England.

Frith was proud to hear that even the great Turner had remarked that it was 'beautifully drawn, well composed, and well coloured'.[4] Frith of course was fascinated to meet Turner, and his book contains many anecdotes about him. In general Turner was kindly and considerate towards younger artists, and on occasions helped Frith by retouching small details in his pictures. Turner was also extremely reluctant to criticise other artists, and the most he could bring himself to say about a poorly painted picture was that 'it was a poor bit'.[5] Frith denied that Turner painted entire pictures during varnishing days, but he was not above re-painting large areas of a picture to make it stand out from the pictures around it. Frith tells one story of Turner steadily adding huge amounts of blue to a picture, which was hanging next to a rather pale and delicate view of Edinburgh by David Roberts. Eventually Roberts was moved to protest, in a broad Scottish accent. 'You are making that varra blue,' he observed. Turner said nothing, but went on adding more blue. At last Roberts could stand it no more, and remonstrated, 'I'll tell ye what it is, Turner, you're just playing the devil with my picture, with that sky – ye never saw such a sky as that!'

Turner moved his muffler, which he constantly wore round his neck and covering his mouth, and replied, 'You attend to your business, and leave me to attend to mine.'[6]

It was at the lunches in the Council Room that Frith had the best opportunities to study Turner, and meet some of the other Academicians. At one of these, Ramsay Richard Reinagle, a landscape painter and something of an inventor, arrived in a considerable state of excitement. He told the company, including Turner, that he had been 'in the City. I have invented a railway to go up and down Cheapside. Omnibuses will be done away with. I shall make millions, and . . . I will give you all commissions.' Then, looking at Turner, he added, 'And I will give you a commission if you will tell me which way to hang the picture up when I get it.' To this Turner replied, 'You may hang it just as you please . . . if you only pay for it.'[7]

Turner was not above ridiculing his own pictures. On another occasion, at a dinner, Turner was offered salad, and observed to his neighbour, 'Nice cool green, that lettuce, isn't it? And the beetroot pretty red – not quite strong enough; and the mixture, delicate tint of yellow, that. Add some mustard, and then you have one of my pictures.'[8] Frith himself admitted he could never understand Turner's later works, and by 1880 was amazed by the high prices they were

making. Buying and selling Turner was one of the greatest speculations of the nineteenth century and became a cornerstone of the Victorian art market. Hugh Andrew Johnstone Munro of Novar, a Scottish laird and collector of Turners, was also a friend of Frith. Munro told Frith that he once tried to buy the contents of Turner's studio for £25,000. Turner refused the offer, saying he could not be bothered, and anyway he was about to die. He said he wanted to be buried wrapped in two of the pictures then in the studio, *Carthage* (Turner Bequest, Tate Gallery) and *Sun rising through Mist* (National Gallery). Both are now part of the Turner Bequest.[9] When Frith visited Turner's famously untidy and uncomfortable studio in Queen Anne Street in the 1840s, he described it as cold, leaky and 'desolate in the extreme'.[10]

Frith also recorded the only known speech made by Turner, at the end of one of the RA exhibitions, when dinners were then held. Frith admitted that 'the stammering, the long pauses, the bewildering mystery of it', were almost impossible to convey, but it is worth quoting it in full:

Gentlemen, I see some . . . (pause, and another look around) new faces at this – table – well do you, do any of you – I mean – Roman History – (a pause). There is no doubt, at least I hope not, that you are acquainted – no, unacquainted, that is to say – of course, why not? – you must know something of the old ancient Romans (loud applause). Well, sirs, those old people – the Romans I allude to – were a warlike set of people – yes, they were – because they came over here, you know, and had to do a good deal of fighting before they arrived, and after too. Ah! They did; and they always fought in a phalanx – know what that is? (Hear, hear, said someone.) Do you know, Sir? Well, if you don't I will tell you. They stood shoulder to shoulder, and won everything (great cheering). Now then, I have done with the Romans, and I come to the old man and the bundle of sticks. Aesop, ain't it? Fables, you know – all right – yes, to be sure. Well, when the old man was dying he called his sons – I forgot how many there were of 'em – a good lot, seven or eight perhaps – and he sent one of them out for a bundle of sticks. 'Now,' says the old man, 'tie up those sticks, tight', and it was done so. Then he says, says he, 'Look here, young fellows, you stick to one another like those sticks; work all together,' he says, 'then you are formidable. But if you separate, and one go one way, and one another, you may just get

broke one after another. Now mind what I say,' he says (a very long pause, filled by intermittent cheering). Now, [resumed the speaker] you are wondering what I am driving at (indeed we were). I will tell you. Some of you young fellows will one day take our places, and become members of this Academy. Well, you are a lot of sticks (loud laughter). What on earth are you all laughing at? Don't like to be called sticks? – wait a bit. Well, then what do you say to being called Ancient Romans? What I want you to understand is just this – never mind what anybody calls you. When you become members of this institution you must fight in a phalanx – no splits – no quarrelling – one mind – one object – the good of the RAs and the Royal Academy.[11]

Varnishing days were abolished in 1852, the year after Turner's death. Charles Eastlake, who became President of the RA in 1850, apparently admitted that varnishing days were only kept on because of their huge importance to Turner.[12] When told of their proposed abolition, Turner responded, 'Then you will do away with the only social meetings we have, the only occasion on which we all come together in an easy, unrestrained manner. When we have no varnishing days we shall not know one another.'[13] But it was not only Turner who enjoyed varnishing days, the other RAs missed them too, and they were reinstated in 1862, with a separate day for non-RAs, or 'outsiders', as they were called. At first, only a select group of outsiders were invited to their own varnishing day; after 1869, when the Academy moved to larger premises at Burlington House, the privilege was extended to all exhibition artists. Their varnishing day became a kind of private view, with amateur artists, leading artists, lady artists, and even journalists invited.

As ever, Frith read widely in search of new subjects. This was a period when art and literature went hand in hand. The novel-reading public of the early Victorian period could understand a picture that was virtually a novel in a rectangle. Frith was one of its most successful exponents, and he went on painting literary subjects to the end of his life. Sterne and Goldsmith had already proved popular; Shakespeare he avoided as too difficult and too much the province of his friend Charles Robert Leslie. Two further sources he explored were Molière, and *The Spectator* by Joseph Addison. In the late 1840s he exhibited two scenes from Molière, *A scene from the Bourgeois Gentilhomme* (RA 1848) and the more long-winded *Mme Jourdain discovers her husband*

*at the dinner which he gave to the Belle Marquise and the Count
Dorante* (RA 1846). Literary pictures like this were often exhibited with
lengthy quotations from the text. One of Frith's *Spectator* scenes, for
example, was entitled *An old woman accused of witchcraft; the scene is
supposed to take place before a country justice – time of James I* (RA
1848). In the same year he exhibited *A Stage Coach Adventure in 1750
– Scene, Bagshot Heath*, showing a highwayman holding up the
terrified occupants of a coach. It was pictures like these that taught the
Victorian public to equate painting with literature, taught them that a
picture was something to be read. This type of small, intimate history
picture was first popularised by Bonington, and those French artists
painting in what is now known as *le style troubadour* in the 1820s. The
vogue quickly spread to England, and reached the height of its
popularity in the 1830s and '40s. In these pictures, the artist becomes
story-teller, novelist, historian, as well as painter. A picture had to tell a
story by means of objects, clues, costumes, facial expressions, literary
quotations; the spectator had to become a detective, assembling these
clues, creating a past and a future outside the frame. It was exactly
these methods that Frith was to use when he eventually turned to
modern-life painting.[14]

The Old Woman accused of Witchcraft was bought for 500 guineas
by Thomas Miller of Preston, who was to become one of Frith's most
loyal and important patrons. Miller was a Lancashire cotton spinner;
Horrocks, Miller & Company's 'long cloth' was famous not only in
England, but around the world. Frith often stayed with the Millers in
Preston, and they corresponded regularly. Many of Frith's letters to
Miller survive (in the Royal Academy library) and they give us a
wonderful picture of the artist–patron relationship in Victorian times.[15]
Miller also bought a picture by Frith's great friend Egg; the subject was
Queen Elizabeth discovers she is no longer young (location unknown).

Egg and Frith were very close friends, and Frith recalled in his book
the many lively dinners he had enjoyed at Egg's house in Bayswater,
where the guests included Dickens, John Forster (later his biographer),
Mark Lemon (editor of *Punch*), John Leech (of whom Frith wrote a
biography) and many fellow artists and former members of the Clique.
Egg was one of the very few RAs to support the Pre-Raphaelite Brother-
hood in its early struggles. Frith obviously did not share his friend's
sympathies; in his book he makes no reference to the Brotherhood at
all. In 1850, Frith, Egg and Frank Stone (a painter, who became an

ARA in 1851) went on another trip to Brussels, Ghent, Bruges and Antwerp to look at pictures. Once again Frith was impressed by Rubens, and also by Cuyp, whose pictures they saw in Dordrecht.

In 1848, following the success of *An Old English Merrymaking*, Frith embarked on his most ambitious picture to date. A large composition, with many figures, it was entitled *A Coming of Age in the Olden Tyme* (Plate 1). Frith claimed that he was still nervous of modern life: 'The hat and trousers pictures that I had seen attempted had all been dismal failures.'[16] Modern dress was still thought to be an insuperable barrier. As Millais was said to have observed: 'Just imagine Van Dyck's Charles the First in a pair of check trousers.' So Frith put his *Coming of Age* in the Elizabethan period. The scene was set in the courtyard of an old mansion; this was based on two houses, Hever Castle in Kent, and Heslington Hall, near York. The young squire, and heir to the family estate, stands at the top of a flight of steps, listening to an address. Below him in the courtyard is a throng of local peasants, and neighbours, some bringing presents. In the background a whole ox is being roasted. As usual, Frith had difficulties with models, and had to consult old books and prints to get the costumes right. He went to see an ox being roasted at an Islington cattle-market. The picture was begun in September 1848, and finished in April 1849, after months of incessant labour. Much against his mother's will, Frith occasionally painted on Sundays. Most Victorian artists did not have scruples about painting on Sundays, but often it was the patrons who objected. Atkinson Grimshaw, the Leeds artist, had a patron called Walter Battle, who made Grimshaw promise that no picture destined for his collection had been painted on a Sunday. *Coming of Age* was placed in a good position at the RA, and received good notices, except for Thackeray, who questioned, 'Why, when a man comes of age, it should be thought desirable that he should come of the age of Elizabeth?'[17]

Along with his major works, Frith often exhibited one or two lesser pictures, sometimes single figures. At the RA in 1850 he exhibited a scene from Cervantes – *Sancho tells a tale to the Duke and Duchess, to prove that Don Quixote is at the bottom of the table*. Cervantes was a popular subject with artists at the time and especially with C.R. Leslie. Frith's *Sancho* was commissioned by a new patron, Frederick Huth of Palace Gardens, another collector, like Miller, to form a large English collection.[18] Frith also painted a picture together with another artist friend, Richard Ansdell, entitled *The Keeper's Daughter*. Later Frith

Study for figures in *The Coming of Age*. Frith made careful drawings and studies for all the figures in his pictures, a practice he was to continue throughout his career. *(Private Collection)*

found it in a private collection, changed into a Landseer by an un-scrupulous dealer.

One of the greatest early Victorian collectors was John Sheepshanks, whose collection is now in the Victoria and Albert Museum. Sheepshanks had also made his money in textiles and clothing, in Leeds. Most of his collecting was done in the 1830s and '40s, when prices were lower, and by 1850 he had stopped collecting. One of his last purchases was a Frith scene from Goldsmith's *Good-Natured Man*. The title was

Mr Honeywood introduces the Bailiffs to Miss Richland as his Friends, and Frith exhibited this picture at the RA in 1850. Sheepshanks was a feisty bachelor, who became irritated by the number of important visitors wishing to see his collection. As he got older, he generally refused them entry, but there is a charming picture of him in his house at Rutland Gate, by David Wilkie, entitled *The Letter of Introduction*. His collection is a perfect example of early Victorian taste, and particularly strong on Landseer and William Mulready.[19]

In the following year, 1851, Frith exhibited a picture of a well-known incident from the life of Hogarth. The title was *Hogarth brought before the Governor of Calais as a Spy*. This had happened because Hogarth was arrested for making a drawing of one of the city gates. Frith had long been an admirer of Hogarth, and later wrote that it was Hogarth's pictures that had spurred him on to turn to modern-life subjects. In about 1851, Frith wrote, 'I now approach the time when the desire to represent everyday life took an irresistible hold on me. . . .'[20] Using one of his own maids as a model, he depicted her carrying a tray with a bottle of wine and some glasses on it, knocking at a door. The picture was bought by his old friend Jacob Bell, who was convinced there was 'copyright' in it. Bell duly had the picture engraved by Francis Holl (father of the painter Frank Holl) and published with the title *Sherry, Sir?* He did not ask Frith's permission to use this title, and although the print was a great success, it came to haunt him. Frith could never go out

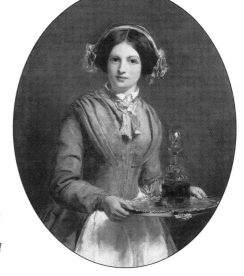

Sherry Sir? 1851. One of Frith's first modern-life pictures; its success haunted the artist ever afterwards, as whenever he went out to dinner the butler would inevitably ask 'Sherry, Sir?' *(Williams and Humbert Ltd, London)*

to dinner after that without the butler, or one of his friends, offering him 'Sherry, Sir?' The picture, and a smaller replica of it, ended up in the collection of a famous sherry company, Williams and Humbert, who used it on their label for many years, well into the twentieth century.[21] Frith was eventually prevailed upon to paint a sequel, entitled *Did you ring, Sir?*

By 1851, Frith had already started work on his first major modern-life picture *Life at the Seaside*, or *Ramsgate Sands* as it is more generally known. But while he was working on this painting he continued to turn out historical subjects, and what he called 'pot-boilers', single-figure pictures, often of pretty girls. Pictures of pretty farm girls became such a cliché in the mid-Victorian period that critics began to complain that they gave the impression that all farmers were married to artists' models. In 1852, Frith's main RA picture was *Pope makes love to Lady Mary Wortley Montague*. Lady Mary is shown laughing scornfully at Pope's grovelling advances. For Pope's features he used the celebrated bust by Roubillac. The picture was sold to a new patron of the 'vulgar type' as Frith described him, who had never heard of Pope or Lady Mary, but thought the picture depicted the Pope making advances to a married woman. Frith had to reassure him, and duly sold him the picture for 350 guineas. He also obtained permission to make a small replica of it, something he did with increasing frequency.[22]

Frith painted replicas of many of his large-scale works, both for engraving purposes, and for sale direct to patrons. About this practice he is noticeably coy in his *Autobiography*, and very rarely mentions it. It was common practice in the nineteenth century; Rossetti made no fewer than seven versions of *Proserpine* (privately owned); for which the model was Jane Morris. Frith's *Pope and Lady Mary* was later sold at Christie's for 1,200 guineas. Although Frith cultivated many private patrons, and remained great friends with some of them, he wrote that increasingly he sold his pictures to 'the trade'.[23] He not only found it easier to deal with dealers, who understood the nature of the business, but realised that the secondary market in engravings and prints was becoming increasingly both important and lucrative.

As last, in 1852, after seven years of waiting, Frith's name went forward for election as a full Royal Academician. Perhaps appropriately, it was the death of the great Turner that produced the vacancy that Frith was to fill. As Turner had exhorted them, Frith was to remain a loyal and hard-working member of the Academy. He did his share of

teaching; he served on the council, and on many hanging committees. Of the latter he had many stories to tell in his book. RAs had the right to exhibit up to eight works on the line. They were not meant to be vetted by the hanging committee, but by mistake this sometimes happened, and RAs' pictures were rejected. When this happened once to Constable, he refused to allow the picture to be retrieved and hung up.[24] Frith disapproved of the automatic right of RAs to enter eight pictures, and by mutual agreement, most RAs reduced this to four, but the rule was still in force when he was writing in the 1880s. Frith only once exercised the privilege of exhibiting eight pictures, in 1875. In general, he was to be a reformer, advocating change, and better treatment of outsiders, many of whom had great difficulty finding out if their pictures had been accepted or rejected. Artistically, he was always a conservative and, as he grew older, a reactionary. In 1863 Frith appeared before the Royal Commission Committee, appointed to look into the affairs of the Royal Academy. After becoming an RA in 1852, Frith exhibited nothing in 1853; he was too busy working on his first great modern-life picture, which was to change the course of his career.

FOUR

Life at the Seaside
1852–6

Frith spent his summer holidays of 1851 at the Kentish resort of Ramsgate, a genteel, middle-class town, already very popular with Londoners, and a cut above its more cockney neighbour, Margate, a great favourite with Turner. Frith by this time had five children, three daughters and two sons. His eldest daughter, called Isabelle after her mother, was born in 1846. The Frith family loved Ramsgate, and often returned there. Linley Sambourne (1844–1910) the *Punch* cartoonist and his wife Marion, who were friends of Frith, had a house at Ramsgate, and Sambourne was eventually buried there.[1]

Francis Burnand, editor of *Punch*, was also a resident, as was A.W.N. Pugin, the architect. Ramsgate boasted a good beach, some fine public buildings and by 1863, a railway station. Before that, visitors had to take the train to Margate. Frith later explained what drew him to Ramsgate:

> I had determined to try my hand on modern life, with all its drawbacks of unpicturesque dress. The variety of character on Ramsgate Sands attracted me – all sorts and conditions of men and women were there. Pretty groups of ladies were to be found, reading, idling, working, and unconsciously forming themselves into very paintable compositions.[2]

What Frith failed to mention, understandably, is that Victorian illustrators had got there first. Frith's friend John Leech had already been drawing modern-life scenes, such as the Great Exhibition of 1851, and seaside subjects as well. So had other illustrators, such as William McConnell and Hablot Browne.[3] But it was Frith who first attempted to bring such subjects into the realm of painting.

Back in London, Frith worked on his sketch for the picture through October and November 1851. In mid-November he showed it to his

friends E.M. Ward and Augustus Egg, both of whom approved, and advised him to go ahead and paint a large picture from it. He almost certainly also showed it to John Leech, who had already encouraged Frith to try his hand at modern life.[4] The sketch, which later belonged to Thomas Miller of Preston, and is now in the Dunedin Art Gallery, New Zealand, shows that Frith had already worked out the composition, which included large numbers of people on the beach below the East Cliff with a row of buildings in the background. The most striking thing about the composition was the viewpoint. Frith painted the picture as if he was out at sea, looking back towards the shore. This was a daringly original touch, and had not been attempted before, certainly not by any Victorian painter.

Frith had already shown his aptitude for composing large groups of people in his historical pictures. Now he was to display his skill to even greater effect in *Life at the Seaside* (Plate 2). Almost the entire foreground consists of groups of Victorian ladies, in full-length dresses, shawls, gloves and hats, many carrying umbrellas and parasols. To the modern viewer, it seems astonishing that ladies could go to the beach wearing quite so many clothes. Some are sitting on chairs, which seem to be ordinary Victorian side-chairs with cane seats, perhaps brought down from the houses and hotels above. Others sit on the beach with their dresses spread out around them. This was a subject later to be exploited by the French painter Boudin, who became famous for his pictures of crinolines on the beach at Trouville, on the other side of the Channel. But it was Frith who first discovered the possibilities of the subject, some years before any French artist was to attempt it. It has often been claimed that the French Impressionists were the first to paint large groups of people in modern dress. This claim is false; Frith was the first to do so. Manet's *Concert in the Tuileries* (National Gallery) dates from 1862; Degas, Renoir and Caillebotte were not painting modern life until the 1870s.

The ladies read their novels and newspapers, chat to each other, or gaze out to sea. There are very few men in the foreground groups. One, to the left, looks through a telescope, another in the centre is trying to sell toys to a very disdainful older lady; a gentleman, said to be Richard Llewellyn, a friend of Frith's, sits reading a newspaper,[5] while on the right a young man lounges in his chair, chatting to a lady under her parasol. The group on the right, a family group with a little girl, is the only noticeable difference between the sketch and the finished picture.

Detail of *Life at the Seaside*. The group in the centre includes one man reading his newspaper; the rest of the picture is dominated by ladies in crinolines, and their children. Behind is the man with performing animals. *(The Royal Collection)*

In the sketch, there are three men in this position.[6] Among the groups of ladies are a number of children, also very elaborately dressed, and mostly wearing shoes. One little girl with bare feet is paddling fearfully in the water, helped by her mother: a particularly delightful touch, and one which the eye is immediately drawn to. Others are digging in the sand, and making sandcastles.

Behind the holidaymakers, there are a number of entertainers. To the left is a group of coloured minstrels and a boy playing what may be a mouth organ. In the middle there is a Punch and Judy show, and a man with a performing hare, some white mice and other animals in cages. Frith found out that this man, Mr Gwillim, came from London, and paid him to come and model in his studio with his animals. To the right are the inevitable donkeys, and bathing machines, indispensable elements of the Victorian seaside holiday. The bathing machines, cumbersome symbols of Victorian prudery, have 'modesty hoods' at one end, invented by a Quaker in Margate, so that ladies could enter the water unobserved. The machines were expensive, requiring men and horses to operate them, so not many ladies used them. Men, if they

swam at all, usually swam naked, on some remote beach well away from the public areas.

In the background, most of the buildings can be identified. From left to right, they are: the clocktower of the Pier Yard of Ramsgate Harbour; the Royal Hotel; the Obelisk in the Pier Yard built in honour

Detail of *Life at the Seaside* with a little girl paddling. It was a daring touch for Frith to paint Ramsgate Sands as if seen from the sea. It now seems incredible just how many clothes Victorian ladies wore on the beach. *(The Royal Collection)*

of George IV's visit in 1821; the Committee Rooms of the Ramsgate Harbour Trustees; the castellated Pier Castle; above the cliff are, at right angles, Kent Terrace, and to the right Albion House, East Cliff House, and Wellington Crescent. To the left of the donkeys are Barling and Foat's Baths, and to the left of them, a stone yard with blocks of stone stacked up.

The summer of 1852 found Frith back in Ramsgate again, this time mainly to paint the buildings in the background. He attempted to use photography, or Talbotyping, as he referred to it in his book, but the results were disappointing, and he was unable to use them. (What Frith meant was calotype photography, the first images to be printed photographically on paper and the invention of William Henry Fox Talbot (1800–77) of Lacock Abbey, Wiltshire.) Later, Frith was to use photographs to better effect when painting his second great modern-life picture, *Derby Day*. Frith also had great difficulty painting the sea, something he had never done before.

Returning to London in the autumn, Frith showed the picture to his friend John Leech, who thought it would be 'a great hit'.[7] Frith already realised that he could not finish the picture in time for the RA exhibition of the following year, 1853. So he found time to work on a few smaller pictures, his pot-boilers. Following his election as RA in February 1853, he had to present the Academy, as tradition demanded, with his Diploma Work. (The RA now has a collection of nearly a thousand of these.) Many newly elected RAs gave a picture which they had failed to sell. Frith determined not to do this, and gave a recently painted picture, which he could have sold, entitled *The Sleepy Model*.

The model for the picture was a pretty orange-seller, whom Frith spotted one day in the street. He thought her smile very bewitching, and after buying a large number of oranges, asked her to sit for him. Being a good Catholic girl, she said she must first ask her priest's permission. He refused, but eventually the girl came all the same. Trying to engage her in conversation, Frith asked if she was pestered much by the soldiers and street-loafers in Albany Street, where she worked. Her reply was worthy of Eliza Doolittle. Yes, she said, she was bothered, mainly by the swells. 'Gentlemen,' she pronounced, 'is much greater blackguards than what blackguards is.'[8] Frith particularly wanted to paint the girl laughing, but after a while she fell asleep. Nothing Frith could do or say would keep her awake, so he decided in the end to paint her as she slept. Thus she became *The Sleepy Model*. The girl sits asleep in the

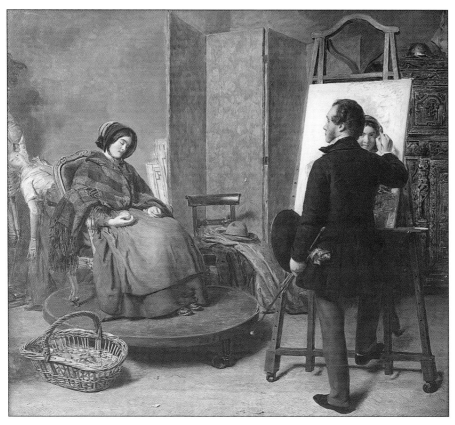

The Sleepy Model, 1853. Frith painting a pretty orange-seller, who he persuaded to sit for him by becoming 'a large purchaser' of oranges. *(Royal Academy Diploma Collection, London)*

chair, holding an orange, her basket beside her. On the right Frith stands with his back to the spectator, his canvas and easel before him. The picture shows the girl awake, and smiling, as Frith had intended to paint her. It is one of the most delightful and original of all images of a Victorian artist and his model.

For most of 1853, Frith toiled away at the big picture, using models for every figure. As usual, delays were caused by his failure to find suitable models. With some difficulty, Frith succeeded in persuading Mr Gwillim to come and bring his animals, consisting of dogs, cats, rabbits, mice and a hare. He decided to depict Mr Gwillim with a performing hare, which played the tambourine. Frith also painted Gwillim's assistant, who banged a big drum, and went round collecting money. Frith wrote that he 'wore a wonderful green coat; he was very

ugly, but an excellent type of his class'.[9] He appears to the left of Mr Gwillim, in front of the Punch and Judy show. By 31 December, Frith noted in his diary that he had finished Mr Gwillim and his animals, 'paid the man thirty shillings, and bade him adieu'.

In turning to modern-life subjects, it became of even greater importance to Frith that he find the right models for each figure. The model he chose not only had to fit the part, but he or she had to correspond to the Victorian public's idea of what a person of a particular type and class might look like. The Victorians were deeply interested in questions of race and class, and with their passion for analysing, recording, and tabulating everything, had already tried to turn phrenology and physiognomy into scientific subjects. Numerous books had already been published on the subjects by the 1850s, and Frith and his artist friends would certainly have been aware of them. Like any Victorian artist, Frith fancied himself as an amateur physiognomist, although he never actually used the word in his memoirs. At Sass's Academy he received some instruction in phrenology, but did not find it useful. He preferred to use his own instinct in seeking out suitable types, often in the streets, or in the workhouse. He also used professional models, and friends and family could be roped in, if necessary. Artists knew that physiognomy was not an exact science; it was more a question of finding the right type to fit your preconceived idea.[10]

As he toiled on with his picture, Frith was constantly assailed by doubts. He consulted numerous fellow artists, in particular William Mulready, then a senior RA, and greatly admired by Frith. Mulready's verdict was damning; he criticised the picture for its lack of strong colours, and its patchy use of light and shade. Depressed by this, Frith went to visit his friend Egg, who reassured him, saying that Mulready was too used to using bright colours in his own pictures.[11] In reality, Frith had succeeded very well in conveying the muted and drab colours of a Victorian crowd.

Frith also showed the picture to several prospective purchasers, but none of them would commit to buying it. One buyer said he wanted first refusal, but then confided to a friend, who knew Frith, that he thought the picture 'a tissue of vulgarity, and that he wouldn't have such a thing on his walls'. Another complained that the picture 'wanted something'. Frith's friend Frank Stone, who was present, suggested, 'What do you say to a balloon, sir? Would something of that kind finish the picture?'[12] Eventually, against the advice of his friends, he sold the

picture to a dealer, Messrs Lloyd, for 1,000 guineas. Frith wrote that they 'had no cause to repent of their bargain'.[13] Frith was to find it easier, and more profitable, to deal with dealers in the future, although he continued to deal with faithful old patrons as well. This was to become common practice for many Victorian artists, as the role of the dealer increased. Show Sunday came, and with it many visitors, but still Frith felt nervous; 'on the whole feel the picture is thought successful; cannot tell – it may be the reverse'.[14]

In 1854 Frith, as a new RA, served on the all-important Hanging Committee for the first time. He had two senior RAs, Thomas Webster and Thomas Sidney Cooper, serving with him, so had to defer to the older men. He saw to it that *Life at the Seaside* had a good place, and also tried to help some of his friends, with varying degrees of success. In his diary for 22 April he wrote: 'Finished my first hanging. It is a painful and most disagreeable business – so many interests to consider. Tried to do my duty, though perhaps with too much thought for my friends.'[15] Frith was surprised that none of the members of the RA Council so much as mentioned his picture. But when some of the other RAs began to arrive, they were loud in its praise. Frith was already referring to it as *Ramsgate Sands*, the title by which it is better known today.

At last the great day came; the opening of the Royal Academy Summer Exhibition, traditionally the beginning of the London Season, which ended with Goodwood Races in July. Frith's diary records what happened first: '28 April – Drove to RA, at quarter to twelve; the Royal Family came. Eastlake presented me to the Queen. She was delighted with "Seaside". Wanted to buy it – found she couldn't, and gave me a commission for a similar subject. Everybody likes it. I find myself and Maclise the guns this year.'[16] This is a reference to Daniel Maclise's great picture, *The Marriage of Eva and Strongbow*, now in the National Gallery of Ireland in Dublin.

From his brief conversation with Queen Victoria and Prince Albert, Frith could tell that they both understood and appreciated a great deal about art. Sir Charles Eastlake, President of the RA, who was taking the royal party around, then returned to Frith, to enquire who had bought *Life at the Seaside*. Frith replied, 'Bought by a picture dealer, who for a profit would sell it to Her Majesty or anyone else.'

Eastlake returned to the royal party to convey the news. Frith observed 'a slight shrug of the Royal shoulders', indicating that a picture dealer would obviously want an outrageous profit. Frith wrote

later, 'A few days solved the question', as Messrs Lloyd, hearing of the Queen's interest, offered it to her for the same price as they had paid. Their proviso was that they should borrow the picture for three years to make an engraving of it, and that the profits from the engraving should go to them. This was to prove a very satisfactory deal for Lloyd; the plate was engraved by a well-known line engraver, D.W. Sharpe, and the Art Union of London then bought the plate for £3,000.[17] The Art Union was a kind of art club to which members subscribed. Works of art were then given as prizes, sometimes engravings, or bronzes. The invention of the steel plate made it possible to produce much larger quantities of prints than before, and this revolutionised the Victorian print market. Artists benefited enormously from this, as they were able to sell both the picture and the engraving rights for separate amounts. The print business was at its height in the 1850s and '60s, and Frith was one of the artists particularly to benefit from it.

After such a stunning first success, it hardly mattered to Frith what the critics said, but in general they were complimentary. *The Athenaeum*, *The Builder*, *The Times* and *Punch* all gave it coverage, *Punch* comparing Frith and Leech, and praising them both for choosing to depict the life around them. The writers mostly all agreed that it was the variety of characters in *Ramsgate Sands* that had made it such a success. The *Art Journal* devoted more than a column to it, predicting that it would become valuable 'as a memento of the habits and manners of the English "at the seaside" in the middle of the nineteenth century'.[18] The writer also speculated about the social origins of the various families and groups, suggesting that the central group might be from Peckham, but the family behind somewhat lower on the social scale. The older people, they thought, hailed from 'every part of the wide area between Whitechapel and Paddingtonia'.[19] All of them look respectably middle class, but there is considerable variety, ranging from the more plebeian-looking group on the far left with the newspaper and the telescope, to the more elegant group in the centre underneath a parasol. The entertainers form a distinctly different group, and are mostly relegated to the background. As a group, they are clearly differentiated from the middle classes, and are given the facial types and clothes expected of them. Three of them are trying to sell their wares in the foreground groups, and the affronted dignity of the ladies' expressions is one of the best humorous touches in the picture. One can understand why Queen Victoria preferred *Ramsgate Sands* to Frith's later modern-life pictures.

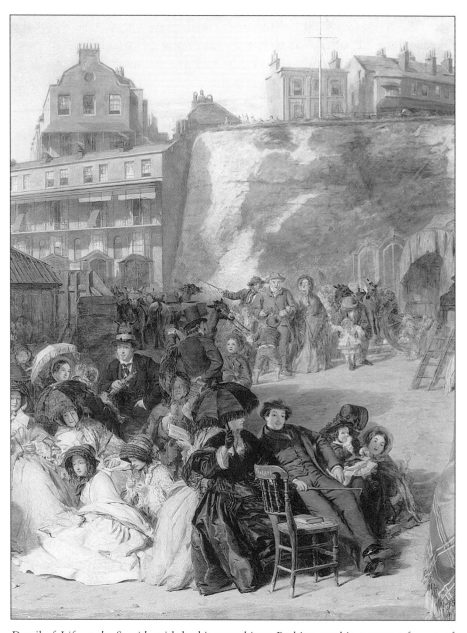

Detail of *Life at the Seaside* with bathing machines. Bathing machines were a feature of all Victorian seaside resorts. *(The Royal Collection)*

It is mainly about family life, it is full of women and children, and an aura of happy domesticity hangs over it. There is no hint of vice or crime. It is Victorian domestic genre painting taken out of doors, and on to the beach. Looked at today, it is surprisingly small, 36 by

61 inches, the smallest of Frith's big panoramas. It is also brilliantly colourful. The *Art Journal* also predicted, wrongly, that Frith had exhausted the possibilities of modern-life painting. His greatest triumphs were still to come.

Many of Frith's fellow artists had dismissed the picture, one describing it as 'a piece of vulgar cockney business unworthy of being represented even in an illustrated paper'.[20] Now they had to eat their words. John Leech expressed it perfectly in a *Punch* cartoon in 1856 entitled 'Scene in a Modern Studio'. Two 'high art men', Feeble and Potter, are looking at Jack Armstrong's modern-life picture, which has found a buyer, whereas their pictures have not. The figure of Armstrong, with his back to the viewer, is clearly intended to be Frith.[21]

Frith's next modern-life picture was to be another middle-class domestic scene, but much smaller in scale, and this time painted indoors. This was the birthday scene, *Many Happy Returns of the Day*, exhibited at the RA in 1856 (Plate 3). Although not such a success as *Ramsgate Sands*, it is a delightful picture, and shows us exactly what a prosperous middle-class household might look like in 1856. Frith used himself and his family as models – his mother is the old lady at the end of the table, and the birthday girl in the middle is one of his daughters, Alice, later Lady Hastings. His wife Isabelle, still looking young and pretty, sits at the end of the table. Frith himself sits at the head of the table holding a wine glass, the very picture of a Victorian paterfamilias. His hair is beginning to recede, and there are signs of the side-whiskers he was to wear for the rest of his life. The model for the old grandfather on the right was found by Frith in the workhouse, which he often visited in search of models, until the practice was discontinued.[22] Ruskin reviewed the picture in his *Academy Notes* and thought it 'much above Mr Frith's former standard. Note the advancing Pre-Raphaelitism in the wreath of leaves around the child's head.' This did not please Frith, who was not keen to be identified with the Pre-Raphaelites. In a typical moralistic outburst, Ruskin went on, 'one is only sorry to see any fair child having too many and too kind friends, and in so great danger of being toasted, toyed, and wreathed into selfishness and misery'.[23] A curious comment from a man who himself had no children, and was later to display an unhealthy obsession with under-age girls. Frith was disappointed at the reception of *Many Happy Returns*, which he felt was as good a picture as *Ramsgate Sands*. But he realised that the subject 'offered no opportunity for the display of character and variety

of incident that distinguished the "Sands"'.[24] He knew he had to find another major subject, and spend up to two years working on it. He was soon to find the answer – on the racecourse.

Many Happy Returns also presents us with an ironic commentary on Frith's own family life. By this time, he and his wife, and their growing family of nine children had moved to a more fashionable address at 10 Pembridge Villas in Bayswater. Then, as now, it was a prosperous and respectable middle-class area. But there was a catch. Frith, like many a successful Victorian, had acquired a mistress, Mary Alford, who he had installed in Oxford Terrace (now Sussex Gardens), about a mile away to the east. In 1856 Mary Alford was to bear their first child, a girl called Mary; there were to be six more children of this union. This brings Frith's tally to an impressive total of nineteen children by the two ladies. As the late Jeremy Maas was fond of remarking, Frith seemed to like crowds. In his book *The Prince of Wales's Wedding: the Story of a Picture* (1977) Maas also repeats a story passed down by the Frith family. Apparently, Mrs Frith's suspicions were first aroused when her husband had been away for a few days, and she saw him in the street posting a letter. The letter arrived, saying that he was having a lovely time in Brighton.[25] This story has never been substantiated, but is part of Frith family legend. It goes a good way to explaining why Frith was keen to draw such a veil of secrecy over his family affairs and why he never even mentions them in his autobiography. His daughter Cissie, who later, as Mrs Panton, wrote her memoirs, referred to Mary Alford and the second family, as 'the one great and fatal error of his life'.[26] It is now thought that Mary Alford was in fact Frith's ward, and lived with the Frith family before becoming his mistress. Frith was apprehensive when he went to the Royal Academy elections in 1855, but was relieved to encounter 'no unpleasantness whatever – all the men – most of whom must have known my position – treated me with the greatest kindness', as he wrote to his fellow RA John Callcott Horsley.[27] As might be expected in Victorian times, the men closed ranks.

FIVE

Life in the Frith Family

Frith himself may have been extremely reticent about his private life, but fortunately we know a great deal about his family life from another source. This is his third child and second daughter, Jane Ellen, known as Cissie, who was born in 1848. Encouraged by Shirley Brooks, the editor of *Punch* and a close friend of the Frith family, Cissie, later Mrs Panton, became a writer, and published many articles, and several books. In 1908, only a year before Frith's death, she published her own autobiography *Leaves from a Life*. Three years later, in 1911, she published a sequel, *More Leaves from a Life* which is more about her own life, and less about the Frith family.

Mrs Panton dedicated her second memoir, *More Leaves*, 'To the memory of one much loved, much misunderstood, much mourned, who lives now in his pictures only . . .' – a clear reference to her father, who had died two years earlier, in 1909. In this book, she draws an extra-ordinary picture of her father's character:

> It was astonishing how easily he endured everything untoward that happened to his family, to whom he was an affectionate parent, as long as we wanted nothing from him, and as long as none of us gave him any trouble about either our present or our future. I have never known any father of a family so completely shirk his responsibilities as did my venerable papa. It was 'light come, light go' with him in every possible relation in life, which perhaps was what made him so distinctly charming, as he most undoubtedly was to everyone who ever met him and required neither advice nor assistance at his hands.[1]

Mrs Panton was clearly fond of her father, but well aware of his failings as a parent. She never refers directly to Frith's mistress Mary Alford, or to his second marriage. But she drops several very clear hints.

On page 9 of her memoirs she refers to the 'one great and fatal error of his life becoming public property', a clear reference to Frith's second marriage which took place on 30 January 1881.[2] Reading between the lines, one can detect other veiled references. Talking about the artistic temperament, she writes, 'There may be, there are, concealed lapses from the strict code of morals prescribed by Mrs Grundy. . . .'[3] Later she describes the death of her mother and 'the final crumble and fall of our once happy and distinguished household'. Some years later, Frith sold the family house in Pembridge Villas, 'but all the home atmosphere was gone; another evil influence came into force'.[4] Not only is this a clear reference to Mary Alford, but also an expression of Mrs Panton's unwavering support for her mother, whom she thought a wronged woman, shabbily treated by her father. Again and again in her book, Mrs Panton goes out of her way to praise her mother, and emphasise the importance of her role in Frith's life. Frith's re-marriage, for her, was the beginning of his decline, as an artist, and as a father to his first family. Of the second family she makes absolutely no mention. It is clear that she, and her brothers and sisters, regarded them as socially inferior.

Significantly, Mrs Panton did not publish her first book of memoirs until 1908, by which time Frith was old and frail, and widowed a second time. She begins with her childhood, and paints a delightful picture of an early Victorian middle-class household. Nannies and governesses played an important role in their lives. Their first nanny was Miss Dadd, 'a subdued, sad, wearisome creature, whom I frankly hated at the mature age of three, and wondered about even then. I should have wondered more had I known that her brother was then in Bedlam, confirmed as a criminal lunatic there, for murdering his own father in a fit of ungovernable frenzy.'[5] This, of course, refers to the painter Richard Dadd, a friend and fellow-student of Frith, to whom he was trying to do a kindness. Miss Dadd soon departed; then came Miss Wright, whom they preferred, and who was better at teaching and good at needlework. She was followed by a prim widow, Mrs Port, whom they disliked, and then by a German governess, Fraulein Haas, who was quite unable to keep order in the schoolroom. Those children who wanted to learn did so; the others drew rude pictures on their slates, read what they liked, and left the schoolroom as they pleased. Clearly education was not taken very seriously in the Frith household: the boys were later sent to boarding school, while the girls had to educate themselves by reading.

All Victorian households, rich or poor, were stalked by illness; the death of children was commonplace. Scarlet fever, whooping cough, and diphtheria were greatly feared, and sometimes carried off entire families. Two of Frith's children died in infancy, but Mrs Panton does not mention them. She does record some of her mother's own remedies, which sound positively terrifying. In particular, every spring she made a jorum of brimstone and treacle, which she administered with a wooden spoon. Then there was sienna and prunes, rhubarb and magnesia and hot castor oil and milk. The doctor would prescribe various powders; if pills were needed, they went to their chemist friend Jacob Bell's shop in Oxford Street. Bell was the man who commissioned Frith to paint *Derby Day*. When she was older, Mrs Panton was sent by Frith on errands to his bank, or to Mudie's Lending Library, where the books were guaranteed fit for Victorian family reading.

Mrs Panton writes in great detail about daily life in the Frith household. When she was born, the family still lived in Park Village West. At that time, Frith's younger brother Charles lived nearby, and Frith was devoted to him. Sadly, he died young, about 1851, of typhoid fever, and Mrs Panton wrote, 'How well I recollect my father's mad and uncontrollable grief, and how he tore out of the house. . . .' She describes him as 'brilliantly clever, very joyous, very charming and full of life . . .'. Frith declared that he would have been Lord Chancellor, had he lived.[6] Frith's children watched Charles's coffin being carried out of his house, and thereafter one of their favourite games was playing funerals.

The Friths' garden at Park Village West sloped down to Regent's Canal, and Frith's painting room was in the garden. Mrs Panton recalled how the young Frith would rush out of his studio to quieten his children down: 'Then I saw him, young, lithe, active, wrath personified, yet with a humorous twinkle in his eye and a suppressed smile around his mobile mouth, rush out, palette and mahl stick in hand, to chase us away . . . our dear young father! How we worshipped him, his talents, his never-failing, delightfully amusing talk, and his never-ending stories.' Although Mrs Panton was writing nostalgically, long after the event, she gives the impression of a very happy, very lively household, with plenty of reading, discussion and fun. 'I can honestly say that, despite the trouble, the great trouble my father once gave my mother, I never remember the smallest row or unpleasant wrangle in our household. . . .'[7] Once again, Mrs Panton is trying to demonstrate that,

Bedtime: Isabelle Frith with one of her children, *c.* 1847. This is Frith's wife Isabelle, with ther eldest daughter, also called Isabelle. There were to be twelve children of the marriage, of whom ten survived. *(Private Collection)*

in spite of Frith's later transgressions, theirs was a happy household. This has to be seen against the background of Frith's relationship with Mary Alford, who must have been living in the Frith household by the early 1850s, if indeed she was Frith's ward. Frith's first child by Mary

Alford was born in 1856, when Mrs Panton was only eight. Seducing one's ward was a serious offence, so no wonder the Frith family have locked this unpleasant skeleton in the cupboard ever since.

In 1852, Frith's grandfather and an uncle died, leaving him enough money to buy a larger house. This is when they moved to Pembridge Villas, which was to remain their family home for the next thirty years, and where Frith was to enjoy the great triumphs of his career. The house was in a very dilapidated state, and had belonged to a family of Greeks, who were duly demonised by the children. 'The Greek family haunted us children for many years,' wrote Mrs Panton, 'and whatever was found unsatisfactory . . . we put down to the Greeks. . . . I have always hated the Greeks as a nation because of them.'[8]

Mrs Panton recollected 'the manner, the fearsome manner, in which the house was first decorated. In the dining room was a heavy dark red flock paper and grained paint. . . .' Frith's studio was painted dark green, and was noted for its austerity, and complete absence of decoration. Later, after 1870, Mrs Panton writes, 'the house was made artistic and beautiful'.[9] Frith also made numerous additions, including a studio on the top floor with an outside staircase for models. Writing long after the Friths left, Mrs Panton clearly retained great affection for the house. From the outside, it may have looked ordinary, and like its neighbours, 'Yet up that long flight of steps, glassed in for us when we began to go to parties, has passed every notable in England from the late Queen Victoria, the present King and Queen, and all the princes and princesses, to what we prized still more – raging republicans as we were and indeed as I still am – all the literary, artistic and musical celebrities of the mid and later Victorian era. . . .'[10] This statement is borne out by a collection of letters, pasted into five volumes, written to Frith and his wife, which are now in the Victoria and Albert Museum library. The letters are from, among others, Dickens, John Forster, Wilkie Collins, Shirley Brooks, George Augustus Sala, Sir Henry Irving, W.C. Macready, Anthony Trollope, Bulwer Lytton, Mrs Mary Maxwell (the novelist Miss Braddon) and Mrs Rhoda Broughton (another novelist). The majority are from other artists, notably Landseer, J.F. Herring, Daniel Maclise, Charles Eastlake, David Roberts, Thomas Creswick, Henry Nelson O'Neil, Frederic Leighton, Augustus Egg and many, many others. Many of them are simply replies to invitations to dinner, or thank-you letters, and they give a good idea of the scale of Frith's hospitality. A great deal of camaraderie existed between

Victorian artists at that time, and a huge amount of entertaining went on. Both Leighton and Alma-Tadema gave famous At Homes in their grand studios, with recitals by some of the best-known musicians of the day. The Friths also kept another album full of letters from royals; this is still in the possession of the family. Frith's visitors' book was regrettably stolen from his studio by a visitor on Show Sunday.

The day began in the Frith household with breakfast at 8.30 a.m. prompt. Any latecomers were likely to receive a severe ticking-off from Frith, who sat at the head of the table, eating first fish, then ham and eggs, marmalade and toast. At the same time he wrote letters 'in a fearfully illegible hand'. Frith was in his studio by 9.00 a.m. and sat reading *The Times* until the first model arrived. At lunchtime, 'Papa used to come in for five minutes, a biscuit in one hand and a glass of sherry in the other (his usual luncheon) leaving the model to consume hers. . . .'[11] In the afternoons, the children were taken for walks in Kensington gardens, where they looked for fairies (this was long before Peter Pan made the subject fashionable). Sometimes there were outings to the Zoo, or to the Crystal Palace, by then in Sydenham. Sometimes the fog was so thick they could not go out. In a particularly thick fog, Frith encountered a man repeatedly asking, 'Am I near the butter shop?' This became a Frith family expression, used to enquire if someone had nearly finished something, a book, a meal or any task in hand.

After dinner, Frith and his wife would sit in two heavy leather arm-chairs. 'Papa used to sit for half an hour after dinner,' wrote Mrs Panton, 'smoking and reading, and generally searching for a "subject".'[12] In the drawing-room window was a large red sofa, which was the children's favourite perch, from which they could look down on any distinguished visitors below. In the 1840s Frith had occasionally painted on a Sunday, of which his mother strongly disapproved. Mrs Panton wrote that Frith had given it up, 'not from any religious scruples, but because he found the one day of rest an emphatic necessity, so he used to spend the morning going around the Kensington artists' painting rooms: Egg, Mulready, Creswick, Ansdell, Henry O'Neil and others; the afternoon we generally got him to go out with us; and in the evening we had those delightful gatherings of which I shall speak later'.[13] The Friths generally entertained on Sunday nights, when actors and magazine editors, who worked on Saturdays, were free. No one went away for weekends then, so the rounds of work and relaxation were continuous. The great season for parties, especially dances, was

Isabelle Frith asleep in a Chair, c. 1850. Mrs Frith asleep in one of the leather chairs described by Mrs Panton in her memoirs. When young, Isabelle was dark-haired and pretty; she often appears in Frith's pictures. *(Christopher Wood Collection)*

Christmas and New Year, and some of these Mrs Panton describes in detail. Most of the traditions of Christmas today were first laid down in the reign of Queen Victoria; Victoria and Albert themselves set an example in the scale and lavishness of their Christmas parties. Artists dutifully recorded the presents laid out every year. Children's parties were often given by rich bachelors, or childless couples; one gets the impression from Mrs Panton that Victorian children were never short of entertainment. Later in life they would look back nostalgically to those happy times. At many of these parties, the grown-ups or the children would perform amateur theatricals. Frith and his friends, in particular Dickens and Augustus Egg, would often write and perform these for the children's entertainment. Contrary to the general opinion, Victorian children seemed to have a lot of fun.

Summer holidays lasted from the end of July to early October, and like many Victorian middle-class families, the Friths went to the seaside, usually renting a house, or a house whose landlady had enough rooms to fit them all in. They very rarely used hotels. They tried various resorts – Weymouth, Tenby, Scarborough, and Eastbourne, but Mrs Panton's

favourite was Ramsgate, to which they often returned. Many of Frith's artistic, literary and theatrical friends, and their children, joined them on these holidays, which were obviously huge fun for all the children, and for the grown-ups too. One also gets the impression from Mrs Panton that Victorian children spent a great deal of time with their parents' friends, and greatly appreciated their company. Mrs Panton writes especially fondly of Shirley Brooks, the editor of *Punch*, who first encouraged her to write, and also of 'Dear, kind, good Mrs Shirley Brooks, my mother's stand-by and champion, the "Shirlina" of our set!'[14]

Mrs Panton is particularly interesting when she devotes chapter five to 'More Especially our Set', in which she analyses the artistic circles in which her father moved. 'Artists in our day were divided into sets, much more, I fancy, than they are now. There was our set, centred in the Kensington and Bayswater districts; there was the St John's Wood set; and there was another set which comprised Millais, Leighton, Sir Francis Grant, and some of the more aristocratic members of the Academy.'[15] 'Sir Francis Grant,' she wrote, 'was an extremely courtly and delightful gentleman, always scrupulously polite when we met him out, but we never went to his house. . . .' Of Leighton, she wrote, 'Sir Frederic Leighton used to come to Pembridge Villas in quite early days, and we girls one and all respectfully worshipped him, and to us, at any rate, he was known as "Cupid". He had a magnificent head and torso, but was too short in stature to be quite perfect; he had a wonderful command of foreign languages. . . . And in the days I knew him he used to sing beautifully.' Millais, although one of the aristocratic set, was more friendly and easy-going, 'tall and good-looking . . . with curly hair and very bright eyes, with a hearty laugh . . . and an extremely merry addition he was to any gathering'. He came to Pembridge Villas to play whist where his caution and parsimony earned him the nickname of 'Sixpenny Jack'. Grant, Leighton and Millais, although not part of Frith's set, were nonetheless friendly, and paid visits.

'One of our favourite expeditions,' wrote Mrs Panton, 'was to Kensington to see the Leeches, who then lived in the house he died in; a terrace of three or four houses just beyond the turning known as Wright's Lane. We were devoted to John Leech, and I can see him quite well as I write – tall and blue-eyed, irritable and energetic – stamping up and down the room as he swore at the hateful organs that killed him, and at the noises which nothing would keep out of his workroom.'

Leech, the greatest of the early *Punch* illustrators, died young, in 1864, and was widely lamented by all his friends, including Frith, who was later to write a book about him. Leech, who loved hunting, persuaded Frith to buy a horse, and went riding with him in the park.

Another close friend and neighbour was Augustus Leopold Egg, who had been a fellow-student of Frith, and member of the Clique. Both men were close friends of Charles Dickens, and great lovers of theatricals. Like Frith, Egg painted historical and literary subjects; unlike Frith, Egg was one of the very few RAs to support the Pre-Raphaelite Brotherhood. Egg only attempted one or two modern-life scenes, one being a set of three pictures entitled *Past and Present*, now in the Tate Gallery. The subject is adultery: an unfaithful wife, who is of course punished, is seen in the last picture huddled under an arch of the Adelphi, by the Thames. The set has been described as a Hogarthian moral progress turned into a Victorian three-volume novel. The first picture is a drawing-room scene, with the husband confronting his wife with an incriminating letter. To the left, two children are playing at building a house of cards, which symbolically collapses at that moment. One of the girls was modelled by Mrs Panton, who recalls that she had absolutely no idea what the picture was about. In fact, she mis-remembers it in her memoirs, and describes it wrongly as *The Gambler's Wife*.[16] She fainted during one of the sittings, and awoke in the kitchen, to find a maid bathing her head, 'regardless of the fact that soapy water was meandering down the front of my very best frock'. She also wrote that, in common with most Victorian girls, she knew absolutely nothing about 'that unpleasant word sex'.

Mrs Panton thought that 'the Ansdells' was the most perfect household I have ever beheld . . .'. Richard Ansdell was a sporting and animal painter, and follower of Landseer. 'Mr Ansdell must have made an enormous fortune by his pictures', wrote Mrs Panton, because he had a big house in St Alban's Road, Kensington, a house at Lytham St Anne's in his native Lancashire, and a moor in Scotland, where he went to shoot and fish every year.[17] Behind his house in Kensington was a field where he kept deer, horses and donkeys to use in his paintings. The Ansdells also had a large family, and all the children enjoyed rampaging about the house and garden, making a lot of noise, and then consuming an enormous tea. Ansdell would occasionally help Frith by painting the animals in his pictures.

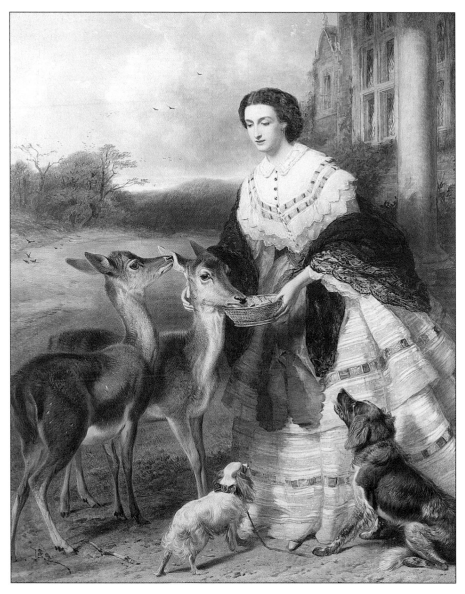

The Gamekeeper's Daughter, painted by Frith and his friend and neighbour, Richard Ansdell. Frith often painted pictures in partnership with his artist friends Richard Ansdell, Thomas Creswick, and Frederick Richard Lee. *(Photo: Christie's, London)*

In nearby Linden Gardens, just off the Bayswater Road, lived both the Mulreadys and the Creswicks. William Mulready was a senior RA who Frith looked up to, and often asked for advice. Mrs Panton remembered Mulready as a 'small, very neat man, very deaf, and very kind . . . the inventor of the black and blue Mulready envelopes' which

were the predecessors of the postage stamp.[18] Mulready was by this time old and ill, living alone, and had virtually given up painting. He died in 1863.

Next door lived Mr and Mrs Thomas Creswick. He was a close friend of Frith and a fellow Yorkshireman, and they often collaborated on pictures, Frith painting the figures into Creswick's landscapes. Creswick was a jovial, rollicking character, but 'too fond of both food and drink to be always in the best of health', and was often laid up with gout. He also made a good living from painting, and turned his house into a 'small palace'. Although they had no children, the Creswicks gave lavish parties for the Frith children, and the children of other artists. When Mrs Panton married, he gave her 'a most exquisite landscape' as a wedding present. While she was away on her honeymoon, in 1869–70, Creswick died.[19] Cissie married Mr Panton, a brewer from Wareham in Dorset, and they had five children.

'The first artist I really adored and worshipped,' confessed Mrs Panton, 'was Sir Edwin Landseer.' She first met him when she was nine, at a party at the Friths' house, and thought, 'he looked to me like one of his own most good-humoured white poodles. He was curled and scented and exquisitely turned out, and I said at once, "Oh what a delightful old gentleman."' Frith then relayed this to Landseer, who proceeded to propose to Cissie, to her great embarrassment. Landseer never married, and was a great favourite, not only with Queen Victoria and Prince Albert, but with many aristocratic families. 'Edwin's one fault is duchesses,' his brothers used to say; his most notorious affair was with the Duchess of Bedford, by whom he is thought to have fathered several children. His other fault was inability to finish commissions, which eventually drove him mad. Mrs Panton also remembered his brothers Charles and Tom, both engravers. Tom was completely deaf, and used to shout at the top of his voice; he did this when looking at pictures at the Royal Academy, and his critical remarks caused astonishment among the other viewers. Mrs Panton often visited Landseer later, and went to the zoo with him. 'His end was sad,' she wrote, 'he became imbecile, or childish' and was nursed by his devoted sister, 'Miss Jessie'.[20]

Mrs Panton did not like all of Frith's friends. 'Another eccentric couple,' she wrote, 'whom I, at any rate, hated, was Mr and Mrs George Cruikshank.' Mrs Cruikshank, who she thought 'scraggy' and 'ugly', worshipped her husband, and thought he could do no wrong.

Isabelle Frith, the Friths' eldest daughter (later Mrs Charles Oppenheim). A charming picture of Isabelle with her sketchbook. *(Private Collection)*

Cruikshank himself was highly opinionated and boastful, and claimed that he had written *Oliver Twist*; he had, in fact, illustrated *Sketches by Boz*. He was also a militant teetotaller, and spent years working on a large picture about the evils of drink. Mrs Panton described it as 'his horrible picture, *The Worship of Bacchus*'. It is a huge and gloomy picture, made up of numerous scenes and groups, in which drink is

being consumed. In the background are factories, breweries, workhouses and prisons. It may well have given Frith ideas for his modern-life pictures, but this did nothing to endear it to Mrs Panton, who complained of being 'made to listen to the rabid abstainer while he described bit by bit the hideous picture he had spent years in painting. I have an idea he left it to the nation. . . .' The picture languished for years in the basement of the Tate Gallery, but it has now been cleaned, restored and re-exhibited. Mrs Panton thought Cruikshank was a hypocrite, because he tucked into sherry trifle, port-flavoured soup, and plum pudding with brandy at the Friths' dinners. But after Mrs Panton married a brewer, he never came to the house again.[21] Although she does not mention it, Mrs Panton must have been gratified to learn that Cruikshank was found, after his death in 1878, to have a mistress and ten illegitimate children.

A close friend and contemporary of Frith's was Henry Nelson O'Neil, and as a child Mrs Panton often modelled for him. Her first appearance was in his famous picture *Eastward Ho!* (RA 1858) showing troops departing to quell the Indian Mutiny. She also appeared as one of the bridesmaids in his picture of *The Arrival of Princess Alexandra* in 1863.[22] Mrs Panton wrote that her great joy was 'to be allowed to stand behind him while he painted, brushing his longish white hair with the hearth-brush'. She was rewarded for her sittings with packets of gloves, and yet more copious teas, with cake and strawberries. O'Neil never married, although he fell desperately in love with one of Mrs Frith's bridesmaids, who was a Catholic, and refused him. He always came to the Friths' on Sundays, and commanded the girls to sing and play for him, which they clearly found something of an ordeal. They were thankful when the clock struck bedtime, and they could retreat upstairs.[23]

Mrs Panton liked the Scottish painter, John Phillip, 'Phillip of Spain', as he was called, and was painted by him. But she was also afraid of him. He disliked noise or movement disturbing him in the studio, and would snap at his wife, who always sat right behind him, sewing noisily at 'some very stiff material which creaked in the most horrible manner possible'. Mrs Phillip was in the end dispatched back to Scotland. Phillip died in 1867 after suffering a stroke in Frith's studio. Another close friend and fellow RA was Alfred Elmore. Having seen Cissie in a fit of temper, he asked her to sit for Katherine in *The Taming of the Shrew* (location unknown). The picture was not a success, as 'I could not always look furious. . . .' Poor Elmore suffered terribly from neuralgia,

and was clearly in pain when painting her. 'I have seen the perspiration pouring down his face while he worked. . .'. He only had one daughter, and Mrs Panton thought 'there was always a romantic air of sorrow and suffering about the whole house'. This was because Mrs Elmore had died giving birth to a son, who also died.[24]

Not so close by, but nearer to Dickens's house was the Stone family. Frank Stone and his son Marcus were both successful painters in their day, although now Marcus is the better known of the two. As a young man he was employed by Frith to make copies of *The Railway Station*. Both Frank Stone and his wife were tall and handsome, as were their children. They all went on holiday together to Weymouth, where they suspected the cook of theft, and also of drinking. Eventually they sacked her, but summoned a policeman to intercept her with her luggage when leaving. Not only were her boxes full of stolen goods, but she had bags of groceries under her coat, and bars of soap under each arm. Frank Stone died suddenly of a heart attack in 1859; he was sitting at the breakfast table reading *The Times*. Later, a model arrived, and on being informed that Mr Stone was dead, said complainingly, 'Well he might 'a let me know!'[25]

Two lesser-known artists that Mrs Panton writes about were Thomas Brooks and Thomas Musgrove Joy. Both painted domestic and modern-life pictures in the 1850s and '60s, in emulation of Frith. Tommy Brooks, as Mrs Panton records, 'was lame, and had a furiously red head, and often came in after dinner to make up a four at whist . . .'. She often sat for him, but his pictures enjoyed little success. Yet again, Brooks and his wife were immensely kind to the Frith children, and invited them to parties at Christmas time. T.M. Joy also came to visit occasionally, with his two daughters; he gave Frith help with some of his backgrounds.

The jolliest set was the St John's Wood clique. Mrs Panton wrote that she 'never saw such unfailing light-heartedness and joviality as pervaded the St John's Wood men; they were all young and enthusiastic, all determined to succeed, and all loved each other. All were married, except George Leslie and Dolly Storey[26] and these two were the spoiled children of the set. Hodgson, Yeames and Marks made up the inner circle. . . .'[27] High jinks and jokes were the order of the day, and chief jester was Henry Stacy Marks. His speciality was a mock sermon, taking as his text, 'The wilderness, where the Wangdoodle roameth and the mastodon mourneth for his first born'. For Mrs Panton, first and foremost of the St John's Wood artists was Philip Hermogenes Calderon,

dark and handsome, with the looks of a Spanish grandee. 'I loved him then, and I love him now,' she wrote, 'as only a small and romantic girl can love.'[28]

The overall impression is of a very lively and happy household, but also of a very tight-knit artistic community. Everybody seemed to be having fun, grown-ups and children alike. 'Whenever we went to any of Papa's friends' houses,' said Mrs Panton, 'we were always made a great deal of, and allowed to do very much as we liked.'

SIX

Derby Day
1856–60

Whatever gave Frith the idea of painting the Derby, still the most famous English horse race, it was a stroke of genius. *Derby Day* (Plate 4) caused a sensation in its day, and is still the picture for which he is best known. As a subject, it was much more challenging than *Ramsgate Sands*: a bigger crowd, more incidents, and far greater variety of characters, ranging from the aristocratic to the criminal.

The Derby was regarded by the Victorians themselves as more than a great national holiday; it was one of the wonders of the age. Thanks once again to the railway, the Derby became available to all classes and conditions of people. The first special trains began in 1838, enabling far greater numbers of people, and horses, to congregate on Epsom Downs. The twentieth century, with its rallies and rock concerts, has become used to huge crowds; to the Victorians, it was something new, and a symbol of modern life. To some it was exhilarating, even challenging; to others, it was threatening and dangerous. The Church, and the moralistic element, regarded it with distrust, as a breeding ground for vice, disorder, and crime. Most Victorians regarded it as a harmless, even beneficial phenomenon, as it only lasted for one day. Gustave Doré and Blanchard Jerrold devoted two chapters to it in their book *London – A Pilgrimage* of 1872, and wrote that '[The Derby] gives all London an airing, an "outing"; makes a break in our overworked lives and effects a beneficial commingling of the classes.'[1] The Victorians took pride in the Derby, and it was regarded as an essential sight for foreign visitors. The *Illustrated London News* thought the Derby the most remarkable spectacle in the world, and in 1863 even described it as 'the most astonishing, the most varied, the most picturesque, and the most glorious spectacle that ever was or ever can be, under any circumstances, visible to mortal eyes'.[2] All writers agreed that the real interest of the Derby was not the racing, but the extraordinary variety of people to be

found there. Arthur Munby, a Victorian man-about-town who was secretly married to his housekeeper, Hannah Culwick, wrote that he went to the Derby in 1863, 'not to see the race, but to see those who go to see it, and to observe the humours of the course'.[3]

Frith said much the same of his first visit in May 1856, the year Blink Bonny won the race. 'My first Derby,' he wrote, 'had no interest for me as a race, but giving me the opportunity of studying life and character, it is ever gratefully to be remembered.' Inevitably, it was the criminal activities that first attracted his attention: 'Gambling tents and thimble-rigging, prick in the garter and the three-card trick, had not then been stopped by the police.' Frith was to incorporate most of these activities into his picture, and was himself nearly fleeced by a thimble-rigging gang, which included a fake clergyman. Frith was only prevented from getting into a fight by the intervention of his friend Egg. Typically for Frith, he saw a gambler attempting to cut his throat in one of the refreshment tents. He also noted, 'The acrobats with every variety of performance, gypsy fortune-telling, to say nothing of carriages filled with pretty women, together with the sporting element, seemed to offer abundant material for the line of art to which I felt obliged – in the absence of higher gifts – to devote myself. . . .'[4] Frith felt he had found his subject, and on his return home, began to make a rough drawing of the composition. With a disarming lack of modesty he later wrote that he never 'found difficulty in composing great numbers of figures into a more or less harmonious whole'.[5] He considered it a knack, or a gift, that an artist either possessed instinctively or not. No amount of teaching or practice would succeed if an artist did not have this gift. Frith then went on to study from models for all the main figures, before completing his first oil sketch. From this sketch, Frith's friend Jacob Bell commissioned him to paint a picture 5 or 6 feet long, for a price of £1,500. Frith retained the engraving rights, which he later sold to the great art dealer of the age, Ernest Gambart, for another £1,500. He was later to make two larger oil sketches; one of these is now in the Victoria and Albert Museum. The sketches only show the central part of the final picture. As he worked on the composition, it widened in both directions, as more groups and figures were added. Although Frith did not mention it in his books, we now know that he also employed the services of a photographer, Robert Howlett, best known for his portrait of the great engineer Brunel, standing against huge chains used to launch the *Great Eastern*. Frith asked Howlett to 'photograph for him

from the roof of a cab as many queer groups of figures as he could'.[6] Gambart was also involved, and went to the Derby with Howlett. We do not know exactly what use Frith made of the photographs, several of which survive.[7] Although Victorian artists in general feared and disliked photography, most of them made use of it; like Frith, they were generally coy about admitting it.

In January 1857, Frith began the laborious task of posing and drawing all the models for the main figures. As usual, the search for models took up much of his time. The acrobat and his son he found in a Drury Lane pantomime, but they proved incapable of sitting still for long periods. In the end, he bought their costumes from them, and put them on professional models. This was a constant dilemma for Frith; he might find the perfect model, but if they were not used to sitting, they proved to be useless. Thus he had to fall back so often on professionals, or members of his own family. Another model, called Bishop, was a good sitter who then mysteriously disappeared for six weeks. He reappeared, and it transpired that he had been in prison for assaulting a policeman. Frith liked that kind of story, and duly recounted it in full detail.[8] Bishop also kept pigs, and tried to get Landseer, who he also sat for, to ask Queen Victoria if he might have the food thrown out at Buckingham Palace for pig-wash.[9]

Another model mentioned by Frith was the beautiful Miss Gilbert, known as 'The Pretty Horse-Breaker'. These were young ladies employed by Tattersall's, the famous horse-auctioneers in Knightsbridge, to ride their horses up and down Rotten Row. They were generally regarded as fast young women, and little better than prostitutes. Alas, the pretty Miss Gilbert, like Violetta in *La Traviata*, died of consumption a few years later. She appears, in riding habit, on the extreme left of the picture. Frith thanked his friend Mr Tattersall for the introduction to her, and for other advice given during the progress of the picture.[10]

Frith's friend Jacob Bell, who had commissioned the picture, was also tireless in producing models, especially female ones. Frith admitted that almost every female figure in the picture was found by Bell. 'What is it to be,' he would say. 'Fair or dark, long nose or short nose, Roman or aquiline, full figure or small? Give me your orders.'[11] He produced one very beautiful actress, a Miss H., but Frith later had to paint her out, to her considerable annoyance.[12] As he was inexperienced in painting horses, Frith asked his friend and fellow-Yorkshireman, John Frederick Herring, to help. Herring painted the two horses on the right of the

picture.[13] The two jockeys were modelled by a professional jockey called Bundy, sitting astride a wooden horse in the studio. Later he told Frith that 'he would rather ride the wildest horse that ever lived than mount the wooden one any more'.[14] Frith recorded, with regret, that his friend Bundy was soon after killed by a fall in France.

All through 1857, Frith laboured on with his great work, delayed by foggy and dark weather, which prevented him from working at all. Finally, by the spring of 1858, Frith was beginning to pull together and complete his immensely complex composition. He received great encouragement from Daniel Maclise, an artist he greatly admired, who wrote on 25 March: 'I imagine you still very busy at your work [*Derby Day*] but only dropping in here and there little gem-like bits into the beautiful mosaic you have so skilfully put together.'[15]

A beautiful mosaic is a fitting description; Frith has succeeded in fitting together like a jigsaw a hugely complex composition involving roughly eighty-eight distinct foreground figures, quite apart from the crowds seen in the background on the other side of the course, where we can also see the grandstand. It is impossible to analyse every single figure; but they are organised into three main groups.[16] The central group, closest to the viewer, has a group of gypsy children in the foreground, and a boy with a lighted rope selling cigars. Families of gypsies were a familiar sight at the Derby, recognisable at once by any racegoer. Behind them is a man banging a bass drum to advertise the acrobat and his son, who are performing to the right. Behind the drummer are various figures, including a soldier, a bookmaker, a boy pickpocket, and an outraged middle-class couple watching him.

The group to the left is mainly occupied by the criminal classes, and sets out to show the various temptations to which the Derby crowd was exposed. On the extreme left is a gambling tent, with a sign identifying it as the Reform Club tent. Various young men are being lured in; others try to restrain them. On the left, with her back to us, is the pretty horse-breaker. In the centre of the group is the thimble-rigging gang. It consists of a man in the middle with three thimbles and a pea on a portable table. He is surrounded by accomplices. With his back to us is a smartly dressed working man, probably posing as a country squire. He is in league with the thimble-rigger, and is there to draw the victims in to the game. To his left is a shorter man with a lively expression, holding a banknote. To the Victorian viewer, this man looks like the criminal type, low-browed, clever, shifty, untrustworthy; he is clearly

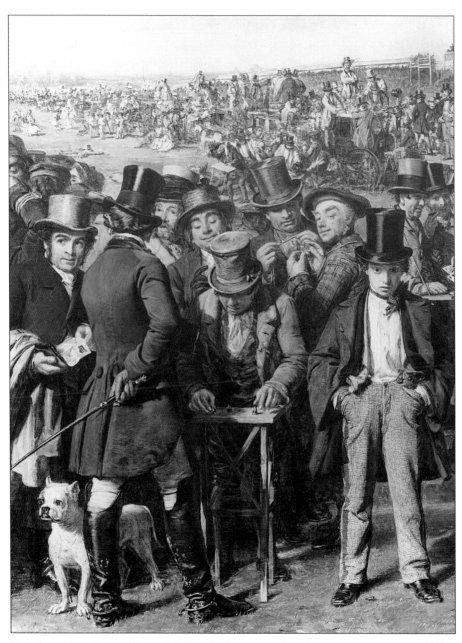

Detail of *Derby Day* with the thimble-rigging gang. The thimble-rigger is surrounded by shady characters, mostly accomplices, including the man with the banknote. The boy with his hands in his pockets, clearly a victim of the gang, was one of Frith's most brilliant creations; a type immediately recognisable to the Victorian audience. *(Tate Gallery, London)*

another accomplice. Behind the thimble-rigger are three more dubious characters: a clergyman, or Quaker, also in league with the rigger; also a Scotsman and a Jew examining a watch and chain removed from their victim, a young boy in baggy check trousers and a coat too large for him, who stands in astonishment with his hands in his pockets. He is clearly the victim, and has been cleaned out by the gang. This figure is one of the most striking in the whole picture, and one of Frith's most brilliant creations. The boy represents a type instantly recognisable to the Victorian audience, the city clerk, boy apprentice, or 'counter-jumper', an overdressed young man trying to ape the manners and clothes of a swell. It was a type already depicted many times in *Punch*, especially by John Leech, and by George Cruikshank in his book *The Progress of Mr Lambkin* (1844). Here was a clear case of Frith playing the anthropologist, portraying a particular urban type, recognisable at once to anyone who lived in London, or read *Punch*. The puny boy clerk is contrasted with the well-built and healthy looking yokel to the left, who is restrained by his female companion from joining the game. Behind him is a policeman, who is explaining to an enraged onlooker that he cannot intervene. Behind the policeman is a man wearing a fez; this is a portrait of Frith's unfortunate friend Richard Dadd, by then confined to an asylum for murdering his father. To the right of this group are two cardsharps fooling another country bumpkin with the three-card trick. Next to them is a man with bare feet and a long cut-away coat, probably Irish, who is shouting and selling Dorling's Race Cards, another type familiar on any Victorian racecourse.

The right-hand group depicts a very different milieu – the upper-classes, carriage folk. In the centre of this group is a carriage containing two very pretty, clearly aristocratic young girls, one holding a race card, the other a parasol. An older woman is seated in the carriage opposite them; she too looks aristocratic, and is perhaps their mother. Leaning against the carriage are two very smartly dressed men, clearly 'swells', and thought by the critics to be army officers. Once again, this is a type that would be instantly recognisable to the Victorian viewer, known through many John Leech illustrations in *Punch*, and also other magazines. The Victorians would expect to find such aristocratic types at the Derby and Frith has not disappointed them. Both the ladies and gentlemen conform to the Victorian upper-class ideal, with long faces, aquiline noses, firm chins, and elegant hands. Many of the newspapers commented on them, citing their elegant appearance as indicative of

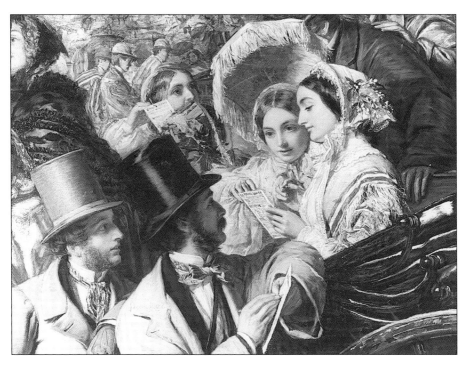

Detail of *Derby Day* with the carriage folk. The ladies and gentlemen in this group are clearly upper class and aristocratic, both in their dress and facial types. The two men are typical Victorian 'swells', a type well known from John Leech's cartoons. *(Tate Gallery, London)*

moral worth too.[17] The upper classes clearly were expected to set an example of good manners, good breeding, and elegant, but restrained dress. Judging by the amount of newspaper coverage, this was one of the most successful groups in the picture. In front of the carriage, a footman is laying out a picnic; the acrobat's boy is looking longingly at a large pie.

In the carriage behind the pretty girls with the parasol, Frith presents us with a carriage or drag full of very different upper-class people, clearly dissipated roués, accompanied by four good-looking but déclassée women. They all look slightly dishevelled, and although aristocratic, Frith has deliberately differentiated them from the group in the other carriage. Their features are not so refined. They are having fun, but not in a way the Victorian viewer could approve of. They are clearly dissolute, and part of the demi-monde, rather than the true aristocracy. It was a measure of Frith's success that the critics unerringly spotted this group: 'dissipated men and loose women', wrote the *Daily*

News.[18] The Victorian middle-class audience, mostly strongly disapproving of racing, drinking and gambling, and attuned to the dangers of sin, would also have got Frith's message.

The message is even more strongly hammered home in the carriage to the right. Here Frith pulls out all the moral stops. Against the carriage lounges another obvious aristocratic roué, elegant but foppish, with a lace scarf tied around his topper, and his hands in his pockets. His expression is sardonic; a cigar hangs from his lips. Here we have the classic upper-class bounder, a stock figure in countless novels, in *Punch* cartoons, and in other modern-life pictures, such as Robert Braithwaite Martineau's gambling classic, *The Last Day in the Old Home* (Tate Gallery). Frith was later to use the type himself in his series *The Road to Ruin*. The Victorians would have no trouble spotting him, and the critics pounced with glee. The *Morning Herald* even detected 'consumption on his cheeks' and 'exhaustion in his colour'.[19] He fails to notice a boy underneath his carriage stealing a champagne bottle. The critics also had no difficulty identifying the woman behind him in the carriage as his mistress, who is beautiful, but clearly miserable and uneasy. She is dark and attractive, but her low forehead, broad face, and strong eyebrows mark her out as mistress material, and not from an aristocratic background. She petulantly refuses the offer of the gypsy woman to tell her fortune. With this poor lady the critics had a field day. The *Daily News* described her as 'a splendidly dressed but evidently wretched English "Traviata" under the protection of a heartless rich coxcomb'.[20]

It is interesting to compare Frith's 'Traviata' with the lady rising from her chair in Holman Hunt's classic *Awakening Conscience* (Tate Gallery) of 1854. Hunt presents us with the possibility that this mistress has been smitten by her conscience, and wishes to repent of her ways. The Victorian belief in sin and redemption would make this seem perfectly plausible; unlikely though it might seem to a modern audience. The lady in Frith's picture is clearly not suffering from that kind of spiritual crisis. But she is miserable because she fears her faithless lover is going to discard her, and turn her out on to the street. Sexual misconduct in women was something the Victorians found very difficult to condone, but most of the critics of Frith's picture blamed the man rather than the woman.

Also exhibited at the RA in 1858 was Augustus Egg's trilogy *Past and Present* (Tate Gallery), showing the descent of an unfaithful wife from

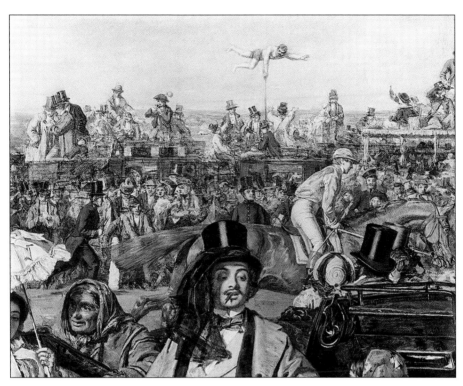

Detail of *Derby Day*, with the bounder, and racehorse in the background (painted by J.F. Herring). The classic upper-class roué, or bounder, is with his unhappy mistress, under the parasol on the left. She refuses to let the gypsy woman tell her fortune (see Plate 4). *(Tate Gallery, London)*

middle-class drawing room to archway by the Thames. One of the girls in the first picture, building a house of cards in the background, was modelled by Frith's daughter Cissie (later Mrs Panton). Both Frith and Egg's pictures, dealing with repellent subjects as they might be, met with approval from the Victorian critics, because they demonstrated that sin was followed inevitably by retribution. What the Victorians could not comprehend was that a woman might actually enjoy illicit sexual relationships. That is why they could not tolerate the novels of Flaubert or Zola. So Frith's picture is an accurate and faithful record of the moral climate of the time, combined with the skilful use of current ideas about physiognomy, character, and class distinction.

Perhaps inevitably, Frith's great picture smacks more of the studio than the racecourse. Combining so many figures, each one painted from a model, the overall composition has a static stilted look, as if the

figures were suddenly arrested in mid-movement. It is modern life as depicted by a historical painter; Frith painted the present as if it was the past. It is a huge, but motionless, tableau, and as a result is best examined in detail, figure by figure, group by group. Right up to the end, Frith was still unsure of its reception. On 6 March, he wrote to his sister, 'Some people go so far as to say "It is the picture of the age. . ." The die is cast, and though I shall work incessantly up to the last moment, nothing that I can do now will make or mar my work. . . .'[21]

Finally, after two years of work, the picture was finished and sent to the RA at the end of April 1858. On 2 May, Frith wrote in his diary, 'Private View. All the people crowd around the *Derby Day*.' The following day, he wrote, 'Opening day of the Exhibition. Never was such a crowd seen round a picture. The secretary obliged to get a policeman to keep the people off. Bell applies to the Council for a rail, which will not be granted.'[22]

The only time the Academy had allowed a rail to be put up was in 1822, to protect Wilkie's famous *Chelsea Pensioners reading the Gazette of the Battle of Waterloo* (now in Apsley House Museum, London). Frith wrote, in typically sardonic vein, that, 'on that occasion thirteen of the elderly Academicians took to their beds in fits of bile and envy; and though a few recovered by steadily refusing medicine, they never were in good health afterwards'.[23] The Council declared that they would never do it again. Frith is clearly suggesting that the Academicians were once again refusing a rail because they were jealous of Frith's success. But Jacob Bell persevered, pointing out that his picture, and also therefore the engraving rights, were in danger of damage. Gambart, as the owner of the copyright, also wrote a letter. With great reluctance, the Council relented, and on 8 May Frith wrote, 'Couldn't help going to see the rail, and it is there sure enough; and loads of people.'[24]

Among the first visitors to the Academy were Queen Victoria and Prince Albert. Frith recorded that the Queen normally looked at the pictures in catalogue order, but when she came into the larger room, she went straightaway to look at *Derby Day*. She later sent for Frith and congratulated him on his 'wonderful work'. Once again Frith was impressed by Prince Albert's understanding of painting; he made several suggestions which Frith later put into effect. One of the young Princes exclaimed to his mother:

'Oh, mamma, I never saw so many people together before!'
'Nonsense,' said the Queen, 'you have often seen many more.'
'But not in a picture, mamma.'[25]

Derby Day continued to draw massive crowds right up to the end of the Summer Exhibition. The picture also received huge press coverage, both in daily newspapers and magazines. Even Ruskin was polite in his annual review of the Royal Academy. He thought it 'quite proper and desirable that this English carnival should be painted', but found it 'difficult to characterise . . . in accurate general terms. It is a kind of cross between John Leech and Wilkie, with a dash of daguerreotype here and there, and some pretty seasoning with Dickens' sentiment.'[26] Ruskin had long been an admirer of John Leech and *Punch*, and recommended them to anyone looking to study English life and character. Even though some critics might disapprove of the subject, nearly all the reviews of *Derby Day* praise Frith's extraordinary talent for bringing together so many diverse characters in one picture, ranging from 'the upper extremity in the drawing rooms of Belgravia and its lower in the darkest nooks of Whitechapel', as the *Art Journal* put it.[27] Even *The Athenaeum*, normally so critical of Frith, devoted a whole page to describing and praising *Derby Day*, comparing it to Raphael, Veronese and Hogarth, and calling it 'a dazzling picture'.[28] The *Saturday Review* covered the picture at length, in two issues in May 1858. While praising the picture as a record of contemporary life, the reviewer warned that 'it is only the extraordinary of the commonplace', and denied that it displayed beauty, grandeur, dramatic intensity, or humour. [29] Many of the reviewers took a similar line, warning that such a representation of everyday life, however well painted, was basically vulgar, and not real art. Many also remarked on the price of £3,000 which Frith had obtained for the picture and the engraving rights.

Gambart owned the copyright, and also bought the exhibition rights. Following complex negotiations between Gambart, Frith and Jacob Bell, Gambart was allowed to take possession of *Derby Day* for four and a half years, both to engrave it, and exhibit it where he pleased. The picture was sent to Paris to be engraved by Auguste Blanchard, a celebrated French engraver, and then went on tour to Australia, America and Europe. Bell, meanwhile, had died in 1858, and bequeathed the picture to the nation. Gambart kept the picture until 1865, by which time a storm erupted over why it had not been

presented to the National Gallery. Letters were published, questions asked in the House of Commons; at that moment it was revealed that the picture was still on tour in Australia. The furore died down when the picture was finally returned from Australia and handed over to the National Gallery. The publicity had no doubt helped Gambart to sell yet more engravings.[30]

The extraordinary success of *Derby Day* gave Frith the confidence to go on painting 'the life about me'. He now knew he had a talent for it. He wrote that 'From long study of the "human face divine" I have acquired . . . a knowledge of the character and disposition that certain features and expressions betray.'[31] Frith, like many Victorians was fascinated by the criminal type; he liked going to trials, and trying to guess the guilty party by looking at their faces.[32] But then came 'the terrible difficulty of finding a subject'. It was a problem that was to dog Frith for the rest of his career.

As a stopgap, Frith began a small picture of a London street scene, featuring a lady crossing the street being offered help by a boy crossing sweeper. London streets could be muddy, dirty and wet, and especially dangerous to ladies in long dresses. Thus the profession of crossing sweeper arose; generally barefoot and ragged urchins with a broom at the ready. For a small tip they would clear the way for a lady to cross. Frith found a model for the lady easily, but had more difficulty with the boy. He later wrote, 'I discovered a young gentleman with closely cropped hair, naked feet, and a wonderful broom – in all respects what I desired, except in regard to honesty. . . .' Frith later found out the boy had stolen his gold watch chain. In his diary for 17 July, he wrote, 'A low, dull Irish boy for crossing sweeper, one degree removed from a pig.'[33] Frith was later to paint several versions of the crossing sweeper, which proved a popular subject. The first version is now in the Museum of London.

After the huge success of *Derby Day*, Frith wrote, 'So convinced was I that I should henceforth devote myself entirely to modern-life subjects that I was on the point of getting rid of a rather large collection of costumes of all ages. It was well I did not, for I have found great use for them in these latter days.'[34] As it turned out, Frith was to go on painting historical and literary subjects for the rest of his life.

Surprisingly, Frith's next picture after *Derby Day* was not a modern-life picture, but an eighteenth-century costume piece. Frith took the story from Macaulay's celebrated *History of England*, recently

The Crossing Sweeper, 1863. The streets of London were wet and muddy, and a boy crossing sweeper with his broom would clear a way for a lady to cross. Frith described the boy model as 'a low, dull Irish boy . . . one degree removed from a pig'. *(Private Collection)*

published, in 1849. The story concerned a handsome young man of
good family called Claude Duval. Having ruined himself by debauchery
and dissipation, Duval became a highwayman. Encountering the
beautiful Lady Aurora Sydney travelling in a coach on some wild heath,
he agreed to return some of his plunder, provided the Lady Aurora
agreed to dance a coranto with him. Frith thought it a good story, and
as usual set to work making drawings, and an oil sketch. He studied
eighteenth-century costume, and learnt how to dance the coranto. At
Cobham Park, Lord Darnley allowed him to make studies of an old
family coach. The landscape for the 'blasted heath', as Frith called it,
was painted in Dorset. While still at work on the picture, Frith sold it to
the dealer Louis Victor Flatow, 'at the agreeable price of seventeen
hundred pounds, which sum also included the sketch and copyright'.[35]
Flatow, who had started life as a chiropodist, was to play an important
part in Frith's career. *Claude Duval* was shown at the RA in 1860, but
was not well received by the critics, who thought he should persevere
with modern-life subjects. The *Saturday Review* praised the picture, but
questioned whether the lady dancing looked sufficiently terrified. The
reviewer quotes Sir Charles Bell's *Anatomy of Expression in Painting*,
saying that fear and terror were not the same thing. He goes on to
labour this point at some length, to show that he at least is familiar with
current thinking about physiognomy and facial expression. He
concludes that 'even if it is granted that there is some physiognomical
inaccuracy in the principal figure of the composition, it must be
admitted that the painting is very clever . . .' and he admits that 'the
general meaning is intelligible at a glance'.[36]

While working on *Claude Duval*, Frith received a much more
important commission – to paint his friend Charles Dickens. Dickens's
great friend and later biographer, John Forster, had suggested this
commission some years before. Dickens, however, decided to grow a
moustache, which Forster much disliked, so the commission was
postponed. 'This is a whim,' said Forster, 'the fancy will pass. We will
wait till the hideous disfigurement is removed.'[37] Dickens then
proceeded to grow a beard as well. Fearing that, if this went on, 'there
would be little of the face to be painted',[38] Forster asked Frith to
proceed.

Thinking that photography might help him, Frith asked Dickens to sit
for a photographer called Watkins. Dickens was photographed in a
velvet coat, with his own table and chair. Frith later wrote that he did

Claude Duval. A young man of good family, Claude Duval was ruined by dissipation and became a highwayman. He has encountered the beautiful Lady Aurora Sydney in her carriage; he agrees to return some of her belongings if she dances the coranto with him. *(Private Collection)*

not 'derive the slightest assistance from it . . .'.[39] He decided instead to paint Dickens in his study at Tavistock House (Plate 5). Dickens sits at his desk, turning around towards the spectator. On the desk is the first chapter of *The Tale of Two Cities*. Frith watched Dickens at work, noting that he spent a great deal of time 'muttering to himself, walking about the room, pulling his beard, and making dreadful faces . . .'.[40] Dickens was constantly sent books to read, and while Frith was there, a novel entitled *Adam Bede* by one George Eliot arrived. With some reluctance, Dickens began to read it; the next day he pronounced, 'That's a very good book indeed, by George Eliot. But unless I am mistaken G. Eliot is a woman.'[41]

Frith was very aware of Maclise's portrait of Dickens painted twenty-five years before (now in the National Portrait Gallery, London) showing a clean-shaven young Dickens with flowing hair. Frith thought the middle-aged Dickens much changed: 'The sallow skin had become florid, the long hair of 1835 had become shorter and darker, and the expression settled into that of one who had reached the topmost rung of

a very high ladder, and was perfectly aware of his position.' He also noted in his diary, 'Dickens most pleasant. No wonder people like him.'[42] The two men talked constantly during the sittings. Frith even made so bold as to criticise Dickens's public reading of *The Pickwick Papers*, suggesting a change to the character of Sam Weller. Dickens later adopted Frith's suggestion. The resulting portrait is both alert and penetrating and is undoubtedly the best portrait of the mature Dickens. It was shown at the RA in 1859, and is now in the Victoria and Albert Museum. Dickens's friends – Frank Stone, Egg, Leech, Mark Lemon and Shirley Brooks of *Punch* – were unanimous in their praise of it. 'At last we have the real man . . .' they said, and most pleased of all was John Forster.[43] *The Athenaeum* also thought it 'the best likeness by far that has yet appeared', comparing it favourably to the portrait of Dickens by Ary Scheffer: 'We have the author at the moment of his ease, quietly seated in an easy coat, at his study table – just as the curious public want to see him.' [44] Only the *Art Journal* demurred, complaining that Dickens looked too severe: 'The action is certainly ungraceful, if not unbecoming. . . .' The reviewer thought the portrait 'a mistake' and that 'the accessories are by no means in good taste'.[45] This seems to be a snobbish way of saying that he would not have such things in his own house; hardly a relevant comment.

SEVEN

The Railway Station
1860–2

In 1860 Frith began work on the third and last of his great panoramas of Victorian life, and the only one to be set in London. We do not know exactly what led to his choice of *The Railway Station* (Plate 6) as a subject, but it was both inspired, and inevitable. The railway was a nineteenth-century creation, and it completely altered the pattern of Victorian life. Like the Derby, it brought all classes of people into contact with each other, especially after Gladstone's Cheap Trains Act of 1844 put third-class passengers into covered coaches for the first time. As with *Ramsgate Sands* and *Derby Day*, the illustrators had got there first. In the 1850s, cartoons involving railway travel frequently appeared in magazines such as *Punch* or *Fun*. The subject of most of them was encounters between different classes, especially the upper and lower.[1]

Although we take it for granted, to the Victorians the city crowd was an object of wonder. And nowhere were the streets more crowded, with a greater variety of people, than in London. Henry Mayhew, author of *London Labour and London Poor* (1861) and most assiduous cataloguer and observer of London types, echoed the thoughts of most Victorians when he wrote, 'Who are these people who pass to and fro? What lives are theirs? What are their stories? Who are their friends? What is their business?'[2] It is precisely this vein that Frith sought to tap in *The Railway Station*.

Several painters before Frith had attempted railway subjects, but most concentrated on scenes in the waiting room, or the carriage. Best known of these were Abraham Solomon's two pictures, *First Class – The Meeting* and *Second Class – The Parting* of 1854. When first exhibited, *First Class* caused something of a furore, as it depicted a young man chatting to a pretty young lady while her father had fallen asleep. Solomon obliged by painting a second version, in which the father is woken up and put in the middle, and the young man transformed into a

naval officer – a tangible example of how Victorian morality influenced art.[3] The *Second Class* picture (Southampton Art Gallery), showing a poor boy and his mother, the boy perhaps going to emigrate or join the navy, aroused no such problems. Charles Rossiter in his *To Brighton and Back for 3s 6d* of 1859 (Birmingham City Art Gallery), showed us a third-class carriage or a cheap excursion train. Frederick Bacon Barwell's *Parting Words, Fenchurch Street Station*, also of 1859 (Private Collection) shows a group of smartly dressed people in a waiting room.[4]

Frith was therefore attempting something new when he decided to paint a busy station platform, with people hurrying to board a train. He selected the most obvious station, Paddington, not far from where he lived. The station had only recently been built, between 1850 and 1852, by Isambard Kingdom Brunel and Matthew Digby Wyatt. By 1861, its wonderful polychromatic interior had been painted brown as shown in Frith's picture. Over 140 years later the interior of Paddington station still looks exactly the same. Frith was concerned that the scene might be too drab, too ugly, for a picture. 'I don't think the station at Paddington can be called picturesque,' he wrote later, 'nor can the clothes of the ordinary traveller be said to offer much attraction to the painter. . . .'[5] Many friends advised him against it, but Frith persevered, and began to make drawings of figures and groups. Only one of these survives, a pen and ink drawing of the whole composition (now in the Elton Collection, Ironbridge Museum). This already shows the main outlines of the finished picture, with the crowd moving from left to right, and the boy putting luggage on the top of a carriage, forming the apex of the composition.

To the left can be seen the train, modelled from a real engine called The Sultan, of which a photograph survives.[6] The architectural background was painted by William Scott Morton (1840–93), a painter who had trained as an architect. Frith toiled on through late 1860 and the whole of 1861, still beset by doubts that it was not as good a subject as *Derby Day*. 'I am doubtful,' he wrote. 'The subject is good, but I don't feel so warm upon it as I did upon the other.' He was also depressed by the lack of enthusiasm of his friends and fellow artists.[7]

One reason why Frith persevered was he had already pre-sold the picture, as he had done with *Derby Day*. But this time he had sold to a dealer. He showed the oil sketch of *The Railway Station* to L.V. Flatow, who had bought *Claude Duval*. Flatow made Frith an offer he simply could not refuse – £4,500 for the sketch, the picture and the engraving

rights. Although payable in instalments, this was a huge sum by the standards of the day. It reflected not only the growing importance of dealers in the Victorian art market, but also the increasing value of engraving rights. The boom in the market for engravings in the 1850s and '60s led in some cases to the engraving rights being sold for more than the picture itself. In 1860, Holman Hunt sold his picture *The Finding of Christ in the Temple* (Birmingham City Art Gallery) to the dealer Ernest Gambart for £5,500, a record at the time for a modern picture. Of this, at least £3,000 was for the engraving rights. Frith felt sufficiently proud of his deal with Flatow that he reprinted the contract in his autobiography.[8] Frith reserved the right to exhibit the picture at the Royal Academy, but later renounced this for a further payment of £750.

Almost at once, speculation began to spread in the art world about this contract, no doubt assiduously fanned by Flatow, who knew the value of good publicity. In 1861 *The Athenaeum* published a letter from Flatow claiming that he had paid Frith 8,600 guineas for the picture, plus 750 guineas for not exhibiting it at the Royal Academy. The magazine commented, 'This sum (in all £9,817 10s) is, we suppose, the largest price ever paid for a modern picture.' Flatow was no doubt well aware of the price paid by Gambart for the Holman Hunt picture, which is why he exaggerated the price of *The Railway Station*. It helped to fuel interest in his picture, and also made him appear to score off his arch-rival.

Once again, Frith made no mention of photography, claiming that everything in the picture was painted from nature. Yet we now know that he did employ a photographer, Samuel Fry, to help him with details of the station, engine and carriages. This was reported in *Photographic News*: 'Mr Samuel Fry has recently been engaged in taking a series of negatives, 25 inches by 18 inches, and 10 inches by 8 inches, of the interior of the Great Western station, engine, carriages etc. for Mr Frith, as aids to the production of his great painting, "Life at a Railway Station". Such is the value of the photograph in aiding the artist's work that he wonders now however they did without them!'[9] Curious, then, that Frith did not see fit to mention it at all. As he was not using a photographer for people, as he did for *Derby Day*, he perhaps thought it not worth mentioning. Yet it was more evidence of his highly equivocal attitude to photography, an attitude shared by most of his contemporaries. It was this attitude that Oscar Wilde was later to mock

in his essay *The Critic as Artist*, when one of the characters enquires if Frith's pictures were all painted by hand. On another occasion he is said to have observed that Frith's pictures had elevated painting to the dignity of photography.

As usual, Frith had trouble with models, but this time decided to include himself, his wife, and four of their children. They appear right in the middle of the picture, engaged in typically middle-class activity of sending two of their sons off to school. (Frith actually sent his sons to a school in Frome, Somerset.) Mrs Frith leans down to kiss one boy, who holds a cricket bat; Frith stands with his arm protectively round the shoulder of the other boy. A daughter stands in the foreground holding a younger son by the hand. The Frith family group sets the tone for the rest of the picture, which is predominantly middle class, like *Ramsgate Sands*. Although Frith introduces a wide variety of characters on to his station platform, it has nothing like the startling juxtapositions of character, class and type found in *Derby Day*. Frith sees catching a train as an

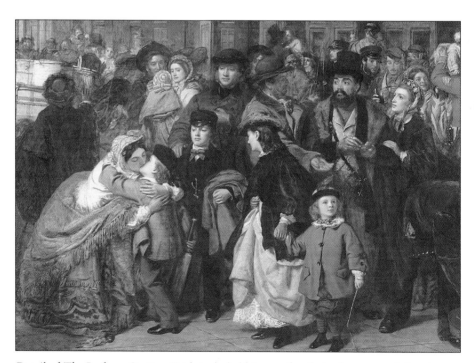

Detail of *The Railway Station*. Frith included his own family in the centre of the picture. Frith, and his wife, to the left, are seeing their two sons off to school; to the right is a daughter, holding the hand of a younger brother. *(Royal Holloway College and Bedford New College, Egham, Surrey)*

exhilarating but generally harmless activity, although he could not resist introducing the criminal element once again, in the shape of two well-known detectives of the day arresting a suspect about to board the train.

The figures in *The Railway Station* fall into four main groups. On the left, mainly lower-class and poorer people, and a porter, all in a hurry to catch the train. In the centre, two groups, the Frith family, and a bridal party, all looking calm and unhurried, a sure sign of their superior status. To the right are the two detectives arresting their man. It is this group that probably aroused the greatest interest of the whole picture. Not only was it gratifying for the Victorian public to see law and order being upheld, but the detectives were based on real models, Michael Haydon (b. 1819) and James Brett (1820–98), two well-known detective sergeants of the day. Tom Taylor, who wrote a description of the picture to accompany the engraving, was keen to point out that these were not 'conventional types of their class' but 'the real men . . .'.[10] The two detectives are smartly turned out, in dark suits and shiny top hats. Their faces look both strong and calm, suggesting energy and intelligence. Frith would certainly have read Dickens's *Bleak House* with its description of Mr Bucket, the detective, as 'a stoutly-built, steady-looking, sharp-eyed man in black, of about the middle age . . .' with 'nothing remarkable about him at first sight'. The man Haydon and Brett are arresting also looks well dressed and affluent, wearing a cape and spats over his shoes. He turns around in surprise, as Brett shows him the arrest warrant; his wife, already in the doorway of the carriage, also looks alarmed. Haydon and Brett specialised in the forgery and fraud type of crime – white-collar crime – and this is clearly the kind of criminal they are arresting. Nearly all the critics wrote approvingly of this incident, saying how well Frith had characterised the two detectives. Obviously, this is just how the Victorian public liked to see a detective – a steady, hard-working citizen doing a very important job. It was a brilliant stroke by Frith to introduce real characters, rather as writers of fiction today introduce real people and places into their books. It helped the public to identify with the picture.

The next group of importance is the bridal party, to the left of the detectives, consisting of a bride and groom, two bridesmaids, the bride's younger sister and brother with a nanny, and the bridegroom's man-servant. Frith clearly intended this group to stand out from the crowd as superior and upper class, but he was criticised for not making them aristocratic enough. William Michael Rossetti, brother of Dante

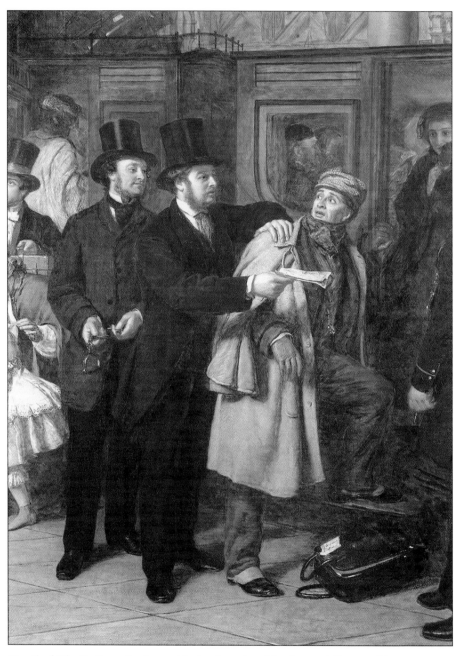

Detail of *The Railway Station*, with the detectives Haydon and Brett making an arrest. By including two well-known detectives of the day, Frith has made his picture totally modern. Paddington station itself had only been completed ten years earlier, in 1852. *(Royal Holloway College and Bedford New College, Egham, Surrey)*

Gabriel, was a prolific writer and critic; he wrote, a few years later, in 1867, that the ordinariness of the scene could have been redeemed 'if the figures were superior in beauty and refinement – but this is not the case. . . . The whole family, though clearly intended to be aristocratic, have in reality an underbred air and get-up. . . .'[11]

The Victorians clearly liked their aristocrats to look aristocratic, even though the reality might be different. Then, as now, there were aristocrats who did not look upper class. Equally, there were members of the working class, who if dressed in the right clothes, could look like aristocrats. But in a painting depicting modern life, the Victorian public wanted the upper classes to look refined and aristocratic. In *Derby Day*, Frith had been praised for doing this with the group round the ladies in the carriage; with *The Railway Station*, many of the critics thought the bridal party was not all it should have been.

With middle- and lower-class types, Frith was much more successful. In particular, the railway officials, the porter on the left with his barrow, and the ticket inspector (to the right of the bearded man with a top hat) were thought to be excellent examples of their type and class. So was the cabby, who is disputing his fare with the bearded man in the top hat, just to the right of the Frith family. The bearded man was modelled by an Italian, who gave Italian lessons to Frith's daughters. Frith wrote that he was 'a man of distinguished manners; and we were given to understand that he was a nobleman whose head was wanted in Venice to serve a very different purpose from that to which I put it in this country'.[12] He later complained volubly to Frith that the portrait was far too like him and he would be recognised.

Frith and his family also met with general approval. They must have represented a typical mid-Victorian, middle-class family that many viewers could identify with. Mrs Frith, in particular, was thought to be a typical English beauty; the boys had the 'blond, frank and manly faces inherited from Saxon ancestors'.[13] The Victorians were keen on their Anglo-Saxon heritage, and regarded it as an important source of national character. In the early nineteenth century, King Alfred was the great national hero; during the Victorian period he was supplanted by King Arthur.

By contrast, the family group to the left is clearly lower middle class. They are hurrying to catch the train, led by the agitated mother, followed by her husband and two children. The critics pounced on this group, mainly in order to make fun of them. Almost all the critics

pointed out that she was a well-known type, 'the full-blown matron . . . the woman we all know and dread, the woman who always fancies she is too late'.[14] Vulgar, probably in trade, the *Observer* critic described her as 'clamorously dragging her meek husband and unresisting children' towards the train.[15] Frith's mother, who modelled for this lady, cannot have been too pleased, but Frith does not record her reaction.

Just to the left of the bridal group is another group, which aroused considerable attention. This is the recruiting sergeant, with his wife and baby. He is kissing the baby, presumably prior to boarding the train. Just to the right of the sergeant, Frith could not resist putting in a deliberately lower-class, possibly criminal type. This is the recruit, who wears a sealskin cap, and sucks on his wooden stick. His face is broad, his features coarse; Frith has given him all the physiognomic attributes of a reprobate, or criminal type. His widowed mother weeps on his shoulder. The critics all spotted him, and vied with each other in speculating about his low and untrustworthy character. Tom Taylor wrote, 'He stands confessed a tremendous blackguard; low excess has written and stamped the character on every line of his face.'[16] He suggested he might be a costermonger, then a byword for a degenerate and disreputable character. *The Athenaeum* went even further, describing the recruit as an 'ugly gallows bird . . . a wasted town sort who, not repentant of his debauch, sucks in his feverish, cracked lips a favourite stick and raps his yellow teeth with it, staring out of his hateful bleared eyes . . .'.[17] Nearly all the critics took this line, except the *Sunday Times*, who thought him 'a healthy, hardy, upstanding rough, who . . . will make an excellent soldier'.[18] All this goes to prove how successful Frith was in depicting characters and social types that conformed to the Victorian public's expectations. He was better at it than any of his rivals or imitators.

The Victorian public displayed their approval, and their enjoyment of *The Railway Station*, by flocking to see it in Flatow's gallery in the Haymarket. A single-picture exhibition like this was still a novelty in the 1860s. Frith recorded proudly that 21,150 people had visited the exhibition in seven weeks. Flatow created a precedent when he began charging 2s 6d on Saturdays, instead of the usual 1s. Tom Taylor's booklet, describing the picture in detail, was also on sale at the exhibition for 1s. The Victorian public wanted to examine the picture in detail and read about it; this was one of the reasons for its success, and went with the vogue for modern-life pictures. An engraving was on show, which would enable Flatow to take orders for the print. Frith wrote that

'Flatow was triumphant; coaxing, wheedling and almost bullying his unhappy visitors. Many of them, I verily believe, subscribed for the engraving to get rid of his importunity.' Frith was once rash enough to bet Flatow half a crown that he could not sell a print to one 'fashionable, languid-looking young gentleman' who was on the point of leaving. Flatow promptly accepted, and went to work. He intercepted the young man and they went back to look at the picture again. A few moments later the visitor left; Flatow walked over to Frith, and triumphantly asked for his 2s 6d.[19]

In her memoirs, written in 1908, Mrs Panton recorded that Flatow badly wanted to appear in *The Railway Station* as the 'hengine driver'. 'After all,' he said, 'it's my money will make the picture go.' But the engine driver flatly refused, saying that 'Me and my hengine goes together.' So Flatow had to content himself with being the mere passenger standing talking to the driver, 'and very like the good, fat, vulgar little Jew the figure is', wrote Mrs Panton.[20] She was obviously very fond of Flatow and his wife Elizabeth, who had no children, and liked to spoil the Frith children with presents. Mrs Flatow, she wrote, 'would have passed muster until she opened her mouth; then her H's flew about like hail . . .'. She always addressed her husband as 'Chum'. Mr Flatow she described as 'not beautiful to look at, and he had the most horrid hands I think I ever saw . . .'. He also dealt in jewellery, 'joollery' he called it, and tried to get Frith to accept some in part-payment. He always refused.

The Railway Station remained on view at Flatow's gallery from April to September 1862. The *Illustrated London News* reported on 20 September that 83,000 people had seen the picture, and 'the subscription list for the engraving is also very large'. Flatow must have been pleased with his bargain. The picture was then sent to Francis Holl (father of Frank Holl, the painter) for engraving. During the period of the exhibition, Frith engaged Marcus Stone, a young painter and son of his friend Frank Stone, to make two copies, for £300. Walter White, Librarian of the Royal Society, visited Stone on 26 May, and found him at work on the copies.[21] Frith was remarkably silent in his memoirs on the subject of copies, nor does he mention Marcus Stone. There are now known to have been at least three versions, plus the oil sketch, which was bought by a Victorian collector and wine merchant, Frederick William Cozens,[22] who also owned one of the Marcus Stone copies. Cozens's version last appeared at Sotheby's in 1980, and is now in a

private collection. Of the other two versions, one is in Leicester Museum and Art Gallery; the other was presented to King George VI in 1947 by the Directors of the Great Western Railway (presumably to keep it out of the hands of the Labour Party, who nationalised the railways in that year). A coloured version of the engraving still survives at Paddington station.

Following the exhibition at Flatow's Haymarket Gallery, the original picture was shown at another gallery in the City, Hayward and Leggatt's in Cornhill. After this it went on a tour of provincial towns. By this time Flatow had already sold the picture on. In 1863 he sold the picture and engraving rights to the well-known print dealers in Pall Mall, Henry Graves, for a total of £16,300. The engraving, by Francis Holl ARA, had been published by Graves the year before, 1862. Once again speculation was rife in the press about this huge price. *The Athenaeum*, always keen on art-world gossip, published a letter from Henry Graves, confirming that the figure was correct.[23]

It was not until twenty years later that the painting finally found a home. In 1883, Graves sold the painting for only £2,000 to Thomas Holloway, the Victorian pill king, who had first seen it in 1864 in Scarborough, when it was on tour. Holloway made a fortune from pills, especially laxatives, and founded with his wife the first college specifically for women, Royal Holloway College, in 1879. On 30 June 1886 it was officially opened by Queen Victoria; Holloway had died in 1883. A huge rambling building in French-chateau style, it sits beside the A30 at Egham, and was long regarded as one of the greatest Victorian monstrosities. Now the wheel of fashion has turned in its favour. Holloway also put together at high speed, between 1881 and 1883, a collection of seventy-seven pictures, all English, and mainly Victorian. The exceptions were three pictures by Turner, Constable and Gainsborough, which the college has now regrettably sold. *The Railway Station* is one of the highlights of the collection, which includes works by Landseer, T.S. Cooper, J.C. Horsley, Thomas Creswick, Daniel Maclise, Millais and Clarkson Stanfield, all friends of Frith. The collection also contains two other social realist masterpieces, *Newgate – Committed for Trial* by Frank Holl (1878), and *Applicants for Admission to a Casual Ward* by Sir Luke Fildes (1874). It is a marvellous example of what a rich Victorian might buy in the 1880s; an extraordinary, and still uniquely intact survival of Victorian taste. Holloway paid the highest price, £6,615, for Edwin Long's notorious

Babylonian Marriage Market, still a controversial picture today, chronicling the Victorians' fascination with the exotic world of orientalism.[24] It may seem surprising now that Holloway only paid £2,000 for Frith's far greater picture, but by 1883 Graves must have felt that the picture had exhausted its commercial possibilities. Obviously they had made so much money from the sale of engravings that they could afford to sell the picture cheap. Meanwhile, *The Railway Station* had been shown at three international exhibitions: London in 1872, Philadelphia in 1876, and Paris in 1878, all of which must have boosted sales of engravings. To a dealer, the engravings market was potentially far more lucrative than the sale of the picture itself.

After the huge success of his third great modern-life picture, Frith was at the pinnacle of his career. He was both rich and famous, the best-known painter of his day. He could afford to ignore the critics. He wrote later, referring to *The Railway Station*, 'The critics contradicted one another as usual, without doing good or harm to me or the picture.'[25] If the length of the reviews is anything to go by, *The Railway Station* created even more of a sensation than *Derby Day*. It was reviewed in all the major newspapers, some devoting whole columns to it. Many magazines, including art magazines, covered it, in particular the *Art Journal* and *The Athenaeum*. In general, the reviews gave Frith credit for the originality of the subject, and for his skill in making such a drab, unpromising scene into such a successful picture. Nearly all agreed with the *Art Journal*, who praised it as 'free from all exaggeration'.[26] 'A pictorial comedy,' said the *Weekly Despatch*, 'which reflects the manners of our day'[27]; ' . . . just the mingled classes which may be seen every day at our chief railway stations – and everyone of them extraordinarily true to life,' wrote the magazine *Era*.[28] Frith's success further fuelled the vogue for modern-life subjects, and inevitably led to imitators and followers, in particular George Elgar Hicks. But none of them could equal Frith as an artist, and none of them came close to equalling his success. For most Victorians Frith was *the* painter of modern life. The *Saturday Review* of June 1859 noticed how Frith's success had brought modern-life subjects into vogue, but concluded that works by George Elgar Hicks and others were 'decidedly inferior to Mr Frith's productions'. [29]

EIGHT

Frith and his Patrons

From the 1850s onwards, Frith preferred to sell his pictures direct to dealers, particularly his larger and more expensive works. The main reason for this was that dealers controlled the lucrative engravings market, of which Frith was one of the main beneficiaries among Victorian artists. As he did with Flatow, Frith could sell the engraving rights for as much again as the picture; sometimes even for more. Dealers were also better at promoting artists, marketing their work, and pushing up prices. As Millais wrote in 1875:

> I am inclined to think we are chiefly indebted to the much abused dealer for the great advance in the prices paid for modern art. It is he who has awakened the Spirit of Competition. Where the artist knows of only one purchaser, the dealer knows many, he has on the whole been the artist's best friend and scores of times has bought on the easel what the connoisseur has from timidity refused.[1]

Frith, as we have seen, dealt with the two biggest dealers of the mid-Victorian era, Ernest Gambart and Louis V. Flatow. He was happy to accept the highest offer from either of them; in fact he played them off against each other. Gambart and his family were close personal friends who paid each other visits, and went to each other's parties. Mrs Panton recalled as a child going to stay with the Gambarts at a house they had rented in the country.[2] The Flatows, being Jewish, and definitely not upper class, were nonetheless good friends of the Frith family. They had no children of their own, and clearly enjoyed visiting the Frith children, and spoiling them. Mrs Panton writes very affectionately of them in her memoirs, but also makes fun of their appearance and their cockney accents. Like her father, Mrs Panton enjoyed Flatow's company; he was the kind of character that Frith appreciated. As a result, Frith devotes more space to Flatow than to Gambart in his memoirs, particularly to

Flatow's premature death. The only other dealers Frith mentions are Lloyd, the dealer who first bought *Ramsgate Sands* before selling to Queen Victoria and Prince Albert, and Agnew's, who bought his picture *Before Dinner in Boswell's Lodgings* in 1867 and sold it to Sam Mendel. At the Mendel sale it sold for £4,567 10s, the highest price at the time for the work of a living artist. We know he sold to other dealers, such as Henry Graves, Maclean and Wallis, but they do not get a mention. As Mrs Panton recorded: 'In our day the picture dealer took all the sordid bargaining out of Papa's hands . . . except when he was inundated with commissions from enthusiastic admirers, who implored him for more pictures than he could ever hope to paint.'[3]

Even though Frith preferred to deal with the trade, it did not mean that he lacked private patrons. On the contrary, private patrons and collectors were very important to him throughout his career, but especially in the 1840s, when he was beginning to make his name. It was in that decade that he met two of his most important patrons, John Gibbons of Birmingham and Thomas Miller of Preston. Both became friends, and correspondents, and both are recalled with affection and gratitude in his memoirs.

Art and money have always been interconnected, but what was different about the Victorian period was that it saw the arrival of a new kind of money – middle-class money. Up to the eighteenth and early nineteenth century, patronage of art was something only exercised by the aristocracy. With the end of the Napoleonic Wars, and the two reform bills of 1832 and 1867, the middle classes got the vote, and their place in the sun. The ethos of the Victorian age was overwhelmingly middle class; the aristocracy were still there, and still enjoyed great power and social prestige, but even they had to adapt to the new middle-class morality. Even the grandest aristocratic families began to have family prayers, with the servants present. Victoria and Albert looked and behaved like a middle-class couple; they both set the tone for the age, and reflected it. And the new middle classes quickly discovered that one way to gain social acceptance, and to meet people further up the social scale, was to collect art. Art was what gave the new money a cultural identity. From the 1850s onwards, the art market, and collecting, boomed. Lady Eastlake, wife of Sir Charles Eastlake, both President of the Royal Academy and Director of the National Gallery, was very much in a position to observe the great change that was taking place. She herself was of middle-class origins, the daughter

of an obstetrician. Writing about the mid-Victorian period, she observed: 'A change which has proved of great importance to British art dates from these years. The patronage which had been almost exclusively the privilege of the nobility and higher gentry, was now shared (to be subsequently almost engrossed) by a wealthy and intelligent class, chiefly enriched by commerce and trade; the note-book of the painter, while it exhibited lowlier names, showing henceforth higher prices.'[4]

Lady Eastlake rightly went on to point out that the new collectors, from the start, were determined to collect modern art, the art of their own age. This was not only because they wanted to display their own independence of spirit, but because they distrusted the Old Masters, an area they associated with the aristocracy and also with fakes and forgeries. The new middle class wanted their own cultural identity, and buying modern art was the obvious way of affirming their own self-confidence and their belief in progress and in British achievements. They believed, as most Victorians did, that everything British was best. Very few of them collected foreign art.

Photograph of Frith at his easel, by Maull and Polyblank. Frith is portrayed as the archetypal Victorian artist – rich, successful, and a respectable figure in society. *(Photo: Witt Library, Courtauld Institute of Art, London)*

Historians have tended to neglect the Victorian middle classes; others have pursued a feminist agenda. Old-fashioned historians, such as G.M. Trevelyan or G.M. Young, tended to treat the middle classes rather condescendingly, lumping them together in one amorphous mass. The truth is that the middle classes covered an enormous spectrum of the social scene, and comprised a large number of different types and gradations. Absolutely the same could be said of Victorian collectors. The prevailing myth was that all Victorian collectors were self-made men from the north, with dirty hands and thick regional accents. We now know this to be absolutely untrue. An analysis of Victorian collectors shows that most of them were educated, and already had second or third generation money behind them. There were exceptions: James Morrison, for example, who made a fortune from the drapery business, was the son of a Salisbury innkeeper. Some Victorian millionaires were proud of their humble origins, and exaggerated them. The Victorians, like us, enjoyed a rags-to-riches story. Much more typical was William Armstrong of Newcastle, the great shipbuilding and armaments magnate. He was a qualified solicitor before he became interested in hydraulics; his father was a prosperous corn merchant. Most of Frith's clients fit very much in to this pattern. A great deal of research has been done into Victorian collecting and collectors; much more is still to be done. It forms an essential part of our understanding of Victorian art.[5]

In the 1830s, a German historian called Dr Gustav Waagen began a series of extraordinary books, surveying and cataloguing all the works of art in English public and private collections.[6] Waagen did for nineteenth-century collections what Nicolas Pevsner was to do for English buildings in the twentieth. Waagen's books reveal the amazing quantity of fine pictures, both Old Masters and modern, that had by then accumulated in English private hands. Many of the new, middle-class collectors were from the great provincial towns, Birmingham, Liverpool, Manchester and Newcastle, but a great many were London-based. Robert Vernon, one of the greatest of the early Victorian collectors lived in London, and made a fortune from the horse-and-carriage hire business and from property. He left his collection to the nation and it now forms an important part of the Tate Gallery collection. John Sheepshanks, a Leeds cloth merchant, and John Gibbons, a Birmingham ironmaster, both retired from business and came to live in London, rather than becoming country gentry.

Sheepshanks, who bought a picture from Frith, left his collection of over 500 paintings and watercolours to the South Kensington Museum, now the Victoria and Albert. In the provinces, collecting art was very much bound up with civic pride, and the desire to benefit one's home town. Many Victorian collectors endowed, and gave their names to, their local museum, such as the Walker in Liverpool, the Harris in Preston, the Laing in Newcastle, and many others. One of the last to do so was William Lever, the first Lord Leverhulme, who founded, built and endowed the Lady Lever Art Gallery at Port Sunlight in 1922, as a memorial to his wife. Leverhulme bought a picture by Frith, called *The New Frock*, and used it for one of his Pears Soap advertisements.[7]

Some collectors preferred to buy direct from the artists; others bought through auction, or were advised by a dealer. Some did all three; many became virtual dealers and speculators in their own right. Agnew's, the greatest of the Victorian art-dealing firms, was founded in Manchester; later they opened a gallery in Liverpool, and another in Old Bond Street, London, where they still are today. Agnew's tended to monopolise collectors in Manchester, Liverpool and the north-west. Sam Mendel, for example, a Manchester cotton and shipping tycoon, amassed an enormous collection through Agnew's, and then sold it at Christie's in 1875, for the then huge sum of £98,000. Over one hundred of Mendel's pictures had already been sold privately to Agnew's before the sale. Mendel owned a Frith, but bought it from Agnew's.

The 1860s and '70s saw a number of big sales of private collections, which helped to underpin the market. These sales demonstrated to everyone that art, if wisely bought, could be a good investment too. This investment element was a key factor in the Victorian art market, and still is today. The first sale to capture public attention was the collection of Elhanan Bicknell, a whale oil importer and ship-owner, which sold at Christie's in 1863 for a total of £80,000. Bicknell bought most of his pictures direct from the artists, and made a substantial profit on them, especially his Turners. In 1872 came the even bigger Gillot sale, which netted an amazing £170,000. The *Practical Magazine* commented that the sale afforded 'proof that art not only yields the highest pleasures, but "pays" in the commercial sense . . .'.[8]

Joseph Gillot of Birmingham invented and patented the steel pen-nib, from which he made his fortune, and perhaps earned the nickname 'His Nibs'. He became a voracious collector, but at the same time both a dealer and speculator. Some idea of what a wheeler-dealer Gillot was is

The New Frock was bought from Frith by Lord Leverhulme for use as a soap advertisement. Millais' picture *Bubbles* was the first picture to be put to such use. The idea caught on, and many other artists, including Frith, were to benefit from it. *(Location unknown)*

revealed by an extraordinary deal he concluded with Frith's friend Flatow: it is recorded that on one occasion, early in Gillot's collecting career, he exchanged *The Elopement* by Van Schendel, landscapes by Schelfhout, Ruysdael, and one "with sheep" by Ommeganck, a portrait by Cuyp and *Fête Champetre* by Henry Andrews with the dealer Louis Flatow for 14,020 gross-worth of steel pens.⁹ One suspects that in Flatow, Gillot had met his match. Gillot bought a picture by Frith, *The Lovers*, and requested that he make changes to it.¹⁰

Frith's career, indeed that of any Victorian painter, needs to be seen and understood against the commercial background of the Victorian art market. In his early years, the patron most important to Frith was John Gibbons. Frith first encountered Gibbons in 1843, when he received a letter from him. Gibbons had seen two pictures by Frith in an exhibition in Birmingham, but they were both already sold. One of them was a scene from the ubiquitous *Vicar of Wakefield* and Gibbons requested that Frith paint him another version of it. The practice of making copies of a popular work was commonplace in the nineteenth century, and collectors did not seem to have a problem with it. Neither did the artists; Frith was not averse to painting second or third versions; he spent the last twenty years of his career turning out versions of his earlier successes. Rossetti was just as bad: buyers of his picture *Proserpine* might well have been alarmed to learn that he painted no fewer than seven versions of it. Gibbons also asked for another picture to serve as a companion piece. Frith suggested a scene from Goldsmith's *The Deserted Village*, entitled *The Village Pastor*, to which Gibbons agreed. The picture was completed, and exhibited by Frith at the RA in 1845. *The Village Pastor* and its companion are still in the collection of Gibbons's descendants.

Many years later, and long after John Gibbons's death in 1851, Frith devoted a chapter to him in his memoirs.¹¹ He titled the chapter 'An Old Fashioned Patron'. Frith lamented that 'Investment, a love of display, and a spirit of speculation – without the least enjoyment in their acquisition – are the guiding stars of many of the picture-buyers of the present day.' This, he maintains, was not the case with the earlier Victorian patrons, such as 'Sheepshanks, Vernon, Miller, Bell, Newsham etc.' several of whom left their collections to museums. Frith is not being entirely fair or accurate here; collectors such as Gillot, Bicknell and Mendel, as we have already seen, were collector/investors, and can certainly be described as speculators. Nor were later Victorian collectors

only motivated by investment; many, such as the Liverpool shipping magnate, F.R. Leyland, were men of taste, knowledge and discrimination, who collected art because they loved it. Collectors often start out as investors, but as they become more and more obsessed with collecting, lose interest in selling.

John Gibbons was born in Bristol in 1777. His family were prosperous sugar merchants, which means they were almost certainly involved in the slave trade as well. Gibbons then moved to Birmingham, where he made another fortune as an ironmaster. He retired in 1845, mainly due to poor health, and moved to London. His house in Edgbaston was bought by Joseph Gillot, who must have felt he was assuming the mantle of an older and more distinguished collector. Frith wrote that Gibbons 'was a confirmed invalid, whose life . . . would have been almost unendurable without his pictures and his books'.

Frith published in his memoirs a number of letters from Gibbons, from 1843 and 1844. They give the impression of a very kindly and sympathetic man. In 1843, Gibbons and Frith had still not met. Gibbons explained in his early letters, 'I have pictures by Mulready, Etty, Webster, Danby, Uwins, etc.', all of which he had commissioned direct from the artists. Gibbons had been a major patron of Francis Danby in his Bristol days, and continued to support him. Like many other early Victorian collectors, Gibbons clearly liked literary and historical subjects, but drew the line at allegory. 'I love finish,' he wrote to Frith, 'even to the minutest details. I know the time it takes, and that it must be paid for. . . .' One could not wish for a clearer statement of the Victorian work ethic, as applied to art. In spite of this, Gibbons did not like the Pre-Raphaelite Brotherhood's early pictures. He bought one, Holman Hunt's *Rienzi*, and kept it in a cupboard.[12] Gibbons also bought one of Richard Redgrave's social-realist pictures of the 1840s. Entitled *Fashion's Slaves*, it shows a rich young lady in her boudoir, rebuking a milliner's girl for arriving late with her dress.[13] Having agreed a subject and a price, Gibbons would then pay an advance, which could be whatever the artist requested.

Gibbons's letters are chatty and gossipy; obviously Frith was giving him information about the art world, and about other artists. This seems to be a characteristic of the Victorian art world; once a patron and an artist had met, the patron asked for opinions about other artists' work. Frith seems to have been scrupulously fair in his judgements of other artists; most of them were good friends of his anyway. In his

letters, Gibbons mentions other pictures by W.E. Frost, Sir W.S. Boxall, C.R. Leslie, Francis Danby and others; he also writes, 'I will be very glad to see you and Mr Elmore, and I will take you on to Mulready's.' Clearly Frith and his fellow-artists helped each other. Gibbons was very confident that Frith would give him good advice; 'Depend upon it,' he wrote, 'that any criticisms you give me on contemporaries are safe.'

Frith also liked to let Gibbons into his confidence, telling him of ideas for pictures, or how he was getting on with something. They also frequently discussed subjects. Gibbons liked Shakespearean subjects,

Portrait of John Gibbons of Birmingham, attributed to George Sharples, pastel. Gibbons was a prosperous ironmaster who formed a large collection of English pictures, mainly by living artists. Most he had bought from the artists direct. *(Private Collection)*

and tried to persuade Frith to paint one for him. Frith must have demurred, as Gibbons wrote in a letter from Leamington on 7 October 1843, 'Shakespeare is rather a dangerous fellow to meddle with, as you intimate in your letter.' He also mentioned that he had been offered a Shakespearean subject by Frith, 'but I did not much like it'. It was Frith's very first RA exhibit, a scene from *Twelfth Night, Malvolio cross-gartered before the Countess Olivia*. Frith had also painted a scene from *The Merry Wives of Windsor* (RA 1843) and Gibbons writes in December 1843 to congratulate him on selling it. Frith must have offered it to Gibbons, but he said, 'I was afraid to buy it "sight unseen", as they say in our country. I had a strong presentiment that if it had reached Edgbaston it would have gone no further.' In the same letter, Gibbons suggested the 'Spectator Club as a subject?' Frith seems to have taken Gibbons's advice; in 1847 he exhibited *A Scene from the Spectator* at the RA. Gibbons also mentions two other pictures of Frith's – a *Mary Queen of Scots* (RA 1844) and a scene from Gray's *Elegy* (RA 1846), which Frith must have described to him, in the hope that he might buy them. This time, Gibbons did not rise to the bait.

The letters give a fascinating insight into the relationship between a Victorian collector and artist. Frith was still young and at the beginning of his career; Gibbons was nearly seventy, and his attitude to Frith in the letters is clearly meant to be kindly, encouraging and benevolent. He sounds a delightful man. Frith and he did finally meet in 1844 when Gibbons bought a house in Regent's Park, not far away. Gibbons must have visited Frith's house, and those of other artists in the vicinity. They also discussed exhibitions, and must have visited them together. As an older man, Gibbons also explained to Frith his ideas about art, and his recollections of the art world in the early part of the century. It was very much a two-way correspondence; Gibbons obviously liked to feel he was taking part in the process of artistic creation. Gibbons died in 1851, just as Frith's career was beginning to blossom. One suspects he would not have liked Frith's modern-life pictures; we shall never know. Gibbons's collection numbered over 200 oils.[14] Several sales took place at Christie's after his death, but his descendants still own a number of his pictures today, including several by Frith; mostly this was because they did not sell at the auctions.

Frith did not have many other patrons in Birmingham, except Joseph Gillot, who was not a big buyer of his work. There was another iron-master, Charles Birch, perhaps a friend of John Gibbons, who owned a

version of *Dolly Varden*.[15] Because of Frith's close friendship with Thomas Miller in Preston, he had several other patrons in Lancashire. Most important of these was Richard Newsham (1798–1883), a Preston barrister and partner in Thomas Miller's firm, Horrocks, Miller & Company. Frith mentions that Newsham bought his picture of *Le Bourgeois Gentilhomme* (RA 1848), but not directly from Frith.[16] On his death Newsham bequeathed his entire collection to the Harris Museum in his native Preston.[17] Near Preston lived William Bashall, another cotton spinner, who owned pictures by Frith, Egg, E.M. Ward, Ansdell and Landseer.[18] Another Lancashire collector, with whom Frith fell out, was James Eden (1797–1874). Eden, a bachelor, was in the bleaching business. Eden seems to have been the buyer of Frith's *Coming of Age in the Olden Tyme*, but he then refused to lend it back to Frith to make the engraving. Frith appealed to Thomas Miller, to help resolve the crisis; later Frith met Eden and the problem was smoothed out.[19] Eden was a big patron of Richard Ansdell, buying eleven of his pictures. He also had a house at Ansdell, near Lytham St Anne's in Lancashire. Eden owned Millais' *Autumn Leaves* (Manchester City Art Gallery), but disliked it, and traded it to another Lancashire collector John Miller.[20] There were certainly other collectors in Liverpool and Manchester who bought Frith's pictures, but probably through Agnew's, and not direct from the artist. James Leathart of Newcastle, the greatest of the Pre-Raphaelite collectors, did not buy Frith, but one Newcastle collector, Jacob Burnett of Tynemouth, a manufacturing chemist, owned at least one Frith, which he probably bought from Gambart.[21] Many of these northern collectors lent pictures to the celebrated Manchester Art Treasures Exhibition of 1857. This huge exhibition, the biggest of its kind in the north, not only brought art to the people, but set the seal on collecting as a respectable and worthwhile activity. Art in the north, and especially in Manchester, was linked to civic pride, and also to the idea of social responsibility. The chairman of the exhibition was Sir Thomas Fairbairn (1823–91) a successful engineer; he was a noted patron of the Pre-Raphaelites, and especially of Holman Hunt. His main adviser was Augustus Egg, Frith's close friend and neighbour.[22] The most popular picture in the exhibition was Henry Wallis's *Death of Chatterton* (Tate Gallery).[23]

The remainder of Frith's clients mostly lived in and around London. There was Charles Peter Matthews (1819–91), a brewer and director of Ind Coope, who lived in Essex and London. He bought Frith's *King*

Charles II's Last Sunday for his historic house in Essex, Bower House.[24] Matthews tried to commission a major work from Rossetti but the commission was never carried out. In 1867 Rossetti wrote to Ford Madox Brown to tell him that Matthews had paid him a visit: 'Mr Matthews is a queer character – seems to buy all sorts. Frith's big daub in the RA belongs to him, also Hunt's *Afterglow* (do you remember what he gave for it?) [Southampton Art Gallery].'[25] This is clearly a reference to Frith's *King Charles II*, which many critics thought his finest work. Not so Rossetti. Matthews also owned six Leightons, four Millais, seven J.F. Lewises and three Holman Hunts. His collection was sold in 1891, and according to *The Times*, sold for much less than he had paid for them.[26]

One London collector Frith liked was David Price, a bachelor and successful wool merchant, who lived in Queen Anne Street, where Turner had lived. Price owned no less than eight works by Frith, including scenes from the *Bride of Lammermoor* and *Kenilworth* (RA 1854, numbers 468 and 485). Price was a generous host, and Frith wrote that his 'gallery in Queen Anne Street is filled with pictures, and frequently on Monday evenings with artists, who find the heartiest welcome and the best cigars etc. always awaiting them'.[27] Soon after visiting Price, Frith went into Christie's and found that another version of *The Bride of Lammermoor* was to be auctioned there. Frith had never made a copy of it, or even a sketch, so he informed Mr Price, and Christie's, that the picture was a copy and not by him. Christie's obliged by withdrawing the picture from the sale. Mr Price commented that the copy 'must have been done on its way to me by one of those rascally dealers'.[28] Price did buy a copy by Frith later, a version of *Claude Duval*. Frith admitted to making large and small replicas of his works, 'but in no instance without the consent of the owners of the original pictures'.[29] Another collector Frith briefly mentions is John Jones, a successful tailor and military outfitter. Jones left most of his collection, including pictures by Turner, W. Collins, Stanfield, Mulready, Etty, Landseer and Frith, to the South Kensington Museum, now the Victoria and Albert. He also left his collection of furniture and decorative arts, which are displayed in the Jones galleries named after him.[30]

The notorious Baron Albert Grant, a fraudulent company promoter, also bought pictures by Frith. He later went bankrupt; Frith may have had Grant in mind when he painted his *Race for Wealth* series.[31] Other London collectors who bought Frith's work included William Alfred

Joyce, a successful waterman, J.H. Mann, a colour manufacturer, Daniel Roberts, a tanner, George Schlotel, a stockbroker, Henry James Turner, a merchant, Thomas Williams, a conveyancer, and Charles Frederick Huth, a banker.[32] They certainly seem to span widely across the social scale. The social position of artists so improved in the nineteenth century that Frith and his buyers could meet on an equal footing. He could entertain them in his own large house and introduce them to other artists, and to interesting people. The artist–patron relationship had become less servile, less of a patron–tradesman relationship; now it was more a matter of successful men of business dealing direct with each other, and becoming friends in the process.

Frith did have one aristocratic patron, Lord Northwick, of Thirlstane House in Gloucestershire, and wrote a chapter about him in his memoirs.[33] Frith visited him in 1846, by which time Northwick was already an old man. He belonged to that older generation of patron, like Lord Egremont at Petworth, who regularly invited young artists to stay. Frith had shown Lord Northwick a sketch, but refused to name a precise sum for the finished picture. This annoyed his lordship, who liked to know exactly how much a picture was going to cost. Nonetheless, Frith was invited down to stay, with two other artists, W.E. Frost and E.M. Ward. Frith wrote that the gallery at Thirlstane 'was filled with very questionable old masters, and some few good modern ones', including Maclise's *Eva and Strongbow*, and E.M. Ward's *The Fall of Clarendon* (Graves Art Gallery, Sheffield), a work which Frith 'had the great satisfaction of recommending successfully to Lord Northwick'. Once again Frith was recommending another artist's work. Whether he received any commission for this, or merely thanks from the artist, he does not say.

As a young man, Northwick had been in the diplomatic service, and was attaché to the British ambassador in Naples. He had met the King and Queen of Naples, Sir William and Lady Hamilton, and Nelson. He maintained that Nelson and Lady Hamilton were not lovers, and became extremely angry if anyone suggested that they were. 'Poor dear Lady Hamilton,' he would exclaim, in a very high shrill voice, 'a truer wife, a warmer friend, or a better woman never breathed. Why, if she had not prevailed on the King of Naples to victual the English fleet . . . the Battle of the Nile could not have been fought; and it is to the eternal disgrace of this country that the poor dear creature was allowed to die in destitution.' Lady Hamilton was often said to have modelled at the

Life School of the Royal Academy, but Frith denied this. He also commented that his friend Wilkie had met her, and was much disappointed by her appearance, 'which he described as fat and vulgar, with manners to match'. Although the younger men enjoyed Lord Northwick's stories, he was garrulous, and would bang on about the repeal of the Corn Laws to which he was strongly opposed. 'Protection to native industry,' he repeated over and over again. E.M. Ward was a very good mimic, and for years afterwards, Frith wrote that Ward's 'protection speech from Lord Northwick' was a favourite at evening parties.

After a few days, another artist joined the group. This was a little-known Nottingham artist called Robert Huskisson, who had earned some renown as a painter of fairy pictures, in emulation of Richard Dadd. 'Huskisson was a very common young man,' wrote Frith loftily, 'entirely uneducated. I doubt if he could read and write; the very tone of his voice was dreadful.' When a silence fell over the dinner table, Lord Northwick called out: 'Mr Huskisson, was it not a picture dealer who bought your last "Fairy" picture?' 'No my Lord! No my Lord!' replied Huskisson, 'It were a gent!'

Robert Huskisson died young, in 1861, and Frith, writing in the 1880s, thought 'scarcely anyone who may read these lines will remember the young man'. But thanks to the revival of interest in fairy painting, Huskisson is still remembered as the painter of a small number of beautiful pictures.[34]

Lord Northwick had a very old butler, who insisted on placing the dishes on the table. A haunch of venison proved too heavy for him, and it and its silver dish slipped to the floor. 'He is too old,' Lord Northwick whispered to Frith, 'I can't bear to tell him so, dear old man. He is forever dropping something or other.' Instead of venison, a dish was produced 'cooked from the furry covering of the deer's horns,' wrote Frith, 'made into a rich mess, the like of which I had never seen before, nor have I since, and devoutly do I hope I shall never see it again . . .'. W.E. Frost tasted it, and whispered to Frith, 'this is not cheap and nasty, but deer and nasty'. With that 'feeble pun' Frith closed his chapter about Lord Northwick. It gives us a wonderful insight into an old-fashioned, aristocratic patron of the 1840s. Much of Northwick's collection was sold by his descendant, George Spencer Churchill, at Christie's in 1964.

NINE

Thomas Miller of Preston

The reason we know so much more about Thomas Miller than any other of Frith's patrons is the discovery of an extraordinary cache of nearly 700 letters, which came on to the market some years ago. By great good fortune, they were purchased by the Royal Academy library.[1] All the letters, without exception, are written to Miller by artists; no fewer than 150 of them are from Frith. They present us with one of the most complete records in existence of the relationships between a Victorian patron and the leading artists of the day. They demonstrate to us, in the most fascinating detail, just how these relationships actually worked.

In many ways, Thomas Miller was an archetypal Victorian collector. He was not a self-made man of humble origins. His father, also Thomas Miller, was a director of Horrocks, Miller & Company, famous all over the world for the quality of its cotton 'long cloth'. Miller senior was mayor of Preston three times, and on his death in 1840 left a sizeable fortune to his son. As with so many families, the first generation made the money and the second generation spent it. Young Thomas, who became an alderman of Preston, was principal partner in the family firm from 1846, and sole proprietor by 1860. A dissenting liberal, he did not become involved in politics, but was a substantial benefactor to the town of Preston. He provided a public park for the town (Miller Park), built a church and endowed a scholarship at Preston Grammar School. He amassed a considerable collection of about 200 or 300 paintings and watercolours; on his death in 1865 he left a fortune of nearly £500,000. He left his oil paintings to one son, Thomas Horrocks Miller, and his watercolours to the other, William Pitt Miller. Thomas Horrocks Miller was to add further works to the collection. The two collections were eventually reunited in the Pitt Miller family in 1941; in 1946 the whole collection was tragically dispersed.[2]

Quite apart from the Frith letters, the other letters in the Miller archive are of equal interest, as nearly all the artists concerned were

friends of Frith. Miller was definitely a conservative and conventional collector by Victorian standards, but he did correspond with several of the Pre-Raphaelites, including Millais, Holman Hunt, Noel Paton and William Dyce. In 1856 Holman Hunt wrote to Miller about *The Scapegoat* (Lady Lever Art Gallery, Port Sunlight), which he had commissioned for 450 guineas. In the end, Miller did not buy the picture; it ended up with Thomas Fairbairn of Manchester, the organiser of the Manchester Art Treasures Exhibition in 1857. Noel Paton also wrote to Miller, about paintings of the 'fairy department'. Although they corresponded about several other pictures, Miller did not in the end buy anything. Robert Huskisson, the fairy painter who Frith met at Lord Northwick's, wrote no less than twenty-three letters, but Miller did not buy from him either. He did, however, buy four pictures from Millais, including *Peace Concluded* (Minneapolis Art Gallery), *The Huguenot* (privately owned), and *L'Enfant du Regiment* (Yale Center for British Art, Paul Mellon Fund). For *The Huguenot* Miller paid £1,100, and for *Peace Concluded* 900 guineas. Millais advised Miller never to varnish *Peace Concluded* but 'a rub with a silk handkerchief or wash leather will bring the surface on again'. Miller bought from Dyce a second version of his picture *Jacob and Rachel* (location unknown).

Space does not permit quoting from all of these letters, but one of Miller's principal correspondents, apart from Frith, was none other than Frith's old friend, Augustus Egg. Miller clearly liked Egg's pictures and bought at least five, including *Queen Elizabeth discovers she is no longer young*, *Peter the Great sees Catherine, his future Empress, for the first time* (location unknown) and a scene from *The Taming of the Shrew*.[3] Egg clearly both advised Miller and acted as his agent. He bought a picture by Turner for Miller for 1,100 guineas; he also bid 345 guineas, successfully, for William Etty's *The Coral Seekers* (location unknown). In his letters Frith also advises Miller to buy the same Etty, and rather takes the credit for it. Obviously Miller consulted both men before making his purchase. Miller bought at least four pictures by Turner, probably from Agnew's. He also bought two Boningtons, and a Constable, *Dedham Vale* (one version is in Leeds City Art Gallery). Although he doubtless did not realise it at the time, these were to be by far the best buys in his collection. In the twentieth century, the values of most Victorian pictures were to collapse, then to rise again after the Second World War. The reputations of Turner, Constable and Bonington survived the general decline of nineteenth-century art; by the end of the

twentieth century they had become among the most expensive and sought after of all English artists.

The other artists whom Miller corresponded with, and bought from, range right across the whole spectrum of Victorian art. Above all Miller seemed to like historical and literary pictures, like so many collectors of his generation. Apart from Frith and Egg, Miller particularly liked the work of Charles Robert Leslie, and owned at least fourteen works by him. The subjects are very similar to those of Frith – *Sir Roger de Coverley*, *The Vicar of Wakefield* (both locations unknown), *Le Bourgeois Gentilhomme* (Victoria and Albert Museum), *Tristram Shandy* (location unknown), *Lady Jane Grey* (Duke of Bedford, Woburn Abbey) and *The Merry Wives of Windsor* (Victoria and Albert Museum). He also bought two pictures by E.M. Ward, one of them *Byron's Early Love* (location unknown). Ward wrote to say, 'I have just sent the Byron to the railway.' Most of the pictures Miller bought were sent to him by train; often the artists asked if the empty box could be returned, as did Frith. Frederick Goodall wrote to complain that 'One of my pictures was lost on the Birmingham Railway for three weeks.' Miller also bought other narrative pictures, some of them religious subjects, from Daniel Maclise, Alfred Elmore, J.C. Hook, J.C. Horsley, Frank Stone, J.R. Herbert, John Phillip, Henry Nelson O'Neil, Paul Falconer Poole and W.E. Frost, and at least seven pictures and sketches by William Etty. Like so many early Victorian collectors, Miller liked those historical and literary subjects that transported him to some dimly romantic 'golden olden tyme', so infinitely preferable to the Victorian world of steam, slums and cotton mills.

Miller also shared the general Victorian nostalgia for the beauties of the English countryside, which was seen as under threat from the advancing cities, and the march of the railway.[4] Miller bought landscapes by John Linnell, Thomas Sidney Cooper, William Collins, and Frith's friend and neighbour, Thomas Creswick. He also bought cottage scenes by Thomas Webster, founder of the Cranbrook Colony in Kent. Like most Victorian businessmen, Miller liked to be reminded of cottage and village life, which the Victorians held up as an ideal of lost innocence, in contrast with the corrupting influences of the big bad cities. Webster thanks Miller for his 'kind present of long cloth – excellent material. The shirts are to be put in hand forthwith, and I already dream of exceeding comfort.' Miller was in the habit of sending presents of cloth to his favourite artists, including Creswick and Frith.

Miller also bought exotic pictures of the Middle East from J.F. Lewis, David Roberts and W.J. Muller, views of Venice from James Holland and E.W. Cooke, coastal scenes by Clarkson Stanfield, still lifes from George Lance and animal pictures by Landseer and Richard Ansdell. There are letters and receipts from nearly all these artists in the archive. Miller's watercolour collection was equally typical of its time, and included works by David Cox, Copley Fielding, William Henry Hunt and Peter de Wint.

It is not known exactly when Frith and Miller met, but their correspondence begins in 1847. Frith later wrote in his memoirs that, 'An intimacy, such as so frequently exists between artist and patron, arose between Mr Miller and me. I spent many happy hours with him at Preston. He was one of the truest gentlemen and the warmest lover of art for art's sake that I have ever known.'[5]

Frith's first letter to Miller is dated 4 October 1847. Frith writes to offer Miller first refusal of his picture – 'The subject is an old woman accused by the mother of a peasant girl of having bewitched her daughter. The scene is laid in the reign of James I. It is full of figures – it is thought by my friends on whose opinion I am accustomed to rely to

Portrait of Thomas Miller. A Preston textile manufacturer, Miller was one of Frith's most important early patrons. Like many Victorian patrons, Miller was not a self-made man; his family was already prosperous, and his father had been mayor of Preston three times. *(Harris Museum, Preston)*

be so far . . . the best I have done.' As he often did, Frith is quoting his fellow artists' approval as a reason for recommending the picture. Frith also knew that Miller might well have asked Augustus Egg's opinion. Frith and Egg were good friends, and happy to recommend each other's pictures. Frith also asks if 'the size be a decided objective to you?' The size eventually was 45 by 72 inches. 'Of course the price will be comparatively large,' he goes on, without specifying how large. He also mentions in a postscript, 'The smaller picture is a scene from Molière, and quite certain not to be at liberty – as a gentleman has seen it and fancies to take it if the person for whom it is intended should decline it.' This sentence seems to be deliberately tantalising Miller, but also emphasising that he should forget the Molière picture, spend more money, and go for the larger picture. In the end, Miller bought both.

Frith's next letter is dated only five days later, 9 October. Such was the speed and reliability of the Victorian post that he has already had a reply from Miller. Sadly, none of Miller's letters survives. Frith writes:

> I am very pleased to find by your last note that the size of my picture will not be a decided objection by you. I cannot very well say in the present state of the picture – about a third finished – what the price will be, as so much depends on a successful carrying out of the design. From what I can judge at present I think the price will be five hundred guineas (500 gn) – it may be less. It certainly will not be more. In the prices I am guided . . . by the sums I have received from previous works. I was paid last year for the largest of my pictures 350 gn by a dealer. He immediately sold it for 400, and the Gentleman in whose hands the picture now rests refused 500 for it. I do not mention these things for the sake of boasting but to explain to you my reason for asking a sum which may . . . appear to you large.

Frith is here trying to justify, just as an art dealer would, the price he is asking for his picture. He also explains that he does not want to hawk the picture around all his patrons: 'I have promised to let one person have the refusal of this subject but beyond that I do not think myself bound to let the picture run the Gauntlet of all those from whom I have commissions. . . .' Later in the letter he says, 'The picture will of course be exhibited at the Royal Academy, and I have now applied for the loan of it for engraving, but that of course must depend on the purchaser.'

In reply to a question from Miller, he wrote: 'In reply to your other question – the scene is laid in the interior of a County Magistrates House in the days of James I, and I have been down to Knole House, an Elizabethan mansion in Kent, where I made many studies of oak work windows, stained glass . . . chimney pieces, fire dogs . . . so that I have the advantage of getting my background from reality. . . . If you find the price I have named a decided objection I hope you will allow me the pleasure of painting something for you at some future time.' He concludes, 'indeed on looking back at my letter I feel I ought to apologise for inflicting a lengthy epistle on you'.

This letter shows how skilfully and carefully Frith is handling an important new client. Frith knew that these delicate negotiations were vital in establishing a rapport with Miller. He puts his cards on the table, trying to give Miller an impression of open and honest dealing, something that Miller, as a fellow northerner, would appreciate. In the next letter, dated 8 January 1848, over three months later, Frith goes into great detail about the picture's progress:

I was just about writing to you to 'report progress' when I received your note. . . . I have been at work uninterruptedly except for dark weather occasionally . . . on the witch . . . but I can safely say that the progress I have made is as satisfactory as I have ever known it to be with any of my previous pictures and perhaps rather more so; I shall be grievously deceived and disappointed if this is not by many degrees the best I have done.

By this time, Miller has obviously been to London and seen the picture, as Frith refers to 'The figures about which you have expressed some apprehension when you were here – the young Falconer . . . he is now certainly one of the best figures in the piece. . . .' Frith goes on to explain how long it is taking him to do the background details: 'On account of the quantity of minute detail which always marks the simplest form of Elizabethan architecture, to give you some idea of the labour – the ceiling – one of those of oak tracery on a white ground – took me two days to draw in . . . and then I had to paint it.'

Frith wanted Miller to know that he is certainly going to get his 'money's worth' of man hours devoted to the picture. He also mentions that his friend Richard Ansdell is helping him: 'Ansdell has painted in the dogs and they are very well liked, though there is still much to do. . . .

The bloodhound is uncommonly good. . . .' Frith goes on to describe in yet more detail exactly what he is doing: 'I mean to leave no part in the slightest degree unsatisfactory nor will I have any part unfinished – even the most unimportant. If I did not think you felt an interest in the progress of my work I would not trouble you with all these details.' One gets the impression that it is precisely these details that the patron wanted to know about. Frith is letting Miller know that not only is he getting value for money, but that he is gaining an insight into the mysteries of artistic creation. This has always been part of the artist–patron relationship; the Victorians were no exception to the rule.

On 30 January Frith writes again, another long letter giving precise details of progress. Yet again, Frith draws on the approval of his friends: 'I am happy to say that I am now drawing to a conclusion, and if I can trust my own opinion and that of my friends, a successful one.'

All the details were now virtually complete except for some heads and hands; Frith is concerned now with:

> the general effect . . . light and shade, colour, breadth and everything . . . if you knew, as an artist must, the exquisite nicety and discrimination that is required to keep the eye of the spectator to the principal figure or group – to make all naturally subservient to the chief action, to vary every tint and tone of colour and yet, with harmony, to make a background recede so as to produce the effect of air amongst the figures. . . .

Yet again, Frith is letting Miller in on the mysteries of composition, and harmony of tone; on more artistic secrets, without which no picture can succeed, he explains. He also reports, 'Ansdell is to come on Monday and finish the dogs. . . .' Frith promises to 'let no other engagement stand in the way of a satisfactory completion of this the most important in subject and design of any I have yet undertaken'. He ends by referring to his family, and also to Miller's: 'I think I heard you admit to a somewhat similar position as regards a family. I hope they are well.' Frith at this point had three young children; this was well before the appearance of Mary Alford on the scene.

In his next letter, on 13 February, Frith is reporting to Miller on an exhibition he has seen, and writes, '. . . in reply to your query about the exhibition I regret to be unable to give a favourable one. The present is perhaps the worst exhibition that has ever appeared on the walls.' This

is not a reference to the Royal Academy, but to one of the other winter exhibitions, such as the British Institution, or the Royal Society of British Artists. Frith praises pictures by T.S. Cooper, Thomas Creswick, and John Linnell, but is dismissive about everything else. This was to be one of the staples of Frith's letters to Miller: in many of them he reports in detail on the Royal Academy's Summer Exhibitions. There can be no doubt that in great measure Frith shaped Miller's taste, and his collection, by guiding him towards the artists whose work he liked. He also reports more progress on the *Witch* picture, especially the foreground, and the carpet, which he had to repaint. 'I got Ansdell to paint in the Black Cat, holding it up for him myself, and I can assure you I was pretty well scratched.'

On 5 March Frith writes to say, 'I hope by the time I see you to have completed the *Witch*, or as nearly as may be, for one never feels that a picture is finished.' He also reports that he is getting ready to send in to the Royal Academy – 'I am making a great effort to raise myself in the next exhibition. If I have my health I shall have three pictures of yours.' This refers to the *Witch* picture, a scene from Molière's *Le Bourgeois Gentilhomme* and a third picture which Miller has not yet seen. Frith describes it as 'a humorous scene'. This must be *A Stagecoach Adventure, Bagshot Heath*, showing the inside of a coach with a highwayman at the window. The alarmed passengers and their attempts to conceal their belongings make it a decidedly humorous picture. So it would appear that Miller bought all three of Frith's RA pictures for 1848. He was indeed turning out to be good client.

On 26 March Frith writes again to say that all three pictures are now nearly finished, and ready 'to go to that tribunal whose judgement is final and from which there is no appeal'. Frith also writes about a picture by Egg which Miller has bought, and praises it. He also asks if Miller wants tickets to the RA Private View. On 5 April, Frith writes to inform Miller finally that the price of the *Witch* picture is to be 500 guineas. He points out that this price would not include a frame. He also tells Miller that he has five clients wanting the sketches of the *Witch*, or small copies of it, and a publisher wishing to engrave it; he says all these matters can be discussed when Miller comes to London. He also tells Miller that 'Mr Vernon would have bought it (the *Witch*) if it had not been sold. . . .' Frith is trying to impress upon Miller that he is not the only one interested in buying Frith's picture, thus also reassuring him about the price. On 9 April, Frith writes to acknowledge

receipt of two £50 notes. He reassures Miller that, 'The sketches being so small can in no way detract from the original. . . .' Obviously Miller was concerned about there being too many versions of his picture.

By 24 April Frith is able to write and say that, 'The varnishing commenced on Saturday, and I found my pictures very well hung, with the *Witch* in pride of place.' He describes details of where all three pictures are hung, and who is hanging next to them. He encloses a ticket for the Private View on Friday, and hopes to see Miller there – 'I shall be there between two and five.' In the next letter, on 4 June, Frith writes to say he has been asked to lend the *Witch* to the Liverpool Exhibition, and asks if Miller would be prepared to lend it. He also sends Miller copies of *The Spectator* and *The Illustrated London News*, which contain good reviews of the *Witch* picture. Frith boasts that he had received a message from the Queen praising both the *Witch* and the Molière picture. He adds that he is shortly off to Scarborough for his holidays.

The next three letters, penned during June and July, are all written from the Esplanade in Scarborough. Frith apologises for not going to Preston, but pleads that his sick mother – 'a great invalid' – did not want him to go. Egg had obviously already been to Preston – 'Egg gives

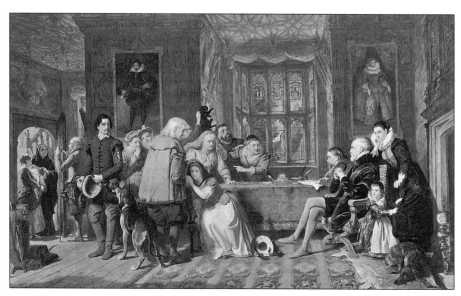

The Trial for Witchcraft, 1848. The first picture by Frith bought by Thomas Miller, who commissioned it in 1847 for 500 guineas. It was the subject of many letters written to Miller by Frith. (*Private Collection*)

a glowing account of Preston and of the future resting place of our pictures.' Frith also writes with his opinions about pictures by Alfred Elmore and Paul Falconer Poole, but says 'I should be afraid to call on Poole without an invite – he is such a singular fish. . . .' He writes that he is returning to London in time for the closing of the Academy exhibition.

On 10 September, Frith writes to ask if the picture has arrived safely 'from the printsellers?'; he enquires nervously, 'How does Mrs Miller like the picture?' He also tells Miller about his next picture, *A Coming of Age in the Olden Tyme*. This has been commissioned by another Lancashire collector, and friend of Miller's, James Eden of Bolton, who had a house near Preston. This pattern of collectors recommending artists to other collectors is common throughout the Victorian period. Frith has still not managed to get to Preston, and apologises for this, but promises to fix a date soon. He also plans to visit James Eden at the same time. In his next letter, 9 October, Frith asks for the return of the case for the *Witch* picture. He also writes that, 'I was delighted to find that my picture is approved by Mrs Miller and those who have seen it in Preston. . . .'

After a long gap Frith writes again, on 29 April 1849, about the *Coming of Age* picture, which he reports is hung in a very good place at the Academy. He also reports on many of the other pictures in the exhibition, with his opinion of them, a familiar subject in many of the letters. 'I haven't sent Eden his ticket for the Private View as we shall meet if all's well at R. Newsham's dinner on Thursday.' This refers to yet another Preston collector, Richard Newsham. The Preston connection was certainly proving profitable for Frith. He also thanks Miller for his hospitality – clearly by this time Frith had at last been to Preston, with his family.

The next few letters chiefly concern a problem which arose with James Eden over the picture *A Coming of Age*. Miller asked if he might have a smaller version of it; Frith agreed to make a copy 4 feet 6 inches wide, which would also be used by the engraver. On hearing of this, Eden objected to having two large versions of the picture hanging in the same town. Frith had already agreed terms with the engraver, so was placed in something of a dilemma. Frith asked Miller to try and help him resolve the matter. In the end, the picture dealer Lloyd took over the commission from Eden and bought the picture from Frith. Later he sold it to a Mr Grundy of Liverpool for £650. Frith complained to

Miller of Eden's 'most illiberal conduct', but later the two met again, and Frith reported, 'Mr Eden and I got on uncommonly well when he was in town. He was more than commonly friendly, and very pressing in his desire that I should paint for him again. . . .' No doubt Miller had spoken to Eden, and helped to bring about this reconciliation – yet another example of the artist–patron relationship in action.

The letters continue in a familiar pattern, mixing family news with studio gossip about other artists and their pictures, and reports of exhibitions. In 1850 Frith viewed the Etty studio sale in York – Etty died in 1849; York was his home town. Frith reported to Miller that there were over a thousand lots in the sale, some of them mere scraps. Miller presumably bought some of his Ettys in this sale. It is obvious from the chatty style of the letters that Frith and Miller had by this time become very close friends, even confidants. In 1851 he promises Miller to get him a ticket for the prestigious RA Dinner.

Later in the same year, on 28 September 1851, Frith writes about 'the death of poor Mr Gibbons', but adds, 'I hear from excellent authority that his pictures will not be sold.' The underlining seems to indicate that Miller was hoping to buy some of them. Frith also writes with chatty news about other artists: E.M. Ward and Augustus Egg had been commissioned to decorate rooms in the new Houses of Parliament. Frith has been to Ramsgate on holiday, also making sketches for *Life at the Seaside*. He had to return to London because of the illness of his uncle and his mother; they both died later that year, leaving Frith enough money to buy Pembridge Villas. Frith enquires as usual about Mrs Miller and the children.

In the next letter, 7 October, Frith says thank you for another present of long cloth – 'the very thing my wife declared she was wishing for'. He also reports that 'all the picture dealers are in full feather doing no end of business'. Frith himself often acted the dealer with Miller, advising him on his purchases and, more importantly, discussing prices. Miller often worried about paying too much, and consulted both Frith and Egg about what the right price should be. On 27 December 1851, Frith writes about a picture by C.R. Leslie, suggesting £1,000 as the correct price for it; 'we all agreed that 1,250 gns would be much too large a sum to pay for the picture . . .'. In another letter, 15 April 1852, he writes advising Miller that £1,800 is too much for Wilkie's *Rent Day*; he suggests £1,000, but admits that it is one of Wilkie's finest works. On 23 January 1853, Frith writes to congratulate him on buying Turner's

Quilleboeuf, one of four Turners eventually bought by Miller. Clearly, many Victorian patrons like Miller consulted their artist friends about what to buy, and how much to pay for it. Frith, Egg and others of his circle were obviously happy to oblige; Miller was a rich man, a prolific collector, and he bought their pictures as well.

In addition to passing on free advice, Frith let Miller in on art-world secrets, insider information, as it were. In one letter, dated 26 February 1852, Frith explains just how the elections of new RAs and ARAs worked, a process as elaborate as electing a new pope, and not always guaranteed to produce the best result. Frith also confides to Miller that he received £3,000 for *Derby Day*, £1,500 from Jacob Bell, and £1,500 from Gambart for the engraving rights (letter dated 10 February 1857). He insists that 'This is strictly private and confidential.' Frith might well have thought by the 1860s that this price was too low.

Frith's letters are full of gossip about other artists, about their pictures, their health, their whereabouts, their families. Frith tells Miller his own family news, and always enquires most solicitously about Miller's family, his wife's health, and news of their children too. Frith also used the Miller correspondence to keep in touch with other Lancashire clients, particularly Newsham and Eden, in effect using Miller as a go-between: 'Please tell Mr Newsham . . . I am not neglecting him.' In this way, Frith was using Miller to help sell his works to other collectors. This was an important aspect of the artist–patron relationship. Frith tells Miller just how his own pictures are coming on, knowing that he will pass this on to Newsham, Eden, and other northern patrons among his acquaintance. In return for this help, Miller got free advice from Frith about other artists, their pictures, their prices. He also got dinners with the Frith family at Pembridge Villas, where he would no doubt meet other artists, and interesting people such as the editor of *Punch*. If he was lucky, Miller would also get invited to a Royal Academy dinner, as he did in 1852. Frith wrote (on 15 April) 'Wonderful too that the Academy has asked you to the dinner – you may be proud for I think it is the first time they have asked a patron without a handle to his name, or a prestige of some sort about him.' Miller might well have felt proud, but also not a little patronised by Frith's remarks. Any artist would have been glad to meet Mr Miller, the largest textile manufacturer in England.

Frith's correspondence with Miller continued until Miller's death in 1865. But during the late 1850s and early 1860s, the letters begin to tail off; they are not so long, or so frequent. The intimate, chatty tone of the

earlier letters seems to fade. Perhaps Miller had found out about Frith's guilty secret, and if so he would certainly not have approved. Frith must have met Mary Alford in the early 1850s, and their first child was born in 1856. Frith's popularity and great success had made him enemies, and no doubt one of them would have been happy to spill the beans to Thomas Miller. But nonetheless, the Frith–Miller letters are one of the most detailed, most fascinating records of the relationship between a Victorian artist and his patron. Let us hope that one day they will be published, and made available to scholars and students of nineteenth-century art.

Miller's art collection was written up by the *Art Journal* in February 1857.[6] Its editor, S.C. Hall, a friend of Frith's, was an assiduous propagandist for modern English art, and did everything he could to encourage his readers to appreciate it, and collect it. The *Art Journal* was the most prestigious, and long-lasting, of all Victorian art magazines, and its support of modern English art was therefore highly important. Thomas Webster also wrote to Miller to ask if the German professor, Dr Gustav Waagen, might pay him a visit, with a view to including him in his book.[7]

In 1865, Thomas Miller died. His funeral was a very grand affair: he had been a loyal benefactor and employer to the people of Preston all his life, and he therefore deserved a good send-off. But his two sons, preferring the life of country gentlemen, were not interested in the business. Miller therefore left it to an employee, his manager Edward Hermon. Hermon became a rich man, but he ran the business into the ground. By the time of his death, in 1881, the once-mighty business of Horrocks, Miller & Company was in decline. Hermon was also an art collector, and bought pictures by Frith. He also commissioned Edwin Long to paint his now notorious *Babylonian Marriage Market* for £3,000. This, and many of Hermon's other pictures, were bought by Thomas Holloway, the pill king, and are now in the collection of Royal Holloway College.[8] Like Miller, Hermon died worth over £½ million, a very large estate for a Victorian manufacturer.

Miller's collection cost him a total of £40,352. Tragically, almost all his pictures, and those of his sons, were dispersed at Christie's in April 1946, following the deaths of Thomas Pitt Miller and his widow. It could hardly have been a worse moment. Not only were Victorian pictures still totally out of fashion, but the London art market was at a low ebb after the war. Christie's premises had been destroyed by

bombing in 1941, and they were operating from Derby House, just off Oxford Street, and later Spencer House, on St James's Park. As might have been expected, Miller's collection sold for a disappointing sum – £33,619. The only four-figure prices were for the Turners, Boningtons, and a Constable; if the family had held on to these alone, they would now be worth millions.[9] Most of the Victorian pictures sold for much less than Miller had paid for them a hundred years earlier. Frith's *Witchcraft* picture, which had cost Miller £525, sold for only £136. Only the *Ramsgate Sands* sketch did better, selling for £336; it had cost Miller £200. Egg's *Queen Elizabeth* sold for £110 (it had cost £310); even Etty's *Coral Seekers* sold for only £115 (it cost £361). Some did even worse: a J.R. Herbert of *Christ subject to his Parents* made only £5. It was a sad end to what had been a significant collection; if it had survived to this day it would be one of the most remarkable of all Victorian collections.

TEN

The Marriage of the Prince of Wales
1863–5

Queen Victoria and Prince Albert had given a tremendous boost to Frith's career by buying his first modern-life picture *Life at the Seaside*. They were also to give him one of his biggest and most difficult commissions, *The Marriage of the Prince of Wales* (Plate 7). But first he received a new offer from Ernest Gambart. After his rival Flatow's huge success with *The Railway Station*, Ernest Gambart, the greatest dealer of the age, was clearly determined to reassert his position as the king of the Victorian art market, and in particular to beat off the competition in the unlikely shape of the wily Flatow. To this end, Gambart approached Frith in August 1862 with a major new commission – to paint three London street scenes, to be entitled *Morning*, *Noon* and *Night*. For these Frith was to be paid the gigantic sum of £10,000, the biggest commission of his life. Frith proudly reprinted the contract in his autobiography.[1] It was to be paid in instalments, and it included the sketches, drawings, and the engraving copyright. So that there could be no doubt as to Gambart's supremacy over the upstart Flatow, the contract also stipulated that 'the figures in the said Pictures shall not be of a less size than the figures in the picture called "The Railway Station"'. There was also a paragraph stating that Frith 'shall touch up Photographs of the said Pictures in order to assist the Engravers in Engraving the said Pictures'.[2]

Through the autumn and winter of 1862/3, Frith worked on oil sketches of the three street scenes. Though he does not say so in his book, Frith was clearly trying to produce a Victorian equivalent of Hogarth's *Times of Day*. He also knew that the Victorians mostly found the cruel satire, immorality and vice in Hogarth's pictures shocking, so his *Times of Day* are fairly tame by comparison.[3] The first scene, *Morning*, was set in Covent Garden. In the foreground a detective arrests two burglars; to the left two drunken swells accost a flower girl

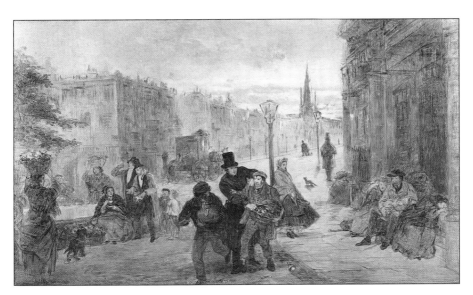

The Times of Day – Morning, Covent Garden.

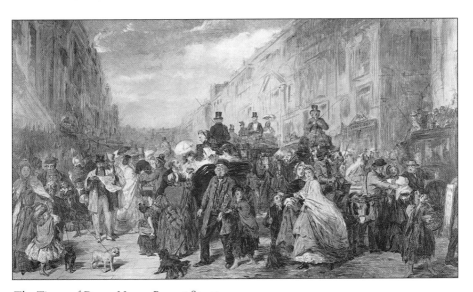

The Times of Day – Noon, Regent Street.

drinking her morning cup of tea; to the right homeless figures huddle in doorways. Frith wrote that the scene represented 'the early dawn of a summer's morning', and described the two swells as 'belated young gentlemen whose condition sufficiently proved that the evening's amusement would not bear the morning's reflection'.[4]

The second scene, *Noon*, showed, in Frith's words, 'Regent Street in full tide of active life, ladies in carriages, costermongers in donkey-

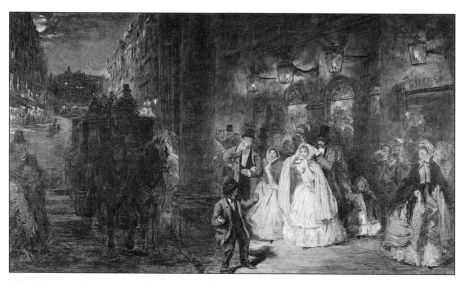

The Times of Day – Night, Haymarket. The three *Times of Day* pictures were commissioned by Gambart for the gigantic sum of £10,000. Frith sadly had to renounce the work to paint *The Marriage of the Prince of Wales* for Queen Victoria; only the sketches survive. *(Private Collection)*

carts, dog-sellers, a blind beggar conducted across the street by his daughter and his dog, foreigners studying a map of bewildering London etc. etc.'[5] This was the most crowded of the three scenes; it is full of figures, carriages, and men on horseback, in what was then one of London's most fashionable streets, full of high-class shops, stores and tradesmen.

The third scene, *Night*, is in many ways the most interesting of all, as it is set in the Haymarket, and shows a party of theatregoers leaving the Theatre Royal. The Haymarket was a notorious haunt of prostitutes. 'Every hundred steps one jostles twenty harlots,' wrote Hippolyte Taine, whose *Notes on England* were published in 1872. Frith included one on the right in his picture, describing her as 'an over-dressed, and be-rouged woman, whose general aspect proclaims her unhappy position; and by the expression on her faded though still handsome face, she feels a bitter pang at having lost forever all claim to manly care or pure attention'.[6] She gazes wistfully at the couple coming out of the theatre, the reverse of Hogarth, who shows an ugly old maid envying the rollicking couples emerging from a brothel and tavern. In the Victorian scheme of things a prostitute could not possibly enjoy what she was doing; she had to look miserable, and repent. Nonetheless, Frith's

picture would doubtless have caused a huge furore if the finished version had been exhibited.

Sadly, the three London street scenes were destined never to be completed, and only the sketches survive. 'How I should have delighted in trying to realise all that these subjects were capable of, no tongue can tell,' Frith wrote later.[7] But fate intervened, in the unexpected form of a royal commission. On 13 January 1863, Frith received a letter from Sir Charles Eastlake, Academy President, requesting Frith to paint a picture of the forthcoming marriage of the Prince of Wales and Princess Alexandra of Denmark. Frith had received a similar royal 'command' before, and refused it. In 1858, he had been asked to paint the wedding of the Princess Royal and the Crown Prince of Prussia. At that point, Frith was still busy finishing *Derby Day*, so the commission went to John Phillip instead. But Queen Victoria, owner of *Ramsgate Sands* and a great fan of Frith, clearly felt he was the man for the job. He was the painter of crowds, after all.

It did not take Frith long to decide. Perhaps he felt that to refuse two royal commissions might have amounted to lèse-majesté; it also might spoil his chances of a knighthood, something he coveted, in spite of his republican leanings and those of his family. There was, perhaps, another reason. In December 1861, Prince Albert, also a great supporter of Frith, had died, plunging the Queen into deep sorrow from which she was never to recover completely, and the court and the country into deepest mourning. So Frith accepted, even though this would mean giving up the Gambart commission, and the £10,000. Five days later, on 18 January, Gambart called on Frith and agreed to a postponement. Eleven days later, on 29 January, Frith noted in his diary – 'Sir C. Phipps writes to say the Queen agrees to my terms for the marriage of the Prince of Wales – three thousand pounds.' This amount, although much less than the Gambart commission, was thought in some quarters to be exorbitant. A furore in the press followed and Frith had to write and defend himself in the *Art Journal*, which printed an apology in March.[8]

This was only the first of many trials and problems that were to beset Frith over this commission, the most difficult of his career. He immediately began to have doubts, and many fellow artists warned him of the dangers ahead. They could have pointed to the example of Luke Clennell, a Newcastle artist, who had been commissioned to paint the allied sovereigns at a Guildhall banquet in 1814. Clennell was driven

mad by the problems of obtaining sittings, and ended his life in a lunatic asylum. Sir George Hayter was another artist whose youthful promise had been destroyed by accepting too many royal commissions to paint state occasions and very large groups. Landseer, who knew all too well about dealing with royalty, said to Frith that 'for all the money in this world, and all in the next, I wouldn't undertake such a thing'.[9]

The whole story of the commission has been brilliantly recounted by the late Jeremy Maas in his book *The Prince of Wales's Wedding: The Story of a Picture* (1977). As an account of an artist's life in the mid-Victorian period, and of the arrogant antics of royalty and aristocracy, it could hardly be bettered. Reading it might turn even a fervent monarchist into a republican. Queen Victoria herself, and her Lady of the Bedchamber, Lady Augusta Bruce, are about the only two people to emerge from the story with credit. Frith wrote rather a guarded account in his autobiography, and with good reason – Queen Victoria was still alive, and requested that the proofs be submitted to her before publication.

Even fixing the price of £3,000 was not without its difficulties. Queen Victoria wanted a smaller picture, but Frith, the master of the crowd scene, naturally thought that he was expected to paint the whole scene in St George's Chapel, Windsor, with all the figures. Frith had to write to Sir Charles Phipps, the Keeper of the Privy Purse, explaining that he had in mind a large, panoramic picture, similar to his big pictures of modern life. He also explained to Phipps that he had received far more money for *The Railway Station*, and had turned down a commission for £10,000 to take on the royal commission.[10] Frith's letter did the trick; Queen Victoria agreed to the fee, and asked that Frith call and see Phipps at Windsor to discuss the size and shape of the picture.

But it was Eastlake who first went to Windsor to discuss the size of the picture, and the figures. Equipped with a ruler, Eastlake explained to Her Majesty that Frith wanted to paint the foreground figures 22 inches high, on a canvas 6 to 8 feet wide. Queen Victoria at first favoured an upright picture, for the important reason that she herself was going to watch the ceremony from a royal closet, situated above the high altar, looking down from the north aisle. Frith must eventually have convinced her, and Eastlake, that he could paint a horizontal picture but still include the Queen in her closet above, which also meant including a large amount of architecture in the background. The size of the picture was therefore increased to 10 feet long, and about 7 feet high, more of a square shape than Frith was used to in his panoramic scenes.

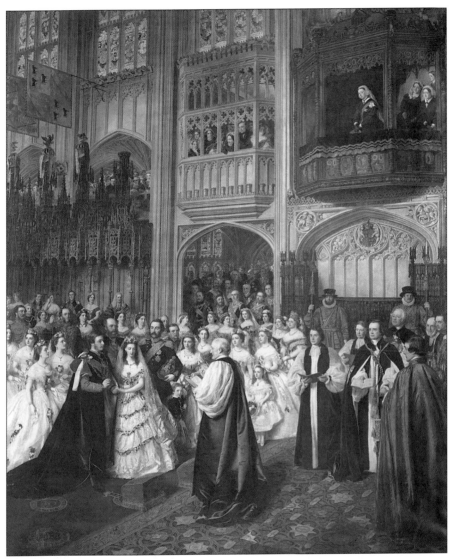

Detail of *The Marriage of the Prince of Wales*. Queen Victoria, in mourning for Prince Albert, who died in 1861, watches the ceremony from above. Frith was paid £3,000 for the commission. *(The Royal Collection)*

No sooner had the size and shape been agreed than another crisis broke out concerning photography, and engraving rights. Frith realised that photographic assistance was going to be necessary, and he approached a Mr Window of Baker Street for advice. Window put forward a plan to photograph the couple outside the chapel, on the day of the wedding. Frith forwarded Window's proposals to Eastlake, for

submission to the Queen. Eastlake's reply was a bombshell – not only did the Queen not want Mr Window to take any photographs, but she had already commissioned another photographer, Vernon Heath, to do the job. Heath later proved to be a disaster, as virtually none of his photographs of the wedding came out. Eastlake's letter contained another bombshell – the news that another artist, G.H. Thomas, was also going to be present at the wedding, and that he was going to paint the procession leaving the chapel. George Housman Thomas (1824–68) was a prolific recorder of ceremonials and royal events, much employed by Victoria and Albert. Frith at once thought his picture was being compromised, and also protested to Phipps that it threatened his copyright. Frith had established that the copyright for his picture belonged to him, and he eventually planned to sell it for a large sum. He was in fact already negotiating with Gambart about it. Phipps affected not to understand copyright law, but assured Frith that his rights would not be infringed. The Queen had not commissioned any other pictures, except from G.H. Thomas. Phipps also informed Frith that Thomas, as well as painting the procession, was to paint a picture of the royal couple kneeling at the altar, which was to be made into a print by Day and Sons, lithographers to the Queen. He was also to paint a watercolour for the Prince of Wales. Frith knew that his picture was going to take at least two years to finish, and must already have been full of foreboding. As if this was not enough, the Lord Chamberlain announced that he was not sure if he could even find a seat for Frith at the ceremony. The decision, he said, rested entirely with the Queen. Queen Victoria must have intervened, as Frith was eventually given an excellent seat, with a good view. He was placed among the royal household, in the south aisle, on the right-hand side of the altar.[11]

The great day was Tuesday 10 March 1863. Princess Alexandra had arrived at Gravesend only three days earlier, to be greeted by the Prince of Wales, and rapturous crowds. Public enthusiasm for the wedding was huge, not only because the royal couple were young and the Princess beautiful, but also because of the death of Prince Albert and the intense mourning into which Queen Victoria and the court were still plunged. The public could show their sympathy with the Queen by enthusiastically joining in the celebrations, and they did. The triumphant progress of the young couple through London to Paddington station, and then from Slough to Windsor Castle, drew huge crowds, so huge that the police had to wield their truncheons, and the Life Guards at one point

charged the crowd with sabres drawn. At Windsor the Queen took the engaged couple to the Royal Mausoleum at Frogmore, to visit the tomb of Prince Albert. 'He gives you his blessing!' she announced.[12]

Frith noted in his diary that 10 March, '. . . sees me in a court suit, sword etc. at the marriage of the Prince of Wales, a glorious subject for pageantry and colour. I like the subject, and think I can make a great deal of it.' Frith also wrote in his autobiography that he made virtually no drawings or sketches at all on the day, beyond noting the positions of some of the main figures in the ceremony. Nonetheless, Frith was seen by the writer, Henry Vizetelly, wearing 'court suit and ruffles in the midst of a little crowd of ladies, all desperately coquetting to ensure their portraits figure in the picture. . .'.[13] He committed it all to memory, and began to work on a sketch on his return home. 'The ceremony left such a vivid impression upon my mind that I found no difficulty in preparing a tolerable sketch of the general effect,' he wrote later.[14] Everything went well until the end, when the departure of the distinguished guests to the railway station quickly descended into chaos, even farce. The special train departed, leaving many grandees and their ladies behind. They were then forced to squeeze into the next public train, which was hideously overcrowded. The Archbishop of Canterbury eventually found himself in a third-class carriage, along with Lady Cranworth, who had lost her husband, and the novelist Thackeray. Disraeli ended up on his wife's lap and had to pacify the outraged Austrian Ambassador, Count Apponyi, who thought he should have been invited to the wedding breakfast. Tom Taylor, the journalist, was amused to find an agitated cluster of duchesses in a third-class carriage, their plumes broken and tiaras askew.[15] In spite of it all, it was a day none of them would ever forget; indeed, thanks to Frith's picture, they were to be constantly reminded of their participation over the next two years.

By the beginning of April, Frith had completed his sketch. On 7 April, he wrote in his diary, 'To Windsor to see the Queen, who spent more than half an hour with me. Seemed to be much pleased with the sketch, and was most agreeable; consented to all I proposed. The picture to be ten feet long. All charming so far.' It was not to be charming for very long. Frith's troubles with the sitters were only just beginning. The Danish royal family departed for Denmark without having their photographs taken, so Frith had to rely later on cartes-de-visite, which made getting a true likeness very difficult. Prince William of Denmark

(later King George I of Greece) behaved extremely churlishly, turning up five hours late for an appointment with Frith and a photographer at Buckingham Palace. He also failed to turn up in his uniform, as had been requested. He then insisted on seeing the negative, said he did not like it, refused to pose for another and walked out.[16] Frith later managed to borrow dresses, uniforms, orders, helmets and other accoutrements from the Danish court. Another sitter he had to paint from a carte-de-visite was the Duchess of Brabant, who occupied an important place in the foreground, just to the left of the royal Princess, Prince Leopold and Prince Arthur. Frith's carte-de-visite shows her facing to the left; in the picture he had to turn her around to face the other way. This episode gives some inkling of how great were the demands placed on Frith in carrying out this commission.

'Letters had to be written by the score,' wrote Frith, 'answers came sometimes, and sometimes silence was the answer. In my applications for sittings and dresses I had forgotten to say that the picture was painted for, and by command of, the Queen. . . .'[17] Once he mentioned the Queen, the sitters mostly consented. All the bridesmaids but one gave their agreement; instead Frith received a visit from her mother, who Frith 'found in a bewildered condition in my drawing-room'. The conversation that followed is so hilarious that it is worth recording in full, as Frith did in his autobiography. No doubt he dined out on it for many years to come:

> As I entered, the lady – who was looking with a puzzled expression at the different ornaments in the room – turned to me and said:
>
> 'I think I have made a mistake, it is the artist Frith I wish to see.'
>
> 'Yes,' said I, 'I am that individual.'
>
> 'Oh really? And this is your – this is where you live?'
>
> 'Yes', replied I, 'this is where I live' then mentally, 'and not in the garret where you had evidently been taught that most artists reside.'
>
> 'Oh, then I have called in reply to a letter from you asking my daughter, Lady . . . who was one of the Princess's bridesmaids, to sit for a picture, to tell you it is impossible for her to sit, and as to her dress, which you ask for, she cannot spare it.'
>
> 'Indeed,' I replied, 'I am sorry to hear this, however, I will represent what you tell me to the Queen, and I dare say I shall be allowed to substitute one of my models, who must play the part of bridesmaid instead of Lady . . .'

My visitor looked at me with an expression which, being interpreted, said as plainly as words, 'what does this man mean with his Queen, and his model, and his independent impertinent manner?' After a pause she said:

'Why are you painting this picture? What is it for? Can I see it?'

'If you will walk this way,' pointing to my painting-room, 'I shall be happy to show you.'

'What a queer place! Why do you shut up part of your window? Oh, that is the picture. Well, what is it done for?'

'It is done for the Queen.'

'Done for the Queen? Who presents it to the Queen?'

'Nobody – the Queen presents it to herself, at any rate, she pays for it.'

'Really?'

'Yes, really.' Then in my most respectful manner I added, 'I am well aware how much young ladies are engaged, and how disagreeable it must be for them to waste time in sitting for artists when it can be more usefully occupied, so if you will allow me, I will tell Her Majesty, through Lady Augusta Bruce, that your daughter is unable . . .' etc.

After another pause and in a somewhat petulant tone the lady said, 'Really I think the Queen, when she asks ladies to be bridesmaids, should tell them that they may be called upon to go through the sort of penance you propose to inflict upon my daughter.'

'I thought I had made it clear that I should prefer to use one of my models than that your daughter should be annoyed; and if you find she cannot consent, I will write to Lady Augusta Bruce . . .' etc.

'Well, good morning, I will let you know, I will see what my daughter says.'

This wonderful exchange gives an idea just what Frith was up against dealing with aristocratic and royal sitters. Most of them had never been to an artist's studio or house before. In spite of his large house, and his considerable success as an artist, most of his sitters clearly thought him little better than a tradesman. His dapper clothes and Yorkshire accent did not impress; most people found him commonplace in both appearance and manner. But the superior lady's daughter did come, and Frith found her delightful, and one of his best sitters. Frith does not say which bridesmaid she was, but elsewhere he referred to Lady Diana Beauclerk as one of the most charming of his sitters, whose mother was

the Duchess of St Albans. Frith discreetly does not say if this was the identity of the supercilious lady who called at his house. Even writing twenty years after the event, he had to be careful not to give offence.

Frith realised that, to make progress, he must have an ally at court. On 7 April, he had got on well with the Queen herself. She laughed at his jokes, and they both lamented the absence of Prince Albert, whose knowledge of art would have been helpful to them both. Queen Victoria was herself an amateur artist, and Frith admitted that she had made several useful suggestions. But Frith could not trouble the Queen with all the tedious details of sitters and dresses. Fortunately, he found a friend at court who could help him: Lady Augusta Bruce, the Queen's Lady of the Bedchamber. A daughter of the 7th Earl of Elgin, of Elgin Marbles fame, she later married Arthur Stanley, who was to become Dean of Westminster. She became an important go-between and Frith's confidante as well. Many of their letters survive, in the collection of Frith's family. Frith remained deeply grateful to her ever after, and wrote that 'she was one of the most delightful women that ever lived'.[18] On a visit to Coburg Lady Augusta managed to get hold of the Duchess of Brabant's dress, which was very important because of the Duchess's prominent position in the foreground. The lower part was a magnificent moiré antique robe of a fine purple colour. Frith was allowed to borrow it, but wrote to his sister-in-law Vicky, 'I am to pledge myself neither to smoke nor drink beer in their presence.'[19] It transpired that the reason for this embargo was that the Duchess had in the past lent dresses to Belgian painters, and they had come back smelling strongly of tobacco and beer-stained too.

During March and April, a ceaseless flow of prints, photographs and other souvenirs of the royal wedding was produced. Day and Sons published an account of the wedding illustrated with over sixty lithographs, many of them by G.H. Thomas, who, they proudly announced, had been an *eyewitness* at the wedding. All of this made Frith very uneasy particularly because of his difficulties in getting sitters to pose for him. Lady Augusta wrote soothingly, assuring Frith that none of this would distract from his picture, or prevent the discerning public from 'appreciating and admiring the works of one of our greatest living artists'.[20] Lady Augusta clearly understood the importance of massaging the wounded artist's ego. In any case, she and Queen Victoria both knew that Frith had by this time agreed to sell the copyright, not to Gambart, but to Flatow, for the enormous sum of £5,000. All of which put more pressure on Frith to get on and finish his picture.

By the end of April, Frith was getting seriously worried. Some photographs had arrived, some dresses and uniforms, and a few sitters, including the Duke of Cambridge, and some of the bishops. But the royals had scattered; Queen Victoria and her children were off to Osborne. It was not until 11 May that Frith got his first sitting for the Prince of Wales, one of the most important people in the picture. Even this appointment was cancelled, and the Prince finally came four days later. The Princess of Wales came later in the month, but proved a very bad sitter, who would not keep still. The Princess was also sitting for the sculptor John Gibson for a bust: he too found her an impossible sitter. The Prince reprimanded her, 'There you see, you neither sit properly to Mr Gibson nor to Mr Frith.' 'I do – I do,' replied the Princess. 'You are two bad men!'[21] After that the Princess was as good as gold. The Prince and Princess, standing before the Archbishop of Canterbury, were to be the focal point of the composition. Frith also painted a sketch of the Princess, which he gave to Princess Mary of Cambridge.[22]

Among the first royal visitors was Prince Louis of Hesse, husband of the Queen's daughter, Princess Alice. He smoked cigars throughout the sitting, and brought with him his gentleman-in-waiting, Captain Westerweller, who remained standing throughout. Frith politely suggested the Captain might like a chair. The Prince barked out, through the cigar smoke, 'He vill schtaand.'

Frith was also a great smoker of cigars. To get rid of the smell, Mrs Frith bought incense from a nearby Catholic chapel, and carried it about the house, burning on a shovel. When the Archbishop of Canterbury arrived for his sitting, he sniffed the incense in the air, and enquired with a roguish twinkle, 'Have you had Manning here?' The four bishops, Winchester, Oxford, Chester and London, all came and sat, and proved no trouble. Frith was amused by the animosity between Bishop Wilberforce of Oxford (known as Soapy Sam) and the Lord Chancellor, Lord Westbury. As Lord Westbury was sitting, he noticed Wilberforce's presence in the picture. 'Ah, Sam of Oxford,' he remarked; 'I should have thought it impossible to produce a tolerably agreeable face and yet preserve any resemblance to the Bishop of Oxford.' When the Bishop saw Westbury's portrait, he agreed yes, it was like him, 'but not wicked enough'.[23]

As the summer wore on, Frith found it increasingly difficult to make appointments for the royals; all were too busy, or away. He pressed on with the other sitters, but by July, he still had over a hundred portraits

to paint. His method was to start with the bridal couple, who stand facing the Archbishop, and work outwards, with the bridesmaids to the left and a group of royals and clerics to the right. In desperation, Frith wrote in September to Lady Augusta to ask if he might bring the picture to Windsor and work on it there. He had heard that the Queen would be holding court at Windsor in the autumn, and many European royals would be there. To Frith's delight, the Queen agreed; 8 November found him at Windsor, installed in one of the staterooms, the Rubens Room, where the royals dutifully came to sit for him. Thanks to the Queen's authority, they all came on time, and sat for as long as Frith needed them. Except for one. This was Prince William of Prussia, the son of the Crown Prince and Princess of Prussia, who was later to become Kaiser Wilhelm II. He was clearly a tiresome child, and had already behaved very badly at the wedding, biting the knees of his uncles Prince Leopold (who suffered from haemophilia) and Prince Arthur. At Windsor, he proved a difficult sitter; not helped by the fact that he hated the kilt he was made to wear, with an inordinately large sporran, which hung down below his knees. Frith wrote a long letter to his sister on 8 November, describing his life 'cheek by jowl (rather a vulgar expression that) with royalty'. Of Prince William of Prussia, he wrote 'of all the little Turks he is one of the worst; and how I am to get a likeness of him I don't know'. The 'royal imp' as Frith called him, looked at Frith and said 'Mr Fiff, you are a nice man, but your whiskers . . .' at which point Princess Helena put her hand over his mouth, so Frith never heard what he was going to say about his whiskers.[24]

In order to keep him quiet, Frith unwisely allowed Prince William to paint some unimportant area of the picture. He succeeded in getting a great deal of paint on his face, which Frith then had to wipe off with turpentine. The little Prince unfortunately had a cut or spot on his face which was stung by the turpentine. He screamed with rage, and disappeared under the table where he yelled and howled for some time, until he was exhausted. No doubt the Prince never forgot 'Uncle Wales's Wedding' as he called it; Frith certainly took pleasure in telling the story ever after. Although he did not live long enough to see the First World War, it would not have surprised him.

By Christmas, Frith was back home, writing to his sister on 20 December to report that ' . . . I have finished the Queen and the Prince, nearly done the three English Princesses, advanced the Crown Prince, begun General Grey, Lady Mount Edgcumbe, the Lord

Chamberlain . . . and made a most satisfactory study of the Princess of Wales. . . .' The Queen's reaction was not so optimistic. Before Frith left, she wrote in her journal, 'After luncheon, we went to look at Mr Frith's picture, in which the likenesses are not very good.' By the end of January, Frith had put in more work and she changed her mind, writing in her journal again, 'Mr Frith is here again and the picture has got on very much, and is really a very fine thing.'[25]

Frith toiled on into the New Year, and tried to contact the blacklist of people who had still not responded to his letters. In the end he got nearly all of them. In the summer, G.H. Thomas's picture of the wedding went on show in Bond Street, at Gambart's gallery, giving added urgency to Frith's need to finish his picture. The royals continued to be difficult, but he concentrated on some of the minor figures. One remarkable character was the Hon. Frederick Byng, known as Poodle Byng from his dandified, Regency appearance. Well over eighty, he walked from Duke Street, St James's to Bayswater for the sittings, and regaled Frith with stories about Beau Brummel and George IV, whose wedding to Caroline of Brunswick Byng had attended sixty-nine years before.

Now it was the turn of the *Corps Diplomatique*, who occupied the north aisle below Queen Victoria in her closet above. The Russian, Austrian, French and Turkish ambassadors all came, in their uniforms, along with their wives. The Turkish ambassador, Musurus Bey, can clearly be seen in the centre of the group, wearing a fez. His wife complained that Frith had made her look too old and ugly, and sent him a drawing of her done when she was eighteen. Frith refused to change her. Mrs Adams, the wife of the American ambassador, was so large and plain that Frith managed to hide her behind a pillar. For the architectural background, William Scott Morton, who had done the same for *The Railway Station*, again helped Frith.

Much more exotic was the Maharajah Duleep Singh, last ruler of the Punjab, who had been virtually adopted as a boy by the royal family. He appears in a magnificent jewelled turban, his robes festooned with jewellery. Very late in the day, he finally came to sit. He left his jewels behind, with a servant to guard them. At night they were to be deposited at Coutts Bank. Seeing that Frith had an iron safe, the servant allowed Frith to lock up the jewels inside it, saying as he did so, 'Now if the Prince knew of this, he would be awake all night.'[26] He also told Frith that the Maharajah's favourite book was the Bible, which he knew from cover to cover.

After working flat out over the winter of 1864/5, the great picture was at last finished and ready to go to the Royal Academy. But Frith thought that it must first be shown to the Queen herself. A date was arranged for 28 March. The day before, Frith received a telegram confirming the appointment. On the day itself, the Frith household was in a state of high excitement. Frith's sister-in-law Vicky had dressed up as a parlourmaid. No less than four footmen arrived at intervals, announcing the Queen's imminent entrance. At last the royal party arrived, consisting of the Queen, King Leopold of the Belgians, the Princesses Helena and Louise, and a suite of courtiers and equerries. Frith stood on the doorstep bowing deeply, before leading the Queen up to the drawing room to introduce her to his wife, Isabelle. At this point one of the younger members of the royal party said in a loud voice, 'I didn't know artists lived in such big houses', only to be silenced by a withering look from the Queen.[27] The Frith family must have been amazed at the appearance of King Leopold, who was then aged seventy-five. Extremely gaunt, with rouged cheeks and pencilled eyebrows, he wore an old-fashioned Regency wig, brushed forward, with a curl in the middle of his forehead. Frith would say little about the Queen's reaction, except that 'she found little or no fault,' he wrote, 'and left me under the impression that I had succeeded as well as could be expected, considering the great difficulties of the task'.[28]

After the Queen's departure, the children danced about excitedly and asked if father had been made a lord. The Frith family was to be disappointed: the Queen conveyed no honour or title upon Frith, even though he richly deserved it. Perhaps word got through to her about Frith's irregular marital situation. In her memoirs, Cissie, later Mrs Panton, was plainly disappointed at her father's treatment, and wrote many years later that she could never understand 'why in these days the royal folk always paid less for their pictures than anyone else. . . . I am sure my father lost hundreds of pounds over the picture of the Marriage . . . and what it cost him in wear and tear of nerves, time and temper, no one will ever know.'[29]

During the next few weeks, Frith still had to make final changes and additions to the picture. Finally, it went to the Royal Academy, still at the National Gallery in Trafalgar Square. Private View day was 28 April. It was the first time Frith had exhibited there for two years. Eagerly anticipated, Frith's picture was another huge success. Once again, after a struggle, an iron rail was put round the picture to protect

it from the crowds. Frith had done it again. After the opening, Frith wrote to Sir Charles Phipps, telling him what had happened, and also discreetly hinting that he would like to be paid. He also revealed that he had had to return a large amount of the copyright fee to Flatow. Phipps replied, enclosing a cheque, and congratulating Frith on the picture. 'I believe that a more difficult task never was undertaken by any man.'[30] How right he was.

The reviews, as usual, were mixed. Frith, in any case, never read them, and strongly advised other artists to do the same. The *Art Journal*, often critical of Frith's work, praised the picture highly, saying he had 'made out of a formal state ceremonial a brilliant work of art'.[31] It also praised the harmonious colours, especially the whites of the bridesmaids and other ladies nearby. Queen Victoria had expressly forbidden bright colours, suggesting mauve, lavender or light blue. This helped Frith to achieve an overall unity of tone. The *Morning Post* also praised the balance of colours, as well as Frith's skill in deploying the different groups into a harmonious whole.[32] The *Daily Telegraph* found the colours inharmonious 'patches of crimson, purple and gold'. They also thought the picture airless, and lacking refinement – 'we miss the lady and gentleman'.[33] A curious comment, considering the nature of the occasion. The reviewer clearly expected royalty and aristocracy to look more refined, which they do not always do. They should have praised Frith for being honest, at least. *The Spectator* was also dismissive, seeing little interest in the picture beyond 'looking at the portraits of so many swells'.[34] *The Athenaeum* was more guarded in its praise, warning that the picture 'should be considered under the conditions proper to works of its class; which are extremely unfavourable to the production of a fine work of art'. The reviewer did not think the picture up to Frith's usual sparkling standard, but stressed the difficulties of the commission. He also thought some of the figures lacked dignity. Of course, Frith did not flatter his sitters; he painted the reality of the scene, not some kind of royal fantasy. Would one expect the painter of *Derby Day* to do otherwise?[35] The *Art Journal* wrote again on 1 June that 'The favourite opinion expressed (in their last issue) has since been echoed on all sides. The crowds . . . have rendered the erection of a protecting barrier imperative. . . .'[36]

Frith proudly put all the photographs and cartes-de-visite he had accumulated into an album, and where possible got all the sitters to sign them. This album survives in the possession of Frith's descendants, but a

visitors' book containing many signatures of royalty was stolen from his own drawing room. The finished picture now hangs at Buckingham Palace, and there is a smaller replica in the Walker Art Gallery, Liverpool.

Most writers on Frith, Jeremy Maas included, feel that *The Marriage of the Prince of Wales* was something of a watershed in his career. After it, he seems to have lost something of his old enthusiasm for large-scale modern-life pictures. Except for *The Private View at the Royal Academy* of 1881, there were to be no more big pictures of Victorian life. He was to paint many more modern-life scenes, but smaller. He also took up historical and literary pictures again, and was to continue to paint them for the rest of his career. The *Times of Day* series, commissioned by Gambart, was never completed, to Frith's lasting regret. He knew it was his modern-life pictures that would be remembered by future generations, and he was right.[37] But for the moment, he could rest on his laurels. He was rich, he had a wife, a mistress, and a large family; he was one of the most famous artists in England. His career was at its peak. Nonetheless his failure to receive any kind of award, or honour, for *The Marriage of the Prince of Wales* must have rankled. It was to be another forty years before Frith finally got the reward he coveted, and he was to receive it from the Prince of Wales himself, by then King Edward VII.

ELEVEN

John Leech, Shirley Brooks and Punch

In the autumn of 1864, while Frith was working on the *Marriage* picture, the art world was saddened to learn of the premature death of John Leech, at the age of only forty-six. Leech was a man universally beloved by his friends, including Frith, and his passing was lamented by all. Frith devoted a chapter to Leech in his memoirs.[1] Later, irritated that no good book about Leech had been written, Frith wrote a two-volume biography of him, which was finally published in 1891.[2]

Frith had first met Leech in about 1842, in the studio of a Scottish actor-turned-painter, Robert Ronald McIan ARSA (1803–56). Leech was trying to learn oil painting, but soon realised he had no talent for it, and certainly not enough patience. Watching Frith painting one day, Leech remarked, 'I wasn't created to do that kind of work; I could never muster up patience for it.'[3] Frith wrote that for Leech, 'finish . . . was so much waste of time. When you can see what a man means to convey in his picture, in whatever way he does it, you have got all he wants, and all you ought to desire; all work after that is thrown away.'

Leech's genius was as a draughtsman, a maker of rapid, pen-and-ink sketches. He rarely bothered to make drawings from nature; everything came from his memory and his imagination. He made his first cartoon for *Punch* in 1847, and quickly became the most popular and best loved of the *Punch* cartoonists. He may not have been as good a draughtsman as John Tenniel or Charles Keene, but for many readers, Leech's cartoons were the best thing in *Punch*; for some, John Leech and *Punch* were synonymous. What the public appreciated about Leech was his wit; his drawings are still amusing to us today, even if we do not appreciate their context fully. Leech's humour was a gentle humour; it involved people and situations that everyone could understand. Above all, people could recognise Leech's social types – swells, shopkeepers, railway porters, hunting men, policemen, matrons, beautiful girls, clubmen, irascible old gents, street urchins, children – he ranged across

the whole social spectrum. There is no better way of getting a feeling for the mid-Victorian world than studying Leech's *Punch* cartoons, collected together and published as *Pictures of Life and Character*. Leech is reckoned to have contributed 3,000 drawings to *Punch*, of which at least 600 were cartoons. He also illustrated other magazines and books, but it is with the works of Surtees and Mr Jorrocks that he will always be associated. Leech was a keen rider to hounds himself, and many of his best and funniest illustrations are to do with hunting. He would often do his drawing for *Punch* straight on to the woodblock, so it could go off to the printers, and he could go and catch the train to go hunting in the Midlands. He tried to persuade Frith to come hunting, without success, and also advised him on buying horses.

Frith wrote that Leech, 'has left work behind him which will continue to delight generation after generation, so long as wit, humour, character and beauty are appreciated . . .'. Sadly, his prediction has not come true; Leech is still largely forgotten, and under-appreciated. But his importance to Frith can hardly be overestimated. Not only did Leech encourage Frith to switch to modern-life painting, but he also gave him ideas for his figures, and social types. There is no doubt we can see a lot of Leech influence in Frith's types, particularly his swells, beautiful women, city clerks, cheeky urchins, and many others. Because Leech and the other illustrators of the 1840s and '50s had already depicted modern life, including such subjects as the seaside, the Derby and the railway, it was inevitable that Frith should make use of them, consciously or unconsciously. These cartoons could also help him to get the right physiognomic types for use in his crowd scenes. Ruskin was quite right when he described Frith's *Derby Day* as 'a cross between John Leech and Wilkie'.

When Frith was attacked for painting modern life, Leech was one of those who supported him; he was pleased that Frith was 'leaving what he called "mouldy costumes" for the habits and manners of everyday life'. Leech put his support for Frith into a cartoon in *Punch* entitled *Jack Armstrong*. It shows Frith, with his back to the spectator, showing his modern-life picture to two artists, Potter and Feeble, who belong to the 'high aim school' – those who aim high and always miss. The background, wrote Frith, was 'my old painting room, with armour, cabinets of oak, etc. for which memory alone served the artists'. Frith often suggested subjects to Leech, who would reply, 'Ah, capital', but he only ever used one, of a swell driving back from the Derby with a drunk post-boy in his carriage.

SCENE IN A MODERN STUDIO.

JACK ARMSTRONG HAS PAINTED A MODERN SUBJECT, FROM REAL LIFE, AND PAINTED IT UNCOMMONLY WELL.—STRANGE TO SAY, HE HAS SOLD HIS PICTURE.
MESSRS. FEEBLE AND POTTER (*very high-art men, who can't get on without mediæval costume, and all the rest of it*) THINK IT A MISTAKE.—CURIOUSLY ENOUGH, *THEIR* PICTURES ARE UNSOLD.

John Leech – *Scene in a Modern Studio*. Frith is the figure with his back to the viewer. He is showing his picture to Potter and Feeble, two artists of the 'high aim school', who are no doubt scornful, yet envious of Frith's success. (*Punch, vol. xxx, 19 April 1856*)

Leech became prone to melancholy, and attacks of angina. He was also abnormally sensitive to noise, and was driven mad by the organ grinders and other noisy hawkers who plied their trade in the streets. To escape the noise, he moved from Brunswick Square to a house in Kensington nearer to his great friend Millais. He found this little better, and confided to Frith, 'Rather than endure the torment I suffer all day long, I would prefer to go to the grave where there is no noise.' He died soon after. Something of his great charm can be seen in the watercolour of him, by Millais.[4]

Leech was replaced on *Punch* by Charles Keene and George du Maurier. Keene is not mentioned by Frith in his memoirs, but the du Mauriers became close friends, and joined them for holidays. It was Mrs Panton who wrote at greater length about the du Mauriers; she remembered him living in rooms over a shop near the British Museum. Later he married and, 'Next to Mrs Yates,' wrote Mrs Panton,

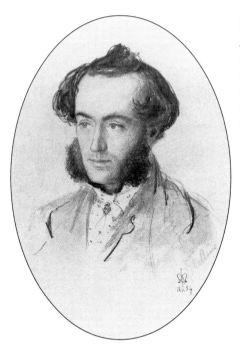

Sir John Everett Millais, PRA: *Portrait of John Leech*. Leech was one of Frith's closest friends, and the one who most encouraged him to turn to modern-life subjects. Frith later wrote Leech's biography. *(National Portrait Gallery, London)*

'Mrs du Maurier was the loveliest creature of the time, and from her statuesque beauty her husband drew his inspiration, and has immortalised her over and over again in his pictures in *Punch*.' Du Maurier also used Cissie as a model when she was a girl, and several of her brothers. 'What wonder then,' she wrote later, 'that we all feel as if Mr Punch was a family possession.' Du Maurier had a beautiful tenor voice, and was much in demand in his friends' drawing rooms. Like many small men, Mrs Panton wrote, 'he had an intense attachment to anything large. He owned the biggest dog, called Chang, I ever saw, and he simply worshipped strength and size in man or woman. Indeed, people . . . say he invented the six foot young woman of the day.'[5] Thanks to *Trilby* and his other novels, du Maurier eventually became rich and successful, after which Mrs Panton saw less of him.

Both Leech and *Punch* were important in Frith's life, and career. He was a friend of all the editors of *Punch* in his lifetime: Mark Lemon, Shirley Brooks, Tom Taylor and Francis Burnand. Although never a contributor to *Punch*, Frith attended *Punch* dinners and undoubtedly swapped jokes and ideas. No doubt they all appreciated Frith's gifts as a raconteur, and his ability to keep them up to date with art-world gossip. He and Mrs Frith also entertained them liberally at their Sunday night dinners at Pembridge Villas.

The first editor of *Punch*, from its modest beginnings in 1841, was Mark Lemon. Large, genial, bearded, he was a regular dinner guest at Egg's house, Ivy Cottage in Hammersmith, where the Friths may well have first met him. Dickens was also a regular visitor, and one day he brought the Danish writer Hans Christian Andersen with him. Lemon was more than usually entertaining, and at the end of the evening, Andersen said, 'Ah Mr Lemon, I like you; you are so full of comic.' [6] Like Frith, Dickens and Egg enjoyed stories to do with highwaymen, murderers, and criminals in general. Another story of Lemon's recorded by Frith concerned a cook who went mad, and refused to let anyone come into the kitchen and serve the food, because she did not think it was up to her usual standards. Eventually, the woman was restrained, and carried off screaming hysterically to her room.[7] Mark Lemon remained editor of *Punch* until his death in 1870. From about 1851, his deputy Shirley Brooks' contribution was so important that he became a virtual co-editor with Lemon. In 1870, Brooks succeeded Lemon as

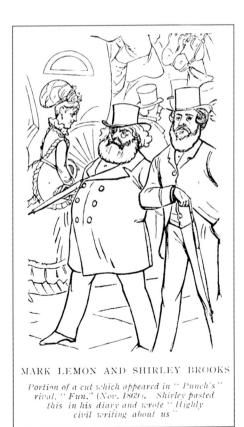

Mark Lemon and Shirley Brooks, the first two editors of *Punch*. The celebrated weekly was founded in 1841, and thanks to Lemon and Brooks it became a national institution. *(From* Fun *magazine)*

MARK LEMON AND SHIRLEY BROOKS

Portion of a cut which appeared in " Punch's " rival, " Fun." (Nov. 1869). Shirley pasted this in his diary and wrote " Highly civil writing about us "

editor, but was only to fill the post for four years, until his death in 1874. But it was Lemon and Brooks who turned *Punch* from a small satirical magazine into a national institution.

Shirley Brooks was the *Punch* editor whom Frith knew best, and for longest. He devoted a whole chapter to him in his memoirs.[8] They first met in about 1856, at a dinner with John Leech, 'and I then became aware,' wrote Frith, 'how well Brooks deserved to be called good company. He had long been on the staff of *Punch* under the leadership of Mark Lemon; and nearly every week that paper owed some of its smartest writing to the pen of Shirley Brooks.' Large, jovial and also with a long flowing beard, Brooks was a naturally exuberant and entertaining character, who clearly felt that because he worked for *Punch*, he had to be funny all the time. Articles, letters, novels, jokes, doggerel verse and bad puns poured from him in a continuous stream, as is attested by both Frith and Mrs Panton. Some of the humour may seem incredibly laboured and cumbersome to us now; we have also lost our forebears' great love of groaningly bad puns, conundrums, limericks and clerihews. It was Brooks who is said to have written the celebrated verses about Ruskin:

'Poem by a perfectly furious Academician'

I paints and I paints, hears no complaints,
And sells before I'm dry
Till savage Ruskin sticks his tusk in,
And nobody will buy.[9]

Brooks and Frith developed a private language, and private jokes, which makes their letters difficult to decipher. Brooks always referred to Frith as 'Cottle'. This name came from a letter Brooks received at *Punch* from a Mrs Elizabeth Cottle, claiming direct descent from King Henry VIII. 'This interesting descendant from a long line of kings lived at Putney,' wrote Frith, 'a locality – as she threateningly put it – soon to be exchanged for Buckingham Palace.' Brooks invented a great many names for himself, including Plantagenet Brooks or Epaminondas Blundersnatch. Among the many letters addressed to 'Cottle' is a long-winded, mock-biblical epic entitled *The Epistle of Shegog*. Frith is referred to as 'the man Cottle, which useth pigments, and maketh the faces of the princes of the people, and the chief lords thereof. Likewise

the highway robber, the man Claude Duval, and the little child who showeth her little fat legs to the sea, even the Ramsgate Sea.'[10] In another letter quoted by Frith, Brooks wrote: 'I made a good joke. We had struggled up a steep mountain, and I rested at a tree and asked, "why it was like a hospital counterpane?" They gave it up with abuse. "Because it's on top of the 'ill." Wit, you see, does not depend on locality.' As an example of Brooks's repartee, Frith tells a story of a man with a noticeably turned-up nose, who objected to Brooks and others 'making my nose a subject of conversation'. 'That is unfortunate,' replied Brooks, 'we wanted a subject, and we took the first that turned up.'[11]

Both Brooks and his wife were particularly close friends of Frith's wife Isabelle, and one suspects, may well have sympathised with her situation. They must have known about Mary Alford and Frith's second family, but nowhere do they mention them. Most of the letters in the Victoria and Albert Museum's albums were addressed to Mrs Frith. Many of them concern invitations to dinner. In September 1866, Brooks writes, 'Do not therefore make any extensive preparations for me; a little turtle, some venison cutlets, an omelette (herb), some meringues, and some of the best Burgundy will amply suffice my modest requirements, and if I do not come, Cottle may eat my share, and drink his own, which will be quite difficult for him.'[12]

On her birthday, Brooks sent Mrs Frith another of his doggerel poems:

'Unto my Friend, Mistress Frith, these: Madam'

Upon your natal day,
My muse would fain a flight essay;
But after months of weather sloppy
Her wings are very wet and floppy
So, with umbrella and galoshes
To Number 7 she slides and squashes
And gives your bell a vicious tugging
And out a limpish card a lugging
Up your dear hospitable passage
She splatters out a kindly message
Which is that I, her keeper, send
Love to my dear and valued friend;
And hope that (spite of infants rancorous

Likewise of Cottle, the cantankerous)
The Day will prove the sort of day
That all who love her wish it may. . . .[13]

The Brooks family often joined the Friths on holiday, notably at Scarborough in 1865. Even on holiday, Brooks 'always wore a top hat and a frock coat, and could hardly be induced to take any exercise'.[14] Instead, like the true journalist he was, he bought all the newspapers and magazines he could find. The only thing he really liked was going to the circus. He also wrote a long and rather tedious comic diary describing the holiday.[15] From Yorkshire he went on to Scotland, where he sent Frith another *jeu d'esprit*:

'Theological Horology'

There's this to say about the Scotch,
So bother bannocks, braes and birks;
They can't produce a decent Watch,
For Calvinists dismiss good works.[16]

Of all Frith's many children the one Shirley Brooks was most attached to was Cissie, whom he referred to as Sissy or Siss. In a letter to Frith in 1867, Brooks wrote, 'My kind love to Mrs Frith, who is the only one, except Siss, that appreciates me.'[17] As Mrs Panton, Cissie later wrote that 'Shirley Brooks was the most genial and riotously amusing of men, and he used to "play" with us all in the extraordinary manner that we loved. I have known us all, from Papa downwards, steeplechase all up and down the two drawing rooms, leaping over every obstacle which came in our way in the shape of chairs and sofas, while Mama and Mrs Shirley Brooks tried in vain to look severe and stop us.'[18] Cissie must have been an intelligent girl, and wrote that 'from the first I was his especial pet and companion'.[19] She and Brooks would go on long walks together, especially when they were on holiday.

Brooks was a regular visitor on Sunday nights. Dickens, although a close friend of Frith, was not a friend of the Frith family to the same extent as Brooks, and did not come on Sundays. Brooks would of course regale them with stories from *Punch* and would tell them about the 'big cut', which meant the main cartoon of the issue. He would also bring an advance copy on Sundays, which the public would not see until

Wednesday. Brooks also sent Cissie, 'the waste paper basket from Mr Punch's office', and encouraged her to write. 'I do not believe people laugh, or know how to laugh, nowadays as we used to laugh,' wrote Cissie later, 'but oh! How we did enjoy life; and oh! What small and absurd things we used to laugh at.'[20] Brooks made a speech at Cissie's wedding in 1870. He was also frequently writing to Frith to congratulate him on his numerous grandchildren. Cissie's eldest sister Isabelle also made a good marriage: she married Charles Oppenheim, a prosperous city merchant, and they lived in Hamilton Terrace. Among their descendants are a lord and a baronet; and the Oppenheims happily are still in London and still prosperous.

Brooks was generally genial and good-humoured, but there were things that annoyed him. 'Anything like pretence or sham roused the lion in Mr Brooks in a moment,' wrote Mrs Panton. This was demonstrated when he and Cissie were introduced to the famous explorer, H.M. Stanley, who had just returned 'from an historic and somewhat theatrically managed expedition into the then little known Central African forests'. Brooks opened the conversation by saying that he had recently seen Stanley's parents in Wales, who were looking forward to seeing him. 'I have no people in Wales,' replied Stanley, turning his back on Brooks. 'Well that's a good 'un,' said Brooks, 'they keep a toll bar, their name is Thomas, and they showed me your letters. . . .'[21]

Sadly, Brooks was not to enjoy the editorship of *Punch* for long. On 31 December 1873, he gave what was to be the last of his New Year parties. The guests included the Burnands, Mark Twain, the du Mauriers, the Friths, the Jerrolds, Linley Sambourne, Sir John Tenniel, and Edmund Yates. Henry Irving and William Farren, also an actor, were unable to come at the last moment. It was very much a *Punch* occasion, and shows just how close Frith was to the magazine, and its illustrators. In January, Brooks fell seriously ill, and on 23 February, still directing *Punch* from his bed, he died.[22] He was buried at Kensal Green cemetery, where his grave is close to both John Leech and Thackeray. Mrs Brooks died six years later, in 1880; her great friend Isabelle Frith died in the same year.

Frith was proud of his literary connections, in particular his friendship with Dickens and John Forster. In his memoirs, he also writes about Thackeray, Trollope, Dr Doran, George Augustus Sala, the Brownings, Miss Braddon (Mrs Maxwell) and many others. But there is

no doubt that his closest friend, and the one most important to him, was Shirley Brooks. They were clearly two of a kind; they enjoyed jokes, telling stories, good dinners, good company, good wine, and cigars. Although Frith was never on the staff of *Punch*, he was in effect an honorary member of the *Punch* circle; its influence on his art and his career can never be overestimated.

TWELVE

Pictures, Actors and an Explosion
1866–9

Following the completion of the royal wedding picture, it was Gambart who was the first to approach Frith for a new commission. No longer interested in the *Times of Day* pictures, Gambart called to see what Frith was working on. Frith showed him a sketch for a historical picture, to be entitled *King Charles II's Last Sunday* (Plate 8). He had found the subject in the diaries of John Evelyn. After visiting the King one Sunday evening, Evelyn wrote, 'I can never forget the inexpressible luxury and profaneness, gaming and all dissoluteness, and . . . total forgetfulness of God (it being Sunday evening). . . .' Within a week, the King was dead. Gambart knew a good subject when he saw one, and immediately commissioned Frith to paint a large picture, at an agreed fee of £3,000. So Frith was back on the historical treadmill once again. For the next two or three years, he concentrated entirely on subjects from the eighteenth century, especially from the writings of Sterne and Boswell. They were becoming old-fashioned, but there were still plenty of old-fashioned collectors, especially outside London, who liked them. In 1866, Frith and his family went for their summer holidays to Scarborough, in his native Yorkshire, together with Shirley Brooks and his wife, Henry Sothern, the actor, and his wife, H.N. O'Neil and the novelist Edmund Yates and his wife.

As usual, the search for models began. He found a man who looked very like King Charles II, but he was in poor health. Like the King, he too died about a week after his last sitting, which was on a Sunday. At about this time, Frith received a visit from his old friend, the Scottish painter John Phillip, a fellow student and member of the Clique in his younger days. Phillip had just told Frith a good story about painting Disraeli: after the sitting, Disraeli's wife had rushed up to Phillip and said, 'Remember his pallor in his beauty!'[1] At this point, Phillip seemed to suffer some kind of stroke, and collapsed into a chair. Frith

summoned a doctor, and a carriage to take poor Phillip home. He died about ten days later, to Frith's great sadness. They had been boys together, he wrote; and Frith considered him 'one of the greatest painters this country has produced, and one of the noblest and truest hearted of men'. History has not endorsed Frith's judgement. Phillip is not well remembered today, and his once popular Spanish subjects remain stubbornly out of fashion.

The other major event of 1866 for Frith was Gambart's celebrated fancy-dress ball. It was to take place at 62 Avenue Road, Gambart's palatial house in St John's Wood, on Derby Day, 16 May. Before long, the art world was buzzing with anticipation, and everyone was discussing costumes. Theatrical costumiers and Wardour Street junk shops were combed; the elderly historical painter Edward Matthew Ward was consulted on the finer points of period detail. Frith had an aversion to what actors called 'leg parts' and at first refused to dress up, as did Rossetti. Both wrote to Annie Gambart, Gambart's very pretty young third wife, whom he had married in 1851, when she was only sixteen, to excuse themselves. Frith painted a delightful picture of Annie in the 1850s.[2] Rossetti wrote, 'If the dress of the nineteenth century is an admissible period, I think I shall be most happy to attend as a chrysalis, and so set off the more brilliant butterflies.'[3] Mrs Panton wrote in her memoirs, 'I think Mr Gambart was a very irritable man, but Mrs Gambart ruled him with a silken thread: she was very dainty and pretty, and he worshipped her, and her "Dear Airnest" (his name was Ernest, but she always pronounced it like that) quelled the rising storm, and became an angel in a moment.' She also wrote that 'I never heard who and what Mrs Gambart were by parentage, but I think they must have been gentlefolk; they knew everyone and went everywhere. . . .'[4]

By early May, huge preparations were in hand at Avenue Road. A parquet floor was specially laid in the gallery, over the billiard room, and large marquees were erected in the garden. Gambart was to come as the famous Flemish patriot, Count Egmont, and Annie's costume was to be based on an eighteenth-century porcelain figurine that sat in a case in the dining room. Frith had relented, and decided to come as the diarist, John Evelyn. His wife was to come as one of the ladies in the Charles II picture, and their daughter Cissie was to be Dolly Varden, the Dickens character who had been the subject of Frith's first successful modern-life picture. A few days before the party, there was an ominous portent: on 10 May, the celebrated city bank of Overend and Gurney went bankrupt

Annie Gambart (née Baines), Gambart's third wife. They separated in 1867, and Annie died in 1870, long before Gambart. *(Mercer Art Gallery, Harrogate)*

to the tune of £19 million. Gambart was said to have been hard hit. But the party had to go on.

Gambart had also decided to put gas lighting in the house and marquees, specially for the occasion. The day before the party, Mrs Frith and her daughter Cissie went to help Mrs Gambart with the

flowers, and admired all the sumptuous arrangements, including the gas pipes, made of lead, and connected by india-rubber pipes. The next morning, several servants woke early and smelt gas. Annie Waters, a pretty young parlourmaid, unwisely went to investigate the billiard room, and lit a match. There was a shattering explosion, which could be heard all over St John's Wood. Although the house was full of guests, including Alma-Tadema and his wife, miraculously only one person was killed, a temporary kitchenmaid called Elisabeth Etall, who died later in hospital. Annie Waters survived, although badly injured and burned. The entire back wall of the house had collapsed. The force of the explosion had blown pictures and furniture into neighbouring trees and gardens. A 6-foot canvas by David Roberts ended up in an apple tree; two paintings by Creswick were found impaled on railings; a grand piano was blown into the road. Fortunately, Holman Hunt's *The Finding of Christ in the Temple*, which was in the house at the time, survived, as did an important Alma-Tadema, which the artist retouched and restored.[5]

For a time, the story of Gambart's explosion was the talk of the town, and the newspapers were full of it. Philip Hermogenes Calderon, an artist and friend of Gambart's, who lived nearby, made a witty drawing of Gambart sitting at a table in front of his ruined house (called Rosenstead), coolly sipping tea.[6] One of the so-called St John's Wood Clique of artists, George Adolphus Storey, recorded in his memoirs that Gambart gave a 'picnic' for about thirty of his friends, including Frith, in the restored but still empty house: 'We were each to take our camp-stools and our own knives and forks; he would provide the eatables and the champagne, but we must not mind having a carpenter's bench for a table.'

True to form, Gambart laid on a sumptuous meal, accompanied by 'the choicest wines'. Afterwards, there was an old-fashioned Punch and Judy show. Storey commented, rather sourly, 'Whether this was a compliment to the supposed perpetual youth of genius, or the expression of our cynical host's feeling that artists were a parcel of babies and mere puppets for the Gambartian picture-dealer to dangle, is a question that he alone could answer. . . .'[7]

Gambart eventually held his fancy-dress party, at Willis's Rooms in King Street, St James's. Inevitably, it was something of an anti-climax. Although doubtless a jolly occasion, no one could forget the reason for the postponement. Also, many of the guests may have known that all

Philip Hermogenes Calderon, RA: *Gambart taking Tea amid the Ruins of his House*, 1866. Gambart quickly rebuilt the house, but gave his fancy-dress party at Willis's Rooms in St James's instead. Miraculously, only one maid was killed in the explosion, which virtually destroyed the house. *(Private Collection)*

was not well between Mr and Mrs Gambart, who were to separate the following year, 1867. In a letter to the Newcastle collector, James Leathart, the painter William Bell Scott wrote, 'by the way, Tebbs is conducting a separation between Gam and his wife. They say he is found to have various little girls in different lodgings about.'[8] Another inveterate gossip, Shirley Brooks, also wrote about it: 'I don't know whether you know Gambart, the picture man; he is a sort of power, and gave a huge fancy ball last year. He hath other fancies which, not delighting Madame Gambart, have sundered them, and she wipes her eyes on a settlement of £500 a year: there are worse pocket-handkerchiefs.'[9]

Although Brooks was editor of *Punch* and a close friend of his, Frith made no mention of any of this in his book – hardly surprising, considering his own delicate domestic situation. By this time, Frith had already had twelve children by his wife Isabelle; by his mistress Mary Alford he had also had a further five children, born between 1856 and 1866; two more were to be born in 1868 and 1870. Later photographs of Mrs Frith show her to have become immensely fat; perhaps this is one of the reasons why Frith sought consolation elsewhere.

Frith worked incessantly on his King Charles picture for over a year, aiming to complete it in time for the RA exhibition of 1867. He wanted to show King Charles wearing the Order and Star of the Garter. He discovered that the Orders worn by King Charles I at his execution were in the possession of the Duke of Sutherland. Frith was able to borrow them, and get the details of the Star of the Garter correct. While he was working on the picture, Frith sold it to a collector called Matthews. This was almost certainly Charles Matthews, an Essex brewer and director of Ind Coope, who lived at Bower House, a historic house where many English kings had stayed, including Charles I. Matthews amassed a considerable collection, including works by Leighton, Millais, and Holman Hunt, including his *Finding of Christ in the Temple*.[10]

So Frith did not have much to worry about when the picture finally went to the RA for the summer exhibition. But it was hung in a dark place, and Frith was at first bitterly disappointed with its appearance, 'brown and dingy, all the bright colours gone. I wretched in the extreme; couldn't sleep; still all seemed pleased with it.' A few days later, on 4 June, his gloom turned to joy: 'To RA where I find a rail round the "Charles" to my great surprise and pleasure. This is the third rail round my work in the Exhibition – first the "Derby Day"; then the "Royal Marriage" and now "The Last Sunday of Charles II" – Eureka!'[11]

The reviews were some of the best he ever received. The *Art Journal* was categorical. '*King Charles II's Last Sunday* is the best picture ever painted by W.P. Frith RA, and that is saying a great deal.' It was a long and glowing review, the only cavil being that King Charles did not look ill enough. It concluded, 'The work, as a vivid picture of the times is historic.'[12] *The Athenaeum* agreed: 'It is long since Mr Frith was represented on these walls by a work so fresh and brilliant as *King Charles II's Last Sunday*. . . . This work will add to Mr Frith's great reputation.'[13] In his professional life, at least, Frith could do no wrong. He was at the height of his powers, even though he seemed to have lost his taste for modern-life subjects. In 1867, his great supporter L.V. Flatow died prematurely, at the age of only forty-seven. This not only left the field open to Gambart, but also closed off a lucrative source of patronage for Frith. If Flatow had lived longer, perhaps Frith might have painted more modern-life subjects. He was later to pay lavish tribute to Flatow in his memoirs. Although Gambart may have been the bigger dealer, it was Flatow whom Frith liked better. Frith wrote of his first meeting with Flatow, about 1858:

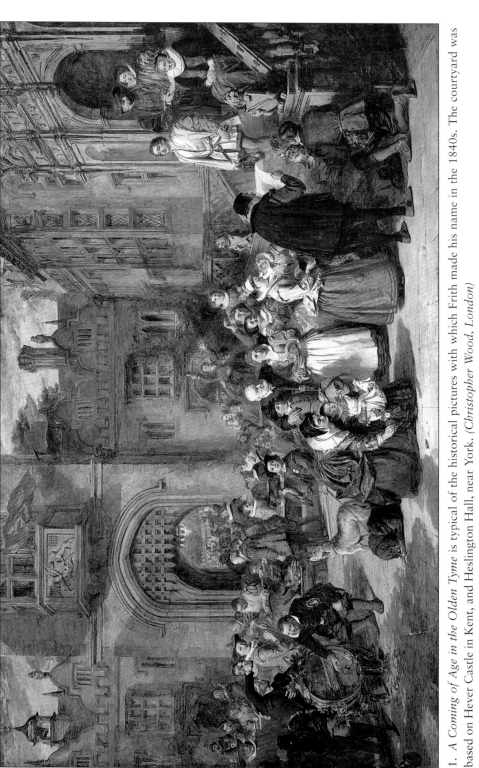

1. *A Coming of Age in the Olden Tyme* is typical of the historical pictures with which Frith made his name in the 1840s. The courtyard was based on Hever Castle in Kent, and Heslington Hall, near York. (*Christopher Wood, London*)

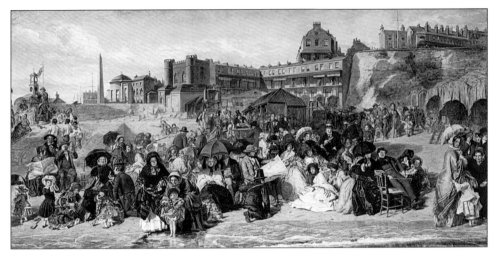

2. *Life at the Seaside*, Frith's first great modern-life picture. A rail had to be put up at the Royal Academy to protect it from the crowds. It was purchased by Queen Victoria and Prince Albert. *(The Royal Collection, © HM Queen Elizabeth II)*

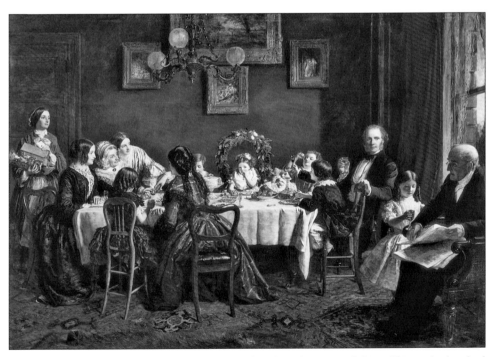

3. *Many Happy Returns of the Day.* The Frith family at home. Frith himself is at the head of the table; his wife Isabelle, and his mother, are at the far end. The birthday girl is Frith's daughter Alice, later Lady Hastings. *(Harrogate Museums and Art Gallery/Bridgeman Art Library)*

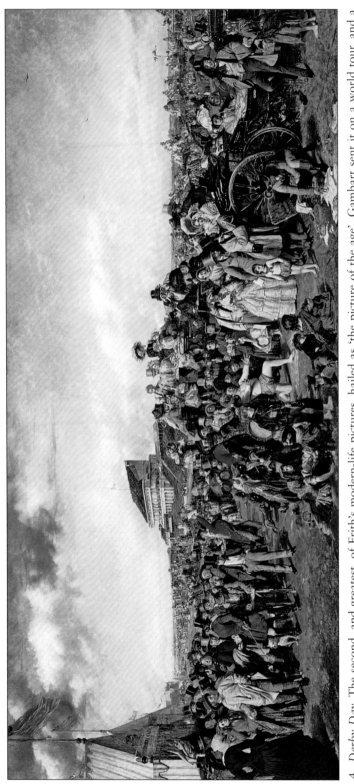

4. *Derby Day*. The second, and greatest, of Frith's modern-life pictures, hailed as 'the picture of the age'. Gambart sent it on a world tour, and a huge number of engravings of it were sold. *(Tate Gallery, London)*

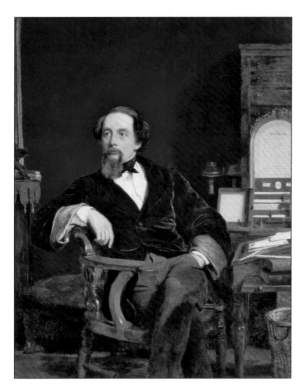

5. *Charles Dickens.* Frith first met Dickens in 1842, and they remained firm friends until Dickens's death in 1870. The portrait was painted in Dickens's study at Tavistock House. *(Victoria & Albert Museum, London)*

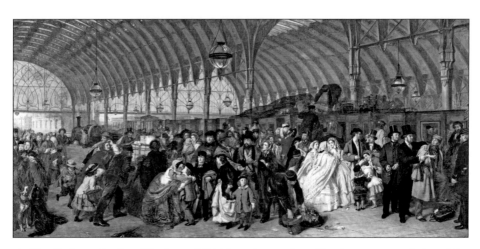

6. *The Railway Station.* The last of Frith's major modern-life pictures, commissioned by the dealer L.V. Flatow for £4,500. The picture was exhibited at Flatow's gallery, and not at the Royal Academy. *(Royal Holloway College and Bedford New College, Egham, Surrey)*

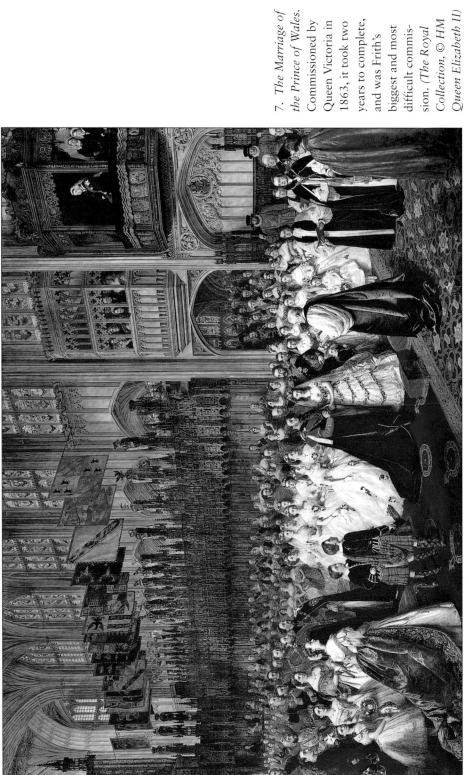

7. *The Marriage of the Prince of Wales.* Commissioned by Queen Victoria in 1863, it took two years to complete, and was Frith's biggest and most difficult commission. *(The Royal Collection, © HM Queen Elizabeth II)*

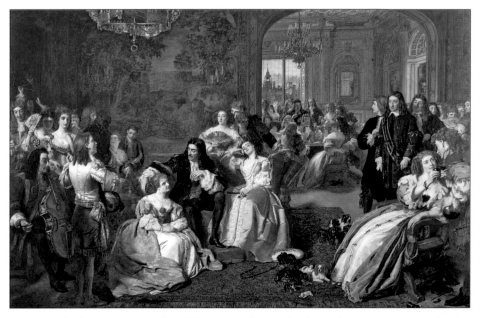

8. *King Charles II's Last Sunday.* This large-scale homily on the decadence of King Charles II's court was considered by many to be Frith's finest historical picture. *(Sotheby's, London)*

9. *At Homburg.* Painted in the gardens of Bad Homburg, Frith wrote 'I was mercilessly attacked for painting such a subject at all.' In 1870, it was still not thought proper for ladies to smoke. *(Christopher Wood)*

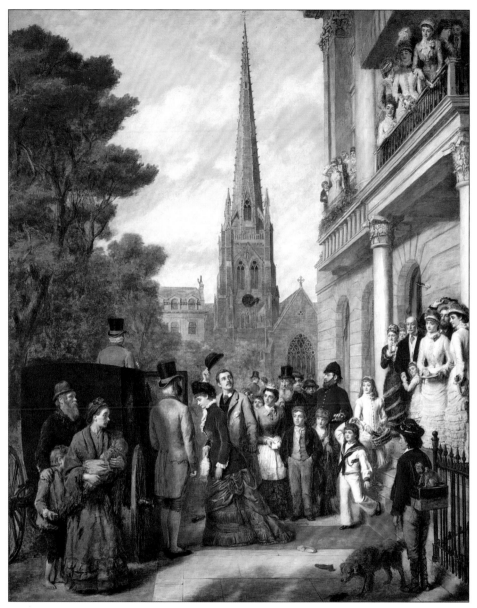

10. *For Better, For Worse.* Painted in Paddington, where Frith lived, the church is based on Christ Church, Lancaster Gate. In the same year, 1881, Frith married his mistress, Mary Alford. *(Photo courtesy of the Forbes Magazine Collection, New York)*

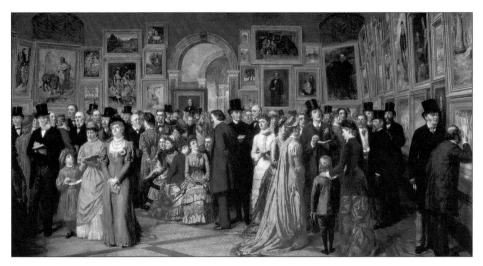

11. *A Private View at the Royal Academy.* Frith's purpose in painting this collection of Victorian celebrities was to attack Oscar Wilde and the follies of the aesthetic movement. *(Pope Family Trust/Bridgeman Art Library)*

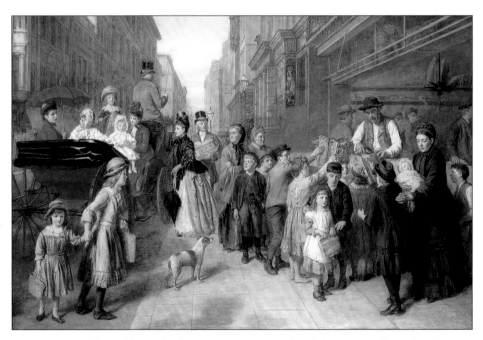

12. *Poverty and Wealth.* Frith's last attempt at a modern-life picture. Thereafter he confined himself to historical works, portraits, and copies of his previous works. *(Sotheby's, London)*

A single glance at Mr Flatow was enough to prove that a very energetic and astute individual stood before you – the Israelite strongly in evidence, and by no means a favourable type of that great race. The undisguisable feature, the mouth was, mercifully covered by a beard . . . I am always of opinion that the face is a sure index of character, but there are exceptions to every rule. . . .

Frith is here arguing against the practice of physiognomy, and pointing out its essential weakness, that there always are exceptions. Physiognomy never was, and never could be, a precise science. Frith also thought himself a shrewd judge of character, and had no reason to regret his confidence in Flatow, who proved to be an extraordinary salesman. The secret of his success, particularly with the engravings of *The Railway Station*, was that he 'performed with it himself', as he expressed it.

Flatow was taken ill in middle age, and became an invalid, at his house in Porchester Terrace, not far from Frith, who no doubt visited him there. Flatow was attended by his wife, and a former model of Frith's called Wall. Just before he died, he asked to be wheeled to the window. Seeing a workman passing, with his tools, he said, 'I'd give all I possess, and more if I had it, to change places with him.' He died a few days later.[14]

In 1867, the Frith family went on holiday once again to their beloved Ramsgate. Mrs Panton later wrote that it was one of their best-ever holidays: 'Here we were all in Royal Crescent, the Calderons and the Storeys, the Sotherns, the du Mauriers, and the Twisses, each with their overcrowding families of children. There were nine of us, four or five du Mauriers, four or five Calderons, four or five Twisses, but I was the most grown-up of all. . . .'[15] Later there were more arrivals: 'Then the Shirley Brooks came, and more laughter, while we made the acquaintance of sundry of the Ramsgate folk, notably the Pugins. He was living with his mother in what I thought was a hideous house, with painful and hideous furniture too, demonstrating what was supposed to be a Gothic revival, which I am truly thankful to say never took on; she handsome, elderly, severe, always much afraid of any girl who might want to catch her "Augustine" and scornful to a degree to any one the least bit under forty-five.' This seems to refer to the famous gothic architect, A.W.N. Pugin, who died in 1852; perhaps Mrs Panton was recalling an earlier visit.[16]

Mrs Panton tells another story about Sir Francis Burnand, later to be editor of *Punch*: Burnand arrived for lunch, and Mrs Panton's young

sister Louey (May Louise, born in 1851) was sent to escort him up the cliff: 'She was then just eighteen, and I think one of the daintiest and prettiest little creatures I ever saw. At the same time she had a most consequential air, which made up, in her mind at all events, for her lack of inches. She duly met Mr Burnand, and they were walking home, my sister instructing him on all the beauties of the place, when, waving a hand towards the town, she said grandly, "That is Ramsgate proper, Mr Burnand." "Indeed," he replied, "and which is Ramsgate improper?" But Louey was too shocked to reply, and she told us the story as a proof of how rude men could be when they liked.'[17]

Mrs Panton's description gives a wonderful picture of the Frith family together on holiday, enjoying themselves, and functioning as a typical, middle-class Victorian family; this is not a picture one ever finds in Frith's own *Autobiography*. He seemed to think family life was too trivial to mention.

For the rest of the 1860s, Frith contented himself with turning out yet more historical pictures. He went back to his old eighteenth-century favourites – Boswell, Sterne and Goldsmith – with occasional forays into Shakespeare, and a few historical heroines, Nell Gwynne, Amy Robsart, and Gabrielle d'Estrées. In his memoirs, Frith mentions *Before Dinner in Boswell's Lodgings*, exhibited at the RA in 1868. He modelled the figure of Dr Johnson from a bust by Joseph Nollekens. For the figure of Garrick, he had to thank his bank manager, a Mr Cundall of the London and Westminster Bank, who found a customer with an extraordinary resemblance to Garrick. It turned out that the customer was actually descended from Garrick: he was his great-nephew. Frith's friends told him the picture was unsaleable, because it contained too many men, and no pretty females, except a maid. Mr Agnew, who bought the picture for £1,200, said, 'It is a capital picture . . . but we shall have to keep it, Frith.' Agnew's prophecy proved incorrect; the picture was bought by Sam Mendel (1814–84) one of the biggest collectors in Manchester.[18] Frith wrote proudly that at the Mendel sale at Christie's in 1875, which lasted twenty-one days, his Boswell picture sold for 'four thousand five hundred and sixty-seven pounds ten shillings, being the largest price that had been paid for the work of a living artist at that time'.[19] So Frith's star was still in the ascendant.

In 1868 Frith also exhibited a portrait of one of his actor friends, Henry Sothern, who had been with them in Ramsgate in 1866. He told Frith how he had created the celebrated character of Lord Dundreary,

Sterne's *Maria*, 1868. The goat butted Frith, his easel and its keeper, and had to be held down. *(Photo: Sotheby's, London)*

who was a very minor character in a play entitled *The American Cousin*, first produced in New York. Disgusted with so small a part, Sothern deliberately overdressed and overacted the role of an upper-class fool; to his astonishment, it was a huge hit, and Dundreary became the star of the play. For many years after, Dundreary whiskers and his affected upper-class drawl became all the rage in society.[20]

One of Frith's RA pictures of 1868 was of Sterne's *Maria*, a pretty girl with a goat. Frith records that he had tremendous trouble with the goat, which butted him, his easel, and its keeper, and had to be held down with the help of one of Frith's sons. The model for *Maria*, a pretty, refined girl, was married to a brute who beat her. She tried to escape from him, but he pursued her to Frith's studio, and demanded money. Even after they separated, the husband continued to demand a share of her income, as a Victorian husband was quite entitled to do. The *Maria* model then disappeared from Frith's life, but later he saw her in a carriage with several children, and assumed her story must have ended happily.

Frith's only return to modern life was a pair of pictures he exhibited in 1869, entitled *Hope* and *Fear*. One represented a young man nervously asking a father for his daughter's hand in marriage; the other picture showed the mother and daughter anxiously awaiting the outcome. Frith did not think they were particularly successful – 'the subject was considered to belong to the "namby-pamby" school', he wrote,[21] but they found a buyer. Pairs of 'before and after' pictures were popular with Victorian painters of modern life. Frith's great friend Henry Nelson O'Neil had great success with his two about the Indian Mutiny, *Eastward Ho!* (Proby Collection, Elton Hall, Peterborough) and *Home Again* (one version is in the National Maritime Museum, Greenwich) of 1857 and 1859. Abraham Solomon had had similar success with his courtroom dramas *Waiting for the Verdict* and *The Acquittal* (both now in the Tate Gallery), also exhibited in 1857 and 1859. The search for subjects was a constant trial for Frith. He wrote in his diary at about this time, 'Try to do better; get newer subjects – all depends on subject.'[22] In 1869, he set off to the Continent, in search of a new, modern-life subject. His destination was Homburg, and the subject was to be gambling.

THIRTEEN

The Search for Subjects
1870–5

Two things the Victorians feared were drink and gambling. Drink was the curse of the working classes, but gambling could be the ruin of an upper-class family. Even one so grandly aristocratic as Plantagenet Palliser, in Trollope's novel *Can You Forgive Her?* (1864), was furious when he found that his wife, Lady Glencora, had been gambling during their stay at Baden. 'Is it nothing,' he fumed, 'that I find my wife playing at a common gambling table, surrounded by all that is wretched and vile – established there, seated, with heaps of gold beside her?' Gambling had already been the subject of at least two narrative pictures; one was Robert Braithwaite Martineau's *The Last Day in the Old Home* of 1861 (Tate Gallery), the other Alfred Elmore's enigmatic *On the Brink* of 1865 (Fitzwilliam Museum).[1] During the late 1860s, Frith was thinking about a modern-life picture to do with gambling. In 1869 he decided to visit Homburg, in Germany, with his friend Henry Nelson O'Neil, in search of inspiration. At that time Homburg was a fashionable spa and gambling resort, later to be superseded by Monte Carlo. In a letter to his sister-in-law, Frith described his reactions on seeing the gambling in progress:

My first sight of the clustering crowd round the tables shocked me exceedingly. Instead of the noisy, eager gamblers I expected to see, I found a quiet, business-like, unimpressionable set of people trying to get money without working for it. . . . Quite time, I thought, that a stop should be put to this, and a stop has been put to it.[2]

In spite of his moral indignation, Frith knew a good subject when he saw one. The picture was large, over 8 feet long, and full of figures. Entitled *The Salon d'Or, Homburg*, it was completed by 1871, and exhibited at the RA in that year. Once again, to Frith's immense

The Salon d'Or, Homburg. Frith included himself and his wife standing in front of the window. They visited Homburg in 1869. Although the Victorians abhorred gambling, Frith knew it was a good subject. *(Museum of Art, Rhode Island School of Design, USA)*

gratification, the picture was hugely popular and had to be protected by the inevitable rail, to keep the public at bay.[3]

Once again, Frith made use of photography, this time to record the gaming room. He also borrowed a croupier's equipment, and one of the chairs, which he brought back to London. The whole atmosphere of the gambling room is rather staid, and businesslike, just as Frith himself had described it. So he tried to enliven the scene with a few incidents. In particular, a couple in the left foreground: the bearded man turns round to talk to a lady, who appears to be giving him some bank notes. In the sketch, the man seems to be smiling, and giving the money to the lady, rather than receiving it. The critics were divided on the matter, but in his book Frith wrote that the man was giving the lady some of his winnings. In the centre foreground stands a woman, looking worried; perhaps she has lost money, or her husband is one of the gamblers. On the far side of the table, in front of the window, Frith has included himself and his wife, looking suitably disapproving.

The critics mostly praised the picture, but deplored the choice of subject. Most censorious was the *Saturday Review*: 'Seldom has an artist succeeded in packing into equal space so much villany [*sic*], never before have so many adventurers met within the four sides of a gold frame . . . the faces are wasted by every conceivable vice. . . .'[4] Evidently this reviewer was not familiar with the work of Hogarth. *The Times* reviewer clearly was, and warned those who might find Frith's gambling saga too sensational, 'Let us not forget the force with which Hogarth's Election series, or the *March to Finchley* [Sir John Soane Museum] . . . might be quoted against the charge.' The same reviewer praised Frith's picture highly, also observing, 'There is no duller and more decorous crowd . . . than that round the Board of Green Cloth in the great German Hells. But all must agree that the intention of this picture is thoroughly wrought out; that its workmanship shows the utmost care and conscientiousness; that its types and expression are well-chosen and ripely considered, and its draperies and dresses thoroughly studied and most dextrously carried out.'[5] In other words, Frith had made the scene dull and decorous, as it was in real life. The *Illustrated London News* also took the moral line: 'He tells his sordid and pitiful gambling story with a point and precision and sagacity of observation not surpassed in any previous work. . . .'[6] The *Art Journal* agreed: 'Indeed for brilliant handling, for a sharp and spicy mode of telling a story, for clever cut-throat character, for costumes the admiration of milliners, for realism in

the way of gold chains, diamonds and other precious stones, this picture has never been surpassed.'[7] *The Athenaeum* was more cautious: 'Mr Frith cannot be said to have improved in painting, but he shows a partial recovery of dramatic power by means of *The Salon d'Or, Homburg*.'[8] All the critics agreed that, good or bad, the subject was one calculated to attract a Victorian audience. As so often was the case, the Victorians disapproved of sin, but they did want to know what it looked like.

While in Homburg, Frith painted one other small picture that was to cause an even greater sensation. Frith tells the story in his memoirs: 'It was not very uncommon to see ladies sitting among the orange trees smoking cigarettes. I was attracted to one – a very pretty one – whose efforts to light her cigarette being unavailing called to a waiter for a light. A candle was brought, and as the fair smoker stooped to it she presented such a pretty figure, and altogether so paintable an appearance, that I could not resist a momentary sketch, afterwards elaborated into a small picture.'[9] The result, entitled *At Homburg* (Plate 9), Frith exhibited at the RA in 1870, the year before *The Salon d'Or* was completed. Innocuous though the picture might seem today, it caused a storm of protest in 1870. For a lady to smoke a cigarette – in public – meant that she must be a very fast, probably *déclassée* lady, and it was certainly not thought a suitable subject for a painting. Most critics concentrated on praising Frith's main exhibit of the year, *Sir Roger de Coverley and the Perverse Widow*, especially her black dress. The young lady smoking was either ignored, or dismissed, as by *The Athenaeum*: 'not remarkable for elevated motive'.[10] *The Times* commented: '. . . a Russian princess from life, and very fast life too, lighting her cigarette in the gardens of the Kur-Saal at Homburg'.[11] To the mid-Victorian mind, a fast woman who smoked had to be Russian.

Frith wrote ruefully in his memoirs, 'I think Hogarth would have made a picture of such an incident, with the addition, perhaps, of matter unpresentable to the present age. It might have adorned our National Gallery, whilst I was mercilessly attacked for painting such a subject at all. I know very well that if I or any other painter dared to introduce certain incidents (such as bristle over Hogarth's works), into our pictures, they would have no chance of shocking the public that admires the Hogarths on the walls in Trafalgar Square, for the council of the Royal Academy would prevent any such catastrophe.'[12] Frith always admired Hogarth, and consciously endeavoured to emulate him.

Many of Frith's contemporaries felt the same, but they also knew that Hogarth was too strong meat for a Victorian audience. Hogarth had to be Victorianised, made acceptable to the Victorian middle classes. Frith spent much of his career doing just that.

But modern-life pictures were now for Frith only a small part of his output. Throughout the 1870s, he was to continue painting his usual historical and literary subjects, based on Sterne, Molière, Pope and incidents from English history, especially the Tudor and Stuart periods. One of the more successful of these was *Henry VIII and Anne Boleyn Deer Shooting in Windsor Forest*, shown at the RA in 1872. The subject was suggested by a passage in Froude's *History of England*. Frith portrayed the royal couple deep in the forest, waiting for the deer to be driven past them. Anne Boleyn holds a crossbow, while the King holds back a branch, and, as Frith wrote later, 'looks down at the head that soon after followed suit amongst the falling heads of that fearful time'.[13] For a likeness of Anne Boleyn he used a portrait of her by Holbein. Sir William Hardman, Chairman of the Court of Quarter Sessions, who bore an extraordinary resemblance to him, modelled the King. The two figures were dressed in green, which made it difficult to differentiate them from the landscape. Frith wrote, with deliberate irony, 'and if I did not succeed in producing what in the slang of today is called a "harmony in green" I made a nearer approach to an agreeable arrangement than many of the inexplicable nocturnes and symphonies that are too often presented to us now'.[14] This was a clear dig at Whistler, whose *Nocturnes* exhibited at the Grosvenor Gallery in 1877 led to the celebrated *Whistler* v. *Ruskin* trial, at which Frith was to testify in support of Ruskin.

Another writer Frith enjoyed was Vanbrugh, especially his play *The Relapse*. He used this as a subject for another of his 1872 exhibits, *Lord Foppington describes his Daily Life*. Frith wrote that, 'The satins and brocades, the wigs and swords of Queen Anne's time afford seductive material for the painter, and I think I took full advantage of them. . . .'[15] At his best, Frith was brilliantly good at depicting rich materials, something often mentioned by the critics, although his 1872 pictures were mostly ignored, or passed over dismissively.

Summer holidays for the Frith family that year were spent at Boulogne, on the French coast. This was to result in several pictures, the main one inspired by an annual procession that took place in the town, in honour of the Virgin, patroness of Boulogne. As Frith described it:

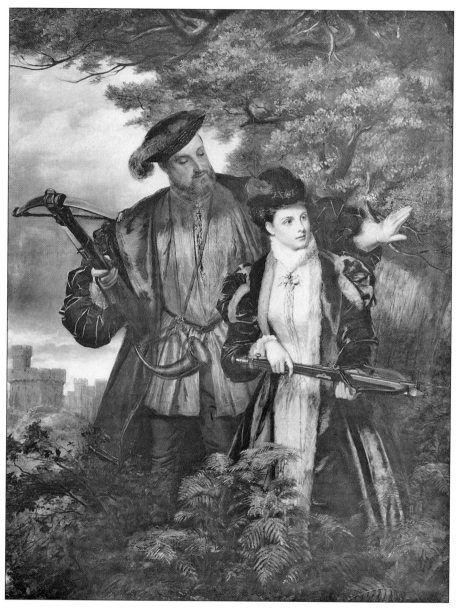

Henry VIII and Anne Boleyn Deer Shooting in Windsor Forest, 1872. Frith described it later as 'Harmony in Green', a deliberate dig at Whistler and the aesthetic movement. *(Private Collection)*

The Bishop, with attending priests, numberless banners, living representatives of Scriptural personages, wooden copies of holy things, and every variety of Catholic ritual, together with crowds of votaries in long procession parade the town; and as they go, women bring their

children, well or ailing, to be blessed by the chief priest. The scene was brilliant in colour and picturesque in every sense of the word . . . I made many sketches, and the longer I thought of the subject, the stronger became my determination to paint a picture of it.[16]

This was not to be finished for the Royal Academy until 1874. The bishop's mitre and vestments were borrowed from Cardinal Manning. In painting such a subject, Frith was following in the footsteps of his friend John Phillip, and many others who specialised in painting picturesque scenes in different parts of Europe. Peasant costumes and customs still survived in most countries of Europe, and they made charming subjects. They were not so much modern-life pictures as 'tourist life' pictures. *The Athenaeum*, generally very critical of Frith, was dismissive: 'Mr Frith sends a large picture, with a by no means interesting subject, the point of which either as to its humour or seriousness, we fail to see.'[17] The *Saturday Review* noticed a sign outside a shop in the picture reading 'Priez pour l'Angleterre', and commented, 'The picture were it seen in the Paris Salon could not fail to move artists to a like merciful petition.'[18]

Another subject suggested by the Boulogne holiday was inspired by the girls who came to the window of their lodgings selling fruit. 'They were dressed in effective costumes, with the high-frilled cap common to their species, and had bright pretty faces. As they stood in the street resting their baskets on the windowsill – the open window forming a frame – they made 'quite a picture'. Frith wrote, 'I bought many peaches and grapes, and the girls' dresses and caps also; and judging from the many demands I received for the picture, and the compliments paid me upon it, I think I may consider it one of my best.'[19] The combination of a pretty girl and a pretty costume was always irresistible to the Victorians; these pictures fulfilled the same function that holiday brochures do now.

Frith also made a brief trip to Paris, where the Franco-Prussian War and the Commune Rising had just ended. He found the city devastated, and the Tuileries ruined. Like the John Bull Yorkshireman he was, Frith felt thankful to be English, and spared the horrors of revolutions. He agreed with his friend Douglas Jerrold that 'the liberty of England was preserved in brine – the brine being the English Channel'.[20]

Back in London, Frith resumed his endless search for good subjects. Like a film director looking for a good script, Frith found it incredibly

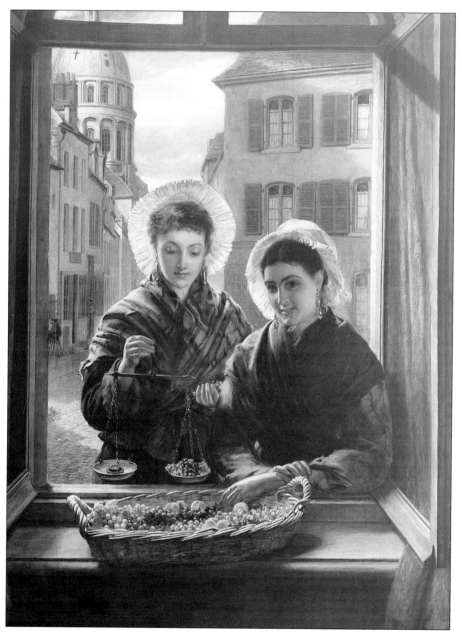

At my Window, Boulogne, 1872. Frith was on holiday in Boulogne with his family in 1871, and was inspired to paint the picture by the pretty fruit-sellers who came to his window to sell their wares. *(Private Collection)*

difficult to find the right modern-life subject, so much so that he was forced to advertise and even offer a reward. He received many suggestions including a Review in Hyde Park, the University Boat Race, The Eton and Harrow Cricket Match, and the Trial of the Tichborne Claimant. William Whiteley, owner of the famous Whiteley's Universal Stores in nearby Westbourne Grove, wrote to Frith suggesting 'Whiteley's at Four O'clock in the Afternoon'. Frith called on Whiteley at his store, and they had a long and friendly talk, but nothing came of it.[21] The writer who suggested the Boat Race enclosed a lengthy description of the proposed picture, complete with suggestions for figures and groups, including 'Nigger with wooden leg . . . Dog, evidently lost . . . two sweeps . . . an old lady in bathchair . . . a young swell smoking a beautifully coloured meershaum pipe . . . an old gentleman . . . who has been robbed of his watch, etc. etc.' Frith quoted large parts of the letter in his book, but wrote, 'I have never been able to adopt one of the innumerable proposals made to me.'[22] One of the reasons that Frith turned down so many of these subjects is that they had already been treated by the illustrators, and had featured in magazines such as the *Illustrated London News*.

Rejecting all these subjects, Frith invented one of his own, which he entitled *English Archers, Nineteenth Century*. It is one of Frith's most charming pictures, intended by him to be an exact record of what ladies wore for archery in the nineteenth century. The models were those of his daughters, Alice (probably the main figure drawing her bow), Fanny and Louise. Fanny and Louise both became artists, and never married. Alice married a distinguished doctor, Sir George Hastings, and it was she and her family who inherited the picture, which is now in Exeter Art Gallery. From the waist of the right-hand sister hangs a large tassel for cleaning arrows, a greasebox (containing beeswax and lard into which the gloved fingers were dipped), two ornamental acorns, and an ivory pencil, probably for scoring. Archery and croquet were the two great mid-Victorian social games until tennis eclipsed them. Both provided opportunities for flirtation and romance. 'Who can deny that bows and arrows are among the prettiest weapons in the world for feminine forms to play with?' wrote George Eliot in *Daniel Deronda*. In the novel the pretty Gwendolyn first catches the attention of Grandcourt at an archery contest. Frith's is probably the best Victorian picture to record the archery craze. Frith exhibited it at the RA in 1873, along with another of ladies playing billiards. *The Athenaeum*, as usual,

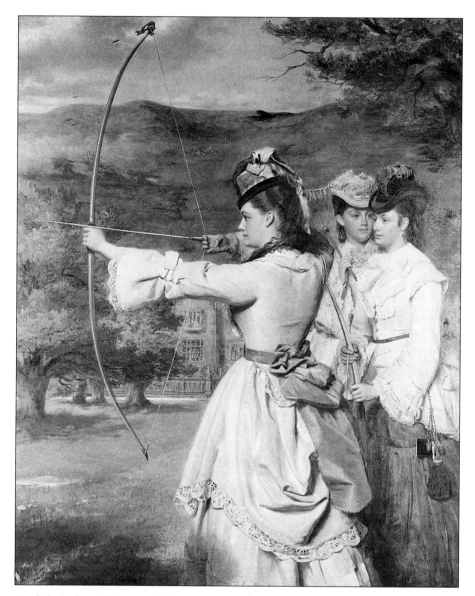

English Archers, Nineteenth Century, 1872. These are three of Frith's daughters, Alice, Fanny and Louise. Archery was a highly popular country-house sport in mid-Victorian times, and offered opportunities for flirtation. *(Exeter Art Gallery)*

was critical: 'Of *English Archers* we would rather say no more than it represents "toxophilites not fair to see" . . . the flesh, as before, needs clearness, unless, indeed, Mr Frith intended to moralise upon the effects of a London season on girls' complexions, and to insist on archery as a corrective.'[23] The *Art Journal* was more complimentary, and praised the

'show of grace in those engaged in the recreation . . .'.[24] *The Times*, more jocularly, described the lady archers as 'formidable scholars of that great bow-boy Cupid'.[25]

The mid-1870s was still an immensely busy and productive time for Frith. Mrs Panton considered that Frith's career reached its peak about 1875, although he was still to live another thirty years. In 1875 he used, for the one and only time, his privilege as an Academician to exhibit eight pictures at the RA. Frith himself admitted that it was an unfair advantage, and wrote, 'it requires the genius of a Reynolds or a Gainsborough to produce eight works in one year that shall be, one and all, worthy of public scrutiny'. *The Athenaeum*, as usual, was sarcastic: 'Examples of self-sacrifice are rare . . . as rare among "hangers" as among other men. To Mr Frith, we are indebted for eight pictures, all on the line, and we trust, in good light.'[26] Frith also admitted that of his eight pictures, 'those worthy of being seen might certainly have been counted on the fingers of one hand . . .'.[27] They were mostly simply pictures of pretty girls, usually in period costume, such as *La Belle Gabrielle* or scenes from *Tom Jones*. They were pot-boilers, but they sold readily, and he no doubt needed the money to support his two households, and staggering total of seventeen surviving children (two others had died young). He had also decided, in 1875, to go on a proper tour of Europe, and make his first visit to Italy.

FOURTEEN

The Grand Tour
1875

For Frith, his tour of the art and architecture of Italy was clearly an attempt to complete, belatedly, his artistic education. Together with his wife and two of his daughters, Frith set off for the Continent, first to Paris, then down to Marseilles and Nice. Like most Victorian travellers of his time, Frith had a healthy distrust of Johnny Foreigner, combined with a firm belief that everything British was best. He admired the port at Marseilles, and its polyglot community, but could not find one pretty flower girl to paint. In Nice, they stayed at a fine hotel overlooking the sea, and went to call on their friend Gambart at his palatial villa, Les Palmiers. Frith described their visit in a letter to his sister-in-law Vicky, with whom he was always on very close terms:

> I must not quit Nice without an effort to give you an idea of the house in which my old friend Gambart is passing, if not the evening, the afternoon of a prosperous life. . . . It is a long, two storied building of purest white marble, with statues on the top relieved against the sky, exquisite in proportion and in taste, outside and in. The rooms lofty and light, filled, but not overcrowded, with pictures, sculptures, china and the rest of it. Baron Gudin, the marine painter, was there; he gave me a very high flown and eulogistic reception, and showed unmistakable symptoms of an intention of kissing me. I am glad he didn't proceed to that dreadful extremity, for I must have submitted. Neither my pen nor my pencil could do justice to Gambart's palace. He has groves of olive trees, miles of palm walks . . . masses of orange trees . . . and every variety of flowers in almost tropical luxuriance.

Typically, Frith thought the two-a-penny oranges in London were better than Gambart's.[1] By this time, Gambart was spending his winters

in Nice, and the rest of the year in Paris, London, and Spa in Belgium.[2] From Nice they followed the coast, first to Monaco, where Frith admired 'its delicious gardens overhanging the sea, lovely beyond description! The place is heaven, with a hell in the midst of it.' He was referring, inevitably, to the gambling rooms: 'Homburg in little, *Rouge et Noir* on its last legs – black legs – a very languid affair compared to what I remember it in Germany, the rooms small and tawdry compared with the Salon d'Or.' Frith confidently predicted that the gambling rooms would be shut down, a prediction that has of course not come true. As to 'his Altitude the Prince of that little country', Frith's comments were scathing: 'The existence of this monarch, with his little kingdom and his little army – the whole affair a kind of doll's house! And then the wee soldiers – tawdry with blue and gold . . . marching about like bantams and keeping sentry over nothing at all – are supremely ridiculous, and would be passed with a shrug and a smile if they did not assist to keep up what is a scandal to Europe. Bismarck is wanted.'[3]

From Monaco they went on to Menton and San Remo, along the famous 'Cornice [*sic*] Road – no pen nor tongue can give an idea of the beauty of it,' wrote Frith, who described ecstatically the panoramic views in another letter. Frith found it difficult to get his wife and daughters to take an interest in the scenery: 'I could only get a languid look up from Miss Braddon or Wilkie Collins. . . .' Both these two novelists were friends of Frith, and he painted Miss Braddon's portrait.

From San Remo, they took the train to Genoa, where they stayed only one night, but Frith packed in a good deal of sightseeing. He lamented that 'the palaces where the Dorias, the Balbis, and the Spinolas lived and plotted are cafes or photographic establishments. So, instead of love murmurs, or the interchange of a look or a rapid word that devoted a rival to perdition, you have the rattle of billiard balls and the smell of collodion.' In some of the palaces, he was still able to admire portraits by Van Dyck, 'as fine or finer, than any I have seen, together with Italian and Spanish pictures of great beauty' hanging in rooms with 'decorations unlike anything you ever saw'. He also visited the local Academy of Arts in which two or three melancholy students were drawing: '. . . a dismal business. The place was filled with bad pictures of the modern Italian school.'

Rain and cold weather deterred them from seeing more of Genoa, so they pressed on to Pisa, taking the train along the coast. 'The railway

journeys are lovely, so far – that from Genoa to Pisa surpassing everything. The Gulf of Spezia where Shelley was drowned, the Carrara marble mountains, and the whole route, form a variety of pictures never to be forgotten.' In Pisa they admired the Campo Santo, and the Leaning Tower – 'alone, silent, but how eloquent'. They enjoyed Pisa, but found no pictures of interest. Frith was shown the Palazzo Ugolino, and the present count of that name, who he described as 'a small good looking dandy, with a little black moustache . . . his cloak thrown over his shoulder in the assassin fashion common in these parts'. Frith thought his manner ridiculously theatrical, as if he had 'either just committed a murder behind the scenes or is on his way to do it'.

After the comforts of Genoa and Pisa, Siena was a severe disappointment. In the same letter Frith wrote, 'Great Heaven! What a place to stop at!' The dirt and discomfort were a shock. But they could not leave, as there were few trains to take them on to Rome. Their landlord, who looked like a brigand, led them into 'a great, rambling, dirty sitting room, with chairs so hard that it was a positive relief to stand. And the bedrooms – mine looked as if forty murders had been committed in it! After a disturbed night, sleeping on straw mattresses, and 'a dirty breakfast served by the dirty waiter, we sallied forth to the cathedral which repaid us to some extent for the discomfort we endured'. Of the Academy, Frith was dismissive of 'a large collection of what Flatow called the "Chamber of Horrors" pattern, not half so good as ours in the National Gallery, and some of it with little more pretension to be classed as real art than that of Japan or China'. Frith was to display more evidence of robust philistinism on his travels, but no doubt many Victorian Academicians would have said much the same. He did, however, admire a crucifix by Perugino and the celebrated frescoes by Pinturicchio in the cathedral library. They admired the town hall and the great piazza, but disliked the narrow, dirty streets, and were glad to leave. From there they went on, with relief, to one of their main destinations – Rome, still for most Englishmen the high point of any Grand Tour.

In Rome, Frith waxed lyrical about the remains of the ancient city, especially the Forum, still a place of pilgrimage for the classically educated Englishman. The Coliseum naturally caused a shudder: 'It must be a dull imagination indeed that does not repair the broken seats, replace the enormous awning, and see the row upon row of passionate eyes watching the struggle of the gladiators, or enjoying with brutal

pleasure the sufferings of the Christians. But he also remarked that 'the Christians have much the best of it now . . . !' so many beautiful churches were there in Rome.

In the same letter Frith wrote, 'I think I may safely assert that there are more bad pictures in Rome than in any city in the world. The good pictures may be counted on your ten fingers, always excepting the works of Raphael and Michael Angelo.' This is not as philistine as it sounds; many Victorians would have agreed. Among his top ten were Titian's *Sacred and Profane Love* (Galleria Villa Borghese, Rome), 'perhaps the finest picture in the world', *Pope Innocent X* (Palazzo Doria Pamphili, Rome) by Velasquez and *Danae* (Galleria Villa Borghese) by Correggio, choices which most people could agree with today. Frith spent two hours alone with the works of Raphael and Michelangelo in the Vatican, and concluded that 'the two men were superhuman, unrivalled, and forever unapproachable'. He concluded that only their sincere belief in God and the Bible made such great art possible, 'notwithstanding their god-gifted genius'. Once again, his letters reveal him to have been a man of surprising sensitivity, knowledge and taste, combined with a streak of dogged British philistinism. As usual, he makes virtually no mention of his fellow travellers, his wife and two daughters. For a man with so many children, he seems to have had little or no family feelings. If he did, he kept them to himself, and did not commit them to paper.

After Rome came Naples, which was something of a shock; nonetheless Frith wrote about it at equal length to Rome. Visitors to Naples today can still be shocked by the dirt, the smells, and the noise. Victorian travellers were even more offended: '. . . of all the dirty places and dirty people I ever saw,' wrote Frith, 'the like of those we passed through on our way to the hotel surpassed all previous experience'. But the famous bay was 'ample compensation.' Interestingly, Frith compared the slums of Naples to 'the worst parts of Ramsgate, Folkestone, or Hastings'. He was also much disappointed by the Neapolitans too: 'I had imagined the lazzaroni of Naples with red caps, faded velvet jackets of every shade of colour, naked legs and thighs, mending nets, chatting to dark eyed beauties . . . instead of which they are drab, shabby, dirty creatures, ugly and revolting in every way.' Nonetheless, Frith painted one picture, of a Neapolitan flower girl putting a posy in his buttonhole; it was one of the very few pictures to result from his travels.

The highlight of the Naples visit was a day trip to Pompeii and Herculaneum, although the long drive was 'filth and beggars all the way'. At first, Pompeii looked unpromising, but as a reader of Bulwer Lytton's *Last Days of Pompeii*, Frith was quickly fascinated, especially by the amphitheatre. They were amused by their French courier, and his comical English accent: while looking round Pompeii he rushed up excitedly to Frith and announced, 'Mosseu, on a trouvay oone cadavre.' Excavations were in progress, and Frith was able to watch the preserved body of a woman and her children being excavated before his eyes. He marvelled at his good fortune, to be able to see a body that had been 'concealed under the fatal ashes for eighteen centuries'. Like anyone who visits Pompeii, Frith was astonished by the houses and their interiors, many of them with food, plates, and implements still sitting on the table, as if the occupants had just left.

From Naples, they made an excursion down the coast, and had an alfresco lunch looking over the sea to Capri in the distance. Frith felt it was all highly theatrical; even the albergo 'had been uncommonly well imitated on the stage. The landlord and landlady bustled about, just as they do at a theatre. I felt I was acting a part, and had only come on to the terrace from the side scenes.' After lunch, the landlord laid on a performance of the tarantella, a subject much beloved of Victorian painters, in particular Thomas Uwins (1782–1857), an RA who had made a particular speciality of it. Frith hugely enjoyed the performance: 'It was delightful to watch the supple, stayless figures performing the national dance as if they enjoyed it to the full.'

After Naples, they headed back to Rome, then on to Florence, calling at Perugia and Assisi on the way. Perugia they enjoyed, and Frith delighted in the beauty of the Umbrian landscape. He was not so delighted by Umbrian painters, or the early Italians: 'As to Messieurs Cimabue, Giotto, and even Perugino, I fear I must confess I am sick of them . . . in fact these pictures are curiosities, and not works of art at all in the true sense of the term.' Even so, Frith wrote at length describing the famous frescoes by Giotto of the life of St Francis in the cathedral at Assisi.

In Florence, he was more impressed by the Uffizi, admiring the Raphaels, Titians, and Botticellis, but not the *Venus de Medici*. He thought the *Venus de Milo* far superior. After a brief stay, they pressed on to Venice, to the Hotel Danieli. Like many Englishmen before and since, Frith was smitten by Venice: 'Infinitely beyond all I could have

The Neapolitan Flower Girl, 1902, one of the very few pictures to result from Frith's Grand Tour. This particular version was produced more than 25 years after his trip to Europe. *(Private Collection)*

conceived of it in exquisite beauty.' He was very conscious of Venice's history: 'To those who have never seen Venice it is impossible to impart the sensation with which one finds one's self standing on the marble steps from whence the head of Marino Faliero rolled from his

shoulders. . . . I have walked on the Rialto, where Shylock was taunted by Antonio. I have stood in front of the empty seats of the Council of Ten, on the spot from which Othello addressed the "potent, grave and reverend signors". I have been on the Bridge of Sighs, and into the fearful prisons below them; have seen the exact spot where the headless bodies of the two Foscari were dropped into the secret water. . . .' The Princess of Prussia was staying at the Danieli too, and the Venetians laid on a water pageant for her, which the Friths greatly enjoyed, watching from their gondola. Turner had stayed nearby, at the Albergo Europa, on his last visit to Venice in 1833 and he painted many of his watercolours from its roof. Here again the Frith family was vastly amused by the pidgin English spoken by their Swiss guide, Gustav Zimmerman, whom Frith quoted at length in his letters.

At the Accademia, Frith admired the works of the great Venetian painters, especially Titian, Tintoretto and Veronese. Frith also made a trip by himself to Bologna, where he was not so taken with the Bolognese School. 'The brothers Carracci, with Guido and Guercino, were the most prominent members of the Bolognese school; indeed they were the founders of it, and an ugly school it is – coarse, big, exaggerated and black. Their works gave me little or no pleasure.' After sampling Bologna and its sausages, Frith returned to Venice, and to his family. From there they went on to Milan, and the Italian Lakes. Frith himself did little painting in Italy. One picture of the Doge's Palace was exhibited at the RA in the following year, 1876.

The Italian Lakes were a great favourite with the Victorians, and Frith was no exception. In his last letter from Italy, he extolled the beauties of the lakes, and the islands, Isola Bella, Pescatori, Isola Madre and others. Of Como, he wrote, 'enchantment prevails in this favoured spot. As to Maggiore, where we are now it is the realisation of a poet's dream. . . .' This was the end of their great tour, and Frith writes nothing of the journey home, except to mention briefly Turin and Paris, and a Salon Exhibition – 'and a sorry sight it was'.

FIFTEEN

The Road to Ruin
1876–8

Back in London, Frith finished the two pictures that resulted from his Grand Tour. One, the Neapolitan flower girl, he sold to an old Scottish friend who wanted a portrait of Frith in his collection. The other, which he entitled *Below the Doge's Palace, Venice, 1460*, shows a monk hearing confession from a beautiful Venetian woman who has been incarcerated in the dreaded prisons behind the Doge's Palace which had made a deep impression on Frith when he saw them.

Frith had trouble finding a suitable model for the monk. He applied to a London monastery, and was refused. Providentially, an old model called Bredman turned up out of the blue, and proved perfect for the part. Bredman's story, which Frith tells at length, is typical of his Dickensian relish for describing odd characters. Frith first used Bredman as a model when working on *Ramsgate Sands*. Aged about thirty, Bredman looked a typical Alfred Doolittle, in fustian jacket and much-patched trousers. He seemed a steady character, and religious. He read the Bible, having been recently converted at a chapel in Tottenham Court Road. He took a particular interest in Frith's children, and hoped very much that he and Mrs Bredman would soon be blessed with offspring. One dark and wet night, Bredman called at Frith's door, in apparent distress. Mrs Bredman, he said, had had a baby, somewhat earlier than expected, and they had no baby clothes. Frith and his wife obliged, giving Bredman some baby clothes, and a bottle of port to fortify his wife. On future visits, Bredman reported that the baby was fine, but that Mrs Bredman's health had taken a turn for the worse. More money and port wine were handed over. Frith had recommended Bredman to several other artist friends, including Egg, and he found out that Bredman had told them all about his wife and baby, and that more baby clothes, money and port had been given to him. Finally, Frith decided he must pay the Bredmans a visit. Finding his lodgings in a poor

quarter of Southwark, he rang the bell. The landlady informed him that Mr Bredman was not at home. When Frith enquired about Mrs Bredman, the landlady answered, 'He ain't married; there ain't no Mrs Bredman. He has lodged here two years and a half, and I am quite sure he is not married.' She also said he was a quiet and steady character, and very fond of playing with her children. At their next sitting, Frith was painting Bredman for one of the foreground figures in *Ramsgate Sands*, a man offering a lady a tombola prize which she does not want. Frith proceeded to enquire about Bredman's wife and child, and then confronted him with the truth, that he had no wife or child, and that he had been obtaining money and goods under false pretences. Bredman broke down, and confessed. 'I am an infernal rogue, ain't I?' Frith dismissed him, and his modelling career was at an end when the other artists found out what had happened. They agreed, however, to subscribe a sum of money sufficient to send him to Australia. There he found his way to the gold diggings, and wrote to Frith saying he was prospering, and also helping 'the good cause by the sale of religious works in a store at Ballarat'.[1]

And so, like a real-life Magwitch in Dickens's *Great Expectations*, Bredman reappeared twenty years later at Frith's studio, looking clean and smart in a shiny black suit. He was back in England to collect a legacy of £200. This time he really was married, with several children: 'My sons are in the Bush, doing well, all of 'em' (I trust not bush ranging, was Frith's immediate thought); 'my daughters married pretty middling too'. Bredman himself had been town crier of Melbourne, but now he was working as a steward on an Australian liner. He had always been a good model, so Frith promptly re-engaged him for his new series of five pictures, *The Road to Ruin*.[2] He also sat for the monk in the Venice picture, which went to the RA in 1876, with other pictures based on Molière, and yet again, *The Vicar of Wakefield*.

At about this time, Frith was asked to sit on a committee, formed to produce a public statue of the poet Byron. The other artists on the committee were the painter Alfred Elmore, and the sculptor Thomas Woolner who had been a member of the Pre-Raphaelite Brotherhood. It was Woolner's departure for Australia in 1852 that inspired Ford Madox Brown's *The Last of England* (Birmingham City Art Gallery). Woolner later returned to England, to become a well-known sculptor, and an RA. The committee met in the rooms of John Murray the publisher, in Albemarle Street. It was John Murray who had first been

Byron's publisher. For Frith the most interesting member of the committee was the aged Trelawney, who had been a friend of both Byron and Shelley. Millais was later to use Trelawney as a model for the main figure in his picture *The North West Passage* (1874) (Tate Gallery). Frith wrote bitterly about the committee's choice of sculptor. He and his fellow artists were outvoted by the non-professional members of the committee, who clearly thought they knew better.[3] The sculptor was, and still is, a little-known artist, Richard C. Belt. His statue of Byron with his dog stands in Park Lane, behind Apsley House and is now, with a certain poetic justice, Frith might think, marooned on a traffic island.

Shelley and Mary Godwin in St Pancras Churchyard, c. 1877. Frith was a great lover of Shelley's poetry, and knew the Shelley family, and Mary Godwin. For likenesses, he used two portraits in the Shelley family collection. *(Private Collection)*

Frith was a great admirer of Shelley, and friend of his son Sir Percy Shelley. He often visited the Shelleys' house at Boscombe, which was full of Shelley relics and memorabilia. At Boscombe he also met Grantley Berkeley, a descendant of the Berkeleys of Berkeley Castle, who also had an interesting historical collection. Frith's interest in history was genuine; he was an artist-antiquarian at heart. He also met Shelley's widow, Mary Godwin, at Royal Academy soirées. As a result of all this, and meeting Trelawney too, Frith decided to paint a picture of one of the trysts that took place in St Pancras Churchyard between the young Shelley and Mary Godwin. He found a suitably flat old tomb in the churchyard, and used it to place the two figures. For likenesses, he used two portraits at Boscombe, but he was not satisfied with the result.[4] The picture must have been a private commission, perhaps from the Shelleys, as Frith did not exhibit it at the RA.

In 1877, Frith did not exhibit anything at the RA, so busily engaged was he on his new series, *The Road to Ruin*. Amazingly, he also fails to mention in his *Autobiography* the one major artistic event of 1877, the opening of the Grosvenor Gallery. Housed in a handsome Italianate building in Bond Street, the Grosvenor Gallery was the brainchild of an aristocratic amateur, Sir Coutts Lindsay and his artistic wife Caroline, who was fortunately a Rothschild and whose money was to fund the project. The aim of the gallery was to provide a new and more sympathetic showcase for the very latest in modern art, both English and European. It was to become the headquarters of the newly emerging aesthetic movement, and this first exhibition, in May 1877, made Burne-Jones famous. It was also to enhance the careers of many other artists, including G.F. Watts, Albert Joseph Moore, Tissot and Whistler.[5] The first exhibition was also to lead to Ruskin's celebrated diatribe against Whistler, accusing him of 'cockney impudence . . . flinging a pot of paint in the public's face'. This was to result in the *Whistler* v. *Ruskin* libel trial of 1878, in which Frith was forced to appear, reluctantly, as a witness. Of all this, Frith makes absolutely no mention. It was clearly something he wanted to forget. He had never liked the Pre-Raphaelites (they are not even mentioned in his book), and he liked the aesthetic movement and French Impressionism even less. He was already a total reactionary.

Frith's *Road to Ruin* scenes were his first attempt at a Hogarthian *Rake's Progress*, set in Victorian times. In his *Autobiography*, Frith was careful to qualify his Hogarthian inspiration: 'Without any pretension

to do my work on Hogarthian lines, I thought I could show some of the evils of gambling; my idea being a kind of gambler's progress, avoiding the satirical vein of Hogarth, for which I knew myself to be unfitted.'[6] What Frith really meant by this was that he could not imitate Hogarth too closely, because if he did the Victorian public would be outraged. Instead, what Frith produced was a very Victorian homily on gambling.

For all the figures, he made careful chalk drawings: 'All the thinking part of the business was settled before the small oil-sketches were made,' he wrote.[7] The oil sketches, which survive in a private collection in England, reflect the final pictures almost exactly.

The first picture, entitled *College*, shows our well-born young hero at an all-night card party in his rooms in college. It is early morning; one young man blows out a candle, while another opens the curtain to see the dawn breaking. Another is asleep on a sofa. Empty champagne bottles lie on the floor. Frith visited an undergraduate's room at Cambridge to make studies for the setting; he also had photographs

The Road to Ruin 1878 – College. Frith greatly admired Hogarth, and intended this series to be a Victorian 'gambler's progress'. The first scene shows the well-born young hero at an all-night card party in his rooms at college. *(Private Collection)*

The Road to Ruin 1878 – Ascot. Frith was inspired to paint his Hogarthian series when he saw the royal enclosure at Ascot, outside which illegal betting took place. Here we see the raffishly dressed hero heading full speed for ruin. *(Private Collection)*

taken. The tower seen out of the window looks like the main gateway of Caius College, which was designed by Alfred Waterhouse.[8] The second scene, *Ascot*, shows our hero raffishly dressed, heading full speed for ruin in the enclosure at Ascot. He is standing on a platform by a fence, over which the touts and bookies are leaning in their eagerness to take his bets, which the young man writes down in his notebook. It was witnessing a similar scene at Ascot that first inspired Frith to paint the series. An older man, smartly dressed in a black shiny topper, tries to restrain the reckless gambler, but to no avail. Both the hero, and the other men around him, are clearly swells, with refined, aristocratic features, and fashionably smart clothes. The group of ladies on the right are also intended to represent aristocratic and upper-class ladies, obvious not only from their elegant and expensive dresses, but also from their calm demeanour and refined expressions. On the extreme right is a lady who looks like the gambler's wife. By contrast, the bookies to the left have coarser features, and a dark, bearded type looks

Jewish. They are all betraying obvious signs of eagerness, greed and excitement in their keenness to get a bet from such a reckless gambler. One of them is almost certainly Frith's pious model, Bredman.

In the third scene, *Arrest*, the gambler's debts have caught up with him; the bailiffs have arrived at his house to deliver a warrant. The gambler, languid and unconcerned, wearing a dressing-gown and smoking a cigar, leans on the mantelpiece and stares arrogantly at the dark-suited, swarthy, Jewish bailiff who holds out the warrant. The figure of the upper-class rake was a familiar character in Victorian society novels, such as the wicked Sir Francis Levison in Mrs Henry Wood's best-selling tear-jerker, *East Lynne*. To underline the point, at the gambler's feet lies a fashionable society newspaper of the day, *Bell's Life in London*. Behind the bailiff stands his nervous young assistant, clearly a clerk at about the same social level as Mr Pooter and his son Lupin, the main characters in George and Weedon Grossmith's later novel, *Diary of a Nobody*. Frith has made this obvious from his shabby

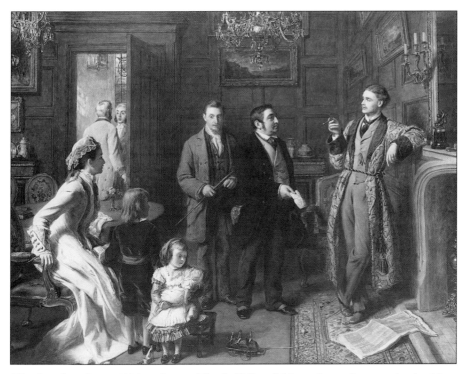

The Road to Ruin 1878 – Arrest. The bailiff and his assistant have arrived with a warrant in the gambler's house. The hero looks unconcerned in his dressing-gown. *(Private Collection)*

clothes and scarf, his thin face and nervous expression. He glances sympathetically at the mother, who rises from her chair in alarm to the left; her two children, a boy and a girl, are playing with their toys beside her. In the doorway two servants are discussing the affair in astonishment. Once again, Frith has demonstrated his skill in both physiognomy, and class distinction. The Victorian public would get the message; the critics, this time, made no mention of this, as mostly they concentrated on the moral lessons to be drawn. By this time, Frith was clearly the accepted master of modern-life painting. He could be relied on to get these details absolutely right.

In the fourth picture, *Struggles*, the scene has shifted to France, as we can guess from a crucifix hanging on the wall. The gambler sits at a table, like Hogarth's *Distressed Poet* (Birmingham City Art Gallery), trying to write a play. They are clearly in lodgings in France, perhaps in Calais or Boulogne, where English gamblers and bankrupts frequently took refuge, as indeed did Beau Brummel. The wife is trying to placate

The Road to Ruin 1878 – Struggles. The scene is France, where the gambler and his family are living in straitened circumstances. He is trying to recoup his fortunes by writing a play. *(Private Collection)*

The Road to Ruin 1878 – The End. Back in a garret in London, the ruined gambler is locking the door before shooting himself: the gun is on the table. *(Private Collection)*

the landlady, who stands at the door with a long bill in her hand. The wife has been trying to earn money by painting watercolours, as we can see from a table on the left. The boy tries to comfort his father, while the little girl sits warming her hands at the fire. Behind the door we see that another child has arrived: there is a baby in a cradle. Matters are clearly going from bad to worse.

For the last, grim scene, *The End*, Frith has moved the story back to London. We are in a shabby garret, and the ruined gambler is locking the door; behind him a loaded gun lies on a table. A letter on the floor reveals that the Theatre Royal, Drury Lane, has rejected his comedy, and the untidy squalor of the room testifies to the despair of his situation. The wicker cradle and broken toys remind us of the hardships that must now have come upon his wife and children, who have left him. Frith found the furniture in junk shops in a poor quarter of London.

As usual, Frith had trouble with models; in his autobiography he devotes considerably more space to this subject than to the *Road to Ruin* pictures themselves. One called Green modelled for numerous figures, but proved to be a drunk, in spite of his protestations that he

was a teetotaller and had taken the pledge. Frith dismissed him, with regret. Another model, called Gloster, gave himself airs and was over-familiar. He also complained that the lunch Frith provided was inadequate; when presented by the cook with a chop, he remarked that it was so small he needed spectacles to see it. Frith put up with his insolence, as he was a good model, and looked a gentleman, but in the end had to dismiss him too. For female models, he mostly used friends rather than professionals; they gave him no trouble, except for unpunctuality – 'a deadly sin'. Frith devoted a whole chapter to these model stories.[9] As to the pictures, Frith need not have worried. They attracted huge attention, and the policemen and rail were needed yet again – for the fourth time in his career. 'I received many compliments,' wrote Frith wearily, 'and no doubt much abuse.' Among the other highlights of the exhibition were Millais' *Princes in the Tower* and Frank Holl's great modern-life masterpiece, *Newgate – Committed for Trial*, both in Royal Holloway College, Egham, so Frith was not without competition.

The pictures were favourably received by the critics, except for his old adversary, *The Athenaeum*, whose editor, Frederick George Stephens, had been a painter in his youth and a member of the Pre-Raphaelite Brotherhood. While praising the moral purpose of the pictures, *The Athenaeum* critic thought 'Mr Frith's works are eminently wanting in freshness of idea; they are sensational without being impressive, and they are over-laboured in execution – particularly in the modern costume. . . .' He concluded by dismissing all Frith's modern-life works as '. . . a monument of misapplied labour'. This critic simply did not think modern-life pictures were worth painting; a common view among the high-minded.[10]

The *Art Journal*, still the most prestigious art magazine of the day, took a diametrically opposite view. For their writer, Frith was a genius of the age, whose works would always be remembered. He had just one cavil: 'What we object to most, however, is the inadequacy of the motive. A card party at college does not improve one's book learning, but it need not necessarily end in suicide. . . .'[11] This is certainly a view that would be shared by the modern viewer, but this is to misunderstand Victorian morality. Both the Bible and the Victorian novel taught the Victorian middle classes that sin was followed by retribution. In Dean Farrar's famous novel *Eric, or Little by Little*, the hapless Eric begins slipping into temptation while still at school. Bad language and

cribbing lead to lying and stealing; smoking, gambling and even drinking follow, and before long Eric is on the inevitable deathbed, with agonising pages of tears, confessions and forgiveness. In Victorian novels there is no sex, but there are plenty of deathbeds; now the opposite is the case. And did not the Victorians have a real life example of a feckless aristocrat – the young Marquess of Hastings, who ran through a huge fortune on the horses, and died of dissipation in 1868 at the age of only thirty-two?

The *Illustrated London News* took the same line as the *Art Journal*: 'Technically, Mr Frith has never done better work than is manifest in *The Road to Ruin*. The composition in all the five pictures of the series is varied, skilful and harmonious; the drawing unerringly correct, but easy and flowing; the colour singularly luminous and refined, and the execution of the multitudinous details simply wonderful in their minute truthfulness.' The reviewer praised the choice of subject, and expressed the pious hope that it might have some effect.[12] *The Times* took a similar view, and thought the success of the pictures 'must be judged by the effect of his painted drama on the hearts and minds of the crowds . . .'.[13] Even at this date, when the aesthetic movement was in full swing, preaching the gospel of art for art's sake, Victorian critics still expected pictures to impart the moral lessons. *Punch*, as might be expected, made a joke of the whole thing, observing that 'Even the policeman (Constable RA) who is placed there to keep the spectators moving, is deeply affected . . . ever and anon he turns away to wipe a manly tear. . . . He is a study in Blue.' With this swipe at Whistler and his *Nocturnes*, this critic clearly knew all about the aesthetic movement and the Grosvenor Gallery.[14]

Many critics also mentioned that the pictures were to be etched for the Art Union. Frith thought the etchings unsatisfactory, but large numbers were printed nonetheless. Nowadays, *The Road to Ruin* is only known through these prints, as the originals, which appeared on the London market in the 1960s, have for many years been in a private collection in Italy.

The success of *The Road to Ruin* series established Frith once again as the master of modern life. He had imitators, such as George Elgar Hicks and Arthur Boyd Houghton, but none could rival his extraordinary success in dominating his chosen field, and perpetuating it through worldwide sales of engravings. But Frith was by this time fifty-nine years old. Although a senior and respected RA, he was out of

touch, and out of sympathy, with new developments in the art world. He was a reactionary, and clearly identified with the establishment in the minds of younger artists. Nothing would make this clearer than his reluctant involvement in the most sensational event in the art world in 1878 – the *Whistler* v. *Ruskin* libel trial.

SIXTEEN

The Whistler v. Ruskin Trial
1878

The opening of the Grosvenor Gallery in 1877 was a glittering social event. On 9 May a banquet was held for over a hundred guests, including the Prince and Princess of Wales. It was fully reported in *The Times* the next day, with the guest list. Sir Coutts and Lady Lindsay wanted not only to make the Grosvenor Gallery a showcase for their latest modern art, they wanted it to be fashionable. In this, they certainly succeeded. For the first few years of its existence, it was the talk of the town. In the public mind, it was closely identified with the aesthetic movement, an image reinforced by a series of wonderful cartoons by George du Maurier in *Punch*, ridiculing the antics of the more extreme aesthetes. The most famous of these shows an aesthetic couple looking at their blue and white teapot, and wondering if they can live up to it. Oscar Wilde frequently wrote about the Grosvenor Gallery, and appeared there wearing a special suit designed as a cello. Later, Gilbert and Sullivan were to parody the whole aesthetic craze in their brilliant operetta *Patience*, in which the hero Bunthorne is described as 'a greenery-yallery Grosvenor Gallery, foot-in-the-grave young man'. But underneath all the fashionable flummery, the Grosvenor did have a serious purpose. During the fourteen years of its existence, from 1877 to 1890, it did an enormous amount to increase public interest in art. It forced the Victorian public to take art more seriously.[1]

Artists could only exhibit at the Grosvenor by invitation from Sir Coutts Lindsay and his wife. Although numerous Academicians, including Leighton and Millais, were to exhibit at the Grosvenor, Frith was not invited. Nor did he expect to be. He was not only a senior RA and known conservative, but his art, so sensational in the 1850s and '60s, was beginning to look out of date. Although he never mentions the Grosvenor in his memoirs, he was certainly known to disapprove of the

aesthetic movement, and the antics of its more extreme adherents. He was later to caricature them in his picture *A Private View at The Royal Academy* in 1883.

Among the most prominent and controversial artists at the Grosvenor was the American-born painter, James McNeill Whistler (1834–1903). Whistler spent his formative years as an artist in Paris, and only settled in London in 1859. His art was regarded with suspicion, as too avant-garde and too French. Whistler was not in fact a follower of French Impressionism; he evolved his own, very individual, decorative style compounded of classical and Japanese elements. Witty, combative, prickly and with a sharp tongue, Whistler was also constantly involved in controversy and personal quarrels. Just before the Grosvenor exhibition, he was finishing his decorations to the now notorious Peacock Room in the house of his patron, Frederick R. Leyland. As the full extent of these decorations had been carried out without Leyland's knowledge or approval, it led to a furious row, and a rift between Whistler and Leyland that was never to heal.[2] Later Whistler was to write a book entitled *The Gentle Art of Making Enemies* (1890). Animosity towards Whistler was to surface at the first Grosvenor exhibition, with devastating effect.

Whistler sent eight paintings to the first exhibition of 1877. One of Sir Coutts Lindsay's aims at the Grosvenor was to hang the pictures more sympathetically. The main artists' works were hung in groups, and more spaced out, so they could be better appreciated. This was in contrast to the floor-to-ceiling hanging at the Royal Academy, where the pictures were arranged in a seemingly haphazard fashion. Whistler's exhibits consisted of portraits, including his fine full-length of Thomas Carlyle, which he entitled *Arrangement in Grey and Black* (Musée d'Orsay, Paris), and night scenes on the Thames, which he called *Nocturnes*. These were some of Whistler's most controversial works; they looked dark, sketchy, and unfinished to the average Victorian viewer and to many of the critics too. It was one of these, *Nocturne in Black and Gold: The Falling Rocket* (Detroit Institute of Arts) that was to arouse the ire of Ruskin.

Press coverage of the first Grosvenor exhibition was extensive; all the leading writers and critics of the day rushed into print to record their views. The American novelist, Henry James, wrote a long and serious review, singling out, not Whistler, but Burne-Jones's pictures as 'by far the most interesting things in the Grosvenor Gallery'.[3] He described the

Grosvenor, as did many critics, as 'a palace of art . . . with many chambers, and that of which Mr Burne-Jones holds the key is a wondrous museum'. Of Whistler, Henry James was dismissive, saying of his 'Arrangements, Harmonies and Impressions . . . they do not amuse me.' In writing about Burne-Jones, James brilliantly defined and described what the aesthetic movement stood for: 'It is the art of culture, of reflection, of intellectual luxury, of aesthetic refinement, of people who look at the world and at life not directly, as it were, and in all its accidental reality, but in the reflection and ornamental portrait of it furnished by literature, by poetry, by history, by erudition.' One can see why Frith, the painter of 'accidental reality' had no sympathy with this new philosophy.

One art critic not present at the opening was John Ruskin, still revered as England's greatest writer on art. Ruskin was in Venice, working on a revised edition of *The Stones of Venice*. Although still Slade Professor at Oxford, and a writer on art, Ruskin had become increasingly involved with social problems. Following the breakdown of his marriage to Effie Gray, who left him and married the Pre-Raphaelite painter Millais, Ruskin became obsessed by a teenage girl, Rose La Touché, who he wanted to marry when she came of age. Under the strain of all this, Ruskin began to suffer the first signs of the mental illness that was to cloud his later years. It was not until June that Ruskin returned to London, and was able to review the Grosvenor, which he did in one of a series of published letters addressed to the 'workmen and labourers of Great Britain', which he entitled *Fors Clavigera*.[4] This curious publication, which one writer has likened to the Epistles of the New Testament, was mainly a vehicle for Ruskin's views on politics and society, but he also used it to write about art. It was full of lengthy and fervent passages of vituperative abuse, this time to focus on the paintings of Whistler.

Letter no. 79, entitled 'Life Guards of the New Life' was published in July. In it Ruskin reviewed both the Academy and the Grosvenor, where he too singled out Burne-Jones as 'simply the only art-work at present produced in England which will be received in the future as "Classic" in its kind'. Ruskin had already attacked Whistler in one of his Oxford lectures in 1873; now he was to renew his attack more forcibly and publicly. Of Whistler's works, he wrote the now celebrated diatribe:

For Mr Whistler's sake, no less than for the protection of the purchaser,
Sir Coutts Lindsay ought not to have admitted works with the gallery

in which the ill-educated conceit of the artist so nearly approached the aspect of wilful imposture. I have seen, and heard, much of cockney impudence before now; but never expected to hear a coxcomb ask two hundred guineas for flinging a pot of paint in the public's face.

Ruskin was later to admit that his pen had run away with him, and that his language had been intemperate. But thereafter he resolutely maintained that he had only written what he considered to be the truth, and that as a critic, he was justified in doing so. It was already too late – Whistler went to see his solicitor, James Anderson Rose, and on 8 August, Ruskin was served with a writ at Brantwood, his house on Coniston Water. Whistler was suing for libel, and demanding a thousand pounds in damages. Whistler was in financial straits, and there is no doubt his action was motivated by hope of financial gain, as well as anger and resentment against Ruskin. He also genuinely wanted to put his case before the British public, to explain his art and aesthetic philosophy. Over the winter, Ruskin's mental state worsened, and his doctors advised that he should not attend the trial. Nonetheless, legal matters moved ahead, and the trial was scheduled for November 1878.

The biggest difficulty for both sides was finding witnesses prepared to appear in court, and speak on their behalf. Whistler approached several artists who refused, including Charles Keene and Tissot, another Grosvenor Gallery exhibitor. Eventually William Michael Rossetti, Dante Gabriel's brother, agreed to appear, as did Albert Joseph Moore, the painter, and a very minor Irish artist called William Gorman Wills. Ruskin's side had even more of a problem. Burne-Jones, who disliked Whistler, and was greatly indebted to Ruskin for his praise and support, agreed with great reluctance to appear. Numerous distinguished RAs were approached, but all were understandably reluctant to testify against a fellow-artist. Finally Ruskin himself chose Frith, and asked his nephew Arthur Severn to approach him. Frith agreed to appear, not out of any high regard for Ruskin; Frith's contempt for the critics was equal to that of Whistler. But in the Ruskin camp, Frith would have been perceived as an independent witness, owing nothing to Ruskin. He proved to be a good choice. Ruskin's third choice was a well-known, but very conservative art critic, Tom Taylor. It was Taylor who had written the pamphlet for the exhibition of Frith's *The Railway Station*.

In the months leading up to the trial, both sides prepared their cases and engaged the legal counsel who were to represent them in court.

Ruskin's health improved, but he had already decided not to appear in court, and continued to hide behind his doctors. His solicitors, Walker Martineau, therefore retained the services of the Attorney General, Sir John Holker. A large and lumbering Lancastrian, 'sleepy Jack Holker' had certainly never seen a Whistler *Nocturne* or read Ruskin, but he had plenty of down-to-earth common sense, and was known to be good with juries. He proved to be an inspired choice. Whistler's barrister was Sir John Humffreys Parry, sergeant-at-law and therefore known as Sergeant Parry. He was also a leading barrister of the day, and had figured prominently in the trial of the Tichborne Claimant.

Frith was obviously a good choice to support Ruskin's case. He was a senior RA, fifty-nine years old, very well known to the public, a conservative, known to dislike French art in general, and that of Whistler, who, though American, had trained in Paris, in particular. Whistler's solicitor, Rose, thought he could discredit Frith by reference to the low-life elements in his pictures. By an extraordinary coincidence, Frith's main exhibit at the RA that summer was the *Road to Ruin* set, again to do with vice and gambling. From the legal notes that survive, it seems obvious that Rose also knew about Frith's domestic situation. He made a tantalising note, passed to his legal team, repeating a rumour that Frith had himself led a young woman, his ward, down the 'road to ruin' in his own home. This, surely, can only be a reference to Mary Alford, Frith's mistress, whom he eventually married in 1881. By 1878 Frith had already had seven children by Mary. Although there seems to be no proof that Mary Alford was Frith's ward, there can be little doubt that Rose is referring to her in his notes: 'But Mr Frith could give the jury a solemn lesson in the Road to Ruin in his own life, not his own ruin, his ward's. He seduced his own ward in his own house where he lived with his own wife and his own numerous family.'[5] He obviously hoped to discredit Frith's credibility as a witness, but fortunately for Frith none of this highly dangerous information was used in court. In this respect, Frith had a lucky escape. The revelation about seducing his ward would have been both sensational and seriously damaging. Perhaps realising the danger, Frith was highly reluctant to appear in court at all; eventually he was forced to by subpoena. To seduce a ward, especially if still under age, was a serious legal offence, and could result in court action. The consequences of this, in Victorian society, could have been devastating. No wonder the Frith family were anxious to sweep it under the carpet.

The trial finally took place on Monday 25 November, a dull and foggy day, in the old Westminster Law Courts, then in St Margaret Street, adjacent to Westminster Hall. They have since been demolished, and a statue of Cromwell stands in their place. The courtrooms were dark and cramped, and lit by candlelight. Three of Whistler's *Nocturnes* hung in the courtroom, which was so dark that one journalist compared it to a *Nocturne*. The gloom ensured that Whistler's pictures would be almost impossible to see properly. The gallery was crowded with the art world, including a great many young ladies, whose brown and green ribboned hats provided an aesthetically harmonious spectacle. It was extremely stuffy and hot, but no one wanted to miss the fun. The nature of the case, and Whistler's reputation as a wit, ensured that this trial was going to be good entertainment. And it was, although the judgment was to surprise everyone.

The presiding judge was another distinguished figure, Sir John Huddleston. Known as a strong judge, he generally persuaded juries to follow his instructions. The case was opened for the plaintiff by Sergeant Parry, who described Whistler's career, and called him to the stand. This gave Whistler a chance to explain his pictures, and say why he had called them *Arrangements* and *Nocturnes*. Whistler was then cross-questioned by Sir John Holker. This was when the sparring began, and the court was entertained to several amusing replies by Whistler. Holker concentrated on the price of 200 guineas, which was considered too high, and how long it had taken Whistler to paint it.

HOLKER: Did it take you much time to paint the *Nocturne in Black and Gold*? How soon did you knock it off?

WHISTLER: Oh I 'knock one off' possibly in a couple of days – one day to do the work and another to finish it.

The audience roared with laughter, obviously finding this exchange highly amusing. Both the lawyers and the public seemed to regard the whole case as a bit of a lark. Holker then went on:

HOLKER: The labour of two days is that for which you ask 200 guineas?

WHISTLER: No, I ask it for the knowledge I have gained in the work of a lifetime.

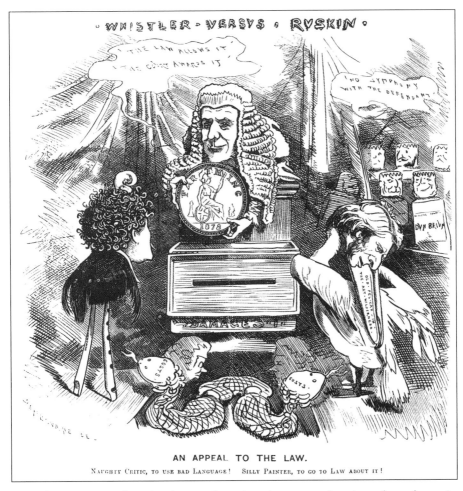

Whistler versus Ruskin. Sambourne has cleverly managed to introduce the main characters – the judge, Ruskin, Whistler and his peacock symbol – and the celebrated farthing awarded in damages. *(*Punch *cartoon by Linley Sambourne, 7 December 1878)*

This celebrated reply drew sympathetic applause from the crowd. It has gone down in history as not only Whistler's most famous statement, but a statement that might be used by any artist defending his work. Several of Whistler's works were then shown to the court, one of them upside down, which produced yet more laughter. Holker cleverly continued to press the point that the price of 200 guineas was exorbitant, considering how little time the artist had spent on it. This goes to the heart of Victorian notions of labour. For Ruskin, like all mid-Victorians, a painting had to display evidence not only of skill and technique, but also that the artist had laboured long and hard in

producing it. 'A fair day's pay for a fair day's work' was a philosophy that any Victorian juror could understand, and this was why Sir John Holker laboured the point. Sergeant Parry then interviewed his three witnesses, William Michael Rossetti, Albert Joseph Moore, and William German Wills. All of them praised Whistler's work, and stated that Ruskin's attack had been excessive, unfair, and libellous.

Sir John Holker then opened the case for the defendant. The court adjourned at 4.30 p.m., so Holker continued his defence the next day, 26 November. The substance of his case was two-fold – firstly, that Ruskin as a famous critic was absolutely entitled to criticise Whistler's work, and secondly, that the price of 200 guineas was exorbitant, considering the sketchy and unfinished nature of the pictures, and the fact that they only took two days to paint. After a lengthy address along these lines, Holker then called his first witness – Edward Burne-Jones. Burne-Jones was a nervous witness, and obviously awfully embarrassed to be there. Although he was known to dislike Whistler, he had to admit under questioning that he was a talented and genuine artist. He admitted that 'in Mr Whistler's pictures I see marks of great labour and skill', but when shown one of the *Nocturnes* he said, 'I think it a work of art, but very incomplete . . .' and when asked if it showed the finish necessary for a complete work of art, he replied, 'Not in any sense whatever.'

The defence then produced a painting by Titian, a portrait of Doge Andre Gritti, as an example of what a finished picture should be. The picture actually belonged to Ruskin, who had paid 1,000 guineas for it. At first the Titian also came in upside down, raising more laughter. The judge then asked how the picture could be proved to be by Titian, and repeated the well-worn story of how a supposed Titian was cleaned, and a portrait entitled *King George III in Militia Uniform* was found underneath. This produced more gales of laughter: the trial was in danger of becoming a farce.

Burne-Jones was then asked about the Titian, and about its value. He admired the picture, as a 'perfect specimen of a highly finished work of ancient art. . . . This is an arrangement in flesh and blood.' On the question of value, he was evasive, saying that was 'a mere accident of the saleroom'. He admitted that some of his own pictures had been exhibited unfinished, and that he agreed with much that Albert Joseph Moore had said in Whistler's defence. Burne-Jones admitted afterwards how much he had hated the whole affair, which earned him Whistler's

undying enmity for the rest of his life. Ruskin, however, was always grateful to him.

Then it was Frith's turn. He was questioned by Holker's deputy, Charles Bowen. In contrast to Burne-Jones, Frith's answers were straightforward and unequivocal. When asked if he considered Whistler's pictures to be works of art, he replied categorically, 'I should say not.' When shown the *Nocturne in Black and Gold*, and asked if it was a serious work of art, Frith replied, 'Not to me.' He admitted that 'There is a beautiful tone of colour in the picture of Old Battersea Bridge, but the colour does not represent any more than you could get from a bit of wallpaper or silk. I cannot see anything of the true representation of water and atmosphere in it; there is a pretty colour that pleases the eye, but nothing more.' He did not think the picture worth 200 guineas: 'I would not give 200 guineas for one of the plaintiff's pictures; they are not serious works of art . . .' nor did he see any connection between Whistler's work and Velasquez, as had been claimed by one of the plaintiff's witnesses.

Sir Leslie Ward. Caricature of Frith for *Vanity Fair*, 1876. The cartoons of Sir Leslie Ward, known as Spy, were one of the features of *Vanity Fair*, started in 1868. *(Photo: Christopher Wood Gallery)*

Frith's downright, no-nonsense approach was no doubt much appreciated by the defence. It went down well with the jury, and must have been damaging to Whistler's case. One of the best exchanges then took place when Frith was questioned by Sergeant Parry about Ruskin and Turner.

PARRY: Have you read Mr Ruskin's works?

FRITH: Yes.

PARRY: We know that Turner is an idol of Mr Ruskin.

FRITH: I believe Mr Ruskin has a great estimate of Turner's work. I think Turner should be an idol of all painters.

PARRY: Do you know one of Turner's works at Marlborough House called *Snow Storm* [Turner Bequest, Tate Gallery]?

FRITH: Yes, I do. I don't know how long ago it was painted – about twenty years ago.

PARRY: Are you aware that it has been described by a critic as 'a mass of soapsuds and whitewash'?

FRITH: I am not.

PARRY: Would you call it a mass of soapsuds and whitewash?

FRITH: I think it very likely I should. When I say that Turner should be the idol of painters, I refer to his earlier works and not to the period when he was half crazy and produced works about as insane as the people who admire them.

All of this aroused great laughter in court. The judge then added his contribution to the general merriment:

HUDDLESTON: Someone described one of Turner's pictures as lobster salad and mustard.

FRITH: I have heard Turner himself speak of some of his productions as nothing better than salad and mustard.

PARRY: Without the lobster.

This exchange shows Frith at his rumbustious best. He was as good a witness as Burne-Jones had been bad. Frith was not afraid of speaking his mind, clearly enjoyed the cut-and-thrust of cross-questioning, and also kept the court amused. He was to repeat the story about Turner

later in his memoirs; he had doubtless dined out on it for years. Even Whistler was forced to admit that Frith had at least spoken honestly.

After Tom Taylor was questioned, the two sides then summarised their arguments. Judge Huddleston himself then summed up and in a long and rather rambling speech, gave his very convincing directions to the jury. He also gave the jury three options for damages – substantial damages, modest damages, or 'merely contemptuous damages, to the extent of a farthing or something of that sort, indicating that the case is one which ought never to have been brought into court . . .'. No doubt thoroughly confused, the jury then retired to deliberate for an hour and a half, but sent a message that they could not reach a verdict. The judge, in a controversial move, summoned the jury back into court, and lectured them again on the question of whether Ruskin's words were 'fair and bona fide criticism'. The jury then retired for a further ten minutes, and then came back with their verdict. The foreman of the jury announced they were all agreed: 'We find a verdict for the plaintiff, with one farthing damages.'

It was one of the most famous, most equivocal verdicts in English legal history. On the face of it, Ruskin had lost, and Whistler had won. But by awarding such deliberately derisory damages, the jury had to all intents and purposes dismissed the case. Worse still, they had condemned Whistler to bankruptcy, as he could not pay his costs, and would not receive the damages he was hoping for. All of which emphasises how risky any libel case can be, as many others have discovered, before or since. Whistler duly went bankrupt, and went to Venice to work on a set of etchings commissioned by the Fine Art Society. Ruskin was not pleased by the verdict either. Not only had he lost, but the derisory damages seemed something of an insult to him. It preyed on his already unstable mind for long afterwards. Even before the trial he had written to resign his Slade Professorship at Oxford. Ruskin remained forever resentful about the result of the trial, and never recanted his opinions about Whistler. He was grateful to Burne-Jones, whose career went from strength to strength thereafter. Of Frith's reaction to the verdict we know nothing; no doubt he would have been pleased by the farthing damages. He would later publish his own feelings about modern art in an article in 1888 entitled 'Crazes in Art – Pre-Raphaelitism and Impressionism'.[6] And his picture *A Private View at the Royal Academy, 1881* was intended by him as an attack on the Aesthetic movement and its followers.

Whistler persisted in regarding the case as a victory for him, and history has of course endorsed his verdict. Ruskin may have won the battle, but he lost the war. His reputation as an art critic had suffered irreparable damage. When Whistler returned to London to give his famous 'Ten O'Clock Lecture' in 1885, he found that Oscar Wilde had usurped his position, and the Aesthetic movement was in full flow. Paradoxically, Whistler deplored this; he felt that art had become trivialised, and had fallen into the hands of enthusiastic amateurs. But art movements, like scientific discoveries, are usually unstoppable, in spite of what critics and writers may say. The *Whistler* v. *Ruskin* trial is now seen as an important milestone, the symbolic moment when the Ruskinian ethos of labour, value and morality applied to art came to an end, paving the way for the aesthetic philosophy of art for art's sake which replaced it.[7] No longer was art to be subject to these mid-Victorian constraints. Art was a matter of form and colour and aesthetic judgement. Only an artist could say whether a work of art was finished or not; it was finished when he felt he had nothing more to add. For the aesthetes, the purpose of a work of art was simply to be beautiful. They were to find their most powerful propagandist in the writer Walter Pater. Frith's part in the trial was nothing more than a rearguard action – the artistic battle had already been lost. Frith's reaction, like that of most of his contemporaries, was to fight doggedly on, defending those traditional values in which they had been trained. They were too old, or too stubborn, to change. And Frith had another thirty years to live.

SEVENTEEN

The Race for Wealth
1878–80

Following the success of the *Road to Ruin* series and with the *Whistler* v. *Ruskin* trial over, Frith decided to produce another Hogarthian series, this time to be entitled *The Race for Wealth*. Frith wrote that it was to be a 'series of five pictures representing the career of a fraudulent financier, or promoter of bubble companies. . . . I wished to illustrate also the common passion for speculation, and the destruction that so often attends the indulgence of it, to the lives and fortunes of the financier's dupes.'[1]

Speculation was a hot topic in the 1870s and Frith was not the first to turn it to artistic use. The great novelist of the Victorian upper class, Anthony Trollope, had already tackled the subject in his novel, *The Way We Live Now*, published in 1875. The main character is one Auguste Melmotte, a mysterious financier of reputedly enormous wealth, who settles in London, buying a huge house in Grosvenor Square. Although suspected of dishonesty, he quickly establishes himself as an important financial figure and is courted by society. He becomes MP for Westminster and at the peak of his career gives a fantastic banquet for the visiting Emperor of China. In the end his fraudulent manipulation of his many companies is exposed, and the whole edifice tumbles down. Melmotte commits suicide; his family flees abroad. Trollope intended the book as an attack on the materialism and corruption of society in the 1870s, when new money was beginning to force its way into the aristocracy and upper classes. Frith was a friend of Trollope for many years, and he may well have got the idea for *The Race for Wealth* series from Trollope's book. In 1881, Trollope was to feature prominently in Frith's picture *A Private View at the Royal Academy*. Both Trollope and Frith could have had in mind a real-life example in the career of Baron Albert Grant, a notorious company promoter, who went bankrupt in the late 1870s, having cheated a gullible Victorian public out of at least

£20 million. Among the countless fake companies he promoted were the Cadiz Waterworks, the Central Uruguayan Railway, the Labuan Coal Company, and the Emma Silver Mine.

The first picture, which Frith entitled *The Spider and the Flies*, shows the shady financier in his office, surrounded by hopeful investors – the flies drawn into the web of deceit. Frith describes 'the principal flies being an innocent-looking clergyman, who with his wife and daughters are examining samples of ore supposed to be the product of a mine – a map of which is conspicuous on the wall – containing untold wealth. The office is filled with other believers, a pretty widow with her little son, a rough country gentleman in overcoat and riding-boots, a foreigner who bows obsequiously to the great projector as he enters the room from an inner office – in which clerks are seen writing – while a picture-dealer attends with "a gem" which he hopes to sell to the great man, whose taste for art is not incompatible with his love of other

The Race for Wealth 1880 – The Spider and the Flies. In the first scene, the corrupt financier, the Spider (in the centre with his thumb in his waistcoat), is talking to prospective clients, who have come to invest in his spurious companies. On the right, a clergyman is examining a geological specimen. *(Baroda Museum, India)*

The Race for Wealth 1880 – The Spider at Home. Frith shows us the Spider entertaining in his picture-filled drawing room, based on Frith's own house in St John's Wood. Beyond, the Spider's wife receives more guests. *(Baroda Museum, India)*

people's money. Other flies buzz round the web.'[2] Frith approached several city stockbrokers and asked if he might paint their offices, but they all refused.

In the second picture, *The Spider at Home*, the financier 'is here discovered in a handsome drawing-room, receiving guests who have been invited to an entertainment. He stands in evening dress, extolling the merits of a large picture to a group of his guests, one of whom, a pretty girl, shows by her smothered laugh that she appreciates the vulgar ignorance of the connoisseur, whose art terms are clearly ludicrously misapplied.' The double drawing room contains many figures, some of whom may be recognised as the clients in the first scene at the office; others are of 'the upper ten, whose admiration of success, combined with the hope of sharing in it, so often betrays them into strange company'. The distinguished-looking man on the right was modelled by Colonel Townsend Wilson, a friend of Frith and a Crimean veteran. In the next room the host's wife receives more guests

The Race for Wealth 1880 – Victims. The clergyman we saw in the Spider's office is now seen with his family at the breakfast table. They have read in the paper that the company in which they invested their savings has collapsed – they are ruined. *(Baroda Museum, India)*

announced by the butler, and dinner can be seen laid out in the room beyond. The drawing room, which was modelled on Frith's own in Pembridge Villas, is full of pictures. Many successful Victorian financiers, including Baron Grant, built huge houses in and around London, especially in Kensington Palace Gardens, which was known as 'Millionaires' Row'. Grant also collected pictures; his collection was sold at Christie's in 1877. Once again, Frith has paid careful attention to physiognomy, differentiating between the refined, aristocratic-looking types among the guests, and the flashy, rather foreign looks of the corrupt financier. His wife, described by Frith as 'a vulgar type', looks suitably short, fat and undistinguished.

In the third of the pictures, *Victims*, Frith writes, 'the crash has come. The foolish clergyman sits at his breakfast table with his head bent to the blow. His wife, with terrified face, reads the confirmation of her worst fears in the newspaper, which a retreating footman has brought.

Two daughters have risen terror-stricken from their chairs, and a little midshipman son looks at the scene with puzzled expression, in which fear predominates. The catastrophe is complete; the little fortune has been invested in the mine, and the whole of it lost.' The poor clergyman and his family will probably have to sell up and leave their comfortable rectory: the breakfast parlour is a particularly charming example of a Victorian middle-class room. Clergymen and widows were the most gullible investors in speculative companies, and Baron Grant is known to have obtained lists of them, to send prospectuses of his new ventures.

In the fourth scene, *Judgement*, we are in a courtroom of the Old Bailey. The swindler has been arrested, and is now on trial. 'See the financier there,' writes Frith excitedly, 'with blanched face listening to the evidence given by the clergyman, which, if proved, will consign him to penal servitude. His victims – recognisable as those in his office in the

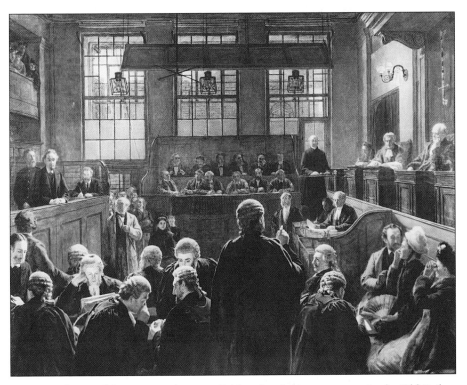

The Race for Wealth 1880 – Judgement. Frith painted the court scene in the Old Bailey, where the Spider is on trial for fraud and corruption. The ruined clergyman is in the witness-box; the Spider is in the dock, to the left. Many critics thought this scene the best in the series. *(Baroda Museum, India)*

opening of my story – stand ready to add their testimony. The widow, the foreigner, the country gentleman are there; and so also are some of his aristocratic guests, one of whom studies his miserable face by the aid of an opera glass. The counsel and the jury examine the real, and the spurious, specimens of ore. The evidence is overwhelming. . . .'

Frith made measurements and took photographs of the Old Bailey to help him with the picture. He also walked the tunnel from the cells to the court, to see what a criminal might feel like coming into court. Frith hoped that if ever the Old Bailey was altered or pulled down, his picture would remain an exact record of it. He also used several court officials as models. First and foremost, the judge was none other than Sir John Huddleston (later Lord Huddleston), who presided over the *Whistler* v. *Ruskin* trial. Frith described him as 'my old friend', and wrote that 'he sat so well for me that a good likeness is the result'. Next to the judge sits an alderman, modelled by Alderman Sir Thomas Gabriel. The barristers in the foreground were Sergeant Ballantine, Mr Poland and Montague Williams. Frith also included the well-known lawyer George Lewis, a friend and counsellor to many artists, including Burne-Jones. All the critics considered that the court scene was the best of the five pictures.

The fifth and final scene, *Retribution*, is in many ways the most striking. It is set in the courtyard of Millbank Prison, where the prisoners are walking round in a circle. The picture is a unique record of Victorian prison life, the only other being Gustave Doré's famous illustration of *Newgate Prison* (now privately owned) which was the inspiration for Van Gogh's picture *The Prison Court Yard* (Pushkin Museum, Moscow). To the left is the now-disgraced financier, in prison uniform, complete with arrow motifs. Frith, as usual, was fascinated by anything to do with criminals, and hugely enjoyed going to Millbank and making sketches there. Armed with a letter of introduction 'from a high personage', he sought the permission of the governor, Captain Talbot Harvey, who allowed him to visit the prison yard. He was warned he must not speak to any of the prisoners, nor must he depict any of them in his picture. Frith described the scene:

My guide conducted me, accompanied by a tall warder, through passages and doors, which were unlocked to admit us to other passages, and always carefully locked behind us, till we arrived at a large irregular quadrangle, where fifty or sixty men in fustian suits

The Race for Wealth 1880 – Retribution. Frith also painted the final scene *in situ*, in the yard of Millbank Prison, where the Spider walks with the other prisoners. The picture is a unique record of Victorian prison life. *(Baroda Museum, India)*

marked with the broad arrow, were walking rapidly one after another, always preserving the prescribed distance, in a dreadful circle; not a sound but the monotonous tramp. Two warders only, placed at the opposite sides of the circle, were enough to control this ghastly assembly.

Frith wondered if the warders were ever attacked by the prisoners, but was told that, should it happen, the other prisoners would come to the aid of the warders. He also thought the prisoners should be clean-shaven, but the governor told him that keeping the razors in good order proved too difficult, so that he allowed beards cut short instead. Frith also noticed that several of the prisoners retained an air of breeding and refinement, something which contradicted the Victorian belief in physiognomy, and the criminal type. Frith was therefore careful to include in the picture some respectable-looking men. 'I carefully selected types that may some day take their constitutional at Millbank, but are

at present more or less respectable members of society.'[3] In doing so, Frith was virtually admitting that the Victorian science of physiognomy was unreliable, and too selective. But he still retained his belief that the face was the mirror of character and that an artist had to be a connoisseur of facial types, and expressions. Frith had photographs taken of the prison yard, and also managed to borrow a convict's outfit. He also, typically, got the warders to talk about their experiences, in particular about a well-known burglar called Peace, referred to by the warders as 'a first-class prisoner'. He was a highly professional burglar, and clearly something of a character, but he eventually committed murder, when disturbed in the course of a burglary, and was hanged.

Millbank Prison was shortly to be demolished (the Tate Gallery now stands on the site). Frith hoped therefore that 'the courtyard, with its surrounding cells, which forms the *mise-en-scène* of my picture, precisely copied from nature as it is, may be interesting as a record of prison life at the time'.[4]

In 1879, while Frith was working on *The Race for Wealth*, he took his family on what was to be their last family holiday together, to Tenby, in South Wales. Frith, as ever, was on the lookout for subject-matter, and, just as he had done in Boulogne, turned his holiday experiences into pictures: '. . . the sight of the Welsh fish women with their picturesque costumes suggested subjects for a variety of pictures. It was common to see these women with their high Welsh hats and bright petticoats, offering their wares to visitors; bargains struck as the ladies stood at their windows.'[5]. At the RA in the following year, 1880, he exhibited two Tenby subjects, *Tenby Fish Woman* and *The Prawn Seller, Tenby*.

Unlike *The Road to Ruin* series, Frith did not exhibit *The Race for Wealth* at the Royal Academy. Instead the series was shown at a gallery called Marsden's in King Street, St James's, in the same street as Christie's. Frith does not mention if the pictures sold, or who the buyer was. Unfortunately, the pictures have for many years been in a museum in India, at Baroda, so have remained virtually unknown in England. Photogravures were made of them, which Frith as usual thought 'far from satisfactory'.[6] A pamphlet describing the pictures was written, once again, by Tom Taylor.

The critics were full of praise for *The Race for Wealth*, even more than for *The Road to Ruin*. *The Times* gave them an especially long and glowing review. The reviewer approved of the subject – 'Mr Frith deals

with one of the largest evils and strongest motives of our time . . . "The Game of Speculation".' He went on, 'Mr Frith has never produced anything better, whether for conception of character or masterly execution, than many of the heads in these pictures. We may particularise the country squire and the country clergyman of the first scene. . . .' The reviewer particularly praised Frith's facial types, especially in the court scenes, but also the swindler himself: 'An excellently imagined type in itself, bringing out the same nature through all its modifications of expression.' Frith was clearly still regarded as the master of the physiognomy game. 'For variety, technical merit, truth of composition, chiaroscuro and effects of light and air, the court scene, as we have said, is beyond question the finest of the series. . . .' The reviewer concluded, 'Altogether, we are glad to be able to congratulate the veteran painter on a work which shows not only unimpaired, but enhanced power. . . .'[7] All this must have been very gratifying to Frith, indeed a veteran at sixty-one, but still the leading modern-life painter of his day.

The *Art Journal* was also full of praise, but questioned whether the second and fifth scenes in the series were really necessary. The reviewer disliked the Millbank scene – 'The taste is questionable, if not altogether morbid, which would be gratified by such a sight as a set of hideously attired, hideously visaged convicts walking round, in single file. . . .' Clearly this reviewer had missed those signs of refinement and breeding that Frith had tried to introduce to some of the faces. 'Nonetheless,' the reviewer continued, 'we regard the series as perhaps his finest achievement. . . . The figures, in size, are admirably related to their surroundings, and in character are as completely differentiated on the canvas as they are in real life.' The use of subdued colours and the interiors come in for praise, in particular the court scene. Frith was, once again, compared to Hogarth, and the review concluded, '*The Race for Wealth*, in short, is a chapter of our contemporaneous history recorded by a hand so cunning, and at the same time so faithful, that it will always be referred to in future as authoritative.'[8]

Another event occurred in Frith's life in 1880 – the death of his wife Isabelle. Astonishingly, Frith does not even mention this in his *Autobiography*, published only seven years later, in 1887. Immediately after writing about *The Race for Wealth* series, Frith then inserts two chapters completely out of sequence, one an interminable shaggy-dog story about a model, the other a further reminiscence of Dickens and John Forster. Only three chapters later does Frith finally mention, 'I had

just suffered a heavy domestic bereavement', citing it as an excuse to go on another trip to the Low Countries with his daughters.[9] Having thus disposed of his wife in one enigmatic sentence, Frith described the paintings he saw on his travels.

Anton Wiertz, the Belgian painter, he thought a madman, but he admired the Rubens pictures in the Brussels gallery. From there they went on to The Hague, where they met Millais and some other friends; they went on together to Amsterdam. Both Frith and Millais admired Dutch painting, especially Rembrandt, and Frith wrote that 'it was delightful to hear his fresh and frank appreciation of those great masters'.[10] Frith made an interesting observation about the Dutch low-life painters, comparing them with his own work: 'Let my reader make a mental comparison between a group of bank holiday makers disporting themselves on Hampstead Heath, and an array of peasantry in a picture by Teniers or Jan Steen – the former either dirty, or primly smug, but in form and colour eminently unpicturesque; the latter gay, with bright colours and dresses that call aloud to be painted.'[11] This interesting passage only serves to underline how unpicturesque the Victorians found their own age. To us now, however, top hats, frock coats and crinolines appear hugely picturesque and glamorous; time has given them a patina of period charm.

What Frith thought about his wife Isabelle's death we shall never know. His letters make no reference to it, and his diaries have not survived. The fact that he hardly mentions his wife of thirty-five years in his *Autobiography* may seem extraordinary, but it is consistent with his attempt to keep his personal and family life a secret. Mrs Panton's heavy hints clearly indicate that Frith's domestic situation had been difficult for some time. And so, in the end, poor Isabelle was virtually written out of history, to make way for Mary Alford.

EIGHTEEN

For Better, For Worse
1880–1

On 30 January 1881, almost exactly a year after the death of his wife Isabelle, Frith married his mistress Mary Alford, in the parish church of Paddington. Mary was forty-six years old, Frith was sixty-two. Between 1856 and 1870 Mary had given birth to seven of Frith's children, two girls and five boys. All these children took the surname Alford, not Frith. Very little is known about the Alford children, but we can be sure that Frith's first family wanted to have nothing to do with them. They clearly took the side of their mother and considered that Frith had behaved disgracefully towards her. Mrs Panton, Frith's second daughter, makes it very clear in her memoirs where her sympathies lie. She also thought that Frith's work declined after the death of Isabelle:

> I do not think, to the day of her death, through all the years that led from comfortable obscurity to a life among the most delightful and brilliant people of the times, that I ever saw my mother idle for five minutes of the day. She was always doing something. In the earliest days she was invariably sewing, sometimes for us, very often for my father, whose costumes she made and arranged, and who owed her many a hint for his pictures and the colours and draperies used therein, that were never known of until she died. Then the taste and fancy she had lavished on him were wanting, and soon began to fade out of his work after her death, and the one great and fatal error of his life became public property.[1]

Reading between the lines, one can sense a bitterness that Mrs Panton clearly felt towards her father, in betraying their mother in what we now know to have been a particularly wounding and unpleasant way. We do not yet know when Mary Alford met Frith, or indeed if she was his ward, living in his house as one of the family. She was born in 1835,

and her first child by Frith, a daughter called Mary, was born in 1856, when she was twenty-one. When she entered the Frith household, and when her affair with Frith began, are things still shrouded in mystery. The truth, so long suppressed by Frith's first family, may in time emerge. Now we can understand just why Queen Victoria bestowed absolutely no award or honours on Frith for painting *The Marriage of the Prince of Wales*.

Maybe because the subject was on his mind, Frith's main picture of 1881 was a wedding scene. Entitled, perhaps with deliberate irony, *For Better, For Worse*, it shows a bride and groom departing from a London house (Plate 10). Frith wrote later that he was inspired to paint the subject when he saw 'an almost identical realisation of it in Cleveland Square'.[2] The house has not been identified exactly, but is almost certainly based on the terrace in Paddington where Frith lived. The church in the background is based on Christ Church, Lancaster Gate.

Frith is clearly showing us what an upper-class wedding in London looked like. It is virtually the only London wedding scene in Victorian art which shows the bride and groom leaving. Most other pictures of

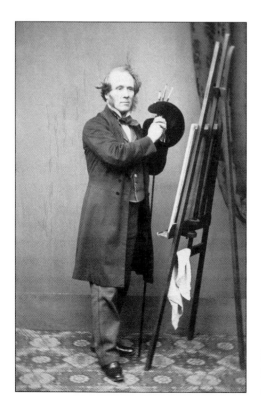

Photograph of Frith standing at his easel, by Maull and Polyblank. *(Photo: Maas Gallery, London)*

the subject concentrate on the reception, and are interiors. Nonetheless Frith confided to his diary on 28 May: 'Sketched out composition of a wedding party, which might do, but fear it is not very interesting. In great despair about subjects.'[3]

Frith had already treated the subject of a marriage proposal with his two pictures *Hope* and *Fear* of 1869. Frith himself describes the picture:

This picture represents a bride and bridegroom on the point of leaving for the honeymoon. Their brougham waits; and a crowd of passers-by watch the departure, while from the doorsteps – on which the bride's family and friends are collected – come the usual showers of rice and slippers, and from a balcony above the portico the guests take a last look at the newly-married. . . .

The *Art Journal* reviewer remarked that 'A crowd of another kind, such as collects in London on the smallest provocation within two minutes, line the path of the happy pair.'[4] Frith described it thus:

The street crowd, through an avenue of which the lady and gentleman go to their carriage, is composed of street boys, the more inquisitive being kept back by a policeman with an unnecessary show of force; a Jew clothes man; a servant whose curiosity has stopped her on her way to post a letter; and, last and best part of the picture, a group of beggars who approach from the street, the man, his wife and children illustrating the latter part of the title of the picture *For better, For worse.*

Frith here deliberately deflects any comparison with his own marital experiences. Introducing a London street crowd into the picture not only provides more interest, but gives Frith once again an opportunity to display his skill at physiognomy. Frith often depicted Jews, and for this picture he wrote that, 'After much search I discovered a Jew of a very marked type, who consented to sit if I would make it "worth his while".' The Jew asked for 10s an hour; Frith refused, offering the same amount for three hours. The Jew then suggested 12s 6d and then 11s. Frith stuck to his guns, and the fee was agreed, with some old clothes thrown in for good measure. After the sittings, the Jew tried to buy Frith's Sunday suit, declaring it was 'already too shabby for any gentleman to wear'. Thereafter, the Jew called at the house many times

Sketch for *For Better, For Worse*, 1881. A middle-class couple depart for their honey-moon. Frith's first wife Isabelle died in 1880, and in 1881 he married his mistress, Mary Alford, so doubtless marriage was on his mind. *(Photo: Forbes Collection)*

in the hope of persuading Frith to part with his suit. This continued for some years, until the persistent clothes dealer finally gave up.

To the right of the picture, Frith has included a boy with a dog and a performing monkey. He modelled both the boy and the monkey in his studio, and found the monkey an impossible sitter. The boy tried to hold the monkey still, but it kept wriggling free, jumping on to the easel, and even attacking the picture. Mercifully, it eventually fell asleep. Frith wrote of this episode, 'Little children are maddening, but commend me to the most terrible of these in preference to a monkey. I suppose it is not possible that the monkey knew what I wanted, and was determined I should not get it; but his conduct could only be accounted for on that hypothesis.'

Another boy who modelled for the picture fainted during a sitting, a common occurrence with amateur models. 'On the occasion I speak of,' wrote Frith, 'a boy was standing for me in an easy position, with his hands in his pockets. I was at work on his face, and saw no sign of a change in his complexion; when, without moving his hands from his trousers he fell like one shot.' This must be the boy in the centre of the picture, standing with his hands in his pockets, next to the policeman. 'I have known soldiers, boxers, and the like,' wrote Frith, 'powerful-looking men, unable to endure the strain of standing still in one position. . . . In one of my friends' studios a girl fell into a stove and disfigured herself for life.'

Frith's picture remains a unique record of a grand town wedding. His rival, George Elgar Hicks, also liked wedding scenes, but he concentrated on receptions, as in *Changing Homes* (1862) and *The Wedding Breakfast*.[5] Most other painters preferred the simplicity and sincerity of country weddings, as in Luke Fildes's *A Village Wedding* of 1883[6] or Stanhope Forbes's *The Health of the Bride* of 1889.[7] They could both have got the idea of painting a wedding from Frith.

Frith exhibited *For Better, For Worse* at the Academy in 1881, together with a historical picture entitled *Swift and Vanessa*. This is based on the story of Swift and the woman he jilted, Vanessa (in real life Hester Vanhomrigh), as recounted by Frith in his book. All the critics liked the picture of *Swift and Vanessa* the better of the two. *The Athenaeum* thought it 'the best picture of his we have seen for many a day', but complained that in *For Better, For Worse*, none of the figures 'seem able to rouse his or herself to cheerfulness. . . . Each of them, individually and severally, is typically faithful, excellent as a specimen of

an ill-favoured class. But the design lacks movement, spontaneity, and combination of its parts into groups with common motives. The colours as such need to be massed, and the light made luminous.'[8] The other critics mostly damned with faint praise. The *Illustrated London News* remarked that 'Mr Frith paints as nattily and evenly, and as heedless of any aesthetic problems of the day, as ever, and, as always, he tells a story of genteel life well. . . .'[9] *The Times* observed sardonically that Frith was 'more Frithian than ever'.[10]

Later that year, Frith had to help the Royal Academy organise a Winter Exhibition of Old Masters. This involved travelling all over England to choose suitable pictures for the exhibition.[11] No doubt Frith found some good and genuine pictures, but in the main he was astonished by the levels of ignorance he encountered in English country houses. In one large mansion in the north, he was shown round by one of the young ladies of the family, catalogue in hand. Frith could see at once that many of the pictures were rubbish, but on asking about one, was told it was by Titian. Another, the young lady said, 'is by-by-Domy-Dom – my sister writes so badly I cannot make it out.' 'Oh Domenichino,' replied Frith, 'is it? – very interesting – I never saw a picture of fox-hounds by that painter before.'

Frith was then taken to the billiard room to see the Van Dycks. He was assured by his young cicerone that, 'They have been here since they were painted. Mamma has all the receipts from Vandyke [*sic*] for the different sums paid for the pictures.'

Frith found that the pictures were mostly by Sir Peter Lely, and some were good examples. Finally, he was told he must see the Gainsborough on the staircase. The young lady assured him that 'it is thought by good judges (emphasis on good judges) to be a very fine Gainsborough'. The 'Gainsborough' turned out to be a full-length portrait of a man wearing armour, of the Elizabethan period.

In Wales, Frith travelled to see a supposed Reynolds portrait, which turned out to be a fine Romney. At first, Frith did not let on to the owners that it was a Romney, but asked that it be sent to London. The secretary of the RA then wrote to the owner, Lord ——, informing him that the picture could only be exhibited as a Romney. The owner very sensibly agreed, and the picture proved to be one of the most popular pictures in the exhibition.

Frith's colleague John Callcott Horsley (known as Clothes-Horsley because of his objection to nude models in the RA Schools) was also on

the committee, and encountered similar problems. Also in the north, he travelled a considerable distance to see a supposed Leonardo, which turned out to be such rubbish that it was sold by the auctioneers, Christie's, for £5, mainly because it had an old frame.

Frith was fascinated by the art market, and many of the stories related in his *Autobiography* are about auction sales, dealers, and artists trying to sell their work. One story is about another Gainsborough portrait. A prominent London dealer, whom Frith calls Mr Stokes, was visited in his gallery by an elderly man 'palpably of the Jewish persuasion', who offered him a portrait by Gainsborough, a full-length of a beautiful woman. Mr Stokes said he would give at least £25 for such a picture, whereupon the Jewish dealer suggested they jump in his cab at the door, and go and look at the picture. To Mr Stokes's surprise, the cab headed for Seven Dials, one of the most notorious slums of central London. Arriving at a shop selling antiques and bric-a-brac, Mr Stokes was led to a room upstairs where he noticed very fine silver and porcelain piled up on a sideboard, tapestries nailed to the wall, and a very beautiful Gainsborough portrait. Sitting at a table was 'an old man of repulsive aspect'. This Fagin-like figure then explained to Mr Stokes how he had purchased these things, including the Gainsborough. He assured Mr Stokes that they were not stolen goods, but had come from the recent sale of a country house in Buckinghamshire. He produced the catalogue. 'I went to the castle myself; nobody there; things given away, sir – literally given away. And look here – here it is – I bought that splendid Gainsborough for six guineas!'

Mr Stokes then asked how much he wanted. The Jew replied £150. Trying not to appear too eager, Stokes wrote out a cheque, and asked for a van to transport the picture back to his gallery. Back in his gallery with the picture, Mr Stokes celebrated his purchase by treating himself to an extra glass of sherry with his dinner. As he was doing so, he was told that Lord ——, an old client of his, was in the gallery, looking at the Gainsborough. He went down, and Lord —— asked: 'A new purchase this, Mr Stokes?' 'Yes, my lord; it hasn't been in the place an hour.'

He then asked the price and was told it was 1,000 guineas. 'I will take it,' he said at once, 'and you will have the frame regilt? And if you think a little cleaning or varnishing desirable, I know I can trust you to see to all that sort of thing. I leave town this evening. You will be so good as to let me know when the picture can be sent to Eaton Place.'

The new purchaser, Lord —— then went to the country, where he caught a fever, and died a few days later. His executors were aware of the purchase of the picture, and acknowledged their liability. However, they wrote to Stokes asking if he would kindly rescind the purchase, to which he agreed. Stokes resolved that the price of the Gainsborough would go up. A few days later, another client, this time a duke, came in, and was immediately drawn to the picture.

'Gainsborough, ain't it? Not such a bad one. What have you the impudence to ask for it?'

'Three thousand guineas.'

'Rubbish!'

The Duke then pretended not to be interested and looked at other things around the gallery. But he was drawn back to the Gainsborough.

'Now you don't really suppose that there is a fool in the world big enough to pay such an unconscionable sum as that you ask for the Gainsborough, do you?'

'Perhaps not,' replied Stokes, 'but I am not fool enough to sell it for less.'

'Suppose me such an idiot – only suppose, mind – as to offer you 2,500 pounds for it, what then?'

'Why then, your Grace, I should decline to take it.'

The Duke then diverted the conversation, and asked about some print he had asked for; Stokes produced it.

'Much obleeged to you,' said the Duke. 'Well I must be off. Cold August isn't it? Did you get the grouse I sent you? All right – no thanks. Fact is, we killed such a lot, didn't know who to send 'em to.'

As they moved towards the door, the Duke turned and said: 'That infernal picture has fascinated me. I will give you three thousand pounds for it.'

'No your Grace, you must excuse me. If you or anyone else were to offer me three thousand one hundred and twenty pounds, I should refuse it. My price is three thousand guineas, and I will never take one farthing less.'

'Well,' replied the Duke, 'of all the unconscionable – I know I am a fool – but – well – send her home!'

Later the picture was shown at one of the Academy's Winter Exhibitions, where, Frith wrote, it was 'greatly admired by numbers who would have been as much surprised as I was, if they could have heard this true story of a "Strange Purchase"'.

This anecdote shows what a natural storyteller Frith was, and why he was a popular guest at dinners, and at the *Punch* table. With his ear for dialogue, he could well have turned novelist, had he chosen to. His description of the Duke could have come out of Trollope. The story also reveals the extraordinary importance both tradesmen and artists attached to the guinea. It was thought to be the more gentlemanly currency, as opposed to the plebeian pound. Many artists would only be paid in guineas, and Christie's continued to conduct all their sales in guineas until as late as 1975. Three thousand guineas was three thousand one hundred and fifty pounds, which is why the dealer Mr Stokes said he would not accept three thousand one hundred and twenty. Very little seems to have changed in the London art world since Frith's day, although now the Duke and the Lord would more likely be sellers than buyers.

NINETEEN

A Private View at the Royal Academy 1881–3

In 1881, Frith began work on what was to be his last big modern-life picture. He chose as its subject something he knew well – the private view of the Royal Academy Summer Exhibition. This traditionally took place at the beginning of May, and it signalled the beginning of the London Season, which ended in July with Goodwood Races. The Royal Academy was still, in the 1880s, the dominant force in the Victorian art world, in spite of continual criticism from young artists and the founding of rival institutions such as the Grosvenor Gallery and the New English Art Club. Under the Olympian guidance of Sir Frederic Leighton (later to become Lord Leighton, the only English artist ever to become a peer) the Academy reached the peak of its power and prestige, never to be equalled since. The Summer Exhibition attracted huge numbers of visitors, and the merits of 'the pictures of the year' were hotly discussed in the press and at dinner parties. The Victorian public, and most of the artists, never seriously questioned the Academy's monopoly. They accepted that the Academy represented artistic excellence, and that an artist could aspire to nothing better than the coveted letters RA after his name. The Royal Academy could confer riches, fame and social position on its members, just as it had done for Frith. Even younger artists such as H.H. La Thangue, George Clausen and Stanhope Forbes, belonging to different artistic affiliations, preferred to exhibit at the Academy, because that was where they would get the best exposure, and with luck find a buyer.

But Frith had another purpose in painting the picture. He was not only painting a gathering of the great and good, who had come to see and be seen. He wanted to expose the follies of the aesthetic movement, his *bête noire*. Above all, he disliked aesthetic dress. He commented:

Some years ago, certain ladies delighted to display themselves at public gatherings in what are called aesthetic dresses; in some cases the costumes were pretty enough, in others they seemed to rival each other in ugliness of form and oddity of colour . . . the contrast between the really beautiful costumes of some of the lady *habitués* of our private view, and the eccentric garments of others, together with the opportunity offered for portraits of eminent persons, suggested a subject for a picture, and I hastened to avail myself of it.[1]

A Private View at the Royal Academy, 1881 is a large horizontal picture, containing over thirty figures, nearly all portraits of well-known people of the day (Plate 11). It was later published as a print, with a key, so all the figures are identifiable. At the centre, predictably, Frith has placed the President, Frederic Leighton, standing talking to a group of ladies on an ottoman, including Baroness Burdett Coutts, Lady Diana Huddleston (wife of Frith's old friend the judge) and Lady Lonsdale. Next to Leighton, the commanding figure in a very shiny black topper is the Archbishop of York.

To the right of Leighton and the Archbishop is another figure, also in a top hat, and with an orchid in his buttonhole – it is Oscar Wilde, surrounded by a group of admirers, to whom he is obviously expounding on the pictures. Frith had no great love for Wilde, who had made sarcastic remarks about Frith's paintings, both verbally and in print. Now it was time for Frith to get his revenge:

Beyond the desire of recording for posterity the aesthetic craze as regards dress, I wished to hit the folly of listening to self-elected critics in matters of taste, whether in dress or art. I therefore planned a group, consisting of a well-known apostle of the beautiful, with a herd of eager worshippers surrounding him. He is supposed to be explaining his theories to willing ears, taking some picture on the Academy walls as his text. A group of well-known artists are watching the same.

This describes exactly what Oscar Wilde is doing, surrounded by three adoring ladies hanging on his every word. One of them has a child with her, probably a boy, in an aesthetic Lord Fauntleroyish outfit. To the left of Wilde and this group, next to the Archbishop is Lillie Langtry, the 'Jersey Lily', already notorious as the mistress of the Prince

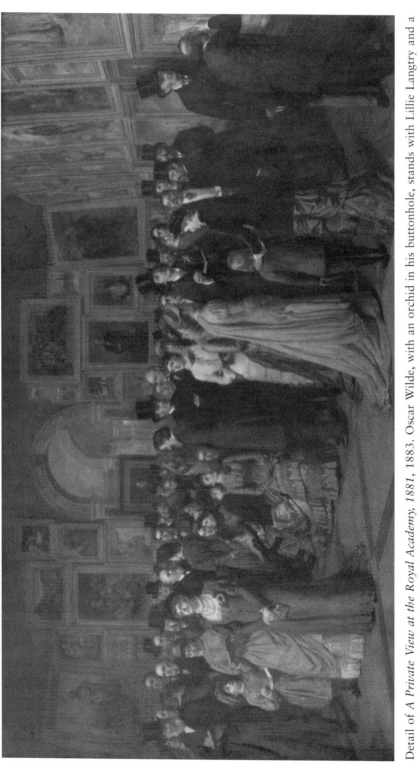

Detail of *A Private View at the Royal Academy, 1881*, 1883. Oscar Wilde, with an orchid in his buttonhole, stands with Lillie Langtry and a group of aesthetic admirers, holding forth. *(Pope Family Trust)*

of Wales, and a great friend of Oscar Wilde. To the right of Wilde, slightly behind him, are two more actors, Ellen Terry and Henry Irving. Frith only knew Ellen Terry slightly, but Irving was a good friend and mentioned several times in Frith's *Autobiography*. To the right of this group, Frith has placed four artists, all RAs, obviously there to counterbalance the aesthetes next to them. They are Joseph Edgar Boehm, the sculptor, Henry Stacy Marks and Philip Hermogenes Calderon, both of the St John's Wood Clique, and on the extreme right, Millais. For Frith, they clearly represent good art and common sense, in contrast to the aesthetic ambience of Oscar Wilde and his acolytes. In this group Frith has also included his old friend George Augustus Sala, a small, moustachioed, red-faced figure. He was well known in his day as a writer, journalist and man-about-town. He was also, like Frith, closely involved with *Punch*, and a friend of its editors. Sala often wrote to Frith suggesting both modern-life and historical subjects, although Frith never adopted any of them.[2] Sala is shown wearing a white waistcoat, his signature, and when requested to model for the picture, he wrote to Frith, enclosing a photo, and requesting, 'Don't forget the white waistcoat. I have worn one every day for the last five-and-twenty years, so that an old washerwoman said to me once, 'How I should like to be your washerwoman!' Frith also wrote asking to borrow Sala's coat. Sala replied that he was flattered: 'Never before, my dear Frith, has it been assumed that an English man of letters possessed a second coat, to say nothing of a change of waistcoats and ties.'[3]

On the left of the picture, Frith placed another aesthetic group in the foreground, which he described as 'a family of pure aesthetes absorbed in affected study of the pictures'. This group consists of two ladies and a girl, all in flowing, aesthetic robes, one with a sunflower, the aesthetic symbol, pinned to her dress. Nowhere were the aesthetes and their antics more ridiculed than in the pages of *Punch*, especially in the cartoons of George du Maurier. Du Maurier invented a whole world of aspiring aesthetes, led by Mrs Ponsonby de Tomkyns, who longed to invite the Cimabue Browns of Passionate Brompton to her soirées. Quite deliberately, no doubt, Frith placed du Maurier himself in the picture, right behind the aesthetic ladies, to underline the point, and amuse his friends on *Punch*. Next to du Maurier is another *Punch* illustrator, John Tenniel. *Punch* also published many humorous verses about the aesthetes, including an often-quoted one about Oscar Wilde:

The haunt of the very aesthetic
Here come the supremely intense
The long-haired and hyper-poetic
Whose sound is mistaken for sense
And many a maiden will mutter
When Oscar looms large on her sight
'He's quite too consummately utter,
As well as too utterly quite.'

The Victorians clearly liked chortling at the aesthetics in much the same way that people mocked the flower-power hippy culture of the late 1960s and early 1970s. One artist particularly responsible for the aesthetic craze was Burne-Jones, the darling of the Grosvenor Gallery. Ladies tried to look soulful and Botticellian, like the figures in his paintings. The aesthetes really were the beautiful people of the 1880s.

Just as he did with the group round Oscar Wilde on the right, Frith has surrounded the aesthetic ladies on the left with contrasting figures. Immediately to the left of them is 'Anthony Trollope, whose homely figure affords a striking contrast to the eccentric forms near him.' Trollope stands, catalogue and pencil in hand, be-whiskered, top-hatted, frock-coated, the very picture of a respectable mid-Victorian. Frith was a friend of Trollope, and wrote of him that 'it would be impossible to imagine anything less like his novels than the author of them. The books, full of gentleness, grace, and refinement, the writer of them bluff, loud, stormy, and contentious; neither a brilliant talker nor a good speaker; but a kinder-hearted man and a truer friend never lived.'[4] Frith also questioned whether his novels would survive the test of time. Just behind Trollope Frith included another novelist, Miss Braddon, a very popular writer in her day, and a great friend of Frith, who painted her portrait in 1865. Mary Braddon (Mrs Maxwell) wrote over fifty novels, all virtually forgotten, except *Lady Audley's Secret*. Mostly they were upper-class thrillers, although most stuffy Victorians probably thought them 'shockers'. Behind Trollope is a group of politicians – John Bright, Sir Stafford Northcote, and Gladstone, all Liberals, perhaps indicating Frith's own political sympathies. Gladstone came to Frith's studio to sit for his portrait, but could never stay long because of the pressure of other appointments. Frith kept him talking, 'to catch an animated expression', in which he has succeeded. Gladstone looks as usual, serious, but he is instantly recognisable. To the right of the aesthetic ladies is another

familiar figure with a grey beard: it is the poet Robert Browning, in animated conversation with another lady in a long, aesthetic dress. For good measure, Frith has included himself in the background behind the ladies on the ottoman. Directly behind him is a portrait on an easel; it is the unfinished portrait by Millais of Disraeli, who died before it could be completed. The random way in which the pictures are hung is typical of the Academy; many artists complained about it, but the RAs seemed to prefer it that way. Among the pictures is John Collier's *The Last Voyage of Henry Hudson* (Tate Gallery), depicting the famous explorer who died trying to discover the North-west Passage. Among the other pictures on display that year were works by younger, up-and-coming artists, such as Luke Fildes's *Village Wedding* (Lord Lloyd-Webber Collection) and John William Waterhouse's *Favourites of the Emperor Honorius* (National Gallery of Victoria, Melbourne, Australia). Frith's *Private View* must have looked out of date and old-fashioned, yet it was one of the hits of the year. Frith wrote with pride:

> Pictures composed of groups of well known people are always very popular at the Academy, and *A Private View* was no exception to that rule, a guard being again found necessary to control the crowds of visitors. I may perhaps be pardoned for recording the fact of this picture being the sixth painted by me that has received this special compliment.

The picture was sold to a Dorset brewer called Alfred Pope, whose descendants still own it today. But it was to be the last time a picture by Frith needed a rail to protect it. It remains an extraordinary and unique record, a tribute to his tremendous popularity with the Victorian pubic. Some critics never ceased to resent this popularity, and denounce it as mere pandering to vulgar taste. Hence the word 'vulgarity' is so often applied to Frith's work. The *Saturday Review* wrote snootily that 'It has many of the qualities which attract a mob in a picture gallery. It is all on the surface – just like a straggling crowd – very spick and span, full of portraits of all sorts of celebrities, great and very little, and it is perfectly vulgar.'[5]

The other critics joined in the chorus with glee. Not one of them had a good word to say for it. Frith's old adversary, *The Athenaeum*, was as usual dismissive, comparing Frith's gathering unfavourably with eighteenth-century groups by Rambert or Zoffany, or Dutch pictures by

Teniers or Old Francks (Frans Francken). 'There are some agreeable and soft points of colour and tone in some parts of Mr Frith's picture, but the whole wants homogeneity and massing of the light, shade and colour. Some of the figures stand badly on their feet, and others are unconscious of their neighbours. Again, a much better selection of portraits might have been made.'[6]

The reviewer concluded by suggesting that Millais might have done the job better, a slightly fatuous suggestion, as Millais never painted large portrait groups in his life, and most likely never wanted to. Even *The Times*, normally a supporter of Frith's work, joined in the general denunciation of it, as '. . . the picture which will probably be deemed the great attraction of the exhibition by those whose ideal of art is the illustrated newspaper'. The reviewer liked the subject, but complained that 'in the hands of Mr Frith, there is no disguising the painful truth that the picture is a failure . . . the slightness of the work, the thinness of the painting, the utter superficiality of the whole carry the picture outside the range of criticism'.[7]

There is no doubt that the quality of *A Private View* is not up to the same standard as Frith's earlier modern-life works. But it remains a fascinating picture for us today, reflecting as it does the interaction between Victorian society and the art world. But the critics do seem to have been more than usually venomous. Not one of them bothered to mention Oscar Wilde and the aesthetes, which was for Frith the point of the picture. Perhaps by then jokes about aesthetes were becoming old hat. Perhaps also the secrets of Frith's private life and his second marriage had become public knowledge, and the press had decided to go for him, as they often do when a public figure is discredited. Frith, as usual, took absolutely no notice; he was used to it. He went on painting throughout the 1880s and '90s, mostly repeating or reworking the historical subjects of his younger days. But he was also preparing for a new career – as a writer.

TWENTY

Frith the Writer

There is a young artist called Frith,
His pictures have vigour and pith,
But his writings have not –
They're the kussedest rot
He could trouble an editor with.
Shirley Brooks

After *A Private View*, Frith's career as a painter started to decline, although he was to continue painting for another twenty years. Already in his sixties, he was too old to change his style, nor did he wish to. Unexpectedly, he embarked on a new career, and one very suited to his talents – as a writer. Hearing that Frith was thinking of writing his memoirs, Richard Bentley, a well-known publisher of the day, wrote to Frith offering an advance, 'for a book still in the air,' wrote Frith later, 'for not a word had been written when the offer was accepted'. The result, after several years of labour, was *My Autobiography and Reminiscences*, published in 1887, in two volumes bound in dark green cloth, with a stamped palette, brushes and mahl stick device on the covers. The book was an instant success, and led to a third volume, *Further Reminiscences* in 1888. Frith wrote in the introduction to the third volume of his great surprise at his book's success: '. . . never in the course of what may be called a long life have I experienced anything like the astonishment created in me by the success of my autobiography'.[1] Not only did he receive many complimentary letters, but also many good reviews. Even his old enemy *The Athenaeum* was complimentary, describing the book as 'two highly amusing volumes', and giving it a long review, repeating many of Frith's stories word for word.[2] The *Saturday Review* observed:

When a man of Mr Frith's position, and one who is well known as a good raconteur in private society, determines to give to the general

public the advantage of becoming acquainted with his biography and recollections, it has to be expected that an amusing and entertaining work will appear. Nor will expectation be disappointed.[3]

Even the normally austere and critical *Blackwood's Magazine* praised Frith's audacious pride in his own achievements – 'we congratulate him on his double success, in literature as well as art'.[4] As to his art, the reviewers hoped that it would stand the test of time, even though it seemed hopelessly out of date in 1887; most were hopeful that it would.

It is not difficult to understand the great success of Frith's memoirs. He had had a long life, seen great changes, and had met many famous and interesting people. But it was the gossipy and chatty style of his writing that made it such a hit with the public. Frith was a born raconteur; he had always been famous for his gifts as a storyteller, among his family, friends and around the *Punch* table. Now he was able to put it all down on paper. Frith's life was a success story, in his view achieved not by genius, but by unremitting hard work. He never lost the attitude of a northern boy who had come down to London and made good. The tone of his writing is down to earth, sometimes cynical and worldly-wise, but full of downright Yorkshire common sense and humour. Frith never ceased to be curious, and to be amazed, by the world and its ways. He kept a diary for some of his life, from which he quotes; sadly it has not survived. He also kept a great many letters, and with the aid of his devoted sister-in-law Vicky included the most interesting and entertaining of them. Frith dedicated his third volume, *Further Reminiscences* to his sister; the first two he dedicated to his wife, without saying which one. By this time one can only assume he is referring to his second wife, Mary. As already observed, he makes very few references to his first wife and family at all. Of Mary Alford and his second family, there is simply no mention. Like many Victorian auto-biographies, Frith's is as remarkable for what he leaves out as for what he puts in. Frith puts on his public, official face; over his private life he seems to deliberately draw a discreet veil. Now we can guess why.

Frith also had a good ear for dialogue, and must have had an amazing memory; he quotes large chunks of actual speech in his book. Some of it, he admits, is an approximation to what was said. He is also highly discursive: even in the first two volumes, he often breaks off from chronology to tell us some ghost or murder story, or yet another tale about a model. Models are a constant thread running through the entire

book; one realises just how important they were to Victorian painters, and how few really good ones there were. Frith is also a joker: he can never resist a funny story, even if it is against himself. Much of his humour is gently self-deprecating, a typically Yorkshire characteristic. 'I know very well', he wrote in the first chapter, 'that I never was, nor under any circumstances could have become, a great artist; but I am a very successful one. . . .'[5]

Frith's description of his early days must have seemed to a late Victorian like that of another age. When in 1837 Frith's father died, Frith and his sister decided to bring their mother down to London. There was still no railway, and Frith's mother was an invalid, which ruled out the rigours of the stagecoach. So a large carriage was procured, and they 'posted' to London, stopping about every fifteen miles to change horses and post-boys. The journey took nearly fourteen days. Frith, by then eighteen and already a painter, enjoyed pretending he was a post-boy, and helping with the horses. At one of their stops, he also enjoyed chatting up a pretty barmaid. 'From my youth up I have been, and ever shall be, sensible to the charm of female beauty.'[6] Painting pretty girls was to become one of the main elements of his art; in the 1840s, he contributed to Charles Heath's *Books of Beauty*, edited by Lady Blessington, which were little more than annuals full of 'keepsake' beauties, pin-ups for the Victorian male audience. For a supposedly puritanical age, the Victorians were obsessed by feminine beauty; in art, they could not get enough of it, and Frith was always happy to oblige.

Although Frith's book is hugely discursive, the majority of his stories concern the art world, the world he lived in, and the one which had made him both famous and rich. He pondered a great deal over his success; why was it he had succeeded when so many of his fellow-students and his contemporaries had not? In many cases, it was because they simply had no talent. He recalled the two students at Sass's Academy, Michael Angelo Green, and Claude Lorraine Richard Wilson Brown. In spite of their parents' great aspirations, neither of them achieved the slightest degree of success. Of Green, Frith wrote, 'Without a particle of imagination, he painted pictures which were destitute of every pictorial quality, and refused at all the exhibitions. He tried portraits, which his sitters declined to pay for; and died before he was thirty, a broken-hearted man.'[7] Brown briefly worked as a studio assistant to Wilkie, but thereafter became a drawing-master at a county

school, where his absurd names no doubt continued to haunt him. Even Douglas Cowper, the most brilliant student at Sass's, and a close friend of Frith's, was a failure as an artist. He painted a few pictures, including a portrait of Frith, before his career simply fizzled out. Frith quotes a long and interesting letter from Cowper, describing and criticising the pictures in the RA exhibition of 1838. He saw the young Queen Victoria there, and wrote 'I think her pretty.'8 Frith concludes that an artist must 'fag, fag, fag' (a favourite expression of Sass's) if he hopes to succeed.

At the Royal Academy Schools, the most brilliant student was the child prodigy, Millais, a lifelong friend and colleague of Frith's. Another student was called Potherd, and Frith could not resist telling the story of how Millais encountered Potherd many years later, in Camden Town. Potherd used to wear a long blue coat with a catskin collar. Walking along the street, Millais spotted the blue cloak and catskin collar ahead of him, and drew level.

'"Why Potherd," said he "it is you! How are you?"

"I am pretty well," said Potherd, "and who may you be?"

"I am Millais," said the painter. "Don't you remember me at the Academy?"

"Not little Johnny Millais, surely?" exclaimed Potherd. "Why how you have grown."

"Well, Potherd, I am very glad to see you again. How are you getting on?"

Potherd replied that he was doing tolerably well, and then asked Millais, "And you? Judging from your appearance, I should say you had given the arts the go-by. What do you do for a living?"'

Millais never wrote his own memoirs, and must have been happy for Frith to use this story. It is a typically wry Frith story, emphasising the fragility of fame and success. One can imagine Frith and Millais having a good laugh over it at one of their games of sixpenny whist.9 Frith reflected that many artists, even famous ones, had not received recognition in their own lifetimes. Hogarth, Frith's great hero, had never achieved worldly success; even the great portrait painters, such as Gainsborough, Reynolds and Romney, were always in danger of going out of fashion. David Cox, probably the most popular of all Victorian watercolourists, never received more than £100 for any watercolour in his lifetime. Frith listed a number of Cox's watercolours, and what they had subsequently sold for, one fetching £3,601.10 He might also have quoted the example of Turner, the great speculation of the nineteenth

century, whose works increased hugely in value after his death. Frith wrote more about the example of Constable, whom he met several times, and whose studio he visited with Sass. Constable not only received little recognition in his lifetime, but his works remained out of fashion for most of the nineteenth century. Frith's friend and fellow Yorkshireman, William Etty, only achieved success at the very end of his life, when he retired to York with savings of £20,000. Frith described Etty in a letter to his mother in 1835: 'Etty is a very curious looking man; his head is much too large for his body; he is very much marked with smallpox; in short, he is what is called a regular vulgar-looking, clod-hopping Yorkshire-man.' Etty's appearance concealed a very kindly, gentle character, and Frith was devoted to him.[11] In spite of all these stories of the vicissitudes of an artist's reputation, Frith always remained confident that his modern-life pictures would stand the test of time. He has been proved right.

Frith was always interested in the vagaries of the art market, particularly where it concerned his own pictures. This produced some of his best stories. One concerned a portrait he painted of a Jewish model with a beard, called Ennis, who he posed wearing a fez. He painted the picture in emulation of Sir Thomas Lawrence, an artist admired by all of Frith's generation. Frith also deplored the sale of Lawrence's great collection of Old Master drawings, which the Government refused to buy for the nation. A few years later, Frith was surprised to see what looked like his picture *Ennis Effendi*, as he called it, in a shop window in York. On close inspection, it proved to be a smaller copy of his picture. He enquired of the gallery owner what the price was, and was told two guineas. He was also told it was by a Mr Rivers of Hull. Frith knew Rivers as an old school friend, and about a year later visited his studio in London. There to his amazement, he found his own picture of Ennis hanging over the mantelpiece. When he asked what it was, Rivers replied that it was obvious from its quality that it was by Thomas Lawrence. 'Lawrence eh?' replied Frith, 'the devil a bit; I painted it myself. It's a portrait of an old fellow I found selling apples in the street.'

Poor Rivers, thoroughly deflated, admitted that he had sold at least six copies of it. He could no longer bear the sight of his 'Lawrence', and soon afterwards sold it.[12] The model, Ennis, was another Dickensian old character of the type Frith appreciated. He could remember the Gordon Riots, and picking blackberries in Oxford Street. Frith devoted a whole chapter to him, entitled 'The Bearded Model'.[13] In the end, Frith's

picture of Ennis was sold at Christie's, correctly catalogued, and came to rest in a grand house in Grosvenor Square.

Another story concerns an early self-portrait, which a friend of his spotted in a shop in Great Portland Street. Frith went there, found the picture hanging in a shabby gallery at the back, and enquired whose portrait it was.

'That,' said the lady, 'is a portrait of the celebrated artist, Frith, painted by himself.'

On asking the price, Frith was told it was £20. Frith thought this excessive, but the lady insisted.

'You see, it is very valuable, because the artist is diseased.'

'Deceased,' Frith exclaimed, 'Dead, do you mean?'

'Yes, sir, died of drink.'

'Surely,' Frith exclaimed, 'you have made a mistake!'

'About the drink? Oh no, sir; most artists is very dissipated. He was dreadful, Frith was. I dare say you have seen the print called "The Railway Station". Well, my husband used to see him when he was doing of it, always more or less in liquor. . . .'

Frith responded that a friend of his had seen Frith only the other day.

'Not Frith, your friend didn't. How could he? When he's dead and buried, as well I know, for my husband attended his funeral!'

Not giving himself away, Frith bought the portrait, took it home, and no doubt dined out on the story for many years afterwards.[14]

One subject that Frith returned to again and again was the hanging committee at the RA. He had to serve on the committee about once every eight years and found it a gruelling experience. In 1888 the committee had to inspect no less than 9,385 works, of which they selected 2,007. In other words, over 7,000 works were rejected. It took eight days of hard work to go through them all. Then came the problem of fitting in the 2,007 that had been selected, something of a giant jigsaw puzzle. All this has to be seen against a background of eager anticipation and bitter disappointment for the artists involved. Frith and his fellow RAs received endless requests for favours, and often furious complaints from those whose pictures had been rejected, or badly hung. One enraged exhibitor broke a stick over the head of the unfortunate RA secretary John Prescott Knight. After this, it was decided that in future the position of secretary should be filled by a salaried outsider and not by an RA as it had been in the past. In Frith's younger days, it was difficult to find out if your pictures had been accepted or rejected,

leading to much anxiety and distress among the RA students, and also disaffection. Frith, although he never had a picture rejected, was sensitive to these complaints, and did as much as he could to alleviate them. Nonetheless, he remained constantly amazed at the capacity for self-delusion among aspiring artists, and quoted Robert Burns:

> See ourselves as others see us,
> It wad frae monie a blunder free us,
> And foolish notion.[15]

The other topic that recurs again and again is that of models. Artist and models had a love–hate relationship; artists could not do without them, yet they caused endless trouble, usually being late, drunk, unreliable or thievish. They were a necessary evil. With Frith's Dickensian eye for character, he could not resist writing about them. The one he relished the most, as we have already seen, was Bredman, the 'pious model', who extorted money from Frith and others for his totally fictitious wife and children. A group of artists, including Frith, clubbed together and paid for his passage to Australia. In the third volume of his *Reminiscences*, Frith quoted a long letter from Bredman, describing the diggings at Ballarat. Bredman painted a picture of almost complete lawlessness, with a hopelessly small police force trying to control over 50,000 miners and speculators: '. . . there is a lot of scamps of all nations,' wrote Bredman. 'But the worst of all countries is the Irish and Cornish people. For impudence and ignorance there is none equal to them.' Bredman, however, had reformed and was running a bookshop selling religious works; he attended the Wesleyan chapel.[16]

The curse of the modelling classes was drink. Frith had already had to dismiss one model, called Green, for drinking.[17] Another model, the beautiful wife of a doctor, called Rose, turned out to be an alcoholic. She proved a good model, until one night the doctor came to Frith's house, clearly very distressed, and confessed that his wife was 'lying maudlin drunk on the sofa at this moment, and I see now she has been drunk night after night'. In spite of sending Mrs Rose to a finishing school in the country, to attempt a cure, she returned to her old ways. About two years later, Frith received a visit from the agitated doctor, saying that his wife had reverted to her old habits, and could he come with him round to Harley Street. When they reached the house, Mrs Rose could not at first be found. Frith 'met a frightened footman,

The Artist's Model, 1859. Frith devoted much space in his book to writing about models. *(Johannesburg Art Gallery, South Africa)*

who pointed to the surgery. We entered, and found Rose on his knees by the dead body of his wife. The smell of prussic acid that seemed to fill the surgery told the fate of the miserable girl.'[18]

Another Frith speciality was mysterious and beautiful ladies who appeared either wanting to model, or sit for their portraits, usually

asking for complete secrecy. One of these, although beautiful and a good sitter, turned out to be mad, and ended up in an asylum. Her husband, who knew nothing about the portrait, did the decent thing and paid for it.[19] Another lady, calling herself Clara Street, turned out to be having an illicit affair with an army officer, Captain Hill, even though she was engaged to another man called William Rivers. This long and rather tortuous story so intrigued Frith that he devoted a whole chapter to it.[20]

Even worse were models who could not sit still, or fell asleep, like the orange-girl in Frith's RA Diploma picture, *The Sleepy Model*. Equally bad were models who never turned up on time. Miss Jenny Trip, who modelled for the aesthetic lady in the *Private View*, had to be sacked by Frith for repeated unpunctuality. The boy who modelled for *The Crossing Sweeper* turned out to be an artful dodger and thief, who tried to purloin Frith's watch and chain. Frith was told by a policeman that the 'boy is one of the worst thieves in London; he's only just out of prison'. Apparently, his whole family were thieves.[21] The problems of models naturally led on to that of servants, to which Frith also devoted a chapter. They too, were plagued by drink, and Frith had to sack a butler called Johnson who kept breaking crockery and glasses, and missing the teapot when pouring the hot water. Frith sacked him, and Johnson took to wheeling old ladies in bathchairs round the park. Unfortunately, he usually went to the nearest pub for a quickie, and forgot all about them.[22]

Somewhat surprisingly, Frith devoted a chapter in his book to lady artists, of whom he was a keen supporter.[23] Although two of the original founders of the Royal Academy had been women, Angelica Kauffmann and Mary Moser, there had been no female ARAs or RAs since then. Frith had done his stint as a teacher at the RA Schools, where he was enormously impressed by the standard of the lady students' work. 'Here, then,' he predicted, 'we have students armed with the means of producing good, even great pictures.' He looked forward to seeing them, and cited Elizabeth Thompson's *The Roll Call* (HM the Queen, Royal Collection), a sensation at the RA of 1874, as an example of what could be done. Among Victorian artists, he singled out many ladies married to painters, such as Henrietta Rae (Mrs Ernest Normand), Mrs E.M. Ward, Alice Havers (Mrs Fred Morgan), Kate Dickens (Mrs C. Perugini), Lady Alma-Tadema, Isabel Dicksee, Mary Gow, and Mrs Seymour-Lucas. He also praised lady watercolourists, in particular Helen Allingham, whom he greatly admired. He confidently predicted female RAs in the future; even 'a female President is not impossible'. That prophecy has not yet

come true, but in 1936 Dame Laura Knight became the first lady RA since the eighteenth century.

One lady artist whom Frith both advised and helped was Louise Jopling. She was a petite and pretty woman, and her portrait by Millais is now in the National Portrait Gallery. She needed help not only to become an artist, but also to obtain a divorce from her first husband. Frith and Shirley Brooks put their heads together, and helped her on both counts.[24] Jopling later wrote her memoirs, and recorded that Frith had advised her against the RA Schools: 'She has originality, and she may lose it there!'[25] She attended Leigh's Academy instead, and went on to become a successful painter, exhibiting at several London galleries. She re-married, happily, the watercolourist, Joseph Middleton Jopling. Louise Jopling also recalled that when she called at Frith's house, the maid thought she must be a model, and told her 'in a most supercilious manner, "The models' entrance is round the corner!"'[26]

Frith reserved his greatest praise for the French artist Rosa Bonheur, 'whose name will never die'. In 1868, Frith and Millais visited the International Exhibition in Paris, where they were impressed by the grand studios of Meissonier and Detaille, far grander than those of Millais and Leighton in London. Gambart also took them out to Fontainebleau to meet Rosa Bonheur. At the station was a carriage, with a coachman who looked like a French abbé. This turned out to be Madame Bonheur, who was also wearing the red ribbon of the Légion d'Honneur. They lunched at her chateau, and Gambart mentioned that Landseer had praised a work of hers on show in London; 'her eyes filled with tears as she listened', wrote Frith. Gambart also took them to visit Sarah Bernhardt at her studio, where Frith greatly admired her sculpture. She told Frith that she hated acting, and would far rather be an artist. In her studio, she dressed as a boy. Frith went to see her perform in several plays, and thought her 'by far the greatest actress I ever saw'.[27]

Frith, as we have already seen, wrote about several of his patrons, such as Thomas Miller, John Gibbons and John Sheepshanks. He also devoted a chapter to the by then legendary William Beckford, whom he encountered at Phillips auction rooms. 'He was a short man,' wrote Frith, 'dressed in a green coat with brass buttons, leather breeches, and top-boots, and his hair was powdered.' Frith had just read *Vathek*, so was fascinated to see its author, who was studying a supposed Raphael. Beckford cursed and swore, denouncing the picture as nothing to do with Raphael, and stalked out.

Frith also recounted how a cousin, for a bet, made his way into the park at Fonthill Abbey, Beckford's huge gothic folly in Wiltshire. He found a gardener, who showed him round all the gardens and hothouses. He then offered to show him round the abbey as well. Having toured the house and its treasures, the gardener said it was five o'clock, and could he stop and have some dinner?

'No, really, I couldn't think of taking such a liberty. I am sure Mr Beckford would be offended.'

'No, he wouldn't. You must stop and dine with me, I am Mr Beckford.'

The dinner was magnificent, and served on massive plate, with superb wines; Beckford's conversation was equally brilliant. After dinner, the visitor nodded off in his chair by the fire; when he awoke, Beckford had disappeared. A footman showed him to the door, with the words: 'Mr Beckford ordered me to present his compliments to you, sir, and I am to say that as you found your way into Fonthill Abbey without assistance, you may find your way out again as best you can; and he hopes you will take care to avoid the bloodhounds that are let loose in the gardens every night. No, thank you sir, Mr Beckford never allows vails (tips).'

Frith's cousin climbed into a tree, and waited for dawn before escaping from the park. He won his bet, but said he would not do it again, however high the stake.[28] Frith's readers no doubt enjoyed his stories of this kind. The Victorians had a limitless appetite for stories about the Duke of Wellington, and naturally Frith had a few of his own. The Duke was a patron of Landseer, and a very generous one; when Landseer asked for 600 guineas for a picture of Van Amburgh the lion-tamer, the Duke wrote out a cheque for 1,200. On another occasion, Landseer was being shown round the pictures at Apsley House. The Duke prided himself on knowing the names of all the artists in his collection from memory, but when Landseer asked about an Elizabethan portrait, the Duke was stumped. He left the room; Landseer went on looking around the pictures, and had almost forgotten about the portrait, when a voice in his ear whispered, 'Bloody Mary!'[29]

Landseer was also a great raconteur, and often asked Frith to come over 'and dirty a plate' with him. Landseer told him another good story about Nollekens, the sculptor, and the Prince Regent, later George IV. Nollekens was completing a bust of the Prince, and leaned forward to blow some dust off the Prince's collar. As he did so he enquired:

'How's your father?'

The King was just recovering from one of his fits of madness.

'Thank you Mr Nollekens, he is much better.'

'Ah, that's all right!' said Nollekens, 'It would be a sad thing if he was to die, for we shall never have another King like him!'

'Thank you,' said the Prince.

'Ah, Sir, you may depend upon that!' replied Nollekens.[30]

Landseer was the source of many of Frith's stories, including several about the legendary dandy and artist Count d'Orsay.[31] Like many of his contemporaries, especially his literary friends, Frith was fascinated by anything to do with murderers, executions, burglaries, ghosts and lunatics. Even in the first chapter of his memoirs, Frith describes how a madman tried to murder a fellow-guest in his father's hotel in Harrogate. Frith's friend William Mulready attended the trial of the celebrated murderer John Thurtell, and made drawings of Thurtell and his accomplices Hunt and Probert, which he no doubt showed to Frith. Thurtell was hanged, and plaster casts were made of his head and limbs, some of which found their way to Sass's Academy, where the students drew from them. The Victorians, with their belief in physiognomy, were obsessed by the criminal type, and how to identify it.[32] Frith certainly shared this fascination, and prided himself on his ability to deduce character from looking at someone's face. He went with a friend to a trial at the Old Bailey, and tried to guess who the guilty party was. He was pleased to learn later that he had got it right – it was the parson, who was sentenced to five years' penal servitude.[33] Later Frith was to use the Old Bailey as a setting for one of his *Race for Wealth* pictures. Frith was certainly interested in physiognomy, without ever studying the subject in depth. He needed to know about facial types and facial expressions, but a deeper knowledge was not really necessary to him. Being the sceptical Yorkshireman he was, he must have realised that physiognomy had its limitations. He was certainly sceptical about phrenology, which was demonstrated at Sass's by one Deville. Frith wrote about him, and his strong cockney accent, in a letter to his mother in 1836. Deville would say, examining a head, 'now ye see this 'ere horgin', pointing at the same time to an immense lump, formed probably by some unlucky thump, 'this is a wice deweloped; and this', pointing to another, 'is wice wersa'.[34]

Frith, like the French painter Gericault, and many other artists of the period, was fascinated by insanity and visited asylums to study the

inmates. In his memoirs, Frith devotes a chapter to 'Asylum Experiences', and to spirit-rapping and table-turning, both of which he was highly sceptical about.[35] Insanity he took more seriously, as he had a real-life example close to hand in the story of his poor friend Richard Dadd, to whom he devoted a chapter.[36] He also quoted a very long letter from Dadd, written from Jaffa in 1842, in which Dadd described excitedly all that he had seen and done. Prophetically he wrote that, 'At times the excitement of these scenes has been enough to turn the brain of an ordinary weak-minded person like myself, and often I have lain down at night with my imagination so full of wild vagaries that I have really and truly doubted my own sanity.'

Frith was above all proud of his literary acquaintances – Dickens, John Forster, Bulwer Lytton, Thackeray, Trollope, Ouida, Mrs Henry Wood and Miss Braddon among them. The one he knew best, and whose friendship he valued the most, was Dickens. As a result of Dickens's commission for the two pictures of *Dolly Varden* and *Kate Nickleby*, the two men became friends and correspondents thereafter, united by their joint love of stories, jokes and the theatre. Frith was proud of having painted Dickens's portrait, and devoted a chapter to Dickens and John Forster, who commissioned it.[37] He was not too proud, however, to record one comment made by a lady friend about the portrait, 'What has Dickens done to you that you should paint him like that?'[38] Frith and Dickens were both from similarly modest middle-class backgrounds, and there is no doubt there must have been some affinity between them. In the third volume of his memoirs, Frith devotes a chapter to Dickens, and quotes several of his letters. None are particularly interesting, though in one Dickens refers to the print of Frith's *The Railway Station*. The publisher of the print, our old friend Flatow, had plastered all over London notices which read 'THE RAILWAY STATION IS COPYRIGHT'.

'Do you know, Frith,' said Dickens, 'the streets of London are unpleasant enough without that warning voice of yours. The sight of that 'Railway Station' threat struck terror into one this morning. I hurried in a guilty way past it, and didn't feel safe till I had left it a street or two behind me.'[39]

Dickens also asked Frith to look at a picture at the RA based on one of his books; Dickens wrote, 'I don't like to be caught looking at it myself.'[40] Through Dickens, Frith met Bulwer Lytton, whose novels he greatly admired. Frith records Lytton's ambitions to write for the

theatre.[41] Frith was proud of his theatrical friends, and recounts many of his theatrical experiences. His closest actor friend was Henry Sothern, of Lord Dundreary fame, who accompanied Frith and his friends on several family holidays. Sothern, like Frith, was a joker, and they both enjoyed practical jokes and those grindingly bad puns of which the Victorians were so fond. As a young man, Frith saw all the great actors of the day – Charles Kemble, Macready and the Keans, father and son – and wrote about all of them. Later in life, he was proud to record meeting Squire Bancroft, actor-manager of the Haymarket, Henry Irving and Ellen Terry, who sat for his picture *A Private View*. Typically, Frith could not resist telling a story about Terry and Irving, who were both performing at the Lyceum. On leaving the theatre, Terry found the stage door besieged by Irving's adoring lady fans, who asked when the great man might be leaving the theatre.

'"That is more than I can say," replied Terry. "I don't think he has begun his supper yet."

"Oh, do tell us what he has for supper," said a shrill voice.

"Well," said naughty Miss Terry, very gravely, "let me see. Tonight – well, tonight I think it is tripe and onions."'[42]

The stories recounted here are but a small selection; there are literally dozens more. Those who criticised Frith's book described him as garrulous, which is a fair comment. As a member of the Athenaeum and the Garrick, Frith had ample opportunity to pick up the latest gossip, stories and jokes circulating in the world of art, literature and the theatre. Many of his stories are unique, and cannot be found elsewhere; some are not new. What is amazing is how much he wrote down or remembered, and the lively recounting of those stories perhaps explains why the book appealed so hugely to his fellow Victorians. At the end of the second volume, not expecting to write another, Frith delivered a homily on the dangers facing English art: 'A new style of art has arisen, which seems to gratify a public ever craving for novelty. Very likely I am posing as the old-fashioned Academician . . . when I declare that the *bizarre*, French 'impressionist' style of painting recently imported into this country will do incalculable damage to the modern school of English art.'[43]

Frith was becoming a professional reactionary, a role he was to play for the rest of his long life. There were still another twenty years to go.

Old Age
1884–1909

Even Frith himself was reluctant to write much about his later work. In his memoirs he wrote, 'As I approach the present time, I feel more and more reluctant to speak of myself and my doings . . . I shall content myself by noting very shortly my professional work of the last few years.'[1] He admitted that his contributions to the RA of 1884 'were of very scant attention'. One was *Dr Johnson and Miss Siddons*; another, *Cruel Necessity*, was of Cromwell contemplating the body of King Charles I, a subject painted by Delaroche over thirty years before. Frith simply went on repeating the historical pictures of his youth – John Knox, Sir Roger de Coverley, Mary Stuart, Juliet and her nurse, Charles II and Lady Castlemaine, and so on. He went on exhibiting at the RA until 1902, by which time he was over eighty, and the oldest surviving RA. He occasionally painted portraits, such as *Mrs Alfred Pope* (RA 1885), and some charming pictures of children, such as *The Sick Doll* (RA 1886), and the usual pictures of pretty girls, entitled *Violets*, *Matchsellers* and the like. He attempted only one more modern-life scene with a message, *Poverty and Wealth* (RA 1888) (Plate 12). This shows a rich family in an open carriage passing a poor family huddled on the pavement. As social comment it is weak and unconvincing; it looks more like a scene from *My Fair Lady* (based on Shaw's *Pygmalion*). Frith's colours become gradually thinner and drier, his outlines more scratchy. He was not averse to producing late copies of his earlier triumphs; there is even a version of *Ramsgate Sands* dated 1905. *Poverty and Wealth* might also be seen as an ironic comment on Frith's declining finances. In 1888 he and his wife Mary, and five of their children, sold Pembridge Villas, and moved to a suburban address in south London, Ashenhurst, Sydenham Rise, Forest Hill. It was near Crystal Palace, and Frith's old friend Millais wrote that he envied him being able to go and 'look at the Mastodon and Ichiosaurus (can't spell

it) in the middle of the fountains, whilst here I only see mist'.[2] Frith was also forced to take on pupils, something he had never done before.

No doubt encouraged by the great success of his *Autobiography*, Frith decided to devote more of his energies to writing. The first fruits of this new urge was a long article in the *Magazine of Art* in 1888, entitled 'Crazes in Art – "Pre-Raphaelitism" and "Impressionism"'.[3] Unfortunately, this is little more than a reactionary rant, which can only have appealed to the older generation. To the younger generation it

Dr Johnson's Tardy Gallantry, 1886. Dr Johnson escorts Mme de Boufflers to her carriage. *(Photo: Sotheby's, London)*

must have seemed both ridiculous and unnecessary; an attempt to fight over again battles that had been long since lost. Frith opened by stating that 'knowledge of drawing (only to be acquired by severe early training) is an absolute necessity for all who desire to arrive at excellence in art . . .'. He then qualified this by admitting that some artists, such as Reynolds or Lawrence, never learnt to draw properly, but overcame this through their natural genius for painting. Frith then sketched a brief history of English painting at the beginning of the nineteenth century, mentioning Wilkie, Mulready, C.R. Leslie and Maclise as following 'true principles'. He then launched into that 'band of young men who called themselves Pre-Raphaelite Brethren . . .'. Although Frith admitted their 'honesty and sincerity', he condemned their ideas as simply wrong-headed. 'Ugliness and angularity took the place of beauty and grace,' he claimed. He also condemned Pre-Raphaelite landscape as something 'the Old Masters were too wise to try', namely painting in midday sunlight. The result, he claimed, with some justification, was a lack of breadth and atmosphere. In a clear reference to Ruskin, he continued, 'This ridiculous movement received the support of a brilliant writer, whose judgement, always expressed in admirable language, is, I hold, often utterly mistaken and wrong. . . .' An interesting comment, coming from a man who had appeared in Ruskin's defence at the *Whistler* v. *Ruskin* trial. Although Frith does not mention Millais by name, Frith also wrote that the Pre-Raphaelite movement 'had the advantage of the co-operation of a distinguished proselyte, who, after producing the best examples of a wrong-headed school, has shaken the dust from his feet and left Pre-Raphaelitism to an almost solitary apostle'. By this he must have meant Holman Hunt. Frith is here not only fighting a battle of nearly forty years earlier, but is choosing to ignore the romantic strand of Pre-Raphaelitism carried on by Rossetti and his many followers – Burne-Jones, Frederic Sandys, J.W. Waterhouse, just to name a few. He claimed that the Pre-Raphaelite craze had long since run its course, an absurd distortion of the facts.

But in its place had arisen 'another, and far more dangerous craze. . . . Born and bred in France, what is called <u>Impressionism</u> has tainted the art of this country. It is singular that this phase of art, if it can be called art, is in exact opposition to the principles of Pre-Raphaelites. In the one we had overwrought details, in the other no details at all.' The New English Art Club, intended as a focus for the influence of French Impressionism, had been founded only two years before, in 1886.

Ironically, one of its founder members was Whistler. Frith also took a swipe at him in the same article, referring contemptuously to 'nocturnes' and 'symphonies' as another 'pernicious example'. Frith hoped that, 'the "Impressionists" will not be allowed to play their pranks in the Royal Academy exhibition . . .'. He had already noticed that pictures he could not comprehend were finding buyers at the RA, probably because 'the buyer thinks it very wonderful because he cannot understand it' – a complaint to be levelled by the philistine against most modern art of the twentieth century. But Frith was sublimely confident that 'the craze itself will as assuredly pass away as everything foolish and false does sooner or later'. And pass away it eventually did, to be replaced by Post-Impressionism, Fauvism, Cubism and all the other-isms of the twentieth century. Although Frith lived long enough to see the beginnings of modernism, he did not write about it. He was too old, and he must have thought the world was going mad. His article in the *Magazine of Art* can only have confirmed the public perception of him as a reactionary old relic. The magazine was normally highly progressive in its outlook, and a keen supporter of modern art. They almost certainly published Frith's article as a curiosity, a tribute to a famous artist of a bygone age, but not something to be taken seriously. It was probably commissioned as a result of the great success of Frith's *Autobiography*.

In 1891, Frith published another book, the biography of his friend John Leech, who had died in 1864. It was published in two volumes by Richard Bentley, the publisher of his *Autobiography*.[4] By 1891, there were not many people around who could remember John Leech; he was already a legendary figure from the early days of *Punch*. For Frith it was a labour of love; a tribute to an old and much-loved friend. But it was also a tribute to someone he regarded as a great artist, the greatest of all the *Punch* cartoonists. It was also perhaps an acknowledgement that it was Leech, more than any other artist, who had helped and encouraged him to paint modern life. Frith was repaying an old debt. Unfortunately, the result was not a good book. Like his *Autobiography*, it was long and discursive, and full of jolly stories about hunting. But, as a biography, it was a failure. It lacked an index, and devoted far too much space to the many obscure books and articles that Leech had illustrated. Where Frith's own *Autobiography* was lively and entertaining, the Leech biography is merely tedious. It has long been superseded by more up-to-date books.[5] But it was a homage that Frith felt compelled to pay.

In 1895, Frith's second wife, Mary, died at the age of sixty. A shadowy figure in life, so she was in death. She died at 7 Sydenham Rise in Forest Hill, Surrey. Frith himself never mentions her, although there may have been something about her in his lost diaries. Frith was now seventy-six, and widowed for the second time. He moved, finally, from Pembridge Villas to a house in Clifton Villas in St John's Wood, where he was to live for another fourteen years. It is on this house that the London County Council have seen fit to place a blue plaque, even though Frith only lived there at the end of his life.

As old age closed in, Frith led an increasingly quiet and private life, out of the public eye at last. The old century grew to a close; in 1899 Frith reached the age of eighty. In 1901, Queen Victoria, Frith's exact contemporary, and once, long ago, his friend and supporter, died. It was the end of the Victorian age, the end of one of the greatest and most remarkable eras in English history. The 1890s had also seen the deaths of many of Frith's contemporaries – Millais, Leighton, Burne-Jones, William Morris, even Ruskin, who died in 1900. Frith must have felt that death had forgotten him; now he really was a relic from another epoch. In 1902 he exhibited his last picture at his beloved Royal Academy. Dogged to the end, he carried on painting in his old style, repeating himself, even when he must have known that his art was completely out of date. His warnings had not been heeded; his article about 'Crazes in Art' had done nothing to halt the relentless march of modern art. He found himself in a new century, a new world, in which there seemed to be absolutely no place for him. Such is the fate of artists who have lived too long, and fail to move with the times. But fate was to intervene; unexpectedly, he was to get his reward in the end.

The next glimpse we have of Frith is in 1906, with the publication of an article in the *Cornhill Magazine*. Entitled 'A Talk with my Father, Aetatis Suae LXXXVIII', the piece was written by Frith's son Walter.[6] He was Frith's fifth son, by Isabelle, and tenth child. By profession a barrister, he also worked for a time at the Royal Academy. Walter sets the scene in Frith's dining room and painting room; on the easel is a replica of *An English Merrymaking*, which Frith first painted in 1846. He has just finished painting the replica, nearly sixty years later. The conversation, between Pater and Filius, is chatty, relaxed and affectionate. Frith offers his son a cigar, and recalls how Turner had praised *An English Merrymaking* as 'beautifully drawn, beautifully composed, and beautifully coloured . . .'.

They discuss Frith's student days at Sass's Academy, and Frith recalls how he used to paint heads, then sell them at an auction room nearby, usually for a few shillings. He also tells the story of his portrait of the bearded model in the fez, *Ennis Effendi*, which was bought by an artist called Rivers, who believed it was a Lawrence, and made copies of it. Now Frith reveals that the artist was his Yorkshire friend Thomas Brooks, not Rivers. He had used the name Rivers in his autobiography to spare Brooks embarrassment. Brooks had become Rivers! As Brooks had died in 1891, Frith now felt it was all right to tell the story.

Most of the stories Frith relates in the article had already appeared in his *Autobiography*. He recalls the hanging committee at the RA, and how one of Constable's pictures was rejected by mistake. He remembered visiting Constable's studio, and how it was full of unsold pictures. They discussed some of Frith's sitters such as the actress, Miss Laura Herbert, who had sat for *Derby Day*, but was then annoyed because Frith did not include her in the finished picture. Then there was Miss Gilbert, the pretty horse-breaker, who died tragically young of consumption. Frith imitated her cockney accent, saying that she would never marry Tattersall – 'I wouldn't 'ave him, not if every 'air of 'is 'ead was 'ung with a diamond!'

Frith recalled many of his fellow artists: Fred Walker, who was always whistling, and was in love with one of Ansdell's daughters; Thomas Creswick, who helped him with his landscapes; E.M. Ward, whose father worked as a clerk in Coutts Bank, where none of the staff were allowed to wear beards. Frith talked at great length about Lord Northwick, Nelson and Emma Hamilton, remembering Lord Northwick's high, squeaky voice, saying '*De-ah* Lady Hamilton!'; he also told again the story of Robert Huskisson, the fairy painter, at dinner at Lord Northwick's, and his terrible accent. No doubt Walter Frith had heard all these stories before, many times. Then there was *Derby Day*, and Jacob Bell insisting that a rail be put up to protect it. Frith could remember the Royal Academy exhibitions at Somerset House, and then at the National Gallery. He thought the general standard of paintings at the RA had improved enormously; many of the pictures shown in the old days would be rejected now. He also praised the standard of drawing in the RA Schools: 'I saw some the other day, and I'm sure I couldn't have done them. Never, at any time.' He mentioned many of the 'Pictures of the Year' that he could remember, from Wilkie and Landseer in the 1840s, up to Frank Bramley's *Hopeless Dawn* (Tate Gallery) of 1888.

King Charles II and Lady Castlemaine, 1899. One of Frith's last historical pictures, harking back to his *King Charles II's Last Sunday*, painted over thirty years earlier, in 1867. *(Photo: Christie's, London)*

Finally, Walter congratulates his father on looking well for his age. Frith replied, 'I never was in bed except with the measles, when I was four. . . . I remember our old nurse, Jane, lifting the sheet to show my mother how covered with spots I was. "Just look at his carcass mum" she said. Those were her very words, I can hear her now.' All no doubt recounted in a Yorkshire accent. With that, Walter took his leave: 'Filius – "Well goodbye! It's a horrible night. Don't you come out." Pater – (chuckles) "I wasn't going to."'

Clearly Frith, aged eighty-eight, was still in full possession of his faculties, and had lost none of his old zest for life.

At about the same time, we catch another glimpse of Frith, this time from one of the leading artists of the younger generation, Stanhope Forbes, the founder of the Newlyn School of Artists in Cornwall. In 1935, Forbes read a paper at the Penzance Library entitled 'Some Story Pictures'. He recalled his early visits to the Royal Academy:

In the first Academy exhibition which I can remember the story-telling picture still abounded and the catalogue was quite good reading, so full of quotations and little extracts descriptive of the pictures. A few of the famous old Victorian painters still remained with us. I remember on one of the first years after I was elected an Associate, I was standing at the top of the staircase in Burlington House when I saw an old whiskered gentleman come toddling up leaning on an attendant nurse. I offered him my arm for I recognised him at once: Mr Frith, the painter of the *Derby Day*, and though we young painters were at that time rather apt to be critical of his work, I recollect I was quite thrilled by the meeting, for he seemed to my young imagination such a link with the great Victorians, Dickens, Thackeray and the rest, whom I had been brought up to revere. I recall how puzzled he was by the work of us young painters of that day. I wonder what he would have said had I piloted him round these last few years.

You all know those famous pictures of his, the *Derby Day*, *Ramsgate Sands*, *The Railway Station*. Perhaps Frith cannot be accounted a fine artist in the highest sense of the word. It was not the sunshine on Epsom Downs, the bright colours of jockeys, or horses, or the tone and colour of those masses of people watching the great race that attracted him. Effects of sunshine and shadows on the crowds which thronged the Sands, and the smoke and gloom of Paddington station did not so greatly appeal to him, but what he was interested in was the character and appearance of that wonderful collection of humanity that people his canvasses, and he drew and painted them with extraordinary skill and fidelity. He invested the little personages of his painted dramas with life and movement, noting every detail of dress and character faithfully and correctly, and these, his little puppets live like the creations of his great contemporaries in literature.

His pictures, apart from their artistic value, which is by no means negligible, will always remain as quite invaluable records of times and manners, which though not so very remote have already so greatly and markedly changed.[7]

Forbes then goes on to discuss the Pre-Raphaelites. This fascinating passage not only gives us a vivid picture of Frith, the venerable Academician, tottering up the stairs of Burlington House; it also reveals the attitudes of the younger generation. Although Forbes is generous in his judgement of Frith there is also an unmistakably condescending tone about it. By 1935, Victorian art could not have been more out of fashion; Roger Fry, Lytton Strachey, Clive Bell and the writers of Bloomsbury had already tried to consign it to historical oblivion, so we should not be surprised at Forbes's remarks, even though they are manifestly unfair, and biased. He is accusing Frith of not being an Impressionist – rather a pointless accusation. Frith was a man of his time, so was Stanhope Forbes. The Victorian writer A.C. Benson in his memoirs *As We Were*, published in 1930, was more just:

The blue riband of the Academy was probably awarded on the day of the Private View, when the smart and privileged crowd in frock-coats and bustles and waists were really more intent on pictorial art than each other. They clustered, they broke up, they formed again, and soon they arrived at the verdict which the popular taste generally endorsed, when next day the gallery was open to the public. *Derby Day* was not only the most popular picture of the year, but for many years the most widely known picture in England. . . . The coaches, the gipsies, the fortune teller, the sky, the bookmakers, the horses were all rendered with the most minute finish, every quarter-inch of the picture was in focus; you might say it was an infinite number of little pictures put together with extreme skill.[8]

Walter Frith's article, 'A Talk with my Father', in the *Cornhill Magazine* in 1905, had one rather unexpected consequence. Unknown to Frith, it was noticed by King Edward VII, whose wedding Frith had painted forty-two years earlier. The King decided to give Frith a surprise. On 9 January 1908, Frith's eighty-ninth birthday, he was summoned to Buckingham Palace and invested with the CVO, the Commandership of the Victorian Order. The King, no doubt, was both welcoming and charming, and he and Frith must have reminisced about the picture that had caused him so much trouble back in the 1860s. So Frith at last had his reward, the honour which Queen Victoria had so signally failed to give him. The King must have felt that it was time to forgive and forget; Frith was an old man, and had outlived both his wife

and his mistress. King Edward was a man of the world, and certainly knew all about mistresses. He had a great many more than Frith, although he did not father children by any of them as far as we know. So, ironically, Frith had to wait for the more morally indulgent Edwardian era to receive the honour denied him in the Victorian age.

The award of the CVO was widely reported. *The Sphere* published a large photograph[9] and *The Graphic* a whole page interview.[10]

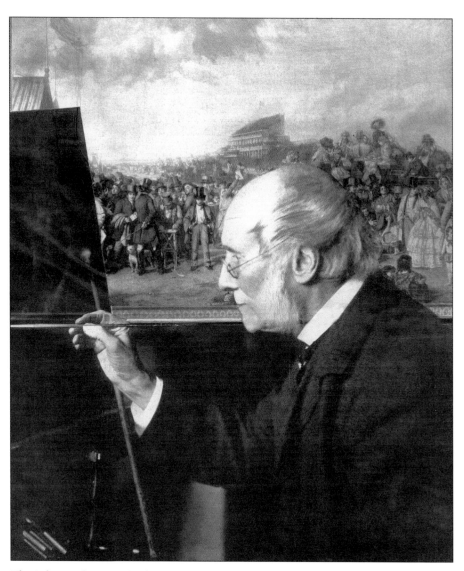

The Sphere. Photograph of Frith in 1908, published to celebrate his award of the CVO by King Edward VII, whose wedding he had painted in 1863, forty-five years earlier.

It described Frith as 'Quitting the royal presence in the highest of spirits, and further sustained by his unfailing sense of humour. . . .' He then went home for lunch, received visitors in the afternoon, and then 'went out in the evening to a grand dinner party given in his honour, dined amid trophies of laurel leaves, and made a capital speech full of point and humour, and as midnight approached drove home one of the brightest and least fatigued of the party . . .'. The writer hailed Frith as 'The very type of hale and hearty old age . . . with nothing of old age about him but his years, his whitened beard and a slightly bent back. Long may he remain among us!' In the centre of the page was a photograph of 'the veteran artist' in his studio; on the easel is another version of his *At my Window, Boulogne*, first exhibited at the RA in 1872. Even as late as 1908, Frith was producing replicas of earlier works. He looks remarkably fit and spry for his age.

The interview ranged over Frith's long career, repeating many familiar stories, particularly about *Derby Day* and how he had come to paint it. Frith claimed that he disliked horses and racing, and that he had only been to Epsom twice, in 1856 and 1865. He also recalled that it was a visit to Kempton Park races in 1854 that had given him the idea for *Derby Day*. He said to one of his companions:

Here is a scene I'd like to paint – 'modern life' with a vengeance.

'What' said my friend, 'all this scene – these groups and tents and sports, the jockeys, course, stands, and all the rest? Why it's impossible to get all that into a canvas.'

Impossible? I don't know so much about that. . . .

Of the Prince of Wales's wedding, Frith recalled: 'It gave me so much trouble . . . that I'll paint no more pictures of Royal ceremonies. If you take my advice, you won't paint 'em either.'

The interviewer concluded by saying that Frith's honour was richly deserved, and hoped that 'he may live long to enjoy it and perhaps – who knows – to climb higher still'. This seems to hint at a knighthood, but it was not to be. Neither Frith nor King Edward would live long enough.

The following January, in 1909, Frith reached his ninetieth birthday. King Edward, staying at Elvedon in Essex, sent him a telegram of congratulations. Frith was not to survive another year. He died, in his sleep, on 2 November. He remained active and alert up to the end.

On Saturday 1 November, he caught a chill which turned to pneumonia, and he died the next day, two months short of his ninety-first birthday. King Edward died the year after, on 6 May 1910. So Frith had lived through both the Victorian and Edwardian eras. It was a long and extraordinary life; very few Victorian artists lived so long, or enjoyed such huge success as he did; even fewer wrote about their careers so entertainingly. Frith deserves to be remembered, both for his pictures and for his remarkable *Autobiography*.

Considering how much money he had earned in his lifetime, Frith died comparatively poor. His will was proved at only £1,310 18*s* 7*d*. He left £150 and the furniture in her room to his nurse Sarah Elizabeth Clarke. His pictures he left to his children, in order of seniority. This meant that his elder children, of his first marriage, got all the best things. His younger children, and especially the children of his second marriage, can only have got scraps. On 13 December Phillips Son and Neale held a house sale of the contents of 14 Clifton Villas, which realised £800. Frith clearly had lived too long, and had spent what capital he had managed to accumulate in his heyday. At his request, he was cremated, unusual at the time, and his ashes buried at Kensal Green Cemetery, where so many of his friends and contemporaries were already at rest.

In spite of Frith's great age, the number and length of his obituaries is quite staggering. Over 220 of them were carefully cut out and pasted into a scrapbook, probably by his eldest daughter, Isabelle, who married the wealthy Charles Oppenheim. It is from her that the most prominent members of the Frith family are descended, including a lord and a baronet. They still possess most of the Frith family portraits, albums and memorabilia, including the album of obituaries. What is amazing to the modern reader is the sheer number of newspapers and magazines in 1909, especially provincial ones. Almost every town seemed to have a newspaper and they carried long and laudatory obituaries for the great Yorkshire hero. Among the many now-forgotten papers are the *Preston Guardian*, *East Anglian Times*, *Burnley Gazette*, the *Nation*, *The Sphere*, *Globe*, *Truth*, the *Cork Examiner*, *Carlisle Journal*, *Midland Counties Express*, *Nottingham Guardian*, *Sheffield Independent*, *Liverpool Echo*, *Harrogate Advertiser*, *Leeds Budget*, and many more. All the major newspapers, including *The Times*, the *Daily Telegraph*, *Morning Post* and *Manchester Guardian* carried long obituaries, some covering a whole page. His death was even reported in some American papers.

The Yorkshire papers led the way in celebrating their famous son: the *Yorkshire Post* saluted Frith as 'one of the great Yorkshiremen', but said of his pictures, 'To most critics they seem to represent the extreme of philistinism in English art.'[11] The *Yorkshire Herald* took a similar line – 'he had outlived his fame. . . . But Mr Frith's turn will, we predict come again.'[12] The *Bristol Echo* was less optimistic; 'According to present day art criticism, Frith's works would be deemed unworthy of serious consideration. . . .'[13] The *Western Daily Mercury* went further '. . . his vogue has gone, and nowadays we generally associate his pictures (in the form of steel engravings) with the horse-hair sofas of a bygone day'.[14] The *Pall Mall Gazette* was even more patronising; of *Derby Day* it wrote: 'To modern eyes it appears stiff, conventional, and uninspired, and it is subject for wonder that it should ever have raised a <u>furore</u>, but it is still of great interest from the point of view of the social historian.'[15] The *Manchester Guardian* carried a long obituary, clearly written by someone who knew Frith, and described his appearance:

> . . . he seemed to me to suggest a Yorkshire horse-dealer. His long, thin-lipped, clean-shaven face, in which his shrewd eyes looked out with a watchful expression, the good out-of-doors complexion that remained with him until recent years, and the tight, wiry old figure, singled him out in a room of painters as a man unmarked by his craft.[16]

Many of the newspapers repeated the same stories about Frith's career; by 1909 Reuter's News Service was in operation, so inevitably many journalists picked up on the same episodes. Frith's youthful talent, and his desire to become an auctioneer rather than an artist; his early days at Sass's and the Royal Academy; his meeting with Dickens and Thackeray; *Sherry, Sir?*, his venture into modern-life subjects, his success with Prince Albert and Queen Victoria, Flatow and the engravings market – all these stories appeared again and again. Many remarked on his kindness and support for younger artists, and his attempts to help them when serving on the dreaded Hanging Committee at the Royal Academy. Many stories from Frith's *Autobiography* were retold, especially the one about Frith's self-portrait which he found in an antique shop, only to be told that the artist had died of drink. Most popular of all was the story of Frith painting the 'royal imp', the Crown Prince of Prussia. Just before he died, Frith gave an interview to a

magazine called *Answers*. After his death, they printed it, with the title 'The Man who washed the Kaiser'.[17] The article opened with the familiar tale of how Frith rubbed the young Crown Prince's face with turpentine, causing him to disappear under a table and bellow loudly for some considerable time. Frith had been dining out on this story for over forty years. The *Answers* article recounts many other familiar stories, about Turner and Munro of Novar, Dickens, the Duke of Wellington, Jacob Bell and Derby Day, Landseer and Millais, the infant prodigy at the RA Schools. All of these stories would have been familiar to readers of Frith's *Autobiography*.

The longest and most comprehensive review appropriately was *The Times*, which covered a whole page, in three columns. Frith would have been forgotten by now, claimed the obituarist, were it not for two things – *Derby Day*, hanging at the Tate Gallery, and his *Autobiography*, 'a record of the life and surroundings of a popular artist of the middle of the century which remains without a rival'. The author praised Frith's refreshingly down-to-earth and honest approach to art, and his modesty. He had demonstrated in his book that art was 'a profession like any other', and had cleared the public's mind of 'any mysterious and sacramental ideas in connexion with it'. It was the 'story of a busy, straightforward, and very practical life'. His pictures were popular, and did 'a great deal to arouse a sleepy public to the possibilities of art', but they also aroused fierce controversy.

The obituary went on to tell the now-famous story of Frith's life, in some detail. *Sherry, Sir?* is mentioned as his first modern-life picture, 'of which a print hung for years, and perhaps hangs still, in the coffee room of half the inns in England'. The most interesting paragraph of the obituary is that headed 'ARTISTS AND DEALERS'. Here the writer describes how art dealers began to dominate the picture business in the 1850s, mainly through their control of the engravings market. This not only gave the artists more money, but it freed them from dependence on the whims of private clients. Both Gambart and Flatow are mentioned; Flatow is described as 'the ugly little alien', a phrase which Frith would have deplored. But it was the dealers who gave the Victorian art world 'thirty years of prosperity'.

The obituary ended on rather a sour note. After describing Frith's great success with *Ramsgate Sands* and then *Derby Day*, the writer held back from venturing upon 'any of that art criticism which Frith was ungrateful enough to detest. Like other too successful

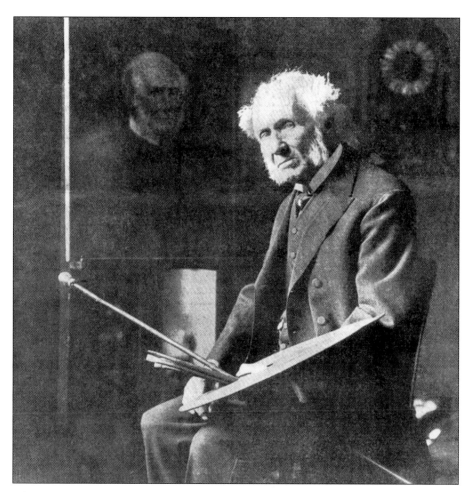

The Mirror, 1909. Photograph of Frith in old age, not long before his death on 2 November 1909.

painters, he was greedy of praise, and was at the same time apt to forget it while retaining a lively recollection of every form of censure.'[18] This sting in the tail of an otherwise good obituary seems to have an element of grudge about it. Perhaps the writer was an art critic, and had read Frith's scathing remarks about critics in his *Autobiography*.

The *Daily Telegraph* carried a long obituary, as well as a notice in its court pages, headed 'London Day by Day': 'The King has, through Colonel Sir Arthur Davidson, sent to Mr Walter Frith, a letter in which his Majesty is graciously pleased to convey to him the expression of his sincere sympathy on the death of his father, the late Mr. W.P. Frith,

CVO, RA.' The letter goes on to say 'The King had known him for many years, and always had the greatest regard for him. The King is glad to learn that the Order which his Majesty conferred on Mr Frith in recognition of his great talents was a source of pleasure to him in the last years of his life, as his Majesty felt it was thoroughly deserved.'[18]

There is a clear implication here that the King wished to make amends for his mother's failure to give Frith any honour or recognition for the *Marriage* picture. Both the CVO, and the letter, are evidence that the King both liked and admired Frith, and felt that he had been unfairly treated. He addressed the letter to Walter Frith, Frith's fifth son, but the one who wrote the article in the *Cornhill Magazine*, which the King had noticed in 1906. He had probably not even realised in 1906 that Frith was still alive.

Truth, a magazine which specialised in scandalous stories about prominent people, was the only one to refer to Frith's guilty secret: 'It was generally believed by those *en connaissance de cause* that a spoke had been put in the painter's wheel, for Frith had his enemies, and the work was effectively accomplished, for he was never again employed by Queen Victoria. . . .'[19] Someone at *Truth* clearly knew the truth. Yet Frith had managed to keep his secret to the end. His luck held.

By the time Frith died in 1909 his art was already out of date and forgotten. But after the First World War, it would get even worse. The fanatics of Bloomsbury dedicated themselves to the destruction of Victorian art in all its forms. Frith, along with the Pre-Raphaelites and the rest, were derided and dismissed; sacrificed on the altar of modernism. For fifty years the Victorians were consigned to outer darkness; prices plummeted – if any picture by Frith appeared at all, it would have sold for virtually nothing.

The prejudice against Victorian art ran deep, and took a long time to eradicate. The revival began in the 1950s, and has continued unabated to the present day. In 1951 a Frith exhibition was held at the Whitechapel Gallery, but only now, almost a hundred years after his death, will he finally receive his due.

Notes

Introduction

1. W.P. Frith, *My Autobiography and Reminiscences* (2 vols, Richard Bentley and Son, 1887), vol. 1, p. 7
2. Christopher Wood, *Fairies in Victorian Art* (Antique Collectors' Club, 2000), ch. 7
3. Richard Muther, *A History of Modern Painting* (4 vols, J.M. Dent & Co., 1907), vol. 2, pp. 88–91
4. Mary Cowling, *The Artist as Anthropologist* (Cambridge University Press, 1989)
5. Diana Macleod, *Art and the Victorian Middle Class* (Cambridge University Press, 1996)

1. The Wonder of High Harrogate

1. Frith, *Autobiography*, vol. 1, p. 5
2. Cowling, *Artist as Anthropologist*, p. 209
3. Frith, *Autobiography*, vol. 1, p. 9
4. *Ibid.*, p. 10
5. *Ibid.*, p. 15
6. *Ibid.*, p. 7
7. *Ibid.*, p. 12
8. *Ibid.*, p. 13
9. *Ibid.*, p. 14
10. *Ibid.*, p. 15
11. *Ibid.*, p. 20
12. *Ibid.*, p. 21
13. *Ibid.*, p. 22
14. *Ibid.*, p. 23
15. *Ibid.*, pp. 23–4
16. *Ibid.*, p. 27
17. *Ibid.*, pp. 27–9
18. *Ibid.*, p. 31
19. *Ibid.*, pp. 32–3
20. W.P. Frith, *Further Reminiscences* (Richard Bentley and Son, 1888), pp. 50–5
21. Frith, *Autobiography*, vol. 1, pp. 41–2

22. *Ibid.*, p. 46
23. *Ibid.*, p. 48
24. *Ibid.*, p. 55
25. *Ibid.*, p. 57
26. *Ibid.*, p. 57
27. *Ibid.*, pp. 60–1
28. *Ibid.*, p. 62
29. *Ibid.*, p. 65

2. Early Struggles and Successes

1. Frith, *Autobiography*, vol. 1, p. 78
2. *Ibid.*, p. 82
3. Published by Hutchinson, 1990, as *Neglected Genius – the Diaries of B.R. Haydon* (ed. John Joliffe)
4. Frith, *Autobiography*, vol. 1, p. 87
5. *Ibid.*, p. 93
6. *Ibid.*, p. 98
7. *Ibid.*, p. 100
8. *Ibid.*, p. 103
9. *Ibid.*, pp. 103–6
10. See Susan Casteras and Ronald Parkinson, *Richard Redgrave* (Yale University Press, 1988), catalogue of the exhibition at the Victoria and Albert Museum, and the Yale Center for British Art, 1988
11. Frith, *Autobiography*, vol. 1, pp. 106–8
12. *Ibid.*, p. 110
13. For details of Gibbons's collection see Diana Macleod, *Art and the Victorian Middle Class* (Cambridge University Press, 1996), p. 420
14. Frith, *Autobiography*, vol. 1, p. 116
15. *Ibid.*, p. 117
16. *Ibid.*, p. 119
17. *Ibid.*, p. 120
18. *Ibid.*, p. 120
19. The drawing, inscribed 'Benny', is in the collection of the British Museum
20. Jane Ellen Panton, *Leaves from a Life* (E. Nash, 1908), pp. 11–12

3. The Young Academician

1. Frith, *Autobiography*, vol. 1, p. 123
2. *Ibid.*, p. 125
3. *Ibid.*, p. 125
4. *Ibid.*, p. 127
5. *Ibid.*, p. 127
6. *Ibid.*, pp. 131–2
7. *Ibid.*, pp. 129–30

8. *Ibid.*, pp. 130–1
9. *Ibid.*, pp. 134–5
10. *Ibid.*, p. 135
11. *Ibid.*, pp. 137–9
12. Quoted in Paula Gillett, *The Victorian Painter's World* (Alan Sutton, 1990), pp. 200–1
13. Quoted in S. and R. Redgrave, *A Century of Painters of the British School* (Smith, Elder, 1866), vol. 2, ch. 3
14. Christopher Wood, *Victorian Panorama: Paintings of Victorian Life* (Faber & Faber, 1976, repr. 1990), see introduction pp. 9–18, and references under Frith
15. Macleod, *Art and the Victorian Middle Class*, pp. 452–3
16. Frith, *Autobiography*, vol. 1, p. 185
17. *Ibid.*, p. 192
18. Macleod, *Victorian Middle Class*, pp. 432–3
19. *Ibid.*, pp. 473–4
20. Frith, *Autobiography*, vol. 1, pp. 218–19
21. See Report and Accounts of Williams and Humbert, 1957
22. Frith, *Autobiography*, vol. 1, pp. 220–4
23. *Ibid.*, p. 224
24. Quoted in Frith, *Autobiography*, vol. 1, pp. 237–8

4. Life at the Seaside

1. For more information about the Sambourne family, see Shirley Nicholson, *A Victorian Household* (based on the diaries of Marion Sambourne), (Sutton Publishing, 2005)
2. Frith, *Autobiography*, vol. 1, p. 243
3. Cowling, *Artist as Anthropologist*, pp. 216–18
4. Simon Houfe, *John Leech and the Victorian Social Scene* (Antique Collectors' Club, 1984), p. 121
5. The name of Richard Llewellyn is mentioned in Sir Oliver Millar, *The Victorian Pictures in the Collection of Her Majesty the Queen* (Cambridge University Press, 1992), p. 75
6. Christopher Lloyd, *Ramsgate Sands: Life at the Seaside* (National Gallery Publications, 1999), pp. 200–1
7. Frith, *Autobiography*, vol. 1, p. 247
8. *Ibid.*, p. 249
9. *Ibid.*, pp. 250–1
10. The whole question of art and anthropology has been researched by Mary Cowling, *The Artist as Anthropologist* (Cambridge University Press, 1989)
11. Frith, *Autobiography*, vol. 1, pp. 253–4
12. *Ibid.*, p. 252
13. *Ibid.*, p. 253
14. *Ibid.*, p. 254
15. *Ibid.*, p. 255

16. *Ibid.*, p. 257
17. *Ibid.*, p. 258
18. *Art Journal*, June 1854, p. 161
19. *Ibid.*, p.161
20. Frith, *Autobiography*, vol. 1, p. 246
21. *Punch* XXX, 19 April 1856
22. Frith, *Autobiography*, vol. 1, p. 263
23. John Ruskin, *Academy Notes*, 1856, no. 131
24. Frith, *Autobiography*, vol. 1, p. 269
25. J. Maas, *The Prince of Wales's Wedding: The Story of a Picture* (Cameron and Tayleur, 1977), p. 43
26. Panton, *Leaves*, p. 9
27. Letter to J.C. Horsley, 6 November 1855 (Bodleian Library MS Eng 2221 fols 213–15)

5. Life in the Frith Family

1. Jane Ellen Panton, *More Leaves from a Life* (E. Nash, 1911), pp. 186–7
2. Panton, *Leaves*, p. 9
3. *Ibid.*, p. 23
4. *Ibid.*, p. 128
5. *Ibid.*, pp. 4–5
6. *Ibid.*, pp. 7–8
7. *Ibid.*, p. 23
8. *Ibid.*, p. 27
9. *Ibid.*, p. 28
10. *Ibid.*, pp. 27–8
11. *Ibid.*, pp. 29–30
12. *Ibid.*, p. 29
13. *Ibid.*, p. 14
14. *Ibid.*, p. 58
15. *Ibid.*, pp. 87–111
16. *Ibid.*, p. 76. (The pictures are illustrated in Wood, *Panorama*, pp. 140–1)
17. *Ibid.*, pp. 79–81
18. *Ibid.*, pp. 88–9
19. *Ibid.*, pp. 89–93
20. *Ibid.*, pp. 93–9
21. *Ibid.*, pp. 99–103
22. *The Arrival of Princess Alexandra* is now in the National Maritime Museum at Greenwich. *Eastward Ho!*, in the Proby Collection, is illustrated, along with *Home Again*, in Wood, *Panorama*, plates 245–6
23. Panton, *Leaves*, pp. 103–5
24. *Ibid.*, pp. 107–8
25. *Ibid.*, pp. 108–11
26. George Dunlop Leslie and George Adolphus Storey

27. John Evan Hodgson, William Frederick Yeames and Henry Stacy Marks
28. Panton, *Leaves*, pp. 129–31

6. Derby Day

1. G. Doré and B. Jerrold, *London – A Pilgrimage* (Grant & Co., 1872, repr. 1970)
2. *Illustrated London News*, 23 May 1866, p. 566
3. Derek Hudson, *Munby – Man of Two Worlds* (John Murray, 1972), p. 162
4. Frith, *Autobiography*, vol. 1, p. 162
5. *Ibid.*, p. 272
6. *Journal of the Royal Photographic Society*, no. 129, 15 January 1863, p. 204
7. Cowling, *Artist as Anthropologist*, p. 268
8. Frith, *Autobiography*, vol. 1, pp. 275–8
9. *Ibid.*, p. 278
10. *Ibid.*, p. 279
11. *Ibid.*, p. 280
12. *Ibid.*, pp. 280–2
13. A study for one of these, with a drawing by Landseer, is in the British Museum, as is Frith's drawing for the acrobat. Also see Cowling, *Artist as Anthropologist*, p. 273
14. Frith *Autobiography*, vol. 1, p. 283
15. *Ibid.*, pp. 284–5
16. Cowling, *Artist as Anthropologist*, pp. 236–7, with diagrams of all the figures
17. Cowling, *Artist as Anthropologist*, pp. 349–50
18. *Daily News*, 3 May 1858, p. 3
19. *Morning Herald*, 1 May 1858, p. 6
20. *Daily News*, 3 May 1858, p. 3
21. Frith, *Autobiography*, vol. 1, p. 285
22. *Ibid.*, pp. 286–7
23. *Ibid.*, p. 289
24. *Ibid.*, p. 289
25. *Ibid.*, p. 285–6
26. John Ruskin, *Academy Notes*, 1858, no. 218, pp. 137–8
27. 'The Arts Season', *Art Journal*, October 1858, p. 296
28. *The Athenaeum*, 1 May 1858, p. 565
29. *Saturday Review*, 15 May 1858, p. 501; 22 May 1858, p. 528
30. J. Maas, Gambart, *Prince of the Victorian Art World* (Barrie and Jenkins, 1975), ch. 10
31. Frith, *Autobiography*, vol. 1, pp. 296–7
32. *Ibid.*, pp. 297–8
33. *Ibid.*, p. 296
34. *Ibid.*, pp. 299–300
35. *Ibid.*, pp. 306–7
36. *Saturday Review*, 19 May 1860, p. 641
37. Frith, *Autobiography*, vol. 1, p. 307

38. *Ibid.*
39. *Ibid.*, p. 309
40. *Ibid.*, p. 313
41. *Ibid.*, p. 314
42. *Ibid.*, p. 309
43. *Ibid.*, p. 317
44. *The Athenaeum*, 30 April 1859, p. 587
45. *Art Journal*, June 1859, p. 165

7. *The Railway Station*

1. See Cowling, *Artist as Anthropologist*, pp. 239–40
2. H. Mayhew, *London Characters and the Humorous Side of London Life* (Stanley Rivers & Co., 1874)
3. The first version of *First Class* is in the National Gallery of Canada, Ottawa; there are several versions of the second version, one in the Lloyd Webber Collection.
4. Wood, *Panorama*, ch. 26
5. Frith, *Autobiography*, vol. 1, p. 327
6. British Railways Board. See Cowling, *Artist as Anthropologist*, p. 272
7. Frith, *Autobiography*, vol. 1, p. 329
8. Frith, *Autobiography*, vol. 1, p. 328
9. Helmut Gernsheim, *Masterpieces of Victorian Photography 1840–1900* (The Arts Council of Great Britain, 1951), p. 12
10. Tom Taylor, *The Railway Station* (1862), p. 7
11. W.M. Rossetti, *Fine Art, Chiefly Contemporary* (1867), p. 265
12. Frith, *Autobiography*, vol. 1, p. 330
13. Anon., *Familiar Things* (2 vols, *c.* 1845), vol. 1, p. 117
14. Taylor, *Railway Station*, p. 17
15. 'Fine Arts: Mr Frith's Railway Station', *Observer*, 20 April 1862, p. 6
16. Taylor, *Railway Station*, p. 13
17. 'Mr Frith's Railway Station', *The Athenaeum*, 12 April 1862, p. 503
18. 'Notes on Art: Frith's Railway Station', *Sunday Times*, 4 May 1862, p. 6; for other reviews, see Cowling, *Artist as Anthropologist*, pp. 310–11
19. Frith, *Autobiography*, vol. 1, opp. pp. 334–5
20. Panton, *Leaves*, p. 119
21. The Journals of Walter White (1898), p. 180
22. Macleod, *Art and the Victorian Middle Class*, pp. 405–6
23. *The Athenaeum*, 25 July 1863, p. 113
24. J. Chapel, *Victorian Taste – the complete catalogue of paintings at the Royal Holloway College* (A. Zwemmer, 1982)
25. Frith, *Autobiography*, vol. 1, p. 334
26. *Art Journal*, May 1862, p. 122
27. 'Mr Frith's New Picture', *Weekly Despatch*, 20 April 1862, p. 10
28. 'Mr Frith's Great Picture of the Railway Station', *Era*, 11 May 1862, p. 6
29. *Saturday Review*, 4 June 1862, p. 683

8. *Frith and his Patrons*

1. Millais' letter 'To the Art Student', 29 May 1875. Pierpont Morgan Library, New York.
2. Panton, *Leaves*, pp. 112 ff
3. *Ibid.*, p. 24
4. Quoted in Sir Charles Lock Eastlake, *Contributions to the Literature of the Fine Arts*, with a memoir compiled by Lady Eastlake, 2nd edn (London, 1870), p. 147
5. For a comprehensive survey and analysis of Victorian collectors, see Diana Macleod, *Art and the Victorian Middle Class* (Cambridge University Press, 1996)
6. Gustav Waagen, *Works of Art and Artists in England* (3 vols, 1838)
7. Macleod, *Art and the Victorian Middle Class*, pp. 341, 344 and pl. 64
8. *Ibid.*, p. 421
9. Jeannie Chapel, 'The Turner Collector Joseph Gillot 1799–1872' in *Turner Studies*, no. 6 (Winter 1986), pp. 43–50
10. Macleod, *Art and the Victorian Middle Class*, p. 421
11. Frith, *Further Reminiscences*, ch. 10, pp. 196–215
12. Christopher Wood, *The Pre-Raphaelites* (Weidenfeld & Nicolson, 1981), p. 13
13. Christopher Wood, *Panorama*, p. 127, pl. 128
14. For details of Gibbons's collections, see Macleod, *Art & the Victorian Middle Class*, p. 420
15. *Ibid.*, p. 395
16. Frith, *Autobiography*, vol. 1, p. 213
17. Macleod, *Art and the Victorian Middle Class*, pp. 458–9
18. *Ibid.*, p. 390
19. See letters from Frith to Miller, Frith Letters in the Royal Academy Library, London
20. Macleod, *Art and the Victorian Middle Class*, p. 411
21. *Ibid.*, p. 400
22. *Ibid.*, pp. 413–14
23. Wood, *Pre-Raphaelites*, p. 68
24. Frith, *Autobiography*, vol. 1, p. 368
25. W.M. Rossetti, Rossetti Papers 1862–70 (1903), letter dated 25 July 1867
26. Christie's sale, 6 June 1891
27. Frith, *Autobiography*, vol. 1, pp. 225–6
28. *Ibid.*, p. 226
29. *Ibid.*, p. 318
30. Macleod, *Art and the Victorian Middle Class*, p. 436
31. *Ibid.*, pp. 424–5
32. *Ibid.*, Appendix, pp. 382 ff
33. Frith, *Autobiography*, vol. 1, ch. 12, pp. 143–51
34. Christopher Wood, *Fairies in Victorian Art*, ch. 7

9. Thomas Miller of Preston

1. All the quotations from letters in this chapter, unless otherwise stated, are from the collection of Frith letters in the Royal Academy Library, London.
2. For details of the Miller collections, see Macleod, *Art and the Victorian Middle Class*, pp. 452–3
3. Frith, *Autobiography*, vol. 1, pp. 155–7
4. For further discussion of this subject, see C. Wood, *Paradise Lost: Victorian Paintings of Landscape and Country Life* (Barrie & Jenkins, 1988)
5. Frith, *Autobiography*, vol. 1, pp. 155–6
6. *Art Journal*, February 1857, pp. 41–2
7. Gustav Waagen, *Treasures of Art in Great Britain* (3 vols, 1854); in the end Miller was not listed in the book.
8. Macleod, *Art and the Victorian Middle Class*, p. 428
9. Christie's, 26 April 1946, lots 1–117

10. The Marriage of the Prince of Wales

1. Frith, *Autobiography*, vol. 1, pp. 338–9
2. A copy of the contract survives in the possession of Mrs Fairbairn and her descendants, who own the three sketches. Details of the contract are quoted by Jeremy Maas in *Gambart*, p. 158
3. The three Frith pictures are illustrated in Wood, *Panorama*, pp. 146–8
4. Frith, *Autobiography*, vol. 1, p. 336
5. *Ibid.*, p. 336
6. *Ibid.*, p. 337
7. *Ibid.*, p. 337
8. Printed in full in Maas, *Prince of Wales's Wedding*; also see Sir Oliver Millar, *The Victorian Pictures in the Collection of Her Majesty The Queen* (Cambridge University Press, 1992), pp. 68–73, no. 239
9. Frith, *Autobiography*, vol. 1, p. 337
10. The letter, in the possession of the Frith family, is quoted in full in Maas, *Prince of Wales's Wedding*, p. 16
11. The seating plan is illustrated in Maas, *Prince of Wales's Wedding*, p. 33
12. *Ibid.*, p. 29
13. Henry Vizetelly, *Glances back through Seventy Years*, 1893, vol. II, p. 77
14. Frith, *Autobiography*, vol. 1, p. 340
15. Maas, *Prince of Wales's Wedding*, pp. 37–9
16. *Ibid.*, pp. 40–1
17. Frith, *Autobiography*, vol. 1, p. 340
18. *Ibid.*, p. 343
19. Letter dated 23 August 1863. Quoted in Frith, *Autobiography*, vol. 1, p. 344
20. Letter quoted in full in Maas, *Prince of Wales's Wedding*, p. 52
21. Maas, *Prince of Wales's Wedding*, p. 59, taken from T. Matthews, *The Biography of John Gibson RA* (1911); also see Frith, *Autobiography*, vol. 1, pp. 348–50

22. This is still in the Royal Collection – see Millar, *The Victorian Pictures in the Collection of HM The Queen*, p. 73, no. 240
23. Quoted in Maas, *Prince of Wales's Wedding*, p. 60
24. Frith, *Autobiography*, vol. 1, pp. 351–3
25. Quoted in Maas, *Prince of Wales's Wedding*, pp. 71–2
26. *Ibid*., p. 86
27. *Ibid*., p. 88
28. *Ibid*.
29. *Ibid*.
30. *Ibid*., p. 93
31. *Art Journal*, 1 May 1865, p. 157, quoted in Maas, *Prince of Wales's Wedding*, p. 90
32. *Morning Post*, 29 April 1865, p. 6
33. *Daily Telegraph*, 6 May 1865
34. *Spectator*, 13 May 1865
35. *The Athenaeum*, 29 April 1865, p. 593
36. *Art Journal*, 1 June 1865, p. 167
37. Frith, *Autobiography*, vol. 1, p. 368

11. *John Leech, Shirley Brooks and Punch*

1. Frith, *Autobiography*, vol. 2, ch. 24
2. W.P. Frith, *John Leech, His Life and Work* (2 vols, Richard Bentley and Son, 1891)
3. All the Leech quotations are from Frith, *Autobiography*, vol. 2, ch. 24, pp. 296–302
4. Now in the National Portrait Gallery
5. Panton, *Leaves*, pp. 194–200
6. Frith, *Autobiography*, vol. 1, p. 180
7. Frith, *Further Reminiscences*, pp. 219–22
8. *Ibid*., ch. 16, pp. 270–93
9. Quoted in Panton, *Leaves*, p. 171, with slight differences, and a different last line: 'And all is up with I'. Also quoted as here, in G.S. Layard, *A Great Punch Editor* (Isaac Pitman and Sons, 1907), p. 144
10. Frith, *Further Reminiscences*, ch. 16, and Layard, *Great Punch Editor*, pp. 151–3
11. Frith, *Autobiography*, vol. 2, p. 260
12. Frith letters in the National Art Library, Victoria and Albert Museum, London, vol. 4
13. Frith, *Further Reminiscences*, pp. 387–8
14. Layard, *Great Punch Editor*, p. 258
15. *Ibid*., pp. 259–67
16. *Ibid*., p. 270
17. *Ibid*., p. 302
18. Panton, *Leaves*, p. 159
19. *Ibid*., p. 161

20. *Ibid.*, pp. 162–3
21. *Ibid.*, pp. 165–6
22. Layard, *Great Punch Editor*, pp. 576–86

12. *Pictures, Actors and an Explosion*

1. Frith, *Autobiography*, vol. 1, p. 360
2. Illustrated in Maas, *Gambart*, opp. p. 97
3. Quoted in Maas, *Gambart*, p. 190
4. Panton, *Leaves*, pp. 114–16
5. For a full account of the explosion, see Maas, *Gambart*, ch. 19; for Cissie's version, see Panton, *Leaves*, pp. 115–17
6. Reproduced in Maas, *Gambart*, opp. p. 160
7. G.A. Storey, *Sketches from Memory* (Chatto & Windus, 1899), pp. 323–4
8. Leathart Family Papers, quoted in Maas, *Gambart*, p. 206
9. Quoted in *The Hardman Papers: A Further Selection* (1930), p. 293; also in Maas, *Gambart*, p. 206
10. Macleod, *Art and the Victorian Middle Class*, pp. 444–5
11. Frith, *Autobiography*, vol. 1, p. 374
12. *Art Journal*, 1 June 1867, p. 137
13. *The Athenaeum*, 4 May 1867, p. 593
14. Frith, *Autobiography*, vol. 2, ch. 16, pp. 228–39
15. Panton, *Leaves*, p. 293. The artists referred to are Philip Hermogenes Calderon (1833–98), George Adolphus Storey (1834–1919) and George du Maurier (1834–96). Sothern was the actor, Henry Sothern; the Twisses are unknown.
16. Panton, *Leaves*, pp. 294–5. Pugin's house is now the property of the Landmark Trust.
17. *Ibid.*, p. 296
18. Macleod, *Art and the Victorian Middle Class*, pp. 450–1
19. Frith, *Autobiography*, vol. 1, pp. 385–9
20. *Ibid.*, pp. 382–3
21. *Ibid.*, pp. 6–7
22. *Ibid.*, p. 13

13. *The Search for Subjects*

1. Both are reproduced in Wood, *Panorama*, pp. 44, 47
2. Frith, *Autobiography*, vol. 1, pp. 14–16
3. Rhode Island School of Design. A smaller version, probably a sketch, was at Newman's Gallery, London, in 1962, but is now in the National Gallery of Canada.
4. *Saturday Review*, 20 May 1871, p. 634
5. *The Times*, 29 April 1871, p. 12
6. *Illustrated London News*, 6 May 1871, p. 447

7. *Art Journal*, 1871, p. 153
8. *The Athenaeum*, 29 April 1871, p. 533
9. Frith, *Autobiography*, vol. 1, p. 17
10. *The Athenaeum*, 4 June 1870, p. 737
11. *The Times*, 30 April 1870, p. 12
12. Frith, *Autobiography*, vol. 2, p. 17
13. *Ibid.*, p. 24
14. *Ibid.*, p. 24
15. *Ibid.*, p. 26
16. *Ibid.*, p. 27
17. *The Athenaeum*, 2 May 1874, p. 600
18. *Saturday Review*, 2 May 1874, p. 561
19. Frith, *Autobiography*, vol. 2, p. 30
20. *Ibid.*, p. 28
21. *Ibid.*, pp. 38–41
22. *Ibid.*, pp. 46–50
23. *The Athenaeum*, 10 May 1873, p. 605
24. *Art Journal*, 1873, p. 167
25. *The Times*, 5 May 1873, p. 12
26. *The Athenaeum*, 15 May 1875, p. 660
27. Frith, *Autobiography*, vol. 2, p. 54

14. The Grand Tour

1. Frith, *Autobiography*, vol. 1, pp. 69–70
2. Maas, *Gambart*, p. 250 *et passim*
3. Frith, *Autobiography*, vol. 1, p. 68. All the other quotations in this chapter are quoted in Frith, *Autobiography*, vol. 2, pp. 64–99

15. The Road to Ruin

1. Frith, *Autobiography*, vol. 2, pp. 56–63
2. *Ibid.*, pp. 116–18
3. *Ibid.*, pp. 119–21
4. *Ibid.*, pp. 123–4
5. See Susan P. Casteras and Colleen Denny (eds), *The Grosvenor Gallery, A Palace of Art in Victorian England* (Yale University Press, 1996)
6. Frith, *Autobiography*, vol. 2, p. 121
7. *Ibid.*, p. 122
8. This and the other *Road to Ruin* pictures are illustrated in Wood, *Panorama*, pls 36–40
9. Frith, *Autobiography*, vol. 2, pp. 115–30
10. *The Athenaeum*, 11 May 1878, p. 60
11. *Art Journal*, 1878
12. *Illustrated London News*, 4 May 1878, p. 410

13. *The Times*, 4 May 1878, p. 12
14. *Punch*, 18 May 1978, p. 225

16. The Whistler v. Ruskin Trial

1. For a full account see Casteras and Denny, *The Grosvenor Gallery*
2. For a full account, see Linda Merrill, *The Peacock Room – A Cultural Biography* (Smithsonian Institution, 1998)
3. All the quotations from Henry James can be found in Rupert Hart-Davis, *The Painter's Eye, Henry James, Notes and Essays in the Pictorial Arts* (1956), pp. 161–82
4. The quotations in this chapter are all taken from Linda Merrill, *A Pot of Paint: Aesthetics on Trial in Whistler v. Ruskin* (Smithsonian Institution, 1992), pp. 110–18, 176–8 *et passim*. A full description of the trial is included.
5. Merrill, *Pot of Paint*, p. 116. The notes are in the Whistler–Pennell Archive
6. *Magazine of Art*, vol. XI, 1888, pp. 187–91
7. For a discussion of this question see Tim Barringer, *Men at Work – Art and Labour in Victorian Britain* (Yale University Press, 2004), pp. 313–21 *et passim*.

17. The Race for Wealth

1. Frith, *Autobiography*, vol. 2, p. 141
2. *Ibid.*, p. 141, for a description of all five pictures
3. *Ibid.*, p. 149
4. *Ibid.*, p. 152
5. *Ibid.*, p. 152
6. *Ibid.*, p. 152
7. *The Times*, 22 April 1880
8. *Art Journal*, vol. XIX, 1880, p. 207
9. Frith, *Autobiography*, vol. 2, p. 193
10. *Ibid.*, p. 196
11. *Ibid.*, p. 195

18. For Better, For Worse

1. Panton, *Leaves*, p. 9
2. Frith, *Autobiography*, vol. 2, p. 38
3. *Ibid.*, p. 38
4. *Art Journal*, 1881, p. 185
5. Both are now in the Geffrye Museum, London.
6. In the collection of Lord Lloyd Webber
7. Tate Gallery, London
8. *The Athenaeum*, 7 May 1881, p. 628
9. *Illustrated London News*, 7 May 1881, p. 459

10. *The Times*, 20 April 1881, p. 10
11. Frith, *Autobiography*, vol. 2, ch. 15

19. A Private View at the Royal Academy

1. All the Frith quotations in this chapter are taken from Frith, *Autobiography*, vol. 2, ch. 19, pp. 256–62
2. *Ibid.*, pp. 252–8
3. Letters are quoted in Frith, *Autobiography*, vol. 2, pp. 259–60
4. Frith, *Autobiography*, vol. 2, p. 335
5. *Saturday Review*, 5 May 1883
6. *The Athenaeum*, 26 May 1883, p. 673
7. *The Times*, 5 May 1883, p. 12

20. Frith the Writer

1. Frith, *Further Reminiscences*, p. 3
2. *The Athenaeum*, 22 October 1887, pp. 529–30
3. *Saturday Review*, 5 November 1887, pp. 631–2
4. *Blackwood's Magazine*, January 1886, pp. 123–7
5. Frith, *Autobiography*, vol. 1, p. 7
6. *Ibid.*, vol. 1, pp. 75–6
7. Frith, *Further Reminiscences*, p. 12
8. *Ibid.*, pp. 79–84
9. Frith, *Autobiography*, vol. 2, pp. 337–8
10. Frith, *Further Reminiscences*, pp. 320–1
11. *Ibid.*, pp. 35–6
12. Frith, *Autobiography*, vol. 2, pp. 110–12
13. *Ibid.*, pp. 100–14
14. *Ibid.*, pp. 312–15
15. Frith, *Further Reminiscences*, p. 304
16. *Ibid.*, pp. 363–4; also Frith, *Autobiography*, vol. 2, pp. 116–18
17. Frith, *Autobiography*, vol. 2, pp. 124–5
18. *Ibid.*, ch. 12, pp. 199–207
19. *Ibid.*, ch. 17, pp. 240–7
20. *Ibid.*, ch. 9, pp. 154–83
21. *Ibid.*, ch. 14, pp. 215–19
22. *Ibid.*, ch. 18, pp. 248–55
23. *Ibid.*, ch. 28, pp. 323–9
24. Frith letters in the National Art Library, V&A; see letters from Shirley Brooks
25. L. Jopling, *Twenty Years of My Life* (John Lane, 1925), pp. 10–11
26. *Ibid.*, pp. 32–3
27. Frith, *Autobiography*, vol. 2, pp. 140–1
28. *Ibid.*, ch. 7, pp. 131–7

29. Frith, *Autobiography*, vol. 1, pp. 323–4
30. *Ibid.*, p. 387
31. Frith, *Autobiography*, vol. 2, pp. 340–4
32. *Ibid.*, pp. 182–3
33. Frith, *Autobiography*, vol. 1, pp. 297–8
34. Frith, *Further Reminiscences*, pp. 71–2
35. *Ibid.*, ch. 4, pp. 85–101
36. *Ibid.*, pp. 177–95
37. Frith, *Autobiography*, vol. 2, ch. 10, pp. 184–92
38. Frith, *Autobiography*, vol. 1, p. 316
39. Frith, *Further Reminiscences*, ch. 12, pp. 229–37
40. Frith, *Autobiography*, vol. 1, p. 121
41. Frith, *Further Reminiscences*, pp. 102–5
42. *Ibid.*, pp. 298–9
43. Frith, *Autobiography*, vol. 2, p. 352

21. *Old Age*

1. Frith *Autobiography*, vol. 1, pp. 274–5
2. Victoria and Albert Museum, MSS Frith, letter from Millais to Frith
3. *Magazine of Art*, vol. XI, 1888, pp. 187–91
4. Frith, *John Leech*
5. Houfe, *John Leech*
6. Walter Frith, 'A Talk with my Father', *Cornhill Magazine*, vol. XX, May 1906
7. MSS of Stanhope Forbes, Penzance Library, 'Some Story Painters'. (Paper delivered at the Penzance Library, Thursday 24 January 1935)
8. E.F. Benson, *As We Were: a Victorian Peep-show* (Longmans Green, 1930) p. 217
9. *The Sphere*, 18 January 1908
10. *The Graphic*, 18 January 1908
11. *Yorkshire Post*, 3 November 1909
12. *Yorkshire Herald*, 7 November 1909
13. *Bristol Echo*, 2 November 1909
14. *Western Daily Mercury*, 3 November 1909
15. *Pall Mall Gazette*, 4 November 1909
16. *Manchester Guardian*, 3 November 1909
17. *Answers*, 27 November 1909
18. *The Times*, 3 November 1909
19. *Daily Telegraph*, 9 November 1909
20. *Truth*, 10 November 1909

Bibliography

PRIMARY SOURCES

Manuscripts

MSS W.P. Frith: 223 letters to Frith and his wife. National Art Library, Victoria and Albert Museum, London. Misc. 13466

MSS W.P. Frith: 105 letters to M.H. Spielman. John Rylands Library, Manchester

MSS W.P. Frith: 20 letters to his great-nephew R. Raine; one to his sister Jane; one to Frith from A.M. Raine. North Yorkshire County Library, Harrogate, Yorkshire

MSS W.P. Frith: Approx. 170 letters by W.P. Frith to Thomas Miller of Preston. Royal Academy, London

MSS W.P. Frith: Letters. British Library, London. Additional MSS

Frith letters, photographs, obituaries, etc. in the possession of the Frith family

Published material

Benson, E.F. *As We Were: a Victorian Peep-show*, Longmans Green, 1930

Cope, C.H. *Reminiscences of C.W. Cope RA*, Richard Bentley and Son, 1891

Forster, John. *Life of Dickens 1872–4*, Chapman & Hall, 1918

Frith, Walter. 'A Talk with my Father', *Cornhill Magazine* no. 119, vol. XX, May 1906, pp. 597–607

Frith, William Powell. *My Autobiography and Reminiscences*, 2 vols, Richard Bentley and Son, 1887

——. *Further Reminiscences*, Richard Bentley and Son, 1888

——. 'Crazes in Art, Pre-Raphaelitism and Impressionism', *Magazine of Art*, 1888, vol. XI, pp. 187–91

——. *John Leech, His Life and Work*, 2 vols, Richard Bentley and Son, 1891

——. *A Victorian Canvas, The Memoirs of W.P. Frith, RA*, ed. Neville Wallis, Geoffrey Bles, 1957

Goodall, Frederick. *Reminiscences*, Walter Scott Publishing, 1902

Graves, Algernon. Royal Academy of Arts: *A Complete Dictionary of Contributors and their Work from its Foundation in 1769 to 1904*, S.R. Publishers, 1905

Hall, S.C. *Retrospect of a Long Life 1815–1883*, Richard Bentley and Son, 1883

Jopling, Louise. *Twenty Years of my Life*, John Lane, 1925

Layard, G.S. *A Great 'Punch' Editor: Being the Life, Letters and Diaries of Shirley Brooks*, Sir Isaac Pitman and Sons, 1907

Leslie, Charles Robert. *Autobiographical Recollections*, 2 vols, Ticknor and Fields, 1860

Millais, J.G. *The Life and Letters of Sir J.E. Millais Bt*, 2 vols, Methuen, 1899

Muther, Richard. *History of Modern Painting*, 4 vols, J.M. Dent, 1907

Panton, Jane Ellen (née Frith). *Leaves from a Life*, E. Nash, 1908

——. *More Leaves from a Life*, E. Nash, 1911

Perugini, M.E. *Victorian Days and Ways*, Jarrolds, 1936

Redgrave, F.M. *Richard Redgrave, A Memoir*, Cassell, 1891

Ruskin, John. *Academy Notes 1855–59*, G. Allen, 1875

Sala, George Augustus. *Twice Round the Clock; or The Hours of Day and Night in London*, J. and R. Maxwell, 1859

Scott, William Bell. *Autobiographical Notes of the Life of W.B. Scott*, 2 vols, Osgood, McIlvaine & Co., 1892

Stephens, Frederick George. *Memorials of William Mulready*, Bell and Daldy, 1867

Ward, Mrs H.M.A. *Memories of Ninety Years*, Hutchinson, 1924

SECONDARY SOURCES

Allderidge, Patricia. *The Late Richard Dadd 1817–1886*, Tate Gallery Publications, 1974

Ames, Winslow. *Prince Albert and Victorian Taste*, Chapman & Hall, 1967

Beck, H. *Victorian Engravings*, Victoria and Albert Museum, 1973

Casteras, Susan P. *The Substance and the Shadow: Images of Victorian Womanhood*, Yale University Press, 1982

Chapel, Jeannie. *Victorian Taste, The Complete Catalogue of Paintings at the Royal Holloway College*, A. Zwemmer, 1982

Cowling, Mary C. *The Artist as Anthropologist: The Representation of Type and Character in Victorian Art*, Cambridge University Press, 1989

Davis, Frank. *Victorian Patrons of the Arts*, Country Life, 1963

Engen, Rodney. *Victorian Engravings*, Academy Editions, 1975

Forbes, Christopher. *The Royal Academy Revisited; Victorian Paintings from the Forbes Magazine Collection*, Princeton University Press, 1973; and Metropolitan Museum 1975

Gaunt, William. *The Restless Century: Painting in Britain 1800–1900*, Phaidon, 1972

Gillett, Paula. *The Victorian Painter's World*, Alan Sutton, 1990

Gordon, Catherine M. *British Paintings of Subjects from the English Novel 1740–1870*, Garland, 1988

Guise, Hilary. *Great Victorian Engravings: A Collector's Guide*, Astragal Books, 1980

Heleniak, K.M. *William Mulready*, Yale University Press, 1980

Houfe, Simon. *John Leech and the Victorian Scene*, Antique Collectors' Club, 1984

Hutchison, Sidney C. *The History of the Royal Academy 1768–1968*, Chapman & Hall, 1968

Johnson, Prof. E.D.H. *Paintings of the British Social Scene: from Hogarth to Sickert*, Weidenfeld & Nicolson, 1986

Lambourne, Lionel. *Victorian Painting*, Phaidon, 1999

Lister, Raymond. *Victorian Narrative Paintings*, Museum Press, 1966

Maas, Jeremy. *Gambart, Prince of the Victorian Art World*, Barrie & Jenkins, 1975

——. *The Prince of Wales's Wedding: The Story of a Picture*, Cameron and Tayleur, 1977

——. *Victorian Painters*, Barrie & Jenkins, 1970, repr. USA 1984

Macleod, Diana. *Art and the Victorian Middle Class*, Cambridge University Press, 1996

Merrill, Linda. *A Pot of Paint: Aesthetics on trial in Whistler v. Ruskin*, Smithsonian Institution Press, 1992

Millar, Sir Oliver. *The Victorian Pictures in the Collection of Her Majesty the Queen*, 2 vols, Cambridge University Press, 1992

Noakes, Aubrey. *William Frith, Extraordinary Victorian Painter*, Jupiter Books, 1978

Ormond, Leonée. *George du Maurier*, Routledge & Kegan Paul, 1969

Parkinson, Ronald. *Victoria and Albert Museum: Catalogue of British Oil Paintings 1820–1860*, HMSO, 1990

Reynolds, Graham. *Painters of the Victorian Scene*, B.T. Batsford, 1953

——. *Victorian Painting*, Studio Vista, 1966

Rosenblum, Robert. *Nineteenth Century Art*, Abrams, 1984

Scharf, Aaron. *Art and Photography*, Allen Lane, 1968

Sitwell, Sacheverell. *Narrative Pictures: A Survey of English Genre and its Painters*, B.T. Batsford, 1937

Strong, Roy. *And when did you last see your Father?* Thames & Hudson, 1978

Tillotson, K. (ed.) *The Letters of Charles Dickens*, Oxford University Press, 1978

Treuherz, Julian. *Hard Times: Social Realism in Victorian Art*, Lund Humphries, 1987

——. *Victorian Painting*, Thames & Hudson, 1993

Wood, Christopher. 'The Dickens Sale, 9 July 1970' in *Christie's Review of the Year 1969–70*, ed. John Herbert, 1970

——. *Dictionary of Victorian Painters*, 1st edn, Antique Collectors' Club, 1971; repr. 1978, 1995, 2006

——. *Victorian Painting*, Weidenfeld & Nicolson, 1999

——. *Victorian Panorama: Paintings of Victorian Life*, Faber & Faber, 1976, repr. 1990

Index

Italics denote illustrations